Pen vs. Paintbrush

PEN VS. PAINTBRUSH

Girodet, Balzac and the Myth of Pygmalion
in Postrevolutionary France

Alexandra K. Wettlaufer

palgrave

First published 2001 by
PALGRAVE™
175 Fifth Avenue, New York, NY 10010 and
Houndmills, Basingstoke, Hampshire, England RG21 6XS.
Companies and representatives throughout the world.

Palgrave is the new global publishing imprint of St Martin's Press LLC Scholarly
and Reference Division and Palgrave Publishers Ltd (formerly Macmillan Press
Ltd).
ISBN 0-312-23641-7 hardback
Library of Congress Cataloging-in-Publication Data
Wettlaufer, Alexander.
 Pen vs. paintbrush : Girodet, Balzac, and the myth of Pygmalion in
postrevolutionary France by Alexandra K. Wettlaufer.
 p. cm.
 Includes bibliographical references and index.
 ISBN 0-312-23641-7
 1. Pygmalion (Greek mythology)—Art. 2. Pygmalion (Greek mythology)
in literature. 3. Arts, Modern—19th century—France. 4. Girodet-Trioson,
Anne-Louis, 1767-1824. 5. Balzac, Honorâ de, 1799-1850. I. Title.

NX652.P87 W48 2001
700'.451—dc21 00-066879

Design by Westchester Book

First Edition: June 2001
10 9 8 7 6 5 4 3 2 1

Printed in the United States of America.

For Walker and Isabelle, the most animated creations of all.

And in memory of my father.

Contents

List of Illustrations

Acknowledgments

Many thanks are due to the institutions who generously supported the research and writing of this book: the American Council of Learned Societies, the Bourse Marandon from the Société des Professeurs Français et Francophones d'Amérique, the Big XII Faculty Fellow Exchange and the University of Texas at Austin's Faculty Research Institute. I am grateful to my colleagues at the University of Texas in the Department of French and Italian, the program in Comparative Literature and the Modern Studies Group for providing a consistently stimulating environment, asking tough questions and always offering encouragement and advice. My graduate students have worked with me for the last few years on many of these questions of gender, representation and rivalry, challenging some of my most basic assumptions and pushing my readings in new and fruitful directions. Earlier versions of many of these chapters were first presented at the annual Nineteenth-Century French Studies Colloquium, and in many ways this study has grown out of the lively dialogue among literary and art historians that the conference nurtured. Special thanks go to Marie Lathers, Michele Hannoosh, Gita May, Richard Shiff, Wayne Rebhorn, William VanderWolk, Julia Null Smith, Betsy Tschurr, and to my wonderful editor and advisor, Marilyn Gaull. Finally, I extend my deepest gratitude to my husband, Art Carpenter and my children Walker and Isabelle, constant sources of love and inspiration.

All translations, unless otherwise noted, are my own. When not included in the text, the original French may be found in the Notes section at the end of the book.

Introduction ⌒◦

PYGMALION AND THE
PARAGONE

In *L'Oeuvre et la vie d'Eugène Delacroix*, a tribute penned in 1863 upon the death of his artistic mentor, Baudelaire observed, "C'est, du reste, un des diagnostics de l'état spirituel de notre siècle que les arts aspirent, sinon à se suppléer l'un l'autre, du moins à se prêter réciproquement des forces nouvelles" (It is, moreover, one of the diagnoses of the spiritual state of our century that the arts aspire, if not to supplement each other, at least to lend one another, reciprocally, some new energy).[1] The poet's "diagnosis" reflects a conception of *la fraternité des arts* that had become an aesthetic commonplace in nineteenth-century France. One need only to think of the sculptural ideal of the Parnassian poets; the literary canvases of Delacroix, Delaroche and the romantic Troubadour painters; the art criticism of Stendhal, Champfleury, Gautier, Baudelaire, Fromentin, Zola and Huysmans; Verlaine's insistence on "de la musique avant toute chose"; Gautier's ballets and Wagner's *Gesamtkunstwerk*, among the many examples of intergeneric borrowing and collaboration, to locate the sources and manifestations of Baudelaire's observation.

Yet close examination of Baudelaire's words reveals an anxiety in this ambivalent *diagnostique* of artistic cross-fertilization. For even as he calls for *des forces nouvelles*, the poet signals the implicit threat of encroachment or displacement, indicating that the arts might just as easily *supplant* as *supplement* each other, through the double sense of the verb *se suppléer*. In their essential transgressions, boundary crossings imply invasion and colonization, arousing in turn both fear and territoriality, and indeed the *fraternité des arts* inspired a sibling rivalry between the sister arts too often elided in critical evaluations.[2] In the pages to follow I will focus on the darker side of the relationship between painting and literature, locating the heart of

the competition between pen and paintbrush in the perceived threat of an invasive and ambitious Other, and in changes, conflicts and controversies surrounding the production and consumption of art at the outset of the nineteenth century.

The rivalries between poets and painters took on myriad forms in postrevolutionary France, but the works of Anne-Louis Girodet-Trioson (1767-1824) and Honoré de Balzac (1799-1850) illustrate these tensions with a self-conscious clarity that illuminates the battle with particular brilliance.[3] Given the gap in their creative chronologies, Girodet and Balzac seem, at first glance, an odd pair of rivals. Indeed Balzac had barely begun his vocation when Girodet died in 1824 and the author so closely associated with the July Monarchy never met the painter whose works mirrored the turbulent decades of Revolution, Directory, Empire and Restoration. Yet Girodet's deliberate appropriation of the poet's mantle, in both his paintings and his vast literary output, and Balzac's equally deliberate efforts in his fiction to divest the painter of any pretensions to poetry, representation or even meaning, emblematize both the open and repressed rivalries between the two art forms and their practitioners from the fall of the Bastille to the rise of the bourgeois monarchy. Their competitive words and images reflect moreover the connections between this intergeneric contention and the very (self-)definitions of art and the artist in relation to society, politics and gender in the postrevolutionary period.

One of the most important and controversial painters of his day,[4] Girodet came of age at the end of a political and aesthetic era and sought to establish his own artistic "voice," public persona and patronage in a new society whose interests and values did not embrace the figure of the artist and his production. Struggling to distinguish himself from his talented peers in David's studio (including Gérard, Gros, Guérin, Prud'hon and Broc), the ambitious and competitive Girodet chose to transcend generic boundaries as a poet and a "poetic" painter, engaging in direct rivalry in his verse and his canvases with both authors and painters. Girodet's oeuvre, from his acclaimed *Endymion* of 1791, to his unfinished poem *Le Peintre* (*The Painter*), and finally his polemical *Pygmalion et Galatée* of 1819, constitutes an illuminating response to the shifting paradigms of art, gender and genre in postrevolutionary France. The painter's struggle to assert his genius, "poetry" and domination is formulated through the figure of the idealized nude, which becomes the site of political as well as aesthetic allegories of ideality. Girodet's career, fueled by rivalries, creative anxieties, public triumphs, scandals and disappointments, inspired Balzac's portraits of

painters in three tales of the 1830s that incorporate specific references to Girodet's life and paintings.

In a trio of variations on the theme of Pygmalion (the subject of Girodet's most controversial composition), Balzac responded to the painter's challenge. In each case, he denies the fictional artists (and by extension, Girodet and his brethren) the triumph of artistic animation enjoyed in the Ovidian intertext, instead portraying painters as deluded and fetishizing failures. For Balzac, the painter and his craft represented a threatening alternative vision of mimesis, and in these early tales the author developed his nascent Realist aesthetic in dialogue with and in opposition to the sister art. The issues of gender and representation, so important to Girodet, carried powerful valences for the author of the *Comédie humaine* as well. Balzac's versions of Pygmalion chart the tensions and rivalries awakened by the increasingly visible presence of women in the public sphere, and by their anxiety-inducing new roles as producers and consumers of art.[5] Girodet, Balzac, and a host of other nineteenth-century artists (James, Morris, Burne-Jones, Gérôme, Zola, Wilde, Ibsen), privileged the myth of Pygmalion as a means of announcing their own aesthetic positions in direct dialogue with painting.[6] As manifestos of creation and domination, these painted and penned Pygmalions offer up the idealized image of the artist and his work, as well as the idealized image of the perfect woman as a work of art, a product of male fantasy. Thus Pygmalion, as a fable of fantasy and mastery centering on an artist's relationship to his own production, serves as an intersection of the negotiations for gender as well as generic domination, while at the same time revealing the anxieties motivating these efforts at asserting ascendancy. These images, which inscribe the competition between the sister arts for aesthetic hegemony, evoke the specter of sexual supremacy as well, and the double sense of the French term *genre* (gender and artistic form/genus)[7] is central to my reading. The visual and verbal texts by Girodet and Balzac examined in the pages to follow emblematize male painters' and authors' complex responses to the social, sexual and aesthetic ideologies of postrevolutionary French culture.

The rivalry between painting and poetry, which reached a crescendo in the nineteenth century, was by no means unprecedented, and by a similar token, Ovid's Pygmalion had enjoyed a long history as a popular artistic trope before being taken up by the Romantics and Realists. Accordingly, Girodet's and Balzac's revival of the rivalry between the sister arts and their use of the myth of the infatuated sculptor must be placed within the historical context of their production: that is, how these issues had been

treated in the past and what they signified for postrevolutionary artists and their audiences. Thus, before broaching the nineteenth-century manifestations of this interarts competition as played out in images of Pygmalion, I will briefly trace the history of the *paragone*, or rivalry between the arts, and of Pygmalion in French art and literature. This overview will situate Girodet's and Balzac's own borrowings and departures, bringing into focus the shadings and specificity of this paradigmatic problematization of the relationship between painting and literature.

The **Paragone:** *The Sister Arts and Sibling Rivalry*

The rivalry between painters and poets is as old as representation itself, and has historically taken the deflected form of a competition between word and image for representional superiority.[8] In critical theory, the makers of signs have been traditionally subordinated to their systems, and the discourse of word and image has concentrated almost exclusively on the formal questions of visual and verbal representation.[9] Lessing's influential *Laocoön* (1766) prescribed the boundaries of representation according to the modes of perception, limiting painting to the reproduction of objects in space and poetry to the description of actions in time, and the nineteenth-century critic's denunciation of painters' efforts to "narrate" time, change and movement took much of its force from Lessing's ongoing authority. Subsequent studies continued to wrestle with these parameters[10] until the early 1980s and the advent of alternative semiotic and structuralist studies of the word/image dyad by critics including Mary Ann Caws, Wendy Steiner, Michael Fried, Mieke Bal and Norman Bryson.[11] These theorists have played an important role in identifying the discursive and figural relations at play in the production of meaning in a picture and in deconstructing the "transparency" of the painted image by analyzing the division between signified and signifier in the painterly sign, projects that Balzac himself embraced in a cruder, if equally pointed manner. Moreover, Bryson, Bal, Caws, Fried and others have contributed to a critical orientation toward perception as interpretation, the dynamics of the "gaze and the glance" and an insistence on the dialectic production of meaning.

While these discourses have shaped my own readings of Girodet, Balzac and their generations of postrevolutionary painters, authors and critics, I am less interested in word/image tensions per se, than in how they reflect and relate to *painter/poet* tensions and rivalries, which have received less theoretical attention. Thus, in this study I map out the social production of these generic border crossings in Girodet's poetry and poetic painting, and

Balzac's narratives of painters and paintings, establishing *why* this became as important and controversial as it did *when* it did, and what forces led artists to embark upon this specific battle. From their earliest manifestations, the tensions between painting and poetry have been rooted in both the aesthetic and the political, as artists contended at once for representational hegemony and social status, seeking to dominate both an audience and each other while establishing a position within the higher ranks of society. The aesthetic and social power struggle, central to the works of Girodet and Balzac, was closely linked to the uncertain position of all artists in postrevolutionary France, but has a long history, arising .from the social ranking of artists according to their form of representation.

Plato dismissed the painter as a base imitator whose physical representation of the appearance of things remained at odds with their "essence," a counterfeiter able to reproduce the image without understanding the function. Classical culture associated the visual artist with ignorance, illusion and deception, and in turn reduced him to the status of an artisan—a maker rather than a thinker—at several removes from the higher planes of philosophy, logic and knowledge. Although Plato was nearly as condemnatory of poetry as he was of the visual arts, painting's exclusive association with mimesis of the physical world relegated it to an inferior status that words were more readily able to transcend. When Hesiod named the nine muses, he assigned goddesses to the "intellectual" pursuits of literature, music, and dance, but not to painting and sculpture. By the Middle Ages the seven liberal arts consisted of the trivium—grammar, rhetoric and dialectic—and the quadrivium—arithmetic, geometry, astronomy and music, while painting and sculpture were again excluded. The liberal arts, "c'est-à-dire des Arts nobles par définition,"[12] relied on intellect and ratiocination. Painting and sculpture, by virtue of the physical nature of their production, were considered (inferior) products of the hand rather than (superior) products of the mind, and classified instead among the mechanical arts, along with medicine, navigation, hunting and agriculture. Over the course of the following centuries, painters and their defenders struggled to gain a place for painting among the liberal arts, asserting its noble and intellectual nature, while seeking to raise the painter from the status of artisan to the more elevated position of artist, a creator rather than a mere imitator.

Thus, although Alberti coined the idea of a *paragone* in *De Pictura* (1435) as a comparison between the arts,[13] it was Leonardo's formulation of the *paragone* as a *competition* between painting, poetry and music that gained long-term popularity with artists and critics alike. Attempting to usurp

poetry's aesthetic hegemony, Leonardo ranks the arts according to the senses through which they are perceived. Since painting appeals to the eye, which is the window to the soul, he insists that it is superior to poetry and music, which are experienced by hearing, "a lesser sense . . . less noble than sight."[14] The synthetic and simultaneous nature of painting, where the entire image may be perceived in a single moment, affords it a greater impact on its audience, while, moreover, the visual image is more "truthful," more "harmonious" and more "realistic" than verbal description. Words, for Leonardo, are at odds with experience because they can only recount over time something that was perceived in a single instant; whereas a painting is viewed "instantaneously, just as natural things are seen. . . . the works of the poets must be read over a long span of time" (23). Anticipating Lessing's distinctions, Leonardo maintains that poetry's linear development in time makes it at once less effective and less realistic than painting's synthetic representation in space.

The creator of the *Mona Lisa* devotes much energy and ink to proving the scientific and intellectual qualities of painting and its practitioners, combating the vilified image of physical labor with a fantasy of genteel erudition:

> The painter sits before his work with the greatest of ease, well dressed and applying delicate colours with his light brush, and he may dress himself in whatever clothes he pleases. His residence is clean and adorned with delightful pictures, and he often enjoys the accompaniment of music or the company of the authors of various fine works that can be heard with great pleasure without the crashing of hammers and other confused noises. (39)

Leonardo's portrait of the painter at work highlights his aristocratic demeanor as well as the cerebral nature of his endeavor. In a paradoxical move, given the nature of his argument, Leonardo here associates the painter with the authors and musicians that he elsewhere scorns, and distances him from his erstwhile brother, the sculptor.

Even more fundamental to his argument is the painter's *power* over the audience, the crux of his representational superiority over the lesser art of poetry. In a passage that clearly defines the competition that Leonardo envisions between the sister arts, he recounts the "Reply of King Mathias to a poet who vied with a painter":

> On King Mathias's birthday, a poet brought him a work made to commemorate the day on which the King was gifted to the world, when a painter presented him with a portrait of his beloved lady. Immediately the King

closed the book of the poet and turned to the picture, fixing his gaze upon it with great admiration. Whereupon the poet very indignantly said, "Read, O King! Read and you will discover something of greater consequence than a dumb painting." The King on hearing the accusation that he was giving credence to dumb objects said, "Be silent, O poet. You do not know what you are saying. This picture serves a greater sense than yours, which is only for the blind. Give me something that I can see and touch, and not only hear, and do not criticize my decision to tuck your work under my arm, while I take up that of the painter in both hands to place it before my eyes, because my hands acted spontaneously in serving the nobler sense—and this is not hearing." (26)

Borrowing the authority of the king, Leonardo demonstrates the superior appeal of the painted image over poetry to an audience, and the power of painting, as a concrete and material object, to stimulate desire in its viewer. In the following paragraph he adds,

If the poet says he can inflame men with love, which is the central aim in all animal species, the painter has the power to do the same, and to an even greater degree, in that he can place in front of the lover the true likeness of that which is beloved, often making him kiss and speak to it. This would never happen with the same beauties set before him by the writer. So much greater is the power of painting over a man's mind that he may be enchanted and enraptured by a painting that does not represent a living woman. (26)

The painter's power to inspire passion and arouse a viewer, a sign of artistic triumph for Leonardo, carried negative, even dangerous, implications for many authors, who saw in this simulacrum of life the threat of idolatry or fetishism. Indeed, Leonardo's claim that the painter can create an image of beauty from his own imagination that has the power to "enchant" and "enrapture" resonates with Pygmalion's own fantasy. This "power of the image" will be central to the ongoing *paragone*, most notably in the dialogue engendered in the nineteenth century as artists negotiated for the attentions of the bourgeois audience.

Leonardo closes his *paragone* with a final shot at poetry that again highlights the competitive nature of artistic relations, and the personal power struggle behind this ostensibly theoretical battle. Blaming poets for painting's degraded status he concludes:

You have placed painting amongst the mechanical arts. Certainly if painters were capable of praising their work in writing, as poets have done, I do not believe that painting would have been given such a bad name. . . . If you call

painting mechanical because it is primarily manual, in that the hands depict what is found in the imagination, you writers draft with your hand what is found in your mind. With justified complaints painting laments that it has been excluded from the number of the liberal arts, since she is the true daughter of nature and acts through the noblest sense. Therefore it was wrong, O writers, to have left her outside the number of liberal arts, since she embraces not only the works of nature but also an infinite number that nature never created. (46)

The *paragone*, as formulated by Leonardo and taken up by subsequent generations, thus fuses the theoretical and the personal, as painters and authors negotiated for aesthetic hegemony, and the power and prestige that accompanied it. Questions of status, both for the work of art and its creator, motivate the *paragone*, while the rivalry between painters and poets centers on the *power* of words versus the *power* of images to persuade, seduce and dominate an audience. As the quarrel continued in the following centuries, the terms of the competition reflected contemporary cultural and artistic debates. During the nineteenth century, when social and political upheaval had destabilized the status of the artist, this ancient rivalry revived in new terms specific to the cultural milieu of postrevolutionary France.

Pygmalion and Galatea: From Ovid to Gautier

Ovid's transformation myth of Pygmalion stands as one of the seminal allegories of artistic creation, embodying the themes of representation, "realism" and desire in ways that have resonated with painters, poets, playwrights from the ancient world to our own day.[15] In Book X of the *Metamorphoses*, Orpheus sings of the Propoetides, dissolute women who dared to deny the divinity of Venus and were transformed into the first public prostitutes by the angry goddess. Deprived of feeling, "all sense of shame left them, the blood hardened in their cheeks, and it required only a slight alteration to transform them into stony flints,"[16] a proleptic chiasmus of Galatea's metamorphosis from stone to flesh. Pygmalion, a sculptor revolted by the Propoetides and "the many faults which nature has implanted in the female sex," renounces all women and devotes himself to art. He carves a statue more beautiful and perfect than any living woman, and "fell in love with his own creation." The statue is so realistically made that it appears to live, to breathe, to be on the verge of moving and speaking, "so cleverly," Ovid says, "did his art conceal its art" (*ars adeo latet arte sua*). Pygmalion gazes longingly at his creation, with "a passionate love for this image of a

human form"; he kisses and caresses it, showers it with gifts and flattery, adorns it with clothes and jewels and lays it on his bed, calling it his "bedfellow" (*tori sociam*).[17] Unsure whether she is ivory or flesh, he imagines she kisses him back. When he prays to Venus for a wife, he dares not ask directly for "the ivory maiden," and thus periphrastically requests "one like the ivory maiden," a likeness of a likeness. But Venus understands his true desire and transforms the ivory statue into human flesh. The gods bless their marriage, Pygmalion and Galatea produce a daughter, Paphos, and live, so to speak, happily ever after.[18]

Ovid's tale encapsulates a panoply of themes and images that will inform my reading of Girodet's and Balzac's respective efforts to define art and the artist in postrevolutionary France through the representation of an idealized female body. As an allegory of creation introduced by Orpheus, the myth posits the artist as the supreme creator; as the only story in the *Metamorphoses* in which an inanimate object comes alive (rather than vice versa), Pygmalion asserts "the redemptive character of the artist's work."[19] Yet the story also offers an intriguing, literal embodiment of an artist's idolatrous worship of his creation. Rejecting real women, Pygmalion creates his ideal mate out of stone and falls in love with his own handiwork, thus preferring an "*image* of a human form" to the human form itself. The statue becomes a projection of his desires; rapidly the sculptor loses his ability to differentiate between fantasy and reality and "would not yet admit that ivory was all it was." He is seduced by his own illusion and confuses the signifier (statue) with the signified (woman), a convergence only possible in a work of visual art. Even before Venus grants his heart's desire, Pygmalion's relationship with his own creation is sensual to the point of explicit eroticism. He kisses, he caresses, he dresses the statue only to undress it again and takes it to bed, laying its head on soft down pillows "as if it could appreciate them." Yet the sexuality is onanistic, for Galatea cannot be distinguished from her maker. As J. Hillis Miller notes, "for Pygmalion, the other is not really other . . . she is the mirror image of his desire."[20] The phallic statue, object of his self-directed love, figures forth the masturbatory erotics of Pygmalion's fantasy and playfully reverses the male response by morphing from hard to soft. When she does come alive "again and again he stroked the object of his prayers . . . the veins throbbed as he pressed them with his thumb." For Galatea, life and Pygmalion are indistinguishable, and as she opens her eyes for the first time "she saw her lover and the light of day together." Art, creation and eroticism are thus inextricably linked in this myth that posits the ideal woman as the product of male fantasy.

Ovid's tale presents a paradigmatic illustration of the power of visual representation and of what David Freedberg has called "arousal by image," where the work of visual art evokes an erotic longing for sexual possession and the correlative hope and fear that the image might come to life. Replacing his desire for the real object (woman) with desire for a representation, Pygmalion's rapport with the ivory maiden partakes of the fetishistic: "the long gaze fetishizes, and so too, unequivocally, does the handling of the object that signifies. All lingering over what is not the body itself, or plain understanding, is an attempt to eroticize that which is not replete with meaning."[21] Pygmalion's hesitations and confusions manifest the essential internal conflict between his yearning for the artifact and his recognition of the forbidden nature of his desire. For the artist's efforts to create life from inanimate form constitute a challenge to the gods themselves, his worship of a manmade form, idolatry.

Indeed, while unique in the *Metamorphoses*, Pygmalion belongs to a long history of tales of the animation of lifeless clay into human form, and the incipient perils therein. From Gilgamesh, Prometheus, and the golem of the kabbalistic tradition, to Genesis 2: 6-7, allegories of divine creation have employed the fashioning of earth into life, merging the image of the sculptor with that of a god. Yet, as foreshadowed by Prometheus and the golem, there is a fundamental *danger* inherent in the fantasy of animating a statue, a hubris leading to an inevitable nemesis from the offended gods.[22] In *The Dream of the Moving Statue*, Kenneth Gross explains,

> The animation of a statue is not a purely liberating metamorphosis, a trope of release from death, and image of achieved mimetic work; the fantasy can entail a fall as well as a resurrection, both a release from enchantment and its perpetuation, both a transcendence and a descent. The fantasy seems in general to convey the idea of a made, constructed image becoming autonomous but also alien; if it suggests a redemptive gift, the restoration of a dead sign to use and relation, it may also suggest a kind of theft of life, as if something already autonomous was forced to yield to the demands of a life not proper to it. (9)

If Pygmalion enjoys only the positive side of this fantasy/metamorphosis, punishment is visited upon later generations, and in keeping with the logic of Ovid's tales, the disaster analeptically mirrors the sin. For the sculptor's erotic relationship with his creation is ultimately incestuous, as he falls in love with and marries the woman he himself created. Accordingly, Pygmalion and Galatea's grandson, Cinyras, king of Cyprus, is unwittingly seduced by his daughter Myrrha. When he discovers the identity of his

secret lover, the king draws his sword to kill his daughte
"bearing in her disgusting womb a sinful burden, the ch'
nally conceived."[23] Myrrha is transformed into a state
death: a weeping myrrh tree. The product of the incestuous u_
nis, is delivered from the trunk of the tree his mother has become a__
grows into a youth who "surpass[es] even himself in handsomeness" (239).
Venus, who had facilitated the union of Pygmalion and his statue, falls in
love with the beautiful boy who is their great-[great]-grandson and tastes
of human suffering when her lover dies, first gored, then bitten in the groin
by a wild boar in a vivid revenge for the sins of the father. The dream of
wish fulfillment eventually becomes a nightmare, if not for the artist, then
for his offspring, as the author hints at the unhealthy nature of this inces-
tuous creation that is ultimately condemned to extinction. In the hands of
an author, the artist's combination of art and eros is lethal, and Pygmalion's
virile fantasy results in the emasculation of future generations.

Before broaching the fate of Pygmalion in the age of Romanticism and
Realism, I will briefly trace the myth in its own metamorphoses in the
intervening centuries. In transformations ranging from subtle to substan-
tial, each successive generation exploited this allegory of creation and
desire according to its own aesthetic and ideological orientations. While
the story was often reproduced intact, subsequent interpretations frequently
favored a single aspect of the story: 1) the artist and his power/desire/fan-
tasy or 2) the status of the statue as object of his desire and/or animated
object. Authors in the early Christian era highlighted Pygmalion's per-
verted lust, using the tale as an illustration of the baseness of human desire
and the dangers of idolatry, while *Ovide moralisé*, a medieval French poem,
offers a reinterpretation of the myth as a Christian allegory representing
the transformative power of God's love for humanity. Rejecting the artis-
tic setting, the poem recasts Pygmalion as a noble lord and Galatea as an
uneducated servant in a formulation that anticipates Shaw's twentieth-
century *Pygmalion*. This early version demythologizes the magical transfor-
mation of stone into flesh, instead proposing that Ovid's story really
presents the way in which the lord might educate and groom the girl until
she is fit to be his wife, much as the Lord may educate and groom Chris-
tians until they are worthy of His love. The author suppresses the themes
of artistic creation and erotic desire in favor of Christian theology. In con-
trast, Jean de Meun's lengthy section devoted to Pygmalion in the *Roman
de la rose* capitalizes on the story's erotic implications while closely follow-
ing Ovid's text. Yet the eroticism is infused with guilt, as well as the fun-
damental fear that the animated statue is the product of demonic forces.

The darker side of Pygmalion's feat—the seductive, terrifying and potentially magical power of the simulacrum—is as integral to the myth as its rosy fantasy of wish fulfillment, and haunts many of its retellings.

The theme of the magical vitalization of a work of art gained popularity from the Middle Ages forward, and from Shakespeare's *The Winter's Tale* to Molière's *Dom Juan*, to Pushkin's *The Bronze Horseman* and Cocteau's *Le Sang d'un poète*, the image of the animated artwork has captured the artistic imagination. One widespread prototype is the tale of "Venus and the Ring," first recounted in William of Malmesbury's twelfth-century *Chronicle of the Kings of England*.[24] This variant on the myth of Galatea focuses on the seductive power of the artistic image of the female form, while the male protagonist is no longer a sculptor, but instead a young man on his wedding day. Having temporarily slipped his ring on the finger of a statue of Venus to play a game with some friends, the bridegroom finds himself "married" to her, for he cannot remove the wedding band from the statue's finger. The stony Venus follows him into his nuptial bed and impedes his union with his real wife until a priest skilled in black magic drives the demonic creature away. Here it is the statue that manifests erotic desire, while the male character is the innocent victim, yet like Pygmalion, Venus and the Ring demonstrates the irresistible force of the artistic image.

As Ziolkowski has demonstrated, the Venus and the Ring story appears in the *Kaiserchronik* of the mid-twelfth century, in Burton's *Anatomy of Melancholy* (1621) and in a variety of seventeenth-century treatises on magic. Like Pygmalion, the tale enjoyed a surge in popularity in the nineteenth century, as witnessed by Joseph von Eichendorff's *Das Marmonbild* (1818), Prosper Mérimée's *La Vénus d'Ille* (1837), William Morris's "The Ring Given to Venus" in *Earthly Paradise* (1868-70) and Henry James's *The Last of the Valerii* (1874), among many others. In each of these reworkings of the Venus and the Ring, the statue remains a pernicious seductress luring an innocent man away from his legitimate love, and the tension between art and life takes center stage. Subsuming questions of creation and authorship, these versions privilege the magical power of the concrete image; Galatea takes center stage as Pygmalion falls to the side, metamorphosed into a guileless victim rather than a triumphant artist. Insisting upon the threatening nature of visual representation, these variations remove male agency: Pygmalion's active rejection of women, his shaping role as creator, and his prayer for the vivification of his own artistic product disappear. Instead, in Venus and the Ring the statue dominates and desires her spectator, developing as well as evoking destructive passions and physically displacing the carnal woman with her stony bulk. Thus, while

the statue is consistently synonymous with sexuality, the valence of the erotic attraction shifts from positive to negative. Real women, who were originally associated with prostitutes in Ovid, are transformed in the age of Romanticism into representatives of pure love; the statue, once the ideal woman, becomes a threatening embodiment of female lust. Yet in both Pygmalion and in Venus and the Ring the tensions between image and flesh, between real women and the forbidden desire for an artistic representation, remain constant. In each case, the statue asserts a powerful erotic pull, while her animation, whether brought about by the positive magic of the benevolent gods or by the black magic of satanic forces, constitutes a dangerous transformation that the author himself is eager to represent.

If the animated statue represents the thematization of Galatea, the figure of Pygmalion develops his own dramatic mythology as artist and lover. As animator rather than animated, the sculptor symbolizes the creative spirit, an emblem for aesthetic meditation or, more often than not, the vehicle for the author's scorn in a variety of reprises of the *paragone*. Like the statue, the sculptor frequently takes on a negative aspect at the hand of the author as an over-reacher or a buffoon. In La Fontaine's fable, "The Sculptor and the Statue of Jupiter," for example, the "*artisan*" decides to carve a god from his block of marble and is so successful in giving expression to "le caractère de l'idole" that all this stony Jupiter is missing is "la parole" (speech).[25] La Fontaine, however, never grants this statue life or words, which remain the exclusive domain of the poet, and instead focuses on the artist's idolatrous and ultimately ridiculous regard for his own image. He points out the sculptor's "faiblesse" (weakness) in his fear of the marble god and compares him to a child with a doll, for both endow inanimate objects with imaginary powers. The sculptor commits an "erreur païenne" (pagan error) in believing his own fantasy, a mistake he shares both with the other pagans and with Pygmalion: "Ils embrassaient violemment/Les intérêts de leur chimère:/Pygmalion devient amant/De la Vénus dont il fut père" (They violently embraced/Their own fantasies:/Pygmalion becomes the lover/Of the Venus that he fathered). While explicitly condemning the worship of idols, La Fontaine also highlights the human penchant for self-deception and the incestuous nature of Pygmalion's passion. Here the sculptor represents human weakness; as an artist he is reduced to an *artisan* while the poet remains in a position of superiority in his ability to recognize the difference between fiction and reality. Pygmalion becomes a symbol for what the artist should *not* do.

During the first half of the eighteenth century in France, representations of the myth took the primary form of theatrical productions, includ-

ing La Motte's opera-ballet, *Triomphes des arts* (1700) and Rameau's popular *Pygmalion*, staged over 200 times from 1748 to 1781.[26] Complementing these pastoral romances, a series of comic Pygmalions parodied the fantastic animation, staging the sculptor's disappointment upon meeting his dream come true, who was portrayed as a shrew or a coquette.[27] Elsewhere, the animated statue became a metaphysical allegory, and occupied a central place in the theoretical writings of the Enlightenment *philosophes*. Condillac, for example, employed the image of a statue progressively endowed with each of the five senses in the *Traité des sensations* (1754) to demonstrate Lockean theories of empirical knowledge. In a similar vein, Diderot's metaphor for materialism in *Le Rêve de d'Alembert* (1769) consisted in pulverizing a statue and then eating the dust, thus illustrating the movement from "sensibilité inerte" to "sensibilité active."[28] Rousseau's *Pygmalion, scène lyrique*, on the other hand, concentrated on the aesthetic and moral conundrums of an artist's involvement in his work, presenting, in Grimm's words "a moving picture of the transports, enthusiasm, delirium that the love of the arts and beauty can excite in a sensitive and passionate soul."[29] This *scène lyrique*, mounted with Coignet's musical interludes at the Paris Opéra in 1772, dramatizes the sculptor's inner conflict in dialogue form and would linger in the collective French imagination as the quintessential Pygmalion well into the following century. For not insignificantly, it was Rousseau who popularized the name *Galatée* for the statue, linking her with nature and endowing the nameless figure with a subject position. As the piece opens, Pygmalion is lamenting the loss of his genius and filled with unease: "I am afraid . . . overcome with fear . . . What trembling! . . . what confusion."[30] Recognizing that he has lost his artistic touch, the sculptor wanders from figure to figure in his studio, observing "there is no soul or life here; it is nothing but stone . . . my chisel, weak and uncertain, has lost its way: these clumsy works remain timid sketches, no longer feeling the hand that once would have animated them."[31]

The sculptor's impotent languor, emblematized by his "weak and uncertain" tool, is infiltrated by a mysterious ardor, the heat of his passion contrasting with the coldness of his marble creation in one of the many antimonies that shape this polarized text.[32] Rapidly he confesses to the fear that it is the admiration of his own work that is causing his distraction and what follows is a prolonged debate (with himself) as to whether or not he should unveil his Galatea, whom he has covered "with a light, colorful cloth, decorated with fringes and garlands."[33] This ornamental shroud echoes the statue's adornments in the original myth while drawing attention to that which it hides; in the words of Louis Marin, the veil is indeed

the "instituteur de fétischisme."[34] Like many post-Ovidian Pygmalions, Rousseau's hero experiences the conflicting emotions of desire and fear that the *philosophe* represents through the sculptor's actions as well as his words. The artist approaches his hidden statue only to withdraw in confusion four times and this *va et vient* renders concrete the simultaneous erotic attraction and shameful repulsion that the statue exerts. When he finally lifts the veil, the sculptor falls to his knees in worshipful contemplation of his own statue, whose beauty outstrips that of Venus. But his adoration is not limited to the marble goddess, and the self-reflexivity that was an undercurrent in Ovid's tale is fully enunciated in Rousseau's. The prostrate creator exclaims "I am intoxicated with self-love; I adore myself in what I have done. . . . No, nothing this beautiful has ever appeared in nature; I have surpassed the works of the Gods."[35] Pygmalion's idolatry is fused with self-love; in worshipping his statue he worships its creator as well and sees himself as a rival of the deities.

As the dialogue continues, Pygmalion vacillates between wishing that Galatea might be endowed with a soul as beautiful as her form and berating himself for loving "cet objet inanimé" (1227). Like his physical back and forth movement, Pygmalion's dialogic debate with himself foregrounds the artist's interior conflict: Rousseau magnifies the hesitation in Ovid's hero at the altar of Venus into a central dilemma of his play. Nor is the request for her animation as simple as in the Classical myth, for here the artist offers up his own soul for the statue, in the hope of fusing his Self with that of the created Other. In a quasi-Faustian exchange he proclaims "I can give her my life and animate her with my soul. Ah! may Pygmalion die in order to live in Galatea!"[36] What the ancient sculptor achieved at no cost (to himself) exacts a far heavier toll in the eighteenth century, as this allegory of artistic creation highlights the artist's sacrifice and the metaphysics of selfhood. Just as his adoration of the statue merged into an adoration of self, Pygmalion yearns for and resists being fused with his creation. He wishes to be her and yet to be other, in order to admire her: "let me always be an other, so that I can always want to be her, to see her, to love her and be loved by her."[37] His solipsistic desire turns on infinite longing and frustration rather than on satisfaction, for he wants to be other so he can always want to be her. In admiring her, as the outward manifestation of his own talents, he may admire himself in a narcissistic doubling that will never be resolved. The subject-object dichotomy, the very basis for our relationship with the world, collapses in the work of art that "exists as a nondialectical configuration of sameness and otherness,"[38] and as such threatens the existence of both.

Pygmalion's prayers are answered in Rousseau's *scène lyrique,* but in keeping with the ambivalent tone of the piece, his reaction is again mixed. When he sees Galatea move he turns away, "his heart heavy with sorrow." Doubting his sanity, Rousseau's sculptor believes the animated statue to be an hallucinated sign of his madness until the marble maiden steps off the pedestal and approaches him, at which point he falls to the ground in worshipful praise. Unlike previous versions of the myth, this Pygmalion verifies the vivification of his creation not by touching her, but by speaking with her. Words become the ultimate path to illumination for artist and audience alike in a final dialogue that provides the key to the signification of Rousseau's drama. Galatea touches herself and says "Moi" and Pygmalion echoes her, repeating "Moi," life thus imitating art. Galatea continues her exploration of the world by feeling objects and repeating sounds: touching herself again she says "c'est moi," then touching another statue she avers "ce n'est plus moi" (this is not me).[39] In the final exchange, as Pygmalion opens his arms to her and covers her outstretched hand with kisses, she sighs, "Ah, encore moi" (Ah, still me), and Pygmalion concedes that indeed she subsumes him: "Yes, beloved and charming object, yes, worthy masterpiece of my hands, my heart and the gods, it is you, you alone: I gave you my entire being: I will only live through you."[40] The work of art, arising from the spontaneous expression of the artist's soul, takes on a life of its own through the vehicle of his creative genius. As James Rubin has argued, "Jean-Jacques thus pleads the cause of the *source intérieure,* the personal and imaginative origins of visual art, the moral status of which is secured by its ties to God and nature," a reading shared by Girodet, who, many believed, was inspired by Rousseau's play when he composed his own *Pygmalion et Galatée.*[41]

Yet again, there is a darker side to this artistic allegory of art and selfhood that demonstrates what Louis Marin has called "the infinite power of the Image," a power that threatens to destroy the maker through his own gaze and [auto-erotic] desire. Reversing the equation where a work of art "lives" through its creator, here Pygmalion may only live through his creation—she has absorbed his entire being and he is no more than an extension of his own masterpiece. The alienation that dominated the beginning of the scene in Pygmalion's loss of genius and pleasure is not resolved, but rather transferred onto the work of art. The self is at once self *and* other, for now Pygmalion's "moi" is both himself and the "toi" (you) that is Galatea, and the metamorphosis is doubled. Demonstrating the power of the artistic-erotic image, Rousseau depicts the ascendancy of the object over its creator. As frightening as any amorous Venus prowling the honey-

moon suite, the awakened Galatea consumes her producer whole. A serious meditation on creation and subjectivity, Rousseau's *Pygmalion* does not per se encode the competitive discourse of the *paragone*, yet this influential treatment of Ovid's tale nonetheless presents the image of a conflicted, guilt-ridden, even mad artist whose love for his own creation is ultimately more dangerous than triumphant.

Rousseau's *scène lyrique* spawned numerous undistinguished French imitations as well as at least six German translations over the next 40 years.[42] The visual arts echoed the dramatic enthusiasm for Ovid's myth, and Pygmalion and Galatea enjoyed an unprecedented popularity in eighteenth-century painting. Before 1700, representations of the subject consisted primarily in illustrations of Ovid and his imitators.[43] These early images of the sculptor and his statue run the gamut from manuscript illuminations of the *Roman de la rose* focusing on Pygmalion's idolatrous worship of the naked female figure to Renaissance engravings of the *Metamorphoses* that highlight Pygmalion's artisanal craft (via scattered tools and marble) and the agency of the gods in this animation. As illustrations, these images closely follow the text at hand, subordinating the visual artist's own position to that of the author, and presenting Pygmalion in the condemnatory light of a lowly craftsman, idolater or madman.

Jean Raoux's *Pygmalion amoureux de sa statue* of 1717 introduced a new era for the motif of the sculptor and his creation, which became a favorite among French painters and the public of the Ancien Régime. The erotic nature of the image, "legitimized" by its Classical provenance, appealed to the Rococo sensibilities of the eighteenth century. Freed from the confines of textual illustration, these painted Pygmalions celebrated the triumph of the sculptor as both artist and lover. Galatea's animation came to symbolize Pygmalion's masculine virility, his phallic chisel bringing frigid femininity to life, for as the chevalier de Jaucourt observed in *L'Encyclopédie*, "It appears that this prince has found the means to transform a beautiful woman, once as cold as a statue, into someone tender and responsive."[44] Rococo period portrayals of Pygmalion, often in the form of *cabinet* paintings, include Lemoyne's *Pygmalion voyant sa statue animée* (1729), Boucher's *Pygmalion et sa statue* (1742),[45] Deshays's *Pygmalion et Galathée* (1749), Monnet's *Pygmalion et Galathée* (1762) and Fragonard's *Pygmalion au pied de sa statue*,[46] while later representations of the 1770s and '80s include canvases by Lagrenée [figure I.1], Regnault and Gauffier. These various *Pygmalions* follow Ovid to a greater or lesser extent, some including the sculptor's gifts to his beloved, others taking great pains to portray the sculptor's atelier. In a departure from Ovid, most eighteenth-century versions of his tale intro-

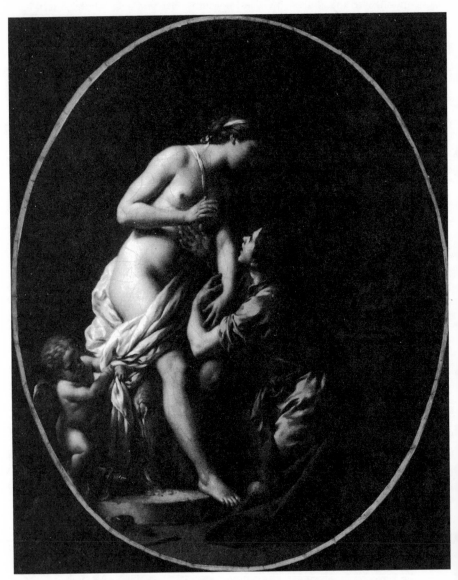

Figure I.1. Louis Jean François Lagrenée, *Pygmalion et Galatée*. 1781. Oil on canvas, 58.4 x 48.3 cm. Detroit, The Detroit Institute of Arts. Founders Society Purchase, Mr. and Mrs. Benjamin Long Fund, Miscellaneous Gifts Fund and City of Detroit Insurance Recovery Fund.

duce cherubs or cupids and often Venus herself to represent the divine intervention in the artistic animation. In each case, however, the statue dominates the painting as the central focal point, and whether fully clothed (Lemoyne), partially draped (Raoux, Lagrenée, Monnet) or nude (Gauffier), Galatea emblematizes an idealized beauty awakening to life and love, her pure and perfect body the symbol of masculine creative powers of generation.

Rococo painters celebrated Galatea's awakening sensuality in rosy flesh tones, a luminous, creamy palette and hovering putti, while the statue's erotic appeal arises from the tension between her innocent chastity and Pygmalion's presumed intentions. Yet in all of these eighteenth-century painted Pygmalions, the artist himself, kneeling before his creation, assumes an expression closer to worship than desire, and despite stylistic variations there is a thematic consistency in these *Pygmalions,* as each painter cele-brates the mystical power of the artist to create life through his craft. At once exploiting the eroticism of the statue while distancing the sculptor from the base connotations of lust, these painters of the Ancien Régime seek to arouse their audience while positing the noble, even spiritual nature of the visual artist. Galatea's painters portray her beauty, whether carnal or marmoreal, as a symbol of the universal power of visual representation over the viewer. Her mythic animation links the human and the divine in a way that reflects as much upon the creator (that is painter, as well as sculptor) as on the creation.

Although Pygmalion was a sculptor, *his* creator was an author, and his tale recounted in words, not images. Indeed the very idea of animation, which encompasses movement, change and development, is formally anti-thetical to the visual arts: neither the painter nor the sculptor can directly represent Galatea's vivification on canvas or in stone. Accordingly, few sculptors have chosen Pygmalion for their craft, for a statue of a statue coming alive is the impossible subject, bound at some level to fail. Fal-conet's *Pigmalion au pied de sa statue qui s'anime* of 1761 is a significant exception that enjoyed both public and critical acclaim. However, Fal-conet's ambitious efforts did not escape the attention of his friend Diderot, and even as he sings the praises of Falconet's "petit groupe" in the *Salon de 1763,* the competitive father of art criticism reminds his reader of the sculptor's generic limitations in a paradigmatic fusion of Pygmalion and the *paragone.*

Diderot begins his section on Falconet by claiming that this would be the statue that *he* would have, had he a *cabinet* in which to display it. With-

out naming the sculpture or its subject, the critic emphasizes its desirability—it is "la chose précieuse" worthy of sacrifice for its possession. While *amateurs* are interested in bagatelles, Diderot hints that this is a piece for a true collector. Having established desire in his reader, Diderot begins the second paragraph by frustrating that desire. He laments that it is useless to tell us that the title of this "groupe précieux" is *Pigmalion au pied de sa statue qui s'anime* because there is only one that exists and that is at the Salon. Aside from creating a buildup that sounds like a sales pitch for Falconet's work, Diderot's introductory paragraphs set the tone for what will follow. By including his readers in the experience of desire for a statue, he allows them to share in Pygmalion's passion; by frustrating that desire and establishing the thematic of impossibility, he suggests an alternative reading of the ancient myth.

Arriving at the statue itself, Diderot first focuses on the figure of Galatea. He concentrates on the incipient life portrayed in the marble form—her eyes have just opened, her head is inclined toward the ground and her creator beneath her, and a slight smile graces her lips. Then, as narrative interpretation overtakes physical description, Diderot shifts his focus to thought, feeling and movement—precisely what the sculptor cannot depict: "She is so innocent! she has been so from her very first thought. Her heart begins to stir; but it will not be long before it beats."[47] The future tense implies development in time, the domain of the poet and not the visual artist, for Falconet's Galatea will be stuck in a perpetual present, on the verge of life, forever waiting for her heart to start beating. Continuing in the exclamatory vein that characterizes much of his art criticism, Diderot engages directly with the fiction of the piece: "What hands! What soft flesh! No, this isn't marble. Press here with your finger and the material that has lost its hardness will yield to your touch."[48] His direct imperative address to the reader once again unites us with the fictional sculptor, for Diderot has surpassed Falconet and returned to the original source, Ovid's own Pygmalion. The author's instructions to the reader reproduce Pygmalion's own actions and emotions as narrated in the *Metamorphoses*, where upon returning from the temple, the sculptor had been surprised to find his statue warm to the touch. Unsure whether she is stone or flesh "he laid his lips on hers again, and touched her breast with his hands—at his touch the ivory lost its hardness, and grew soft: his fingers made an imprint on the yielding surface."[49] Diderot would thus have the reader share in the drama of discovery and animation by reenacting Pygmalion's own gradual experience, yet as he and his reader are well aware, this can only take place

in fiction, be it Ovid's or Diderot's; Falconet's marble will always remain as such. By paraphrasing the original story, Diderot draws the reader's attention to the tension between a physical and verbal representation of the magical metamorphosis. He closes the paragraph devoted to Galatea with a return to her concrete physicality—"What feet! They are so soft and delicate!"[50]—an attribute that will play a role in Balzac's very different portrayal of a painted Galatea.

Moving to the second of the three figures in the group, "un petit Amour," Diderot highlights the cupid's erotic ardor as he devours the hand of the awakening goddess. As in many contemporary paintings, the concupiscent nature of Pygmalion's love is projected onto the lascivious putti who populate the background, while the sculptor retains a dignified mien of inspiration and adoration. Unwilling to abandon the sensual content of the tale yet eager to portray the artist in elevated terms, eighteenth-century artists consistently separated the creator from his desire, and Falconet is no exception. While the single cupid on the left showers Galatea's hand with passionate kisses, Pygmalion kneels before her to the right, hands clasped in admiring veneration, a position more befitting worship than courtship.

Finally turning to the figure of Pygmalion, Diderot addresses Falconet directly, lauding his skill at combining "surprise, joy and love together in a piece of white stone." The author compares Falconet to Ovid's sculptor and the divinities themselves: "rival of the gods, if they animated the statue, you repeated the miracle by animating the sculptor." If Pygmalion animated Galatea, Falconet has animated Pygmalion. Yet Diderot extends the comparison with a more menacing mythic allusion. Apostrophizing his friend, the critic says "come let me hug you; but guilty of Prometheus's crime, beware that a vulture isn't waiting for you as well." [51]Fusing two creation myths, Diderot reinforces the image of Falconet's genius at infusing inanimate matter with life while hinting at retribution. Six years later, in the *Entretien entre d'Alembert et Diderot*, the author reiterates this association as he proposes to grind "le chef-d'oeuvre de Falconet" into a powder and use it as fertilizer to demonstrate the passage "of marble into humus, humus into vegetable matter, and vegetable matter into animal matter, into flesh."[52] In one case the sculptor is threatened with destruction, in the other his work is, and although the tone is always infused with bonhomie, the waiting vulture seems to be Diderot himself.

Indeed if the first half of the *Salon* passage devoted to Falconet's *Pygmalion* is a paean to its conception and execution ("ce morceau de sculp-

ture est très parfait"), the second half presents Diderot's own reworking of the subject—how he would improve this "perfect" grouping with a more "energetic" composition. He proposes inverting the figures so that Pygmalion is to the left of Galatea and the cherub to the right. While retaining the expressions of the characters, Diderot further alters Pygmalion's positioning, so that the sculptor is touching his statue. Diderot creates an image that highlights engagement and the "pregnant moment," for where Falconet's hero leans away from the goddess, Diderot's Pygmalion rises to check her beating heart. Once again taking advantage of prose's linear development, Diderot sets the scene in the moments before Pygmalion moves toward his statue—"he has glimpsed the first signs of life in his statue. He was crouching at that point. He slowly rises . . . "—introducing movement and motivation into what is by nature a static medium. Returning to the sexually charged relationship between creator and creation established by Ovid, Diderot has the sculptor, who has risen "to the place of her heart" gently place his hand "there" and "check if her heart is beating."[53] If Diderot's words are subtle, the image is not, and he would have Pygmalion place his hand upon Galatea's breast, just as Ovid had described it ("and touched her breast with his hands").[54] Meanwhile, the critic's fictitious sculptor gazes into his beloved's eyes, waiting for them to open while the cherub now covers her other hand with kisses, as Falconet's chaste group is transformed into a more intimate and sensual scene. In Diderot's Pygmalion, the artist is subordinated to the lover, reversing the values espoused by contemporary visual artists seeking to elevate one of their own. Diderot unambiguously reclaims the subject for literature while putting ambitious sculptors in their place.

Diderot concludes his section on Falconet's *Pygmalion* by praising his own. He finds his own thought on the matter "newer, more unusual and more energetic than Falconet's" while his imaginary groupings are better than the real sculptor's because the figures "would touch each other."[55] Finally, where the Diderotian Pygmalion's movements would be "promptes et rapides," to express his surprise, the veritable statue's "mouvements" are "contenus et tempérés," limited not only by his fear and confusion, but also by his medium. The contemplative stone figure lacks the passion so vital to Diderot's ideal art ("admiration kisses and hugs without stopping to reflect"), but further, like La Fontaine and others, Diderot asserts the generic superiority of the poet over the visual artist. By emphasizing through his prose precisely what the sculptor *cannot* do, Diderot shows how words are in fact more "animated" than images, and description more "realistic" than depiction. The critic establishes the pri-

macy of the word while demonstrating that the more moving exhibition takes place not in a gallery, but on the page. The eidetic image, summoned by the progressive words of the author and shaped by the visual imagination of the reader, is more "lifelike" than the concrete and static image of the visual artist, and accordingly, Pygmalion's animation of Galatea can only be effectuated by an author and never by a sculptor. The author simultaneously debunks and coopts the "power of the image," while the erotics of the gaze turn inward, fueled by the reader's equally powerful envisioning imagination. For Diderot, who seeks to surpass Falconet by animating Pygmalion as well as Galatea, the pen is mightier than the chisel, and the only way the stony sculptor may come to life is through the author's enlivening words.

For painters and authors, the competitive drive to assert superiority over the sister art motivated much of the attraction and resistance to the myth of Pygmalion; yet the even more fundamental relationship between male and female also lies at the heart of this popular trope. In the postrevolutionary era, as gender roles and women's position in society came under ever greater scrutiny in France, the ideal (and silent) Galatea became a symbol for what many considered the perfect woman. In a century dominated by a dynamic vacillation between a longing for the ideal and a confrontation with the real, Galatea represented a unique hybrid of an ideal fantasy transformed into a "reality" of sorts while remaining superior to real women. Author, art critic and erstwhile painter Théophile Gautier (1811-72) began his career as one of Balzac's protégés and his obsessive return to the theme of Pygmalion offers insights into its sexual, psychological and aesthetic resonances for artists throughout the century. For Gautier, the father of *l'art pour l'art* (Art for Art's Sake) and an enthusiastic proponent of the *fraternité des arts*, the motif of the woman-statue stood as a potent Parnassian symbol for ideal beauty and an idealized past.[56] Yet in Gautier's life, as well as in his art, the statue would hold sway over the real woman, and in a confession that echoes the sentiments of many of his fictional characters (and indeed of most nineteenth-century Pygmalions), he recalls a formative moment in his youth:

En ce temps-là, je n'avais aucune idée de me faire littérateur, mon goût me portait plutôt vers la peinture, et avant de finir ma philosophie j'étais entré chez Rioult, qui avait son atelier rue Saint-Antoine. . . . Le premier modèle de femme ne me parut pas beau, et me désappointa singulièrement, tant l'art ajoute à la nature la plus parfaite. C'était cependant une très jolie fille, dont j'appréciai plus tard, par comparaison, les lignes élégantes et pures; mais

d'après cette impression, j'ai toujours préféré la statue à la femme et le mar-
bre à la chair.[57]
(At that time, I had not even considered becoming an author, for my taste
led me more toward painting, and before finishing school I had joined
Rioult's studio in the rue Saint-Antoine. . . . The first female model did not
seem beautiful to me and disappointed me enormously, to such a degree
does art improve on nature, even at its most perfect. She was however a very
pretty girl, and later, by comparison, I would appreciate her pure and elegant
lines; but after this first impression I always preferred the statue to the
woman, marble to flesh.)

This passage encapsulates the erotic fantasy at the heart of the Pygmalion
myth—a woman who is not a woman, but rather a man-made creation, a
projection of the imagination rather than an independent entity. If reality
is always a disappointment in the nineteenth century, it is because it can
never attain to the perfection of fiction, and in keeping with his preference
for marble over flesh, *chez* Gautier the work of art always triumphs over
the physical woman. Gautier's words, reflecting the dual sensibility of a
painter and an author, demonstrate the belief that art's role is to improve
on nature, and women in particular. At one level, the preference for art over
life constitutes a resistance to death and modernity: the physical perfection
of the ideal antique form is desirable precisely because it is not subject to
the change and corruption that characterized the modern vision of the
world. It is only by losing their humanity that Gautier's women may accede
to the glory of art and thus be loved, and the dichotomy between the real
and the ideal is nowhere more potently realized than in this figuration of
the female.

For Gautier and his fellow Pygmalions, the crux of desire lies in the
fact that the woman-statue is entirely a product of the artist's creative
imagination, and thus entirely dependent upon her male progenitor for
all form and feeling. J. Hillis Miller describes this aspect of Pygmalion as
follows: "This story embodies a male fantasy whereby a woman cannot
be the object of sexual desire and cannot desire in return unless she has
been made so by male effort. The process is linked to the procedure
whereby a passive and formless raw material is given shape by a man's
productive power."[58] Whether crafted by an anonymous artist, as in the
case of the Venus and the Ring stories, or by the hero himself in the
Pygmalion tales, the animated statue represents the sexualized body as a
man-made artifact. The replacement of a real woman with an artistic cre-

ation as the object of erotic desire reflects a fusion of sex with power and control. In the Pygmalion paradigm, it is the artist who controls, desires and is ultimately rewarded for his efforts with a living body that mirrors his desire. Conversely, in the Venus and the Ring narratives, the statue's power and desire threaten to destroy the mortal. In either case, real women and sexual desirability are polarized; the artistic image displaces the living female, whether as prostitutes in Pygmalion or as virgins in the Venus and the Ring. Sex, power and control remain outside of the sphere of the feminine.

In *Body Work: Objects of Desire in Modern Narrative*, Peter Brooks focuses on the fictional desire for the body as a manifestation of the search for symbolic, as well as physical, satisfaction. He explains, "in modern narrative literature, a protagonist often desires a body (most often another's, but sometimes his or her own) and that body comes to represent for the protagonist an apparent ultimate good, since it appears to hold within itself—as itself—the key to satisfaction, power and meaning."[59] The desired body symbolizes gratification outside of the realm of sexual pleasure, encompassing a more totalizing experience. This sought-after cipher represents for the desiring consciousness the answer to all of life's mysteries and thus the act of desiring the body indicates a larger longing for knowledge and its correlatives—power, possession, creation, meaning. In keeping with Freud's connection of erotic desire and the desire to know (epistemophilia) to the child's curiosity regarding sexuality and difference, the body of the [m]other remains in the realm of the forbidden and unknown. Desire for this prohibited body constitutes a quest for knowledge and signification: possession of it becomes the ultimate fantasy, its denial, impotence. In this sense, the body becomes part of the semiotic project, while the creative and sexual urges fuse in the desire to bring the body into the realm of signification so that it may be both possessed and known. In terms of the Pygmalion myth, there is a direct connection between the semiotization of the body and the somatization of the text. Brooks observes:

> The story of Pygmalion and Galatea has exercised a continuing fascination on the creative imagination because it magnificently represents a crucial wish-fulfillment: the bodily animation of the object of desire. It may suggest that in essence all desire is ultimately desire for a body, one that may substitute for *the* body, the mother's, the lost object of infantile bliss—the body that the child grown up always seeks to recreate. As in the case of Pygmalion, that recreated body realizes simultaneously erotic desire and the cre-

ative desire to know and to make. Galatea is a fiction suggestive of that word's derivation from *fingere*, meaning both to feign and to make. She is the supreme fiction that becomes reality as the embodiment of the artist's desire. (24)

Pygmalion's *success*, his ability to attain the object of his desire, to know, possess and be desired by her, represents the fantasy that knowledge, possession and requited desire are *possible*, and that signification may indeed be conferred upon meaningless material through the genius of the creative imagination. Galatea's animation is the concrete realization of the formulation *voir = savoir = pouvoir* (sight = knowledge = power), and her painted or sculpted body stands as a symbol both of desire and mastery. By a similar token, the equivalence of the possession of the body and the possession of knowledge, power, et alia, explains why these representations of the female form became such a critical site of contention between authors and painters, and why the former consistently sought to destroy the fictitious Galateas, denying their rivals access to the fantasy of impossible knowledge and possession. Moreover, if, as Freud and Brooks would have it, the statue represents the mother's body, and artistic creation is merely a *re*-creation of what we can never have, then the marble form becomes simply a substitute, a fetish in the largest sense of the word.

Indeed the hard, erect form of the statue that grows warm and begins to throb at the sculptor's touch, functions either as a surrogate for the castrated maternal phallus or more generally as a surrogate object of desire and/or worship in the pre-Freudian sense of fetish, that is, an idol magically endowed with human qualities. As Freud notes in *Three Essays on Sexuality* (1905), fetishism occurs when "the normal sexual object is replaced by another which bears some relation to it, but is entirely unsuited to serve the normal sexual aim."[60] Just as the fetish takes the place of the normal aim, the fetishized woman (the statue) replaces the real one in a process of symbolic substitutions. For these various Pygmalions, from Ovid to Jean de Meun, Rousseau and Gautier, the desire for the work of art replaces "normal" urges toward living women. Each fictionalized sculptor constructs a female figure who is "more perfect" (Ovid 231) than any other and who is an extension of the male artist and his fantasy, an Other who is one with the creator and lacking that essential "lack" of real women. For Rousseau's Pygmalion, Galatea is so perfect that even "less perfect, you would be missing nothing,"[61] while Gautier's statue-women have the advantage over living women of being "impossible."

In Freud's later essay, "Fetishism" (1927), he introduces the idea of a "divided attitude" toward the fetish that is fully in keeping with the relationship between Pygmalion and the object of his redirected desire. Defining the fetish as a "compromise," Freud contends that the fetishist simultaneously acknowledges and disavows the fact that a woman does not have a penis, consciously accepting the fetish as a viable substitute. In the same way, Pygmalions throughout the ages have vacillated between acknowledging and denying that Galatea is merely stone and not living flesh, while holding fast to their desire. Further, Freud asserts that this divided attitude is reflected in the emotions toward the fetish, which are typically mixed between affection and hostility "which run parallel with the disavowal and the acknowledgment of castration" (21: 157). Indeed, if Pygmalion's fear of the real female body is repressed and sublimated in the act of creating an unavailable substitute, the (impossible) animation of the fantasy figure may also entail a return of the repressed and its attendant terror.

David Freedberg notes, "The extraordinary thing about Ovid's Pygmalion passage is that it also adumbrates two deep fears: in the first place that of the real body, and in the second, that of making an image come alive. . . . it is we who should remain masters of what we make, and not have them turn into phantoms that seem dangerously like ourselves, and therefore both equal and stronger."[62] Freedberg highlights the double thrust of dread evoked in Pygmalion's tale that, in my reading, turns on the underlying fear of female subjecthood. For in considering Lacan's reformulation of Freud's theory of the fetish-subject, it becomes clear that more than castration is at stake. The fetishist is "caught between 'having' and 'being' a maternal phallus that he or she can ultimately never possess, thus vacillating between illusory mastery on the one hand, and phantasms of lack or the permanently barred subject position on the other."[63] Indeed, according to the Lacanian paradigm, masculine subjectivity is constructed through a denial of the feminine Other, or at least a refusal of any kind of autonomous subjecthood that, within Luce Irigaray's more extreme formulation, entails "a total repudiation of the feminine and maternal foundations and a corresponding fantasy of autogenesis."[64] During the early nineteenth century, when French society itself was in a nearly constant state of crisis and redefinition, the ongoing upheaval radically destabilized the very definitions of self, manhood and the artistic identity. Pygmalion and the fetishized statue thus served as a powerful symbol of the male artist's subjecthood, an assertion tinged with the haunting fear of impossi-

bility emblematic of the double attitude of the fetish, which necessarily embraces two mutually contradictory beliefs. Thus, Pygmalions simultaneously assert their subjecthood through the creation of a female who is not Other but an extension of the self, while at the same time fearing that the fantasy will actually come true, and the female Other will take on a subject position that will in turn negate the creator's. At the heart of the myth, then, is a crisis of male identity and a fear of female subjecthood that resonate with political and social as well as aesthetic and psychosexual implications in postrevolutionary France.

Galatea's body, fetishized both by her maker's fantasy of animation and by his and the viewers' gaze, functions within a larger economy of masculine desire at the outset of the nineteenth century in terms of commodity fetishism as well. As French artists such as Girodet and his peers struggled to define their "genius" within the bourgeois marketplace, they displaced the uncomfortable anxieties of commodification onto Galatea's body in a way that simultaneously asserts the "value" of the work of art and refuses its existence as such, in this sense reflecting the very ambivalence at the heart of artistic production for the new bourgeois audience. Marx maintained that in the process of commodity fetishism, social relations between men assume "the fantastic form of a relation between things," while "the productions of the human brain appear as independent beings endowed with life."[65] Galatea's nude form is a site of adoration in her many representations, and as such reflects the power the commodity can assume, "becoming a kind of god to be worshipped, sought after and possessed."[66] Nineteenth-century critics and authors disparaged the "idolatrous" nature of Pygmalion's love for his statue and the dangers of the projection of human attributes on an inanimate object in terms that closely echoed de Brosses's influential anthropological treatise *Du culte des fétiches* (1760). As W. J. T. Mitchell explains,

> The "horror" of fetishism was not just that it involved an illusory, figurative act of treating material objects as if they were people, but that this transfer of consciousness to "stocks and stones" seemed to drain the humanity out of the idolater. As the stocks and stones come alive, the idolater is seen falling into a kind of living death, a "state of brutal stupidity" in which the idol is more alive than the idolater. Marx's claim that commodity fetishism is a kind of perverse "exchange," producing "material relations between persons and social relations between things," employs precisely the same logic.[67]

Thus the myth of Pygmalion and Galatea takes on an iconic resonance in postrevolutionary France. Its very privileging and/or questioning of the sacred relations between creator and created, between male and female, and between subject and object, foregrounds the intensified anxieties directly related to changing discourses and ideologies of art and gender. In the chapters to follow, I will read Girodet's and Balzac's works against the backdrop of the fluctuating definitions of the artist, his audience, and his position in postrevolutionary France, as well as in terms of the changing status of women in that society. These instabilities played a crucial role in the artists' formulations of their *Pygmalions* as painted or written manifestos announcing their aesthetic and sexual dominance over a threatening Other. The first three chapters treat Girodet's paintings and poetry. Chapter 1 examines *Le Sommeil d'Endymion* (1791) as an important precursor to *Pygmalion et Galatée* (1819). It focuses specifically on Girodet's rivalry with his master and his peers, and locates the painter's self-identified "poetic" meaning in the dialectic between presence and absence: between the androgynous nude figure of Endymion and the elided figure of Diana, the amorous goddess usually included in earlier versions of the scene. Girodet reduces Diana's powerful, desiring physical presence—an overdetermined symbol of femininity, the Rococo and the Ancien Régime—to the symbolic acorporeality of a moonbeam. In its stead, the idealized male form becomes the central object of the admiring gaze, metaphorically suggesting Girodet's own proposal for the birth of a new republic, generated within an all-male paradigm of creation and aesthetic contemplation. Chapter 2, "Girodet: Poet and Painter," explores the painter's development of his self-proclaimed "poetic" painting in a series of images that employ suggestion and symbol rather than straightforward visual narration, and presents the first extensive analysis of his verse since the artist's death. Chapter 3 locates the culmination of Girodet's many rivalries and creative anxieties in his last great Salon painting, *Pygmalion et Galatée*, an allegory of artistic and political rebirth that consumed seven years of Girodet's life, and whose genesis and reception bear witness to the larger cultural crises and anxieties around him.

Chapters 4, 5 and 6 turn to Balzac and his responses to Girodet, his paintings, and the power of vision and the visual arts in France on the cusp of the July Monarchy. In *La Maison du chat-qui-pelote* (1829), *Sarrasine* (1830) and *Le Chef-d'oeuvre inconnu* (1831) Balzac deconstructs the assumed equivalence of *voir* and *savoir* by presenting allegories of art, representation, love and failure that demonstrate the visual artist's blindness to real-

ity while implicitly arrogating the *pouvoir* of successful representation to the writer himself. Read specifically in terms of the intertexts of Girodet's life and paintings—for his *Endymion, La Nouvelle Danaé* and *Pygmalion et Galatée* play important roles in these tales—as well as in terms of contemporary artistic ideologies, Balzac's early stories of artists and their work represent his challenge to the hegemony of vision in nineteenth-century France and his desire to reclaim a place for the (male) writer atop the artistic hierarchy.

Chapter 1 ⌁

GIRODET'S *ENDYMION:* PAINTING BETWEEN THE CENTURIES

As an allegory of artistic creation, Pygmalion's myriad reworkings reflect the aesthetic and political particulars of the specific historical moment; in the works of Girodet and Balzac, the upheavals of Revolution and its aftermath shaped both the production and consumption of the myth. Political overthrow was accompanied by cultural transformation, and from the fall of the Bastille (1789) to the installation of Louis Philippe (1830), revolutions in the economic, social, sexual and artistic spheres transfigured the *champ artistique* (cultural field) that both produces and is produced by the artist.[1] The rise of capitalism and the bourgeoisie, the Industrial Revolution, the evolution of gender as a category per se, the reemergence of French feminism and the struggle between Neoclassicism and Romanticism for aesthetic domination collectively formed a socioartistic context of radical instability and professional anxiety. Transformations in the social and economic status of the artist moreover played a significant role in the escalating tensions between painters and authors, as they struggled to define a place for themselves and their art in the new and unfamiliar field of artistic production.

As Bourdieu has established, the real and symbolic revolutions of the early nineteenth century led "to the creation of the figure of the artist and of modern art itself."[2] Yet for the artists forging these new images and forms, as well as for those mired in the discourses of the past, it was an epoch of uncertainty. The movement from the established system of royal and aristocratic patronage toward a market economy profoundly affected the artist's self-definition vis-à-vis society, his audience and his fellow artists. Faced with an unknown and perhaps unknowable public "market," painters and authors turned to the allegory of Pygmalion to posit the

power of artistic genius to potential customers and competitors. Not surprisingly, in an era characterized by the blurring of boundaries between the arts and by a new atmosphere of vital competition for an audience, these versions of the myth of artistic animation further manifested the desire of the individual artist to assert generic superiority. If Pygmalion then serves as a manifesto for what art should—and should not—be, it also becomes, during this period, the battleground for the struggle between Neoclassicism and Romanticism and the site for the renewal of the *paragone*. Moreover, if the Pygmalion myth asserts the artist's identity as creator, genius, hero (or conversely, failure), this identity is consistently predicated in relation to the mastery, or lack of mastery, over the female form, reflecting the no less important "problem" of gender relations in the postrevolutionary period.

Girodet's *Pygmalion* represents the culmination of the artist's own paradoxical, competitive and conflicted career, which closely mirrors the instabilities of France's social and artistic universes on the cusp of two centuries. Indeed, *Pygmalion et Galatée*, Girodet's last effort to reinvent himself as an artist for the new era, reflects the painter's lifelong struggle to define himself in relation to the public, poetry, and the institutional structures of power (the *Académie* and the monarchy) and to recapture the glory of his first masterpiece—*Le Sommeil d'Endymion (The Sleep of Endymion)*. Created when he was a student at the Academy in Rome, *Endymion* (which will play a crucial role in Balzac's *Sarrasine*) announces the major themes of Girodet's later aesthetic, but more importantly emblematizes his nascent theory of "poetic" painting. *Endymion's* poetic aspirations constitute Girodet's own response to the politics and aesthetics of Revolution, and in turn embody his initial effort to posit new definitions of art, the artist, gender and genre in the wake of the dissolution of established paradigms.

Institutions of Art in the Ancien Régime

In 1648, a group of painters in the court of Louis XIV persuaded the king to establish the *Académie Royale de peinture et de sculpture*. Following the model of the Italian academy, the French painters sought to elevate their profession from the status of artisan to artist and to establish a definitive break with the commercial painters' guild, which had dominated artistic production since the Middle Ages. The newly founded *Académie* trained its members to uphold rigid standards of style and subject matter based on the Classical values of balance, harmony and absolute beauty. Embracing hierarchical structures that echoed court society, the *Académie* ranked both its

members and their production.[3] Paintings were evaluated both in terms of their composition and subject matter: history painting—the portrayal of biblical, Classical and mythological scenes—was considered the most elevated form, while portraiture, genre painting, landscape and still life followed in descending order of prestige. For painters in search of a theory, there was no Classical treatise to mine, thus, in its quest for intellectual legitimacy, the *Académie* pillaged literary sources both for inspiration and its foundational *règles*. Academicians appropriated passages from Aristotle, Horace and others, "making them apply in a more or less procrustean manner to the art of painting for which they were never intended."[4] Following in Leonardo's footsteps, the *Académie* turned to words to justify their images and locate the visual arts in the realm of cerebral rather than physical labor.

By 1663, all court artists were required to be members of the *Académie*, insuring that the king's taste would prevail as the national standard, while establishing the "liaison between fine art and the monarchy on the one hand, against métier and bourgeoisie on the other."[5] As a government institution, the *Académie* provided annual pensions, studio space and the prospect of official commissions for its members, while explicitly forbidding them from selling their work in any kind of commercial venue. Thus, Academicians initially resisted Colbert's institution of obligatory expositions of members' paintings in 1663, for they smacked of the very commercialism artists were hoping to transcend. Accordingly, these early academic expositions and later the Salons of the Ancien Régime presented to the general public paintings exclusively by its members, but which were not for sale. They had instead been "previously commissioned" while future commissions, both from the government and from wealthy aristocratic patrons, were based on their reception. This important distinction between what Mainardi has dubbed "pictures to see" versus "pictures to sell" reflects the ideological split between official and commercial art that would play an increasingly important role in the nineteenth century.[6]

During the eighteenth century, the *Académie-Salon* system flourished as an institutional means of regulating both the production and consumption of French art. The *Académie* served as a centralized mirror of the absolutist regimes, training an elite corps of painters to produce works within set aesthetic parameters. The Salon, conceived by Colbert as a way to "control intellectual and cultural life,"[7] presented selected images by selected artists to the Parisian public, yet despite its elitist roots and intention, it functioned as the focal point for an increasingly widespread public awareness of art.[8] Open free of charge to all during its three week run, the Salon attracted a

uniquely heterogeneous public, ranging from aristocrats to burgers to working-class men and women who had never before mixed in a secular public space with such regularity. As the Salon became a social habitus for a broad spectrum of social classes, public opinion became a powerful reckoning force, generating a new public discourse on aesthetics. Counterbalancing the *Académie's* domination of the selection, training and sanctioning of Salon artists, the critical evaluation of the paintings, prints and sculptures displayed at the biennial exposition lay largely outside of the *Académie's* control. Critics began to play an increasingly important role in reflecting and shaping the public's response to official art via articles, brochures and pamphlets published and sold during every Salon. These tracts, explaining, lauding or criticizing the works of art, evaluated the institutional artists' offerings not only in the name of aesthetics, but in the name of the public itself.

The power of the art critics, still negligible in the eighteenth century, nevertheless represented a source of tension and animosity for the *Académie* and its members, and the role of criticism is key in understanding the relationship between painters and authors in the nineteenth century. The earliest publication associated with the Salon was the *livret*, a neutral catalogue first issued by the *Académie* in 1673 providing the spectator with the artist's name, rank, the title of the painting and a brief description, since works of art were not accompanied by any kind of identifying label. The *livret* soon inspired more analytical, critical treatises appearing in newspapers, pamphlets and newsletters, penned by authors who had little knowledge of painting or its vocabulary. From its very inception, the critical response to the Salon provoked the indignation of the artists of the *Académie*, who insisted that "only individuals of the same profession should be permitted to evaluate one another; knowledge of the techniques of the plastic arts allows them to hold forth on these matters. Thus artists claim exclusive right to evaluate works of art."[9]

In 1791, the revolutionary government wrested the Salon from the *Académie's* control and opened it to all artists. The result was a new, unjuried public exhibition that embraced nearly twice the canvases that were shown in 1789, and from 1791 to 1831 the number of exhibitors rose from 258 to 3,182. This "democratization" of the Salon invoked the fury of the *Académie*, which would continue to lament the decline in quality of art at the sporadic open Salons throughout the century to come. As Mainardi comments in *The End of the Salon*, the Salon had become a metaphoric battleground for political ideologies—the rights of the many versus the privileges of the few—while reformers strove either for a conservative "aris-

tocracy of the arts" or a democratic "Republic of the arts" (20). Theoretically, the open Salon allowed non-academically-trained painters access to an audience, making them eligible for state commissions and aristocratic patronage; in reality it remained difficult for a young artist not associated with the institution to break in. The jury's selection process was often politically motivated, while members tended to select canvasses by their friends, students and those with whom they shared a political or aesthetic agenda. Thus, in the course of the nineteenth century, the Salon continued to be the showcase of the *Académie*. Associated with the conservative political and aesthetic doctrines of Neoclassicism, both institutions of official art were initially hostile to Romanticism, with its liberal republican leanings.

As the institutions of art changed, so too did the artist's relationship to them, to society and to his audience. During the revolutionary period a group of artists led by David reconfigured the artist's image and duties from that of an elite lackey of the state to the virile champion of the public good, at odds with the hierarchical system that had dominated his brethren for two centuries. For despite the efforts of the *Académie* and all of its training, until the Revolution the artist remained in a position of dependent subservience, "somewhere between the upper-domestic, and lower-civil, servant"[10] and continued to be seen more as an artisan than an intellectual. During the last decade of the eighteenth century, however, as the church, state and aristocracy collapsed, the artist emerged with a new independence and a new self-directed responsibility, not to the entrenched elites, but to the greater public good.

At once a painter and a public figure, David personified the "new" artist, dedicating both his life and his art to promoting the political values of virtue and patriotism.[11] Although he was a product of the Academic system and winner of the prestigious *Prix de Rome*, David resisted its authoritarian structures. Within his own studio he promoted a democratic atmosphere between master and students, providing his pupils from the *Académie* with intellectual and moral instruction as well as practical artistic training. David's students, including Drouais, Gérard, Gros, Girodet and later Ingres, learned Latin, philosophy, history, and aspired to the idealized image of Greek civic virtue both in their art and comportment, which was infused with a sense of superiority to the usual run of academic recruits.[12] Fully committed to public art, David took the radical position of insisting on the artist's autonomy in determining the nature of his role. Theoretically self-determined and no longer beholden to the aristocracy, the painter now came closer to holding a position of parity in society, or even that of a role model. This model of the artist as self-made man, rather than the product

of institutional guidelines, would inform the nineteenth-century image of the Romantic artist as rebel, while simultaneously throwing the artists of the generations to follow into periods of profound self-doubt as to who or what exactly they were meant to be, and putting them forever at odds with conservative bourgeois society.

David's idealistic vision of the public role of art provided an important transition from the eighteenth to the nineteenth century, but was rapidly replaced by the more profane conception of art as business. In the single most profound change in the Salon system, in 1804 Vivant Denon convinced Napoleon that the state should buy the most outstanding works at the Salon outright, rather than using them as a basis for future commissions, and "in this one gesture, the Salon became a store, and artists became free-market producers."[13] Academic artists had of course depended on patrons to supplement their income in the past, and many had relied on private commissions, but there nevertheless remained a collective understanding that these were "patrons," not customers, "commissions," not purchases. In the nineteenth century, however, the world of wealthy patrons gave way to a bourgeois marketplace, and with a steady decline in state support, artists were forced to rely increasingly on the Salon as a place to make their living.

Thus the Salon became the locus for establishing the reputation of a painter and his price tag, as art moved toward a privatized, commercialized venture.[14] By the early 1800s artists' addresses began to be listed in the *livret* along with their names, so that prospective buyers would be able to locate them, leading to the academic complaint that the Salon had turned into a bazaar. For the first time since it was instituted, artists neither trained nor supported by the state were able to exploit the Salon for their own ends, making a living entirely derived from the new domestic consumers. And while academic and Salon prizes helped a painting's price, so did public and critical acclaim, and thus in the early decades of the nineteenth century art criticism took on an ever greater importance. Following in Diderot's footsteps, unprecedented numbers of authors were trying their hands at art criticism in the hundreds of journals and revues popping up all over Paris. Unlike the more cultured aristocratic patron of the previous century, the bourgeois public was aesthetically insecure and felt the need for some kind of guidance through the maze of paintings, styles and narratives that saturated the Salon walls. The critic gained an enormous power and prestige as he played a decisive role in deciding the public acclaim and failure of painters, sculptors and printmakers, while directing consumers in their aesthetic enjoyment and financial investments. As Bourdieu indicates, "with the end of the Académie's monopoly over consecration, these 'taste-

makers' had become 'artist-makers,' who, by means of their discourse, now had it in their power actually to sanction something as a work of art."[15] In an increasingly competitive market, the critic's role as an arbiter of artistic taste only intensified the rivalry between painters and authors in the nineteenth century, serving as a catalyst for the intergeneric dialogue—and competition—over the language of art and the "right" to write.

Girodet and the Académie

Anne-Louis Girodet-Trioson, dubbed David's "plus bel ouvrage,"[16] occupies a significant place in the history of French art as a staunch adherent to the waning Classical tradition who nonetheless served as an inspiration and even icon for the Romantics, very much in spite of himself. Like the works of many fellow Classicists of the postrevolutionary period such as Guérin, Gérard, Delorme, Meynier and Prud'hon, Girodet's paintings display a lyrical eroticism, poetic dreaminess and mythological orientation that indeed seem, to a twenty-first-century viewer, inflected with a Romantic vision. These stylistic imbrications between two artistic movements, generally seen to be in opposition to each other, highlight the constructed nature of that opposition. For although there were indeed formal divisions between Neoclassicism and Romanticism, the essence of their differences was ultimately more ideological and political than purely aesthetic. And like many of the academically trained painters whose works have fallen outside of the mainstream of art historical categories, Girodet enjoyed a contemporary popularity and influence that was remarkably short-lived. A prominent member of the *Académie* during the Restoration, Girodet drifted into obscurity by midcentury, and by 1855 Baudelaire considered him one of the artists "overly praised of yore, overly scorned today."[17] Yet upon the painter's death in 1824, the king himself regretted "the loss the arts have suffered at Girodet's death," and his funeral procession, led by Chateaubriand, Gérard and Gros carrying laurel wreaths aloft, was so large that only a third of the mourners were able to enter the Church of the Assumption to attend his last rites.[18] But more remarkable than the sheer number of mourners at Girodet's funeral is the constitution of the group, which encompassed stalwarts of the Classical school, including Delécluze, Ingres, and Quatremère, arch-conservative secretary of the *Académie* and sworn enemy of Romanticism, as well as founding members of that fledgling movement, including Delacroix, Scheffer and Chateaubriand.

Indeed, those gathered saw in Girodet's demise the symbolic death of Classicism itself, and the funeral orations focused as much on contempo-

rary aesthetic battles as on the painter's oeuvre or the man himself. For members of the *Académie*, Girodet represented a last stronghold against the rising tide of Romanticism, and they mourned "the irreparable loss for the School at a moment when it needs a strong arm to keep it from being swept into decline."[19] A series of graveside tributes, mostly voiced by fellow members of the *Académie*, expresses a whole litany of loss, from Belloc's invocation of the glory of David to Garnier's lament for the past days of state patronage for all Academic artists. But it was Gros's speech, reported both by Delécluze and the *Journal des débats*, that encapsulates the passionate battle between artistic, and ultimately political, schools, being waged over Girodet's tomb. Echoing the myriad elegies to Girodet's talents, Gros began with the premise that he was the only painter who had the vision and authority to "save" the Academy, and then launched into a full-fledged attack on Romanticism, all but forgetting Girodet himself. Apostrophizing Horace Vernet, Gros invokes the nascent debate on sketch versus finish, exclaiming "soon they will try to make us believe that a piece of canvas somebody has daubed paint on for a couple of weeks is a masterpiece worthy of consecrating the memory of a prince."[20] The eulogist implicitly validates Girodet's own seven-year struggle to complete his *Pygmalion*, but only through a negative counterexample. The hostility of the improvised oration received hearty applause, but "le petit nombre de dissidents"—Delacroix, Scheffer, Sigalon, and others—"ont marqué leur mécontentement." Finally, the coveted insignia of the *légion d'honneur*, posthumously awarded to Girodet by the king, was conferred upon his casket, firmly placing him within the ranks of the conservative power structure of art and politics upon his early and much lamented death.

Yet, ironically, if Girodet served upon his death as a symbolic figuration of the Academic ideal, the leader of the Classical resistance to the new school and the most meritorious of David's many pupils, he spent much of his lifetime revolting against these very structures and categories. His correspondence reveals a lifelong resentment of academic conformity, and in an early but prophetic letter he announced his desire to distinguish himself from David, insisting "I am trying to distance myself from his style as much as I possibly can."[21] From his youthful rebellion against the status quo to his middle-age desire to curry favor with the emperor and king, Girodet's politics closely followed the vicissitudes of academic art of the postrevolutionary era. Like many of his liberal cohorts in David's studio in the 1790s, by the early 1800s he had aligned himself with the right-leaning Institut, battling the new revolutionary art: Romanticism. The contradictions and awkward indeterminacy in Girodet's oeuvre, ranging from his "revolution-

ary" *Endymion* of 1791 to his archconservative *Pygmalion et Galatée* of 1819, challenge our readings of postrevolutionary art in fruitful ways. In his extremity he emblematizes an entire generation of painters caught between academy and marketplace, aesthetics and pragmatics, and perhaps most importantly, identity and ideology.

Born in Montargis in 1767 to a well-to-do family, Girodet entered the Academy's *école* in 1783 and soon joined David's studio for his practical training. After two failed attempts (in one case he was disqualified for cheating), Girodet won the *Prix de Rome* in 1789, but the outbreak of the Revolution (which Girodet supported) delayed the artist's departure for Italy until the spring of 1790. It was there, as part of his prescribed course of study, that he began work on an *académie*—a life study of a nude male model—that would become his first great success: the erotically suggestive *Endymion*. Finishing late in 1791, Girodet submitted *Endymion* to the Salon of 1793, where it was received with enormous enthusiasm, going on to receive first prize from the *Jury des Arts* in 1799 and establishing Girodet's reputation as a first-class artist. Despite his success within the Academic system, even at this early point in his career Girodet was rebellious, resisting the institutionalized nature of his artistic formation. In a letter of 25 November 1791 sent from Rome to Doctor Trioson, his sponsor and adoptive father, Girodet complained of the rigidity of the academic regime and admitted that he had petitioned the director to let him direct his own studies, rather than participating in group classes. In keeping with the revolutionary fever sweeping Europe at the time, Girodet dreamed of eliminating the *Académie* altogether and goes on in his letter to Trioson to assert,

Ce qui me déplaît, c'est d'être réunis comme nous le sommes; d'être, par cette position fixe, forcés de faire à-peu-près tous les mêmes études. Il serait à désirer que l'académie de France à Rome n'existât pas, c'est-à-dire, qu'il n'eût pas une grande bergerie royale pour loger douze moutons obligés de se lever, de travailler, de se coucher aux mêmes heures. (OP 2: 399)

(What bothers me is being assembled the way we are; being forced, following this rigid formula, to all pursue more or less the same studies. It would be better if the French Academy in Rome did not exist, that is to say, if there were no big royal sheepfold to lodge twelve sheep obliged to rise, work and go to bed at the same time.)

Obsessed with the concepts of originality and genius, Girodet chafed at the restrictive, conformist nature of academic training, and in 1793 he penned a petition of support for the Convention, signed by 13 fellow students of the French Academy in Rome. As Colin Bailey explains, Girodet and his

cosigning *citoyens élèves* pledged allegiance to the Republic and the Revolution, while the petition "castigated the 'despotic constitution' of their establishment and called for a more liberal organization which would allow 'each member to follow the path that his genius inspired.'"[22] Later that month, Girodet's actions underlined his commitment to the Republic. As tensions escalated in Rome, where the Pope refused to recognize the French Republic and its consul, Basseville, the students of the Academy were ordered to relocate to Naples, where they would be safer. Girodet remained in Rome, and in a deliberate act of provocation, helped to complete work on a new coat of arms for the Academy, replacing the fleur-de-lis with the insignia of the Republic. The following morning, paintbrush still in hand, Girodet narrowly escaped the rioting Roman mobs that pillaged the Academy and assassinated consul Basseville.[23] He spent the following 18 months in Naples, then, after sojourns in Venice, Florence and Genoa, returned to Paris in 1795, where he obtained a studio and lodgings at the Louvre. Although his politics soon shifted to the right, and he would later become a conservative supporter of the Restoration monarchy, Girodet's youthful flirtation with revolutionary politics marks a long-standing commitment to the values of independence and originality, as well as a vision of himself as a perpetual outsider. His competition with David set the stage for a lifetime of bitter jealousies and rivalries both with his erstwhile friend, Gérard, as well as with poets and art critics, all of whom he sought to better at their own game while taking art to new levels of expression.

Le Sommeil d'Endymion [figure 1.1] serves as Girodet's first and most powerful manifesto of originality and inspiration. Composed against the backdrop of Revolution, at once distant and fully felt, Girodet's mythological allegory inscribes its own political as well as aesthetic agenda in the sensuous form of the sleeping shepherd. In this remarkable canvas, the 24-year-old Girodet tried to reach for something entirely new, both technically and aesthetically. He explains to Trioson in one of many letters on the subject, "the effect is purely ideal, and thus very difficult to render. The desire to do something new, that did not simply feel workmanlike, perhaps made me attempt something beyond my capacities, but I want to avoid plagiarisms."[24] Elsewhere he admits "what pleased me most was the unanimous opinion that I do not resemble David in any way."[25] Girodet is reaching for a new *idéal* that will be manifested in both the subject matter and facture of his academic nude, and indeed, the *Endymion's* ethereal, atmospheric approach to subject and treatment constitute a definitive break with the solid, rational naturalism and moralizing exempla of Davidian Neoclassicism.

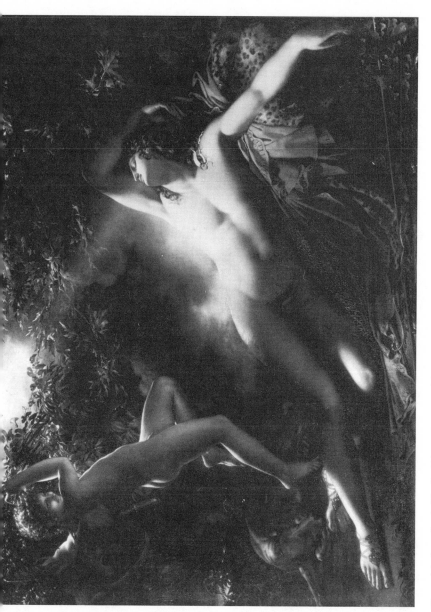

Figure 1.1. Anne-Louis Girodet-Trioson, *Le Sommeil d'Endymion*. 1791. Oil on canvas, 189 x 261 cm. Paris, Musée du Louvre. Photo: Scala/Art Resource, New York.

Thus, critics have traditionally read Girodet's *Endymion* in terms of a dialogue with David, classifying the *académie* as an apolitical image privileging the private world of dream over the public world of heroic battle, "the reversal of the politically engaged art of his master."[26] Yet given Girodet's own political engagement at the very moment that he executed the painting, it is unlikely that the student who queried "and where is the academic revolution?"[27] would have removed his own artistic production from the ongoing discourse of republican values. Although *Endymion* may indeed *not* reflect a Davidian vision of republican virtue, it nonetheless articulates its own revolutionary ideologies of art, the ideal and the nude, as well as of the social ordering of gender.[28] The representation of the androgynous body of Endymion and Girodet's self-conscious search for originality are tied to his conception of a new "ideal" that is revealed both in the luminous, dreamlike facture of the canvas and in the striking choice and treatment of familiar subject matter.

While it was typical for an academic student, in a show of artistic bravura, to transform an *académie* into a history painting, Girodet's choice of the myth of Endymion is remarkable on a number of levels. First, by selecting a myth about love, rather than an historical episode of masculine valor, Girodet distances himself from his contemporaries in a gesture that refers to the immediate rather than ancient past, that is, to the previous generation's Rococo fascination with amorous fable. His treatment of the sleeping shepherd, whose weapons are conspicuously laid to one side, eschews the standard painterly signifiers and visual vocabulary of Roman republican valor, bristling with taut musculature and active energy, that characterized the work produced in David's close-knit studio. Instead, Girodet's *Endymion* represents an hellenicized Classicism in a languid, sensual composition, whose passive hero, stretching horizontally across the canvas, is the very antithesis of the erect verticality of the Horatii. Crow indicates that the originality of the image may be read in terms of "an effort to express the extreme independence of the artist from any entrenched authority or hierarchy,"[29] yet Girodet's rebellion is by no means limited to an assertion of artistic *liberté* from David and the *Académie*. Indeed, the ultimate meaning of this revolutionary *Endymion* emerges from its dialogue not only with Davidian heroism, but also with Rococo representations of the goddess Diana and the mortal shepherd, images intimately associated with the Ancien Régime and its attendant ideologies. In his treatment of the Classical myth of love and immortality, Girodet posits a new version of the ideal encoded at the levels of the *dit* and of the *non-dit* (said and unsaid),

in the figure of the idealized male nude and the absence of the female goddess.

Traditionally, the myth of Endymion recounted the passion of Diana, goddess of the moon, for the beautiful youth Endymion, a shepherd she happened upon as he slept alongside his flock on Mount Latmus. The goddess was so infatuated with the slumbering mortal that she asked Jupiter to let him sleep forever, in some versions so that he might remain eternally young and desirable, in others, so that he would be ever available for her amorous nocturnal visits. Popular both in fiction and art from Homer on, the myth of Endymion figures forth the metaphysical themes of love, death, sleep and immortality. Ignoring customary sources such as Cicero, Ovid or Apollonius for his study, Girodet turned instead to Lucian's *Dialogues of the Gods*, and as George Levitine has demonstrated, follows the Samothracian satirist's description of the sleeping figure almost to the letter.[30] Girodet's erudite inspiration bears witness to his literary aspirations, but further, to his desire to engage in his own "dialogue" with both literature and painting of the present and past. The *Dialogues of the Gods* are pointedly ironic critiques of social hypocrisy. Lucian's humorous, deconstructive reworking of Classical mythology playfully mocks convention with a decided edge, and it is the powerful goddesses, humbled and debased by their lust, who are the target of his satire. In keeping with his Classical source, Girodet's version of Endymion has its own iconoclastic and critical side, for like the ancient dialogist, the painter sought to offer up his own subversion of contemporary mores through the vehicle of ancient myth.

Thus, just as Lucian's Endymion represents a satiric revision of the shepherd's tale, so too does Girodet's *Le Sommeil d'Endymion* set forth a reformulation of conventional treatments, engaging in a metatextual dialogue with earlier *Endymions* and their social, political and sexual implications. While the iconography of Endymion and Diana dates back to Roman sarcophagi, the myth became particularly popular in the eighteenth century among painters including Lagrenée, Van Loo, Boucher and Fragonard. These Rococo versions of the subject lavished equal attention upon the love-struck goddess and the sleeping youth, set beneath the circular form of a full moon. The principal interest lay in the contrast (and implied eroticism) between the awake and animated female figure and the prone and passive male nude, a playful inversion of stereotypical painting and power structures, much in keeping with the active role played by women in the Ancien Régime as the subjects and consumers of art.

In his radical version of the myth, however, Girodet represents the god-

dess symbolically, as moonlight streaming across the torso of her lover. His composition shifts the focus from the tensions between male and female, goddess and mortal, asleep and awake, to the more subtle and erotically charged relationship between the viewer, as voyeur, and this undulating ephebe. The painter dematerializes the female form, replacing the voluptuous image of Diana that had dominated paintings of the past with a Zephyr who holds back the bushes, allowing amorphous moonbeams to wash over the sleeping nude. The winged Eros/Zephyr gazes intently at the unconscious shepherd; a proxy for the lustful goddess, he embodies the displaced desire for the youth and highlights the homoerotic nature of this vision.[31] While Diana's moonbeams bathe the contorted torso of Endymion, the light conspicuously avoids his groin, which remains in shadow. However, if we follow the arc described by the Zephyr's left leg jutting forward in a phallic extension of his tiny but visible penis, to Endymion's waist, across his midsection down through the draped robes upon which he lies, to Endymion's own bent legs, the curled dog and then back to the Zephyr's moonlit buttocks, the epicenter of this inscribed oval is in fact Endymion's own genitals, shadowed, flaccid, but unmistakably present and unmistakably male. If his predecessors highlighted the heaving breasts and titillated smile of Diana, relegating the sleeping—and strategically draped—shepherd to a secondary position, Girodet shifts the viewer's focus and the central tension of the visual narrative to the male figure and the male gaze. Echoing the circular structure that had characterized earlier versions of the tale, Girodet brings our gaze down from the heavens, away from Diana and the moon, to the human shepherd and his darkened sex.

Thus, Girodet's much vaunted originality lies at once in his elimination of the female goddess and in his exclusive privileging of the male nude, innovations that reveal the painter's vision of a new political and aesthetic ideal. As a nude first and foremost, *Endymion* reflects the ideology of gender as well as the aesthetic and cultural expectations of the moment in which it was produced. The politics of the body and masculinity were especially pronounced in the 1790s, and a mythological portrait of a male nude that elides the anticipated presence of a complementary female body would have resonated for the artist and his audience within a complex matrix of political, sexual and aesthetic meaning.

Diana and the Gaze

In order to elucidate the power of Girodet's representation of Endymion, I will turn first to the body that is *not* represented: the absent figure of

Diana. In keeping with Jauss's theory of "horizons of expectation," Girodet and his viewers would have recognized Diana as a conspicuous absence in this image, and the suppression of her corporeal presence evokes the negation of an entire complex of Classical and contemporary associations. Diana the huntress and goddess of the moon was a key figure in the visual vocabulary of Salon and court culture in the seventeenth and eighteenth centuries. Indeed, between 1673 and 1799 there were more than 80 representations of Diana at the Salon, while countless images of the goddess adorn palaces, châteaux and *hôtels particuliers* of the period.[32] Myth served as social code in eighteenth-century France, a shorthand of cultural inclusion and assumed meanings for the educated classes who were privy to the idiom of Classical iconology promulgated in school, Salon painting, theater, opera, fiction, architecture and interior decor. Girodet works explicitly within this language of myth and cultural association, subverting the code by shifting the signifiers in an effort to propose a new language for a new age.

The mythic meaning of Diana in France during the Ancien Régime cannot be separated from the gender politics of the period. As an icon of beauty and power, the goddess became a favorite persona for portraits of well-born women, most notably the wives and mistresses of kings. Thus, one finds portraits of Diane de Poitiers, Gabrielle d'Estrées, Marie de Médici, Louise de la Vallière, Marie-Adélaïde de Savoie, Marie-Adélaïde de France and Mme de Pompadour, all in the guise of Diana, while numerous aristocrats and bourgeoises followed suit and commissioned their own portraits as goddess of the hunt.[33] The image of the mythological Diana thus became intimately associated with the idealized image of "powerful" women in the Ancien Régime.

Seventeenth- and early-eighteenth-century representations of the goddess highlight her role as virgin mistress of the nymphs in the tale of Diana and Actaeon, the most popular of her mythic incarnations. As recounted by Ovid, the hunter Actaeon unknowingly stumbles upon Diana at her bath surrounded by her naked nymphs in a secret grotto. The modest nymphs hurry to cover the exposed goddess with their own bodies, but Diana sees the interloper and splashes him with water, turning him into a stag so that he cannot tell others that he has seen her undressed. Ultimately Actaeon's own hounds tear him to pieces, an unwitting victim of female modesty. An ambivalent metaphor for women's virtuous "control" over male desire in their ability to deny men what they so avidly pursue, the goddess's formidable power lies in her chastity, which will not tolerate the invasive gaze of her masculine observer. But significantly, Diana's power is manifested not only in her body, but also in her *gaze*. Diana, in both myth

and painting, is an active observing subject in her own right, in an important variant on the traditional structures of the gendered gaze.[34] The multiple implications of sex, power and vision converge in the image of the naked goddess who sees her mortal male spectator looking at her and condemns him to a grisly death, in a vivid illustration of the equation of sight, knowledge and power (*voir* = *savoir* = *pouvoir*). For if Actaeon gains knowledge and thus power from witnessing Diana's naked body, she also participates in the formulation, while her empowering sight spells the destruction of the male who shifts from subject to object position. This myth of the virgin goddess underlines the threatening nature of the gaze, of the female body and of female agency, as sight is equated with subjecthood. In the most basic Freudian terms, Actaeon and Diana further enact the fantasy that the glance at the hidden and forbidden will reveal that the woman has no penis, thus invoking castration anxiety in a male viewer who fears that the same punishment will be enacted upon the voyeur.

Finally, the dynamics of viewing and the erotics of the gaze are also played out between Diana and her *other* unseen spectator—the viewer of the painting. Highlighting the tensions between seeing and being seen, the structure of these images of Diana at her bath positions the viewer as yet another voyeur, observing the goddess in her magnificent nudity. The powerful and chaste Diana, who will not tolerate the gaze of the lost hunter, is nonetheless exposed to the viewer of the painting, who, unlike Actaeon, may live to tell others he has seen her undressed. The unsolicited look is associated with the power of forbidden knowledge, and while the goddess destroys the interloper, her unseen viewer (on the other side of the frame) dominates the dominatrix by witnessing her forbidden body, gaining the power of knowledge through seeing what should remain hidden. Thus, the threatening power of Diana and her dangerous gaze is at once enunciated and ultimately defused in the many versions of this popular myth.

In the eighteenth century, however, images of Diana and Actaeon gradually give way to Diana and Endymion, representations of her lustful desire subsuming those of her chastity. Commenting on the Rococo conflation of Venus and Diana, Levine sees the sensual female body of the goddess "as the sign of a new ideology of sexual freedom," while depictions of Diana and Endymion by Boucher and Fragonard "point us generally in the direction of the popular literary themes of feminine initiative in love and the revolutionary traversal of hierarchies" (86). Indeed the chaste Diana is here the sexual aggressor, and in an inversion of the earlier images with Actaeon, it is the moon goddess who is the voyeur, while the mortal shepherd is the unsuspecting object of her gaze. Once again Diana represents

the fantasy of a powerful female figure who takes the subject position as an active viewer, but now the male has been entirely deprived of consciousness and agency. Fast asleep, Endymion cannot see his admirer, and thus the hierarchical structure of sight/knowledge/power has been fully accorded to the woman, who physically as well as scopically dominates the prone and passive male. The implications of sight, however, are less obviously negative here, and the danger and destruction entailed in the myth of Actaeon are no longer at issue. In keeping with Rococo playfulness and contemporary mores, there is no implication of violation, only tenderness and desire in the goddess's gaze, while the partially naked bodies of both are presented to the admiring eyes of the spectator in an open gesture of frank eroticism.

The transformation of the chaste Diana, modest object of a forbidden gaze, into a desiring *voyeuse* reflects the Rococo fantasy of women as "pleasers and teasers" and reveals the gender ambiguities of the movement that "loves only that in woman susceptible of releasing the dream of unfettered desire."[35] The eighteenth century produced a mythologized vision of the French woman as a powerful and dangerous species, an image promulgated not only in art, but in philosophy, literature and political discourse as well. Melchior Grimm, for example, complained of "the libertine social mores, social influence, and political power of French women, whose unwarranted behavior threatened proper family and civic structure."[36] As Madelyn Gutwirth contends, the "*topos* of public conceptions of women as active participants in society" centered on female calculation, licentiousness and depraved "unnaturalness."[37] In reality, however, with the rise of the absolutist state, secular culture and private property in France, "the avenues for women's freedom were foreclosed rather than expanded,"[38] while legal, social and sexual ideologies continued to render this fantasized female domination a virtual impossibility. Yet despite historical evidence to the contrary, this *discourse* of feminine power was an important eighteenth-century myth, and one that became intimately associated with the Ancien Régime in the nineteenth-century imagination.

Rousseau, among the most vocal and influential critics of "the ascendancy of women over men,"[39] reflected in his various tracts on the importance of relegating women to the private domestic sphere, while claiming the public domain, and authority, entirely for men. The threatening specter of public female subjecthood is most clearly bodied forth in the theatrical productions that so outraged the Genevan. There, not only did women play active roles outside of the home, he complains that in "most modern plays it is always a woman who knows everything and teaches everything to the men."[40] This popular masculinist conception of a (fantasized) "renverse-

ment des rapports naturels" reflects attendant anxieties of emasculation: Rousseau adds later in his polemic that, "being unable to become men themselves, women are turning us into women."[41] The existence of a handful of "exceptional women" in the social and artistic spheres—Mme de Pompadour, Mme Geoffrin, Mlle de l'Espinasse, Mme de Graffigny, Mme Riccoboni, Mme de Charrière, Elisabeth Vigée-Lebrun—cannot negate the repressed and dominated status of French women during the period, but helps to explain these widespread anxieties of female expression.[42] Women, and particularly "powerful" women (aristocrats, intellectuals, *salonnières*), stood as potent symbols of the Ancien Régime for its critics, who conflated the sexual and the political into a single image of the corruption of society. The republican gendering of the Ancien Régime and the monarchy as "feminine" reflected its perception of an "unnatural" social order where women were powerful public figures and men were weak and submissive. Revolutionaries accordingly formulated a discourse based on a return to a more "natural" state of gendered hierarchies of masculine domination where women were relegated to subordinated positions in the private sphere.

Rococo painting, the art form most intimately associated with the Ancien Régime, emblematizes the schism between the essentialized eighteenth-century "feminine" and the interests and/or power of real females. When applied to painting and politics, "feminine" and "feminized" connoted artifice, illusion, corruption, decadence, luxury, sensuality, frivolity, overindulgence and sexual licentiousness. Rococo painting, lighthearted, erotic and highly decorative, did indeed focus on the female body, quite often nude, in any number of amorous situations. Its aesthetic gloried in elegance, grace, sensuous line and the surface play of color and curve in reaction to the ponderous imagery of the earlier baroque. Yet, while the female body figured prominently in Rococo imagery as "sublime spectacle," it remained an art of male desire for a fetishized female sexuality. Thus, despite its intimate association with the feminine in both subject and form, Rococo is "a feminocentric art only in the sense that it adores woman in paint for her ability to inspire desire."[43]

Diana and Endymion functions as a quintessential Rococo image both in its mythological, erotically charged subject matter, and in its portrayal of woman as powerful seductress. Diana stands as an emblem of female desire and domination, yet in keeping with Rococo's ultimate orientation toward male desire, she remains a slave to her illicit love, humbling herself nightly as she leaves the heavens for her secret rendezvous. If her lover cannot reciprocate her lascivious gaze, the viewer of the painting, necessarily gen-

dered male, once again penetrates Diana's secrets as he witnesses her illicit tryst, mirroring her desire for a naked body in his own for hers. As with so many contemporaneous images, the portrayal of female power as predicated in a female gaze reveals a fundamental male anxiety and effort to curb or control the specter of female sexuality, desire and mobility.

In choosing to portray this myth of female desire for his *académie*, Girodet enters into a self-conscious dialogue with the aesthetics and sexual politics of the newly dislodged old order in a gesture that his Parisian audience would certainly have recognized. As he observed to Trioson upon beginning the painting, "they may not have studied painting in this manner under the reign of Louis XV, but times have changed and painting has too, thank God! I do not want to seem like a contemporary of Carl Van Loo in my work."[44] By eliminating the central figure of Diana in his *Endymion*, Girodet deliberately negates the political and aesthetic specter of the Ancien Régime and the Rococo as connoted by the feminine, the female body and the assertive female gaze, and asserts a new order based on a masculine ideal. If the goddess Diana came to symbolize the powerful public role played by women in the old order, Girodet obviates her, shifting the focus to her young lover, a mortal whose youth and lower rank are representative of the *peuple* and the new republic. Where she embodies corrupt desire and the wanton sexual mores of the aristocracy, he is innocence and purity, the simplicity and goodness of the working man; where she is society, he is nature; where she is feminine wiles, he is masculine virtue.

Girodet's revisionist representation of the ancient myth refuses Diana's gaze and the Rococo fascination with the female body, for a new republican aesthetic. As an icon of the feminized Rococo, Diana further symbolizes the role played by women both as subjects and as visual consumers of this aristocratic art, hence, in *Le Sommeil d'Endymion*, the goddess no longer sees, nor is she seen. Girodet's *Endymion* announces an aesthetic free from the corrupt and corrupting female presence to privilege the male subject presented to a male gaze.[45] The painter effaces the sexualized female body and her unabashed gaze, overdetermined symbols of the "feminized" art, politics and power structures of the preceding era, and replaces her with a moonbeam that "seemed to me more delicate and more poetic, besides which, it was new and original then."[46] As Girodet would later reiterate, "thus this painting is *not*, as some people have called it, *Diana and Endymion*, but rather *The Sleep of Endymion*."[47]

Endymion and the Male Nude: The Aesthetics and the Politics of Gender

Thus, Girodet's precocious masterpiece enunciates a new aesthetic in deliberate opposition to the feminized values of earlier artistic and political regimes. In eliding Diana, the painter focuses entirely on the male nude in a sexualized representation that furthermore proposes his own response to contemporary myths of manhood. In the Neoclassical idiom of the late eighteenth century, the male nude eclipsed the female as paradigm of virtue and beauty. Crow observes an "increasing masculinization of advanced art. Powerful shifts were taking place in the philosophical underpinnings of the visual arts, the sum of which moved painting more and more into a single sex frame of reference. Artists were asked not only to envisage military and civic virtue in traditionally masculine terms, but were compelled to imagine the entire spectrum of desirable human qualities, from battlefield heroics to eroticized corporeal beauty, as male."[48] This "masculinization of art" reflected the social and political landscape of the 1790s, where "the male-female world of familial and sexual bonds represented by Versailles was overpowered by the all-male contractual universe of the revolutionary assemblies."[49] Girodet's ephebic *Endymion* partakes of the more generalized move in Davidian Neoclassical art toward an all male universe, but in keeping with the young painter's ambitions, takes this paradigm in a new and original direction, working both within and against his master's visual vocabulary of virile manhood.

In the visual rhetoric of Neoclassical art, the human body became a recognized metaphor for the body politic. In paintings such as David's *Oath of the Horatii* or *Leonidas at Thermopylae*, the heroic masculine bodies of Classical warriors united virility and virtue through their close association with the elevated public values of ancient Greece and Rome. This Neoclassical ideology derived in large part from Johann Joachim Winckelmann, a German archaeologist whose writings published in the 1750s and '60s set forth a theory of the superiority of Greek art based on its superior political culture. Within Winckelmann's "sociology of art," the quality of a nation's artistic production is directly linked to the freedom of the individual within that society, and as one declines, so does the other. The beauty of antique sculpture was thus the result of the liberty of its citizens, which allowed its artists the freedom to conceive and express the lofty ideals of the nation unfettered by political or economic tyranny. Although history has tended to conflate David's and Winckelmann's thought into a single and coherent Classicism, Alex Potts has illustrated the disjunctions between David's "austere stoic dramas" based primarily upon Roman history and

myth, and Winckelmann's "epicurean celebrations of beautiful Greek bod-
ies."[50] Indeed, it is David's rebellious student, Girodet, seeking his own
form of politically engaged Neoclassicism outside of the purview of his
master, who comes far closer to a Winckelmannian aesthetic in his helleni-
cized, eroticized Endymion.

Winckelmann's theory of art and beauty combined the spiritual, the
political and the aesthetic into an artistic discourse that oscillates between
the elevated and the erotic. In his influential *History of Ancient Art* (1764),
Winckelmann defines a Classical ideal as embodied in Greek sculpture,
while the artist and his production play a political and quasi-religious func-
tion in society. The work of art (i.e., the Classical statue) signifies both in
its sensuous concrete form and in a spiritual or abstract way; the artistic
process, according to Winckelmann, is less an act of imitation than an
ecstatic experience of inspiration. Thus the Classical statue is both a repre-
sentation and a symbol, a creation arising from the "exalted ideas" of the
artist's imagination whose very contemplation elevates the soul of the
spectator. Art provokes both sensual delight and divine inspiration in the
viewer, while the artist's function is that of intermediary between gods and
men. In a chapter entitled "The Conformation and Beauty of the Male
Deities and Heroes," Winckelmann explains "The great artists among the
Greeks—who regarded themselves almost as creators, although they worked
less for the understanding than for the senses—sought to overcome the
hard resistance of matter, and, if possible, to endue it with life, with soul.
This noble zeal on their part, even in the earlier periods of art gave rise to
the fable of Pygmalion's statue."[51] The German aesthetician indicates that the
ancient sculptors aspired to—and nearly achieved—a godlike status as "cre-
ators," as they sought to endow their images with life and soul; as mediators
between the elevated and the earthly, they are accorded the position of priest
or prophet. However, by invoking Pygmalion, Winckelmann underlines both
the lifelike qualities of Greek statues, and their erotic appeal as well.

The strong sexual attraction exerted by the work of art on a viewer is
a critical subtext both in Winckelmann's formulation of the Greek aes-
thetic and in Girodet's own interpretation of the Classical ideal. Through-
out the text, Winckelmann exploits the analogy between artistic creation
and procreation, a trope turning on the images of conception, fertilization,
gestation, labor and birth as metaphors for artistic production. In the open-
ing sentence of the "The Conformation and Beauty of the Male Deities
and Heroes" he observes, "the most beautiful forms, thus selected, were, in
a manner, blended together, and from their union issued, as by a new spir-
itual generation, a nobler progeny." The character of this progeny, a prod-

uct of the mating of the physical and the spiritual, is the ideal beauty "of which no higher characteristic could be conceived than never-ending youth." Winckelmann goes on to explain the metaphoric value of youth and beauty as expressed in the statue of a male deity, and the experience they produce in a viewer:

> What human conception of divinity in sensuous form could be worthier and more enchanting to the imagination than the state of an eternal youth and spring-time of life, whose recollection even in our later years can gladden us? This corresponded to the idea of the immutability of divine being, and a beautiful godly physique awakens tenderness and love, that can transport the soul in a sweet dream of ecstasy, the state of bliss that is sought in all religions, whether they understand it correctly or not.[52]

This description of the artistic ideal employs a rhetoric of desire that turns the contemplation of the divine into an eroticized spectacle, evoking emotions more closely tied to sexual than religious transport. Winckelmann's reference to Pygmalion immediately preceding this passage further implies that the artist shares this physical love that his statue inspires in a viewer, while the aesthetic bridges the gap between the spiritual and the sensual.

The intersections between Winckelmann's male beauty and Girodet's *Endymion* are significant. The French painter's sensuous image both thematically and physically evokes a Winckelmannian ideal in his hero's "eternal youth and springtime of life," for indeed the youthful Endymion, stretched out in the verdant foliage of spring, is by definition immortal, frozen forever in his adolescent pulchritude. The "beautiful godly physique" of Girodet's shepherd had inspired "love," "tenderness," "ecstasy" and "bliss" in his original observer—that is Diana—and was meant to do the same in her absence, elevating the soul of his male viewer to new heights of spiritual and aesthetic rapture. Further, if Endymion serves as an inspiration for these elevated emotions, he is also a model, for Girodet has portrayed him in his own "sweet dream of ecstasy," while his face, turned heavenward toward the light, radiates a bliss that similarly conflates divine and erotic contemplation.

In this same chapter, Winckelmann categorizes different types of the ideal male, as found in Greek art. His definition of "the second kind of ideal youth," is the Bacchus, a combination of "the conformation of eunuchs . . . blended with masculine youth" (1: 329). This form is represented

> always with delicate, round limbs, and the full, expanded hips of the female sex. . . . The forms of his limbs are soft and flowing, as though inflated by a

gentle breath, and with scarcely any indication of the bones and cartilages of the knees, just these as these joints are formed in youths of the most beautiful shape, and in eunuchs. The type of the Bacchus is a lovely boy who is treading the boundaries of the spring-time of life and adolescence, in whom emotions of voluptuousness, like the tender shoots of a plant are budding, and who, as if between sleeping and waking, half rapt in a dream of exquisite delight, is beginning to collect and verify the pictures of his fancy; his features are full of sweetness, but the joyousness of his soul is not manifested wholly upon his countenance. (1:329-30)

Girodet's androgynous nude fulfills nearly all of Winckelmann's requirements, from the swollen hips and rounded limbs of his voluptuous form to his sweet features and dreaming countenance. Like the Bacchus, whose "face exhibits an indescribable blending of male and female beautiful youth, and a conformation intermediate between the two sexes" (1: 330), Endymion's beauty balances precariously between masculine and feminine paradigms, a far cry from the phallic virility of contemporary Davidian imagery.[53]

There can be little doubt that Girodet was aware of Winckelmann's work at the time he composed *Le Sommeil d'Endymion*,[54] and in a move that is emblematic of his competitive nature and literary orientation, Girodet's Classicism represents a more faithful translation of the Neoclassical sourcebook than that of his contemporaries. Yet what remains to be established is what Girodet hoped to signify via his Winckelmannian nude and specifically, in light of his elimination of Diana, what he intended to communicate, both politically and aesthetically, in his choice of the feminized form of the male ideal. The preliminary key to Endymion's meaning lies in the political or ethical meaning, within Winckelmann's aesthetic system, of the sensuous nude, and the effects of its contemplation on the viewer. Alex Potts explains the connection between "a 'manly' politics of freedom" and "an intensely sensual bodily beauty" through the conception of "ideal beauty as a signifier of an elevated free subjectivity . . . produced by political freedom."[55] This subjectivity could only be figured forth by the male body, for, as Potts contends:

> The unspoken assumption at work in making the figure that is ethically exemplary as well as physically desirable exclusively male is quite clear. The ideal subject, the exemplary subject of 'freedom', is assumed to be a man. The beautiful male figure can thus function both as an ideal object of desire and as an ideal subjectivity with which the male spectator can identify.(11)

Thus, in the republican, masculinist painting of David, Girodet and their contemporaries, the idealized, exemplary subject of art was always male

because subjectivity and its heroic correlates were exclusively associated with the masculine, and further, because it was intended for an exclusively male audience, as a role model with whom the viewer could identify and in turn be edified. By casting his ideal subject as the androgynous youth presenting his undulating form to the doubled gaze of male viewers (the Zephyr and the painting's spectator), Girodet posits an ideal subjectivity not in action or sacrifice, but in aesthetic contemplation. Unlike the Horatii, Leonidas, the Dying Athlete or any number of Classical male figures, clothed or unclothed, in late eighteenth-century French painting, Endymion has no obviously heroic characteristics—he is neither wounded, nor has he suffered physical or mental anguish. He is asleep, the passive object of the gaze, and his expression denotes pleasure, not pain. Endymion's dream brings him the blissful smile that graces his lips, and unlike the mortal heroes of Davidian Neoclassicism, he confronts not sacrificial death, but immortality. The contemplation of this ecstatic youth can only purport to bring on a similar state of ecstasy in the viewer, at least within the Winckelmannian model, and thus lead the male spectator toward a higher state of subjectivity and freedom.

If the political engagement of Davidian art consisted in moralizing exempla of sacrifice and nobility, Girodet, via Winckelmann, offers up another kind of political praxis. In this unabashedly beautiful image of a beautiful male figure, Girodet proposes an ideal state through the aesthetic, where art and beauty (both gendered male) can lead society to a better place than the feminized art of the immediate past. Where warriors die, gods and artists are immortal, and the contemplation of their sensuous images may invoke in viewers divine states of ecstatic pleasure based on the timeless values of freedom and spirituality. In Girodet's painting, the locus of this meaning is a dreaming male figure engaged in his own contemplation, but in the absence of the overtly feminine, he is nonetheless an androgynous, if not feminized, ideal. While the androgynous hero would become popular immediately following the enormous success of this painting, Girodet, as one of the first artists of his time to figure forth this form in public art, had his own specific aesthetic agenda in choosing to present his ideal as a *feminized* male nude.

Abigail Solomon-Godeau has read the androgynous nature of the Neoclassical ideal nude as a manifestation of "male-trouble," that is, "a crisis in and of representation, precipitated in the wake of revolution and large scale political, social and cultural transformation."[56] If the definitions of and relations between genders are indeed not fixed and stable, but a volatile dialectic, then the increasingly negative perception of women, based on

fantasies and projections closely tied to shifting power regimes, destabilized the definition of "male" as well. Girodet's *Endymion* posits a new definition of the ideal male in direct response to the vacuum generated by the absence of a positive female position at this point in history. As Judith Butler has established, "masculinity" is as much a social construct as "femininity,"[57] and thus I will analyze the aesthetics and politics of gender in *Endymion* in terms of Girodet's construction of a new male ideal as androgynous nude.

In Girodet's painting, the sleeping hero takes up the "female" position of the passive object of the admiring gaze while displaying the physical qualities of voluptuous femininity noted above. Presented to a male audience in both the lascivious Amor and the spectator, Endymion invokes the single-sex dynamic of male desire for a male ideal. The homosocial world of the emerging republic, based on the bonds—both social and erotic—between men and to the virtual exclusion of women, is reflected in the visual economy of *Le Sommeil d'Endymion*, where all agents of meaning are male, and the ideal is posited in the contemplation of their relations. However, in a painting so pointedly about vision and dream, that so deliberately invites comparison with earlier paintings of the same topic, the activity of painting itself—the model, the gaze, the artist, inspiration, representation—is also an important theme of *Endymion*. The homosocial/sexual orientation of Girodet's canvas reflects the structure of relations in the contemporary art world, and of David's studio in particular.

A hotbed of oedipal rivalries, David's studio stood as a microcosm of the republican dream of an all-male world of political, intellectual, emotional and professional homosocial bonds; a world predicated on the deliberate absence of the female. The dynamics of love and competition, inspiration and plagiarism, so astutely analyzed by Crow, were played out between David and his young pupils both in their art and in their lives.[58] Davidian Neoclassicism typically relegates female figures—almost always wives and mothers—to secondary positions at the margins of the painting. Generally collapsed in grief or mourning, they represent the "feminine" world of the private as opposed to the "masculine" world of the public. If male equals valor, virtue and virility within this republican visual rhetoric, then female connotes emotionality and weakness, family rather than state, the personal rather than the general good. Yet the massive, muscular nature of these Neoclassical female figures, with their powerful arms, thick, sinewy necks, and chiseled profiles recalls not only Classical statuary, but also *male* models on whom they may have been based. For students of the Academy, all life drawing was based on the male nude, and female bodies

were either based on adjustments to a male nude or sketched after a live model in private, often at great expense.[59] Girodet's *académie* playfully inverts the masculine nature of David's female figures with a feminine male figure, while openly alluding to the nature of contemporary artistic training where female nudes were in fact often based on the feminization of a male body. *Endymion's* personal subtext thus evokes the world of the studio and demonstrates, via the Zephyr, the approving, desirous male gaze that Girodet hoped to elicit from his master and from his fellow pupils. Indeed, this ambitious *académie* is above all an artistic manifesto of originality and ideal art predicated on a dialogue with and rejection of Rococo and Neoclassical norms, as articulated in the gendered nude.

Thus, Endymion's androgyny, a manifestation of "male-trouble," a reformulation of David's paradigms of virile manhood and a direct translation of Winckelmann's dicta, functions dialectically with these intertexts to assert Girodet's own aesthetic ideal for the new republic. *Le Sommeil d'Endymion* serves as an allegory of art, creation and inspiration, and the sleeping figure, a symbol of immortality, represents both art and the artist, Girodet himself, who gained his own immortality from the admiring gazes of an audience infatuated with his beauty. Throughout the rest of his career, Girodet tried unsuccessfully to match the success and glory he received for this early painting. "Endymion" became a trademark of sorts for Girodet, who displayed it at nearly every Salon possible and went so far as to sign a letter "Endymion" in 1800.[60] Similarly, Girodet was conflated with his creation by others, who identified him with Endymion even upon his death some 30 years later.[61] If the beautiful male nude stands as a symbol for the artist as well as his body of work, Girodet here announces not only his desire for admiration, but also his conception of the new role of the painter in republican France.

David and his studio had actively participated in the insertion of the artist into the public sphere. Free from the subservient position of dependence on the patronage of the aristocracy and the Ancien Régime, the republican artist was conceived as an independent leader of men, whose art and life offered uplifting models of virtue to their fellow *citoyens*. Girodet's dissenting model of art and the artist shifts the focus from action to contemplation, from the physical to the metaphysical, while the artist's surrogate stands not for political but aesthetic superiority. Endymion's ambiguous sexuality signals a refusal of the rigidity of previous standards based on the academic ideal of imitation, conformity and rationality, while serving as an artistic metaphor for creation in a masculine universe. Winckelmann's description links Bacchic beauty to "spring-time" and "immortal-

ity"; the ideal youth is likened to "shoots of a plant that are budding," suggesting fertility, reproduction, birth and futurity. As Girodet translates these words into images, he emphasizes the shepherd's swollen hip and protruding belly, extending directly toward the viewer above his shadowed, flaccid sex, and highlights them in luminous radiance. The painter illuminates his right breast with particular brilliance, the nipple almost glowing in the moon's rays. Endymion's exaggerated serpentine form combines visible male genitalia—a penis, testicles and even pubic hair—with the rounded shape of a pregnant woman, allegorically indicating the birth of a new aesthetic and a new republic, free from the corrupting force of women and entirely generated by male genius. His "conception" comes not from physical intercourse (as witnessed by his limp member) but from spiritual inspiration in the form of the moonlight that bathes his ecstatic countenance. As Solomon-Godeau notes, "the repression of [female] femininity in the symbolic order may promote its reinscription under the aegis of an idealized masculinity."[62] In the case of Girodet's formulation, "idealized masculinity" entails a wholesale coopting not only of the "female" position of beautiful, voluptuous, passive object of a desiring, active male gaze, but even more significantly, the feminine reproductive capacity, as well, in the guise of a new, all-male creativity that allows the artist to conceive, gestate, labor and "give birth" to life and beauty in a metaphysical, rather than physical fashion. Thus, while the feminine is banished at one level, it is absorbed and reinscribed both in Endymion's androgyny and in Girodet's claims for the artist in a return of the repressed.

Endymion, as both idealized object of Girodet's painting and as dreaming prototype of the ideal artist, embodies the concept of divine inspiration for art and a privileging of an interior source over mere imitation of extant reality. But what precisely constitutes the essence of this creation, as generated by and through the androgynous figure of the dreaming shepherd, and how it represents a new aesthetic for Girodet, only becomes fully evident in light of the painter's own analysis of his image. Finally, then, it is Girodet's own exegesis of the myth of Endymion, included as an anonymous entry in Noël's *Dictionnaire de la fable* (1803), that provides the ultimate *explication de texte* of the painting and reveals the painter's personal interpretation of the sleeping shepherd's significance.[63] In this typically erudite disquisition on the myth, Girodet emphasizes Endymion's apotheosis—while he may have been born a human shepherd, he was also "the grandson of Jupiter, who admitted him to the heavens."[64] A descendent of the gods, he eventually joins their numbers, and his immortality lies not simply in his eternal sleep on earth but also in his ascension to Olympus.

His entrée seems to be predicated both on his beauty and his fecundity. Girodet explains that as a result of her nightly visits to Endymion's grotto, Diana "bore him fifty daughters and a son, named Etolus, after which Endymion was called home to Olympus."[65] Later in the dictionary entry, Girodet adds an alternative mythology of Endymion's status: rather than being a shepherd, Diana's beloved may have been "the second king of Elide," whose erudite study of the stars led to the fable. In each case, the emphasis falls not on Endymion's simplicity, but on his elevation.

After investigating its roots in Egyptian fable, Girodet turns his attention to representations of the myth, for "this subject has been frequently treated by painters and poets." Yet despite his allusion to the myriad treatments of the subject in both painting and poetry, he refers to only one—his own—which serves as the quintessence of both: "among the painters, I do not think any rendered it as poetically as citizen *Girodet*, whose talents justify this most promising debut" (original emphasis).[66] After describing his own canvas in detail, focusing on the hero's "beauté idéale," the Zephyr, "with his mischievous look," and the moonbeam, "where all the heat of passion resides," Girodet concludes: "The reflected moonlight, and the color of the objects and of Endymion's body itself, leave no doubt as to the hour of night when the action takes place and the presence of the goddess. This is how artists, painters or poets, can rejuvenate the worn-out subjects of old mythology."[67] The painter, in the guise of an anonymous scholar, draws his reader's attention to the symbolic nature of the *Endymion*, where light and color clearly communicate the absent presence of the goddess of the moon to the viewer. It is precisely this *nonrepresentational* quality of the painting that he proposes as model for artists who seek to rejuvenate the familiar subjects of the past, and lies at the heart of what Girodet himself considered the essence of *Endymion*'s aesthetic originality. Indeed, for Girodet, this *académie*-cum-manifesto announces a new aesthetic of *poetic* painting, for as he repeats both here and elsewhere, the painting signifies "poétiquement" and may provide useful lessons for both painters *and* poets.

Thus Girodet sought to revive painting for the new century and the new republic by infusing it with poetry, and *Le Sommeil d'Endymion* presents his vision of aesthetic renewal in the "poetic" nature of its form and content. If the *Endymion*'s symbolic, poetic nature produces its meaning, on yet another level, the figure of Endymion himself presents a paradigm of the hero not simply as artist, but as *poet*. As Girodet asserted both in the *Dictionnaire de la fable* and in his private correspondence, the poetry as well as the originality (and the two are inextricably linked) of the *Endymion* arose from the reduction of Diana's physical presence to an ethereal moon-

beam ("l'idée du rayon m'a paru plus délicate et plus poétique, outre qu'elle était neuve alors"). The powerful goddess, signifier of femininity, sexuality, the Ancien Régime, the Rococo, but also divinity and immortality, is "poétique" in her absence. In her symbolic incarnation as light and color she takes on meaning in relation "du corps d'Endymion même," creating a fertile tension between the seen and the unseen, the *dit* and the *non-dit*, masculine and feminine, absence and presence. Thus it is the dialectic between the invisible Diana and the androgynous Endymion that produces both Girodet's poetry and his meaning, in the form of a new vision of art and the artist outside of the traditional boundaries of gender, genre and meaning.

The dynamic between seen/unseen is of course mediated through the gaze, and in this particular painting centers on the triangulated structure of the Amor, Endymion and Diana. At one level, the visual contemplation of the nude figure leads to aesthetic/erotic pleasure in the Winckelmannian vein, as represented in the Amor's ludic leer and mirrored in the viewer's own enjoyment of Endymion's pleasing form. But Endymion's pleasure, signaled by his own mysterious smile, arises from that which the viewer of the painting *cannot* see—the amorphous Diana, as symbolized by the light bathing his torso and face—as he envisions her behind closed eyes in the eidetic imagination. The original, poetic nature of Girodet's *Le Sommeil d'Endymion* lies then both in Diana's absence to the viewer and in her presence to Endymion, in the realm of sleep, dream and imaginative inner vision. Endymion, as hero-cum-artist, turns to the interior world for inspiration, and in direct contact with the divine, conceives of a beauty far beyond the mere imitation of the real, and one that can lead to a higher knowledge. As a manifesto of poetic painting, Girodet's *académie* announces a multileveled process of signification, generated both through physical representation (Endymion's body) and metaphysical, poetic suggestion (Endymion's dream/Diana as moonbeam). The painter thus lays claim to the poet's world of metaphor and translation while positing an image of the ideal art as a synthesis of the two spheres of representation.

Thus, not only does Girodet's painting *look* distinctly different from the images previously set forth by his contemporaries, it also signifies in a different way, its meaning arising from poetic suggestion rather than narrative assertion. As James Rubin observes, Girodet's *Endymion* "transformed David's mode of narrative or declamatory exposition into something evocative and ambiguous. . . . Girodet moved with *Endymion* from the realm of fact and history to that of myth and allegory."[68] Indeed, if David's dramatic tableaux recall the visual directness of the theater, where action

and gesture are the vehicles of meaning, Girodet's espousal of a poetic paradigm represents a new set of aesthetic values, which in turn signal a modified vision of the relationship between the spectator and the scene. Unlike Brutus or the Dying Athlete, Endymion is not a role model for the viewer, per se, nor does he present a direct lesson of virtue to be emulated. Instead, Girodet's figure presents a lesson to be *interpreted*, and in a more literary or poetic vein, its meaning is generated indirectly, through the symbolic values of the various signifiers, which function as signs within the image. Like Endymion's penis, at once hidden and present, central but dark and mysterious, meaning in this painting must be sought by the viewer, and it is closely tied to the source of creation. The viewer is thus called upon to take an active role not in society, but in art, where he must synthesize signification from the signs and symbols that point to something outside of the physical representation. Meaning is produced internally, in reflection, first by the artist and then by his audience.

Girodet's difficult, labor-intensive poetic painting draws attention to the erudition and genius of the artist, both as creator of this remarkable image and as symbolically figured forth in his proxy, Endymion. *Le Sommeil d'Endymion* actively demonstrates the idea of the artist's divine inspiration, and Girodet asserts his own genius at once in his conception and his realization of the symbolic nature of this inspiration. For by reducing Diana's voluptuous flesh to pure light, the quality most intimately associated with painting and with difficulty, Girodet chooses a metaphor that simultaneously corresponds to the goddess's mythological symbol and to contemporary images of genius and inspiration, thus demonstrating his own virtuosity both as poet and painter. Light, the very essence of painting itself, is also the most challenging effect to portray on canvas. The rendering of the moonlight—mysterious, luminous, magical and almost palpable—generated the highest praise for Girodet's work, and the artist spent the rest of his life trying to replicate the effect, going so far as to paint exclusively at night. But in this early announcement of a postrevolutionary aesthetic, Girodet defines and demonstrates artistic genius in the poetic rendering of light to yield a multilayered representation of a more abstract art, where meaning lies at the intersection of the physical and the metaphysical, the visible and the invisible, the poet's and the painter's crafts.

As he explained in a letter to Trioson, one of Girodet's primary concerns, and indeed the largest challenge in the production of this image was to "faire quelque chose de neuf et qui ne sentît pas simplement l'ouvrier."[69] Eschewing the vision of the artist as artisan, Girodet defines the artist of the new age as poet and mage, infiltrated by divine inspiration, a

leader of the people, and most importantly, a man of thought, imagination, erudition, learning and poetry. Like his forebears, Girodet strives to elevate the painter to a higher position in the hierarchy of the arts, and ironically, in light of his own republican leanings, sets forth a new aesthetic hierarchy headed by the poet-painter. By collapsing all of poetry's values into painting, he proposes a hybrid art that is superior to either one alone. Surpassing the limits of genre, Girodet's poetic painting seeks to fuse the real and the ideal, abstract and concrete, and the natural and conventional sign systems of verbal and visual representation. Finally then, it is fitting that this new vision of a hybrid art is figured forth in androgyny, a hybrid sexuality that also transcends or represses difference for fusion and confusion of what had been seen as distinct and separate. Just as Endymion rose to the status of a god thanks to his beauty and his [pro]creation, so too did the ambitious Girodet hope to achieve his own position on Olympus, through the creation of a new hybrid beauty. Transcending the boundaries of gender and genre [male/female, painter/poet], Girodet's aesthetic proposed a superior art of the visible and invisible worlds, between the mortals and the gods. Girodet's political and aesthetic revolution rejects the artistic language of the past for a new poeticized diction that symbolizes the male artist's creative imprimatur as leader, not by virtue of his valor, but through his insight and imagination, his ability to see what isn't really "there" and make his viewers "see" it as well.

Chapter 2 ✑

GIRODET:
POET AND PAINTER

'La Maladie de la poésie descriptive': Girodet's Poetic Painting

Throughout his career, Girodet cultivated an intimate association with poets and with poetry: among his close friends he included the poet Delille, Bernardin de Saint-Pierre, Chateaubriand, whose portrait he painted, and Alfred de Vigny, to whom he gave drawing lessons.[1] His own literary output, comparable in volume if not quality to his artistic production, included aesthetic essays, anonymous paeans to his own paintings, translations of the Classical poets, a satirical "Critique des critiques" and finally his epic poems, *Les Veillées* and *Le Peintre*. His efforts did not go unrecognized: Girodet's contemporaries almost universally identified him as a "painter-poet," while in the twentieth century, critic George Levitine recognized Girodet as "inarguably the painter who has written the most."[2] In an address delivered to the *Académie* following the artist's death in 1824, Quatremère de Quincy reflected that Girodet could have become, "littérateur artiste, ou artiste littérateur,"[3] and goes on to highlight the poetic nature of Girodet's painting. *Endymion* manifests "des beautés du style poétique" as well as "de l'harmonie et du clair-obscur, une autre partie de la poétique du peintre" (314). The *Scène du Déluge* of 1806 is "un poème," its invention "poétique," and its execution "poésie" (319). Quatremère maintains that Girodet's *Les Funérailles d'Atala* [1808] demonstrates the "the poetry of his paintbrush" and concludes that the painter "never finished a poem without translating it into a drawing."[4] Although the phrase "poetic" was an art critical commonplace, in Girodet's case it almost invariably served as an allusion to his double identity as poet and painter, while also highlighting the suggestive, literary qualities of his canvasses.

Yet praise for the painter's intergeneric aspirations was by no means uni-

versal, and Delécluze, a former student of David's and one of the foremost critics of the time, was less sanguine in his evaluation of Girodet's literary efforts. In both his *Journal* and his biography of David, he expresses the belief that poetry was, in fact, Girodet's downfall. Aligning poetry and disease, Delécluze observes, "it was above all his predilection for literature and poetry that made him waste his time and ruined his health," later adding "his relationship with Delille was fatal, in the sense that he contracted from this poet, like so many others have, the disease of descriptive poetry."[5] For Delécluze, it is not poetry per se, but poetry at the hands of a *painter* that is dangerous, and this interdiction will be central to Girodet's own Promethean endeavor and to his often negative critical reception. While theoretically embraced, crossing the boundaries between genres presented practical and tactical difficulties for artists and critics on both sides of the divide and these conflicts serve as fundamental intertexts in the ongoing dialogue between word and image.

P. A. Coupin's "Notice biographique," the preface to the painter's *Oeuvres posthumes* of 1829, presents the most trenchant comments on Girodet's relationship with literature. Coupin's two-volume tribute to Girodet's life and works shaped the artist's posthumous reputation, and was notable in its broad-based account of every element of the artist's life: youth and maturity, success and failure, and poetry as well as painting. Coupin, who grasped the importance of poetry in Girodet's life and aesthetic vision, presented for the first time to the public Girodet's poetic bildungsroman, *Le Peintre*, and its earlier prototype, *Les Veillées*, both of which consumed much of the painter's creative energy from 1800 on.[6] Calling him throughout the preface "Girodet, peintre ou poète," Coupin attributed Girodet's literary aspirations to an excess of genius and ambition: "the role of painter being insufficient for his burning energies, he had wanted to join the ranks of authors as well."[7] Girodet's friend and biographer highlights the competitive nature of the painter's endeavor at every level of his artistic production: not content to "rivaliser avec Apelle," Girodet engages in an *agon* with the poets as well. Focusing initially on subject matter, Coupin contends that "sometimes he vies with the authors who wrote about the subjects before he painted them."[8] In keeping with the *paragone*, the painter thus engages in a battle with poets for representational superiority. But Girodet's competition transcends his preliminary field of expertise, and Coupin adds that his rivalry with the poets extended to trying to best them in poetry as well. Coupin claims "he is Winckelmann and Delille's rival in taste, passion and sentiment."[9] In revealing Girodet's quest for superiority over both painters and authors, Coupin brings into focus a central facet of the "painter-poet"'s

aesthetic, for Girodet conceived of his work in comparative, competitive and dialogic terms. Whether in rivalry with his master (David), with a peer (Gérard) or with the more theoretical opponent, the archetypal "poet," Girodet's artistic production and his never-ending quest for originality were generated in a constant effort to outdo the Other.

Girodet's poetic aspirations took two distinct forms: poetic painting and poetic composition, both of which must be understood within the historical context of artistic production post–1789. As politics came to dominate every level of social consciousness in the 1790s, art and its makers were pushed to the margins as never before. Socially and professionally liminalized, academically trained painters foundered in an artistic limbo, uncertain of what and for whom they might now create. War, inflation and economic crises drained governmental coffers, and unlike Napoleon in the decade to follow, the leaders of the Convention and Directoire showed little interest in using art to glorify their goals. History painting languished, unable to find support or keep up with the rapidly changing political land-scape. Thus, postrevolutionary artists turned to the *bourses particulières* of domestic consumers, producing and exhibiting the less prestigious por-traits, landscapes and genre scenes in order to survive.

The commercial culture of art, which had been slowly developing dur-ing the final decades of the Ancien Régime, began to blossom during the 1790s, forcing—or allowing—artists to peddle their wares in the bourgeois marketplace. As Susan Siegfried explains, prior to 1789 there had been no commercial system of galleries, dealers or publications for the buying and selling of contemporary art, and thus, "when the Revolution eliminated government controls, the 1790s became the decade of proposals for com-mercial alternatives to the Salon. Few of them succeeded, but all of them point to the commercial realm as the new locus of activity for the Parisian art world."[10] She cites such newly formed groups as the *Société des amis des arts,* formed by artists to encourage bourgeois patronage and to "expand the patronage base to include people who would not normally have been able to buy a work of art" (36). These commercial gambits included engravings offered as subscription incentives and lotteries where art was raffled off in games of chance, vividly illustrating the radical transformation in the rela-tionship between the artist and the consumer taking place in the Paris of the Directoire.

The rise of the illustrated book, an art form uniting technology and aes-thetics, constituted another commercial/artistic attempt to appeal to a new postrevolutionary mass market. The 1790s were the golden age of book illustration, providing a steady income and audience for a large number of

academically trained artists. As Carol Osborne has indicated, "the French Revolution and the Industrial Revolution had helped to accomplish a third revolution—the sudden increase in the distribution of the printed book to the widening middle class audience. And this reading revolution occurred at a time when the association between a printed text and its pictorial illustration was particularly strong. . . . The demand for books with pictures was lively."[11] Entrepreneurial publishers, such as Firmin Didot and Pierre Didot, began producing monumental folio editions of Classical and Neoclassical literature (including Virgil, Homer, La Fontaine and Racine) illustrated with full-page copperplate engravings of images by some of the most important painters of the day, including David, Girodet, Gérard and Prud'hon. As the demand for large-scale history paintings plummeted, many younger artists depended for both their livelihoods and reputations on the commissions generated by these widely circulated mass-produced tomes. Osborne thus observes "at the dawn of the industrial age, the publisher took on the role of intermediary between the painter and the public, generating a new force for the integration of art and society" (6).

In the case of the Didot editions, the enterprise was ideologically as well as financially motivated, and the pairing of Classical texts with Neoclassical painters signaled nationalistic, aesthetic and political considerations. Didot, who sought to establish the preeminence of French art and French publishing, created a *Gesamtkunstwerk* that united the linear, sculptural style of the Neoclassical painters with Classical and Classically inspired prose and poetry printed in his own Neoclassical typeface. By pairing great authors of the past with great painters of the present, Didot and his stable of illustrators sought to impart some of the cachet and legitimacy of the canonized Classics upon the living artists, creating a parallel between the ancient and contemporary worlds.

For Girodet, who devoted most of the 1790s to the Didot Virgil and Racine, the illustrations were the conceptual equivalents of history paintings, requiring similar levels of preparation, thought and talent. In a letter that considers all of his major works, he includes the images he produced for the two folio editions, contending that "The artist who succeeds in these sorts of drawings could only be a history painter or a sculptor."[12] Yet, despite their popularity, the critical response to these illustrated volumes was generally negative and few considered them in terms of the elevated ideals that Girodet and others claimed for them. The hostility from critics and authors focused primarily on the commodified nature of these illustrated books, perceived to be antithetical to Art; as Chaussard sniffed "in the Arts, as soon as the interest in profit approaches, genius withdraws."[13] More-

over, many writers expressed anxiety that words were becoming subordinated to images, and literature reduced to a vehicle for the artist's self-promotion. Indeed, illustrators were frequently paid more and accorded higher billing in advertisements than the authors, while the images often reflected more of the painter's vision than the author's. Thus, contemporary authors rapidly came to resist the intrusion of image within their texts, despite the frequent increase in circulation. The shifting art market and the need to establish new economic and aesthetic footholds with a middle-class consumer—the very forces that precipitated the production of these lavishly illustrated volumes—drove painter and poet into an uncomfortable union, as each competed for the as yet undefined patronage of nineteenth-century France.

As artists in the 1790s responded to the demands of the market, they found themselves condemned by both critics and the power structure that was no longer supporting them. Commercial interest in the elevated genre history painting had evaporated, so artists turned to the less prestigious (but more profitable) genre of portraiture in order to survive. This widespread movement toward this "secondary and mercantile genre" led to a sweeping indictment of painting, as it was officially reduced from fine art to commerce. "Considéré comme négoce" by the *Conseil des Cinq-Cents*, in 1796 painting was subjected to *la patente*, that is commercial licensing and taxation, an explicit degradation of art to commodity. In a speech to the Council, Mercier called for new distinctions in the term *artiste,* reinstating limits between the various disciplines ("Autrefois, un peintre était un peintre, un comédien un comédien . . . Aujourd'hui, ils ne sont plus eux-mêmes, il sont des artistes!") and the hierarchies of yore:

> Les peintres ont cru dans leur pétition s'assimiler aux géomètres, aux poètes, aux écrivains, parce qu'ils peignent la nature, parce que la peinture est soeur de la poésie, parce qu'un tableau perpétue un fait historique. Quelle absurde prétention! qu'est le pinceau d'un peintre auprès du compas de Newton, de la plume de Racine, de Virgile, de Tacite?[14]
> (The painters tried in their petition to liken themselves to geometers, poets and writers, because they paint nature, because painting is the sister of poetry, because a painting portrays an historical event. What an absurd pretension! What is the painter's brush next to Newton's compass, Racine's pen, or Virgil's or Tacitus's?)

Although Mercier proposed exempting all artists not involved in commercial enterprise, the *Conseil des Cinq-Cents* rejected his exemption, "not finding a sufficient distinction from the mercantile or industrial profession."[15]

In a return to the hierarchies of the medieval guilds, painting was once again reduced to a commercial venture and assigned an inferior position to the more "intellectual" arts of poetry and ratiocination.

In response to their beleaguered status, artists in the postrevolutionary period shaped a social persona in antagonistic dialogue with the skeptical, mercantile Other, positing the Artist as morally, aesthetically and spiritually superior to the general public. As Raymond Williams explains, the persona of the "misunderstood genius" was developed in an effort to distinguish the "true" artist from the successful commercial hack and the common man. With the rise of capitalism and industrialism in the postrevolutionary age, there came to be an "emphasis on the special nature of art-activity as a means to 'imaginative truth,' and, second, an emphasis on the artist as a special kind of person. [. . .] At a time when the artist is being described as just one more producer of a commodity, he is describing himself as a specially endowed person, the guiding light of the common life."[16] Girodet's efforts to endow his painting with poetry manifest his desire to position himself and his work on the side of "culture" rather than "market," and to elevate himself to the status of a "specially endowed person" as a painter *and* poet, an *über*-artist. Although Girodet was by no means alone in his efforts to introduce a more poetic aesthetic to the visual arts, nor the only painter to try his hand at verse, he did emerge as the most adamant, even defiant, proponent of this hybrid aesthetic, and the one whose work accordingly drew the most fire for its interdisciplinary ambitions.

'Il est beau de tomber des cieux': La Nouvelle Danaé

In 1798, Girodet took on a typical commission for an artist during the period: a relatively low-paying (600 francs) decorative project for the *hôtel particulier* of a M. Gaudin. His patron was one of the many *nouveaux riches* who had sprung up throughout Paris, beneficiaries of the shifting regimes and skillful *agiotage*, a rampant form of speculation that created a new class of millionaires under the Directoire. Girodet's commissioned *Danaé* represents the mythological object of Zeus's desire in an unusual vertical composition: standing upright on her flower strewn bed, Danaë gazes at herself in a mirror held up by Eros, as jewelry descends from the clouds to adorn her. The painting's metaphoric approach to symbol is neither particularly original nor noteworthy—the poppies crowning the guards' spears point to sleep, cupid's flame directed at Danaë's heart a timeworn symbol of love. But Girodet's approach to the myth as a whole, and to love, sexuality, cupidity and contemporary mores is at once more original and more pointed

than a preliminary interpretation might indicate. For Danaë's posture indicates an active rather than passive approach to her seduction: unlike her painted predecessors she is not lying upon the bed waiting for the god to descend, she is standing up, gathering his gifts and admiring herself in the mirror. The combination of lust and vanity is here made apparent, and Zeus's success is assured precisely because the prisoner is seduced by luxury. In a subtle translation of the rain of gold in traditional versions, the necklace, rings and bracelets that float onto her body render this Danaë amenable to love. Echoing the visual dynamic of *Endymion*, the principle character here is the object of the viewer's admiring gaze, which is seconded by an amorous cupid, while her own gaze is directed away from her voyeurs. But unlike the innocent sleeping shepherd, Girodet's Danaë is awake and aware, and she, like her spectators, is aroused by her lovely nudity and the sensual delights surrounding her. Where Danaë, as subject, had always offered painters the opportunity to portray a female nude in the titillating moments before her sexual conquest, it was also closely linked to allegories of chastity and divine impregnation. More often than not it was her maid who gathered up the falling coins in her skirts. Girodet reverses these associations for a new age and creates a Danaë closer to Venus than the chaste Diana, in a rapacious female figure who reflects "the extraordinary venality and immorality of the Directory."[17] Alone with Eros, she avidly collects Zeus's gifts with her own hands and body. A far cry from the innocent virgins of the past, this Danaë's love is clearly for sale. Although Levitine accurately attributes Girodet's implicit commentary to the *agiotage* that funded the construction of the *hôtel* Gaudin, the highly charged nature of sexual politics during this period in France also is encoded in this image of female cupidity.

During the brief period from 1789 to 1795, female activism in France flourished, as women participated physically and intellectually in the Revolution. Aside from their infamous role on the barricades, women also produced and consumed revolutionary literature, while political organizations united females from different classes and backgrounds around shared beliefs in feminist and revolutionary thought. The patriarchal order of the new Republic only briefly tolerated the overtly "masculine" orientation of these women's groups, with their active political engagement and pursuit of equality, and with the ascension of the Jacobins public sentiment swung toward a vision of an exclusively masculine Republic. By 1795, women were barred from nearly every form of public activity by laws that strove to silence and contain them, prohibiting their free speech and public assembly. As an antidote to the threat of the politically involved woman,

idealized images of femininity emerged in the allegorical figures of Liberty, Equality or the Republic, and in the republican cult of domesticity that glorified woman as wife and mother, while permanently relegating her to the private sphere. In tandem with these legal and ideological efforts to suppress women's public activity, there developed an ever-growing hostility toward women following the Revolution, reflected in a variety of attempts to control the perceived threat of the feminine. Even as the violent specters of the Revolution and the Terror began to fade toward the onset of the new century, France continued to struggle to define itself in its many political incarnations. In turn, the troubling questions of gender—male/female, masculine/feminine and their proper roles within society—continued to haunt nearly every level of public discourse, from state legislation to fashion, journalism, drama, painting, poetry and the novel.

Thus it is not surprising that the gendered metaphor of prostitution came to serve as the preferred trope for the immorality and corruption of the Directoire period (1795-99). Although prostitution had become a highly visible component of Parisian life in the post-1789 era, the metaphor extended to nearly any woman outside the private realm and to society itself, as the image of love for sale dovetailed with a general sense of an almost incomprehensibly commercial world. As women were effectively suppressed from the public sphere of politics by the end of the Terror, a new kind of public female presence emerged in the figure of the *Merveilleuses*, fashionable young women who personified the gay and self-indulgent ethos of the Directoire. An era of extravagance where "partout dans Paris, tout le monde danse et s'amuse,"[18] the Directoire introduced a new class of wealthy investors, politicians, military men and suppliers, and the *Merveilleuses* who cavorted with them at a variety of favorite public haunts. Even more disturbing than straightforward prostitution (ultimately nothing new) was the open sexuality and ambiguous rank of the *Merveilleuses*, who entered the public sphere in various degrees of decadent déshabille. In the wake of the vogue for Republican simplicity in dress, the *Merveilleuses* favored revealing gowns and gauzy tunics based on Classical models, complemented by hairstyles, sandals and jewelry à la grecque, in a tongue-in-cheek tribute to Neoclassical values. These unfettered gowns allowed the female body an unaccustomed level of ease and comfort (and exposure) and were experienced by men and women alike as "revolutionary," in both its positive and negative senses.

Girodet's *Danaé* thus represents an early manifestation of the painter's penchant for encoding political/social/sexual commentary in his mythological images. By portraying the Classical virgin in such a way that she

could be read either/both in terms of the traditional tale and/or in terms of a more contemporary reference signals the artist's own ambition to update antiquated themes, even while fulfilling the increasingly specific demands of his commissions. This symbolic approach to art, where images signify on a number of levels, both literal and figurative, reflects the painter's literary orientation. Girodet's images serve as multivalenced signifiers pointing both to their natural referents and to metaphoric meanings, while the canvas as a whole functions as a symbol system, much like a poem. But beyond Girodet's desire to demonstrate his erudition and superior artistry through ever more obscure poetic reference in his paintings, there arises in his art the consistent image of woman-as-prostitute, and the artist's own painterly attempts to subdue the threatening specter of female sexuality.

In 1799 Girodet executed another version of the subject, this time in the form of a portrait, *Mademoiselle Lange en Danaé*, with disastrous results. Anne-Françoise-Elisabeth Lange was one of the most famous actresses of the Directoire and the established queen of the *Merveilleuses*. By the time Girodet began his ill-fated portrait, the actress/courtesan had already achieved a fair level of notoriety, due to well-publicized liaisons with a series of wealthy lovers, an illegitimate daughter and a custody suit. Lange had recently married Michel-Jean Simons, a wealthy Belgian coachmaker, who commissioned Girodet's painting to celebrate both his wife's beauty and her newly established legitimacy. Although the critics praised the portrait, Lange and her friends did not find it flattering enough. As the actress claimed in a letter to the painter, the painting was one "which does nothing for your glory and would compromise my reputation for beauty."[19] She requested that Girodet remove the painting from the Salon immediately and offered to pay him a mere quarter of his 1,000-franc commission. Both offended and publicly humiliated, Girodet took a double-edged revenge that became the most famous Salon scandal of the end of the eighteenth century, and succeeded in besmirching the reputations of both the artist and his unenthusiastic subject.[20]

Girodet's initial response was a spontaneous act of physical violence: he cut the image from the frame, shredded it, and sent the pieces to Lange, in an understandable, if immature reaction to overt rejection. His subsequent response, of far greater consequence to all involved, was an act of public revenge that combined Girodet's poetic aspirations and his misogyny in an image that outraged not only its target, but the general public. Painted with remarkable speed (somewhere between two and six weeks), especially given Girodet's subsequent difficulty completing a canvas, the second version of Lange's portrait was hung, in the same frame as the original, dur-

ing the final days of the Salon of 1799 to much uproar. *La Nouvelle Danaé* [figure 2.1], a luminous, atmospheric image, painstakingly painted and glazed to a burnished glow, presented a complex network of Classical allusion and satire. Throwing discretion to the wind, Girodet made explicit the subtext of prostitution found in his earlier *Danaé,* while creating a shocking contrast between the beautiful, highly finished surface of the painting and its venal content. An easily recognized Lange is posed as a nude Danaë-qua-*Merveilleuse* who combines Classical and contemporary style in her sculptural curls, plumed turban, sandals and discarded diaphanous tunic. Holding up a cracked mirror, she captures the shower of coins in her gauzy robes with the help of a female cherub in the person of her illegitimate daughter, Palmyre. In a lethal combination of visual and verbal punning, erudite reference and direct allusion to Lange's complex personal life, Girodet skewered his erstwhile subject and patron.

The painter portrays the beautiful actress not as a Classical virgin but as a whore seated on the rough cover of a lowly pallet, while the figures surrounding her present sophisticated rebuses playing on the names of her lovers and their history with the actress, most of which turn on the exchange of money.[21] The encoded references to the sordid details of Lange's very public private life were translated by most of his viewers with relative ease, as witnessed by the *Mémoires* of the Duchesse d'Abrantès. Her firsthand account of the episode, along with a detailed interpretation of the image and its implications, would echo in Balzac's *La Maison du chat-qui-pelote*, written when he was romantically involved with the Duchesse and helping her to edit her memoirs.[22] But in keeping with Girodet's ambitious poetic aspirations, *La Nouvelle Danaé* also includes a level of erudite Classical reference that draws attention to the artist's own wit and learning. Thus, the discarded scroll at Danaë's feet, ignited by the torch held in the turkey's claws, is Plautus's *Asinaria*, a comedy about a father and son sharing a courtesan's offerings, a reference to Simons's relationship with Lange. For when the carriagemaker proposed marriage to the actress, his father objected and came to Paris to intervene, only to fall in love with Lange's friend and fellow actress, Julie Candeille. Father and son married the actresses in 1797, and in an ironic twist, Julie Candeille Simons would later separate from her husband, Jean Simons (Lange's father-in-law), and become an intimate friend and would-be lover of Girodet, who repeatedly refused her marriage proposals.

The recherché Classical allusion continues in the four allegorical medallions attached to the frame. Here, Girodet incorporates quotations from Horace, Virgil and La Fontaine in combination with grotesque images of

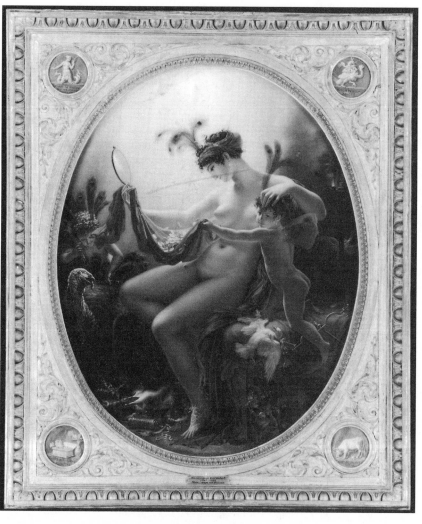

Figure 2.1. Anne-Louis Girodet-Trioson, *Mlle Lange as Danae*. 1799. Oil on canvas, 65 x 54 cm. The Minneapolis Institute of Art. The William Hood Dunwoody Fund.

allegorical creatures uniting human and animal qualities to satirize the actress's greed, duplicity and vanity. Finally, the canvas incorporates a series of visual metaphors pointing to Lange's predatory and rapacious nature. A caged rat, for example, contemplates a snail decimating the grape leaves atop a satyrlike skull. Behind the actress burns an altar to Abundance where a cloud of moths, representing her admirers, immolate themselves, while at the top of the painting a spider's web mirrors the triangle of her pubes, the coins caught in the web. Girodet's powerful and violent image combines direct representation with metaphor, symbol and suggestion to indict his patroness at every possible level.

Public outcry against the painter and his image was immediate, although the painting nevertheless drew enormous crowds for its short run at the Salon. Friends and critics alike judged Girodet's virulent revenge to be vindictive, petty and perhaps most importantly, a dangerous demonstration of the artist's *esprit*. As David was reported to have intoned, "Wit, M. Girodet, is the enemy of genius; wit will play a dirty trick on you, it will lead you astray."[23] Even twentieth-century critics have focused on the literary pretensions of Girodet's effort, contending "his use of visual puns, creation of composite creatures, animalizing of human forms and humanizing of animals echoes the gongoristic excesses of the painter's friend, the poet Delille. [. . .] Without a key, Girodet's agglomeration of emblematic subtleties creates the effect of a puzzle."[24] Girodet's "cryptic satire" translated word play, wit and punning into painting. Appealing to the mind as well as the eye, the *Nouvelle Danaé* pushed visual art in an unwelcome direction that demanded the active participation of an audience to decipher the encoded message, while drawing the viewer's attention to the painter's intellect as well as to his technical prowess.

Girodet, who withdrew the painting, never to display or discuss it again, may well have been ashamed of his behavior, or at least so purported Coupin, Abrantès, Delécluze, et alia. However, the issue of a painter's right to satire rankled, and he took it up on at least three subsequent occasions, each time in verse. The first, his *Critique des critiques* (1807), was a controversial poetic satire of the power of contemporary critics to shape public opinion, and here the painter attacks the ignorance of writers, who have no right to talk about painting, even as he, a painter, pens lengthy satirical verse. Later, in *Le Peintre*, he implicitly defends his actions in painting the *Nouvelle Danaé*, protesting that satire is indeed not the sole province of poetry and that the painter too may express himself in terms of this rhetorical device. But it is in the unfinished *Les Veillées* that Girodet gives his clearest indication of what satire might mean to the artist. In the fifth *Veil-*

lée the painter/poet contends "Pour corriger les moeurs le plus sage est d'en rire;/ Le plus grave sermon vaut moins qu'une satire;/ Le ridicule frappe et tranche dans le vif:/ Le pouvoir est certain, son effet décisif" (To correct morals it is wisest to laugh at them;/ The most serious sermon is worth less than a satire;/ Ridicule strikes and cuts to the quick;/ Its power is certain, its effect decisive) (OP 1: 396). Thus, in keeping with the traditional literary definition, Girodet sees satire as a powerful tool of condemnation and correction, where the ultimate goal is social protest and the hope of amending society's follies and foibles through pointed comic derision. In an era of artistic timidity, when artists strove mightily to attract and retain the patronage of the private sector, Girodet took the contrarian position of social critic, casting the artist as a moral force and leader in a society unlikely to welcome his judgment. In this sense, despite the highly personal nature of the attack and its interpretation, the *Nouvelle Danaé* transcends the particular as the painter's larger critique of all that Lange stood for. As woman, artist/actress and courtesan, his subject came to emblematize what Girodet saw as the corruption and decadence of the day.

The *Nouvelle Danaé*, bodying forth its themes of money, prostitution, and betrayal in the form of a naked woman, reflects the corruption of the Directoire, but at a deeper level inscribes Girodet's scathing condemnation of what it was like to be an artist under the new regime. The *Nouvelle Danaé* is a pointed inversion of his earlier masterpiece: where *Endymion* was male, *Danaé* is female, where he was horizontal and passive, she is vertical and active, where he was a positive model, she is indisputably negative. What had been rendered ephemeral in the *Endymion*—Diana's desire—is here rendered crass and concrete, the golden shower of coins replacing the subtle silver moonlight in the earlier image. Where Girodet obviated the female figure in the canvas of 1791 for a purely male universe of elevated emotion and ideal contemplation, by 1799 she takes center stage, while the men are decapitated/castrated or transformed into animals by corporeal desire and corruption. If *Endymion* was ultimately an allegory of poetic inspiration, *Danaé* is an allegory of consumption, and if the former represented the idealistic hopes of a young artist for the new republic, the latter was his bitter recognition of the realities of postrevolutionary society, and of the artist's place in it. Girodet's anger, so grossly out of proportion to the actual events, was aimed not only at Lange, but also at the contemporary art world and at himself, for prostituting his own genius to the demands of money and patrons who neither appreciated nor understood what he was creating.

Girodet's self-parody is all the more biting in its self-awareness. Metaphor-

ically stretching beyond Mlle. Lange's litany of sexual escapades, Girodet draws the parallel between the artist and the courtesan, each of whom presents an image to the gaze of a "patron" who will reward what is pleasing with a shower of cash. The silvery moonlight suggesting metaphysical inspiration in *Endymion* has given way in the new France to the golden streams of pecuniary motivation. In a last shining moment of anger and idealism, Girodet rejects this image of the artist and betrays his betrayer, dominating the dominatrix as a symbol for society, money and corruption. Exposing her for what she was, he walks away from the shower of coins in order to represent a higher truth than the one dictated by wealthy egos.

In turn, the backlash against Girodet and his image constituted society's negative response both to the artist's indiscretion and his overweening ambition. For in presenting at the Salon a mordant satire of contemporary mores, Girodet was claiming a new position for the painter in relation to the world. Satire, usually the province of the poet, places the painter in the active role of social reformer—he is analyzing and criticizing his milieu, not simply documenting, or at best suggesting. Unlike the idealized allegories of Davidian Classicism, Girodet's satire shows what is *wrong* with contemporary France and places the artist in the position, normally held by the poet, of being not merely society's mirror, but society's conscience. Occupying a place both within and outside of society, as participant and observer, the painter as satirist proclaims a critical distance and a moral superiority to those whom he is documenting. In the case of the *Nouvelle Danaé*, he claims a superiority of self-awareness, as well. Thus, moving away from his earlier paradigm of the artist as poetic dreamer who could lead society to a better state through ideal contemplation, Girodet briefly envisions the artist's social engagement in an oppositional mode. In both cases, however, he endows the painter with greater powers of vision and probity than his audience, while proposing a role for art as a vehicle of a higher good. While this conception would gain great popularity in the decades to follow, Girodet's early and iconoclastic attempts to assert the painter's position at the head of society met with resistance from the public and critics alike.

If the *Nouvelle Danaé* marred Girodet's reputation as a person, *Ossian Receiving the Spirits of the French Heroes* (1802) established Girodet's renown as an obscure, inaccessibly poetic painter and signaled the beginning of the demise of his once promising career. With Napoleon's ascension, both France and painting entered a new era. As the emperor embraced portraiture and history painting in his own myth-making mission, artists once

again had a role to play within the sociopolitical power structure, though the competition for official approbation and commissions was fierce. Sometime around 1800, Charles Percier was entrusted with the redecoration of Malmaison and commissioned his friends Girodet and Gérard to execute paintings for the interior. Girodet's *Ossian* was conceived as a tribute to Napoleon's favorite book, and despite his claims to the contrary, as a challenge to Gérard, Napoleon's preferred artist who was also painting a treatment of Ossian for the Emperor's country estate. A lyric evocation of memory and the past, Gérard's *Ossian* (1801) presents the blind bard in a misty netherworld, illuminated by mystical moonlight, while his harp and his song bring back spirits from the dead. Surrounded by the shades of lost family and warriors, Ossian demonstrates the power of art to overcome death. Sticking closely to his source, Gérard creates a conservative image that is highly "legible" and straightforward; as a "poetic" painting it moves toward suggestion and symbolism in ways that remain unenigmatic for the viewer. For Napoleon, the critics and the public of 1800, this canvas constituted a pleasing and successful melding of the sister arts into a tame hybrid of visual depiction and verbal suggestion without "corrupting" the integrity of either.

Girodet's ambitious *Ossian,* on the other hand, united myth and reality in a complex blend of literary and political allegory so dense that the painter was forced to provide a written gloss when the painting appeared at the Salon of 1802.[25] Unlike Gérard's gentle mélange, Girodet's image was perceived to be so overtly literary that one critic concluded his discussion of *Ossian* by moralizing, "And every allegorical painter/ As soon as he puts down his brush/ Must pick up his pen / To explain his paintings to us."[26] Girodet's self-consciously obscure painting combines imagery from Macpherson's popular Nordic mythology with his own political allegory to refer to the fleeting peace Napoleon had forged with Austria.[27] In a scene that juxtaposes real French heroes (Kléber, Hoche, Dampierre, etc.) with fictitious characters (Ossian, Fingal, Oscar), Girodet once again attempts to infuse ancient myth with contemporary meaning. By combining two heretofore unrelated topics—Ossian and the French military—Girodet unites art and politics, placing the figure of the poet in the central position, welcoming the warriors to the heavens. As he "receives" the spirits of the French heroes, who turn to him in a single gesture of respect and admiration, Ossian endows them with legitimacy, not vice versa, as Girodet reflects on the power of art to give even the most heroic human beings the epic grandeur of life after death. While the allegory reflects a certain level of wish fulfillment, as Girodet eagerly hoped to win Napoleon's favor, it

also defines the painter's vision of what the artist's role might be in Napoleonic France: at once sage and seer, poet and politically engaged leader of humanity.

Although Girodet conceived his ambitious *Ossian* as a means of reestablishing his fading reputation, yet again his efforts misfired drastically. The responses from the critics and his patron were lukewarm at best, Napoleon showing a marked preference for Gérard's more straightforward treatment of the theme. As would become increasingly characteristic of Girodet's oeuvre, *Ossian* strove to accomplish the impossible. Trying to reach beyond the established boundaries of art to achieve new heights of dazzling originality, the painter's allegory merely resulted in being "surely one of the most extravagantly bizarre works of art to appear in France at the turn of the nineteenth century."[28] In keeping with the contemporary vogue for spiritualism and meteorology, Girodet sought to create a purely imaginary world of evanescent clouds, luminous spirits and impalpable beings, a far cry from the solid, stolid world of Davidian rationalism of the recent past.[29] Girodet tried to represent the unrepresentable in a concrete image that centers on the bodies of ghosts—by definition acorporeal, and generally left to the realm of poetic suggestion. Relying exclusively on his own imagination, Girodet literalizes the terms *les ombres* (shades) as he conceives of the bodies of ghosts in terms of "des nuages, des vapeurs . . . les brouillards" (clouds, vapors . . . mists), in human form yet devoid of human substance. Thus Girodet aspires to surpass painting's innate limitations of concrete representation by turning his attentions to the supernatural and that which can only be conceived in the realm of the imagination. Giving form to formless phantoms who are closer to air than to flesh, the painter eschews the reality-bound limitations of concrete bodies in space. In many ways, Girodet's painting sets new goals for art, as it espouses an anti-rationalist aesthetic of suggestion and symbolism, much like his more successful *Endymion*.

However, if Girodet's subjects—Ossian and the supernatural—were à la mode in turn of the century France, his treatment of them was decidedly not, and Girodet's efforts to formulate a new kind of painting puzzled the public and fellow painters alike. As Delécluze recounts it, Girodet, who always worked in great secrecy until a painting was finished, had invited David to come see the completed *Ossian*. After mounting a lengthy stair to the painter's atelier, David and Delécluze pounded on the locked door to rouse the reclusive painter as David explained to his puzzled cohort, "you still do not know Girodet, he is a man of great precaution. He is like a lion, that one, he hides to bring forth his young."[30] Gently mocking his student,

David identifies Girodet's seclusion in the feminized terms of parturition. But by transforming the traditional childbirth metaphor into the image of whelping cubs, the master denigrates his production while drawing attention to Girodet's ferocious love for his artistic "offspring," which he jealousy guards from the dangerous gaze of strangers.

Once they are introduced into the studio, the guests examine *Ossian* and Delécluze recounts the tense scene as Girodet watches David examine his painting. The artist and his two visitors stand before the canvas, Girodet almost mad with anxiety and impatience as David looks on without comment. When he finally breaks the silence, David "began to give some simple praise, truthful and well justified . . . while avoiding mention of background of the composition." As Girodet grows increasingly frustrated, he finally pushes David to comment on the painting itself, to which the master replied "my good friend, I must confess, *I do not understand this painting; no, my dear Girodet, I do not understand it at all*" (original emphasis). They leave shortly thereafter, and upon reaching the courtyard the astonished David exclaims, "Girodet is mad! . . . he mad or I no longer understand anything about the art of painting. Those were characters of crystal that he showed us there. . . . What a pity! With that wonderful talent, this man will never make anything but follies . . . he has no common sense."[31] This image of Girodet's madness, his wasted genius and his self-destructive propensity for embracing his own fantasies would haunt the artist in both life and death. Balzac's own view of the *génie avorté* (failed genius) was indelibly shaped by Girodet's legend, while Delécluze's account of the scene in Girodet's atelier would find an unmistakable echo in the dénouement of *Le Chef-d'oeuvre inconnu*.

For Girodet, the universal resistance to his ambitious work merely signaled the illdisguised envy of his fellow painters and authors, a theme that haunts nearly all of his writing from 1800 on. Until his death, Girodet continued to maintain the importance of *Ossian* within his personal oeuvre as a manifestation of his poetic painting. In a letter to the author of *Paul et Virginie*, he insisted "these ideas, or at least their application, is, I dare say, original and poetic,"[32] the same adjectives he used to describe *Endymion* more than a decade earlier. The painter goes on in this missive to elucidate his conceptions of both, in one of his clearest statements on his goals:

> Les romans ne sont point bannis de la littérature; les fictions ne sont point bannis de la poésie, pourquoi le serait-elles de la peinture dont les bornes, sans être infinies comme celles de la poésie, sont cependant plus reculées qu'on ne le pense? La peinture qui sait si bien parler au coeur sous le pinceau

de Raphaël et du Poussin, peut encore s'adresser à l'esprit et à l'imagination; ces maîtres l'ont prouvé. Pourquoi ne serait-il pas permis d'essayer d'étendre plus loin encore les effets et les bornes que ces grands hommes ont connus? Mais on s'égare dans l'espace, on ne suit plus de routes certaines.—Eh bien! quand on échouerait, il est beau de tomber des cieux. (OP 2: 278-79)

(Novels are not banished from literature; fiction is not banished from poetry, why then would they be so from painting, whose boundaries, without being infinite like poetry's, are nonetheless less restrictive than one might think? The painting that speaks to the heart through the brush of Raphael and Poussin can also address the mind and the imagination; these masters have proven it. Why would it not be permissible to try and extend even further the effects and boundaries that these great men knew? But one gets lost in the uncharted territory, there are no longer established paths.—Fine, when one fails, it is glorious to fall from the heavens.)

Girodet thus explicitly announces his desire to transcend the boundaries of painting to embrace new forms of expression and address the heart, the mind and the imagination as well the eye. Embracing a literary model, Girodet hopes to bring painting into the realm of fiction, fantasy, narrative and imagination, breaking with the rationalist, reality-based parameters of the Neoclassical mold and pushing art in new directions. And as this passage indicates, Girodet acknowledges failure as integral to the process of breaking down barriers, preferring to reach for the clouds than to remain eternally earthbound. While he longed for success and prestige among his peers, he was never willing to forego his iconoclastic vision. Girodet's most experimental and challenging art, the paintings he himself characterized as "neuves et poétiques," may have failed by contemporary standards yet they were, for the artist, the pinnacles of his creative output.

"Peintre, mais égaré sur le mont poétique . . .": Girodet the Poet

Despite Girodet's identity as a painter-poet and his voluminous literary output, little critical attention has been focused on Girodet's poetic production, especially in light of its social and political context.[33] Girodet began writing in earnest toward the turn of the century, and his first important publication, the anonymous *Critique des critiques du Salon de 1806 (Critique of the Critics of the Salon of 1806)*, appeared from Firmin Didot in 1807.[34] Written in response to the negative critical reception of his *Scène de Déluge*, Girodet's satirical *Critique des critiques*, much like the *Nouvelle Danaé*, was partially motivated by the desire for personal revenge. But like the satirical painting, Girodet's poem has larger implications and presents a

sweeping indictment of the state of art criticism under the Napoleonic Empire, while exposing the acute tensions between painters and authors over the right to evaluate and criticize the work of art.

By 1800 the art critical genre had begun to flourish, fueled by a nearly limitless supply of eager, if ignorant, authors searching for a means to launch their careers in the burgeoning postrevolutionary press. As the bourgeois audience emerged, eager to buy "quality" artwork with the imprimatur of critical and public approval, the demand for "definitive" evaluations of the Salons skyrocketed. The critic became an important force in the art market, much to the dismay of painters, who found the power wielded by authors, almost all of whom were unschooled in the visual arts, as inappropriate as it was threatening. New press laws in 1800 specifically exempted from censorship any "journals devoted exclusively to sciences, the arts, literature, commerce, or announcements and advertisements,"[35] allowing cultural news, considered politically neutral by the official power structure, to acquire unprecedented importance. Consigned to the supplementary *feuilleton*, art reviews and other cultural commentary became the locus of veiled political as well as aesthetic criticism, thus carrying a double-valenced power while remaining untouchable by the censors. The signed review brought with it an increased accountability, yet there was little pretense of neutrality or "fairness," as journals openly supported certain artists and defamed others. But increasingly, the *compte-rendus* of exhibitions and Salons were written and read in terms of political allegories. Thus, the critic Geoffroy's praise of the art of the age of Louis XVI was an encoded call for a return to monarchy understood by most readers, while an aesthetic critique of contemporary military scenes was an implied condemnation of the Napoleonic regime.[36] Art, regardless of its subject or the painter's intentions, became an overdetermined political signifier at the hands of critics more versed in current affairs than aesthetic discourse.

The increasing politicization of criticism, combined with the unschooled critics' power over an artist's career in the commercial art market, contributed to heightened levels of animosity between painters and the authors of art criticism, and to repeated attempts, by individuals and the *Académie*, to limit their influence. In *Critique des critiques* Girodet decries the critics for their ignorance and prejudice, insisting that authors are incapable of evaluating a painting with any validity. His tract begins with an *avertissement* to the reader, explaining that it is only toward those critics "whose ignorance is united with partisanship"[37] that he will direct his criticism, not with the hopes of correcting their flaws, which he deems impossible, but in order to enlighten the public. Girodet outlines the victimized state of

the artist in contemporary society, and paints the prejudice, injustice and jealousy that plagued him, in a blatant attempt to convert readers to the side of the painters.

La Critique des critiques consists of 24 pages of alexandrines and 13 pages of explanatory notes. Girodet divides his essay between straightforward criticism of the critics, written in the poet's own voice, and satirical pastiches of contemporary criticism. He begins by reducing the critic to "an envious fop" wielding "a brutal pen" and indicates that criticism is too often born of the critic's envy: "Attacking the talent that his own work lacks,/ Denigrating beauties that he secretly admires."[38] From the very opening lines, the painter-poet foregrounds the competition between the sister arts and in keeping with the tradition of the *paragone* polarizes words and images. Yet Girodet's polemic, like Leonardo's, paradoxically turns to poetry to establish the aesthetic dominance of the visual arts over the verbal.

In his tract, Girodet highlights the commercial and commodified nature of the contemporary state of the arts ("Tout se vend ici bas, et la célébrité/ Est de tous les faux biens le plus cher acheté" [All is for sale here, and celebrity/Is of all these false goods the most dearly bought]), while creating a stark contrast between fame and popularity on the one hand, and genius on the other. Establishing a clear difference between painting as Art and criticism as mere ephemera, Girodet posits the painter's revenge in the authors' inevitable oblivion, and then turns his focus to the dangerous sway held by the critic over a gullible public. With an ill-concealed scorn he lambastes the masses, whose bad taste is self-affirming and self-perpetuating:

> Le troupeau se grossit; ils parlent tous ensemble [. . .]
> Tel dit blanc, tel dit noir; et de la même chose:
> Où l'un voit un chardon, l'autre voit une rose.
> C'est la tour de Babel, peut-être pire encore:
> Mais pour l'écrivailleur tous ces gens parlent d'or. (10)
> (The flock increases; they all talk at once [. . .]
> One says white, another says black; and about the same thing:
> Where one sees a thistle, the other sees a rose.
> It is the tower of Babel, perhaps even worse:
> But for the scribbler, their words are golden.)

Subtitled *Etrenne aux connaisseurs*, *La Critique des critiques* addressed an elite public, educated in art and eager to distinguish itself from the *peuple*, who are here reduced to a milling flock of sheep. Girodet foregrounds their lack of critical understanding and senseless babbling, all of which are capitalized upon by the critic/scribbler. The painter defines a reciprocal relation-

ship between critic and public, for the canny journalist, eager for profits, will produce what the public wants to read, thus both shaping and mirroring popular opinion. In his reference to Babel, Girodet further attacks the critic's authority by underlining the instability of language and the inevitable gaps between words and things. The critic, trafficking in words, exploits their open-ended nature to his own advantage, while truth or accuracy are subordinated to *l'or*. Thus the painter erects an ethical hierarchy between word and image, where the writer, here personified as the hack journalist, embodies the crass and commercial goals of self-promotion, while the painter alone is the proponent of "high art" and the elevated values of truth and beauty.

Girodet ends his poetic polemic with an anecdote from the life of Apelles, an ancient artist who enjoyed a surge in popularity during the early nineteenth century. Court painter to Alexander, Apelles decided to display a newly completed work in public and to hide nearby so that he could hear the people's commentary and learn from it (*s'instruire*). While praise abounded, when a cobbler objected to his depiction of a sandal, Apelles emerged and corrected the painting immediately. Yet, when the shoemaker, "tout fier, poursuit son avantage" (quite proud, pursued his advantage) and criticized the painted leg as well as the shoe, Apelles replied: "Alte-là . . . à chacun son métier:/ Borne-toi, cordonnier, à parler de chaussure" (Stop there . . . to each his own profession:/ Limit yourself, shoemaker, to speaking about shoes) (21–22). Aligning himself with the most revered painter of the ancient world, Girodet makes his central point: critics should limit themselves to their realms of expertise. He concludes, "Censeurs, Apelle ainsi censurait la censure:/ Apprenez à douter. Vous eussiez dû savoir/ Pour parler peinture il faut au moins la voir" (Censors, Apelles thus censored censure:/ Don't be so sure of yourselves. You should have known/ That to talk about painting you must at least see it). But, as he deems writers and journalists incapable of transcending their generic limitations and evaluating art, the painter who has penned this verse holds himself to an entirely different standard. Despite his call for the limitation of criticism to one's personal purview of experience, Girodet does not hesitate to author *La Critique des critiques*, thus signaling that poetry lies within the painter's realm, while painting is beyond the grasp of the writer. Although published anonymously, *La Critique* nonetheless takes part in Girodet's larger project of defining the painter as a superior, elevated and educated soul with an ability to transcend his own genre to a higher, hybrid form of expression.

Le Peintre (The Painter) and its earlier incarnation, the fragmentary *Les*

Veillées (Visits at Twilight), represent Girodet's most sustained poetic efforts, and consumed the greater part of his creative energy during the last 20 years of his life. He admitted of *Le Peintre* "There is not a single bit of my poem that I have not frequently reworked and often even rewritten entirely, after having first penned it with care."[39] Closely modeled after Delille's descriptive, didactic verse, both poems combine an elegant, contorted diction with philosophical meditation on the nature of art and the formation of the artist.[40] *Les Veillées* is decidedly more conservative in nature: structured in six cantos, the unfinished poem is full of practical advice for the young painter, while still heavily imbued with overtones of Girodet's academic and Neoclassical training. The grounds of intersection between the two poems are considerable, and in each Girodet focuses on the development of the artist, contemporary aesthetics, and the relationship between painting and poetry. Thus *Les Veillées* begins with the narrator's attempt to identify himself as both painter *and* poet, while creating an equivalence between the two arts: "Peintre, mais égaré sur le mont poétique,/ Je veux, n'écoutant plus qu'un désir périlleux,/ Parler d'un art divin dans la langue des dieux" (A painter, straying on the poetic mount,/ Heeding nothing but a dangerous desire, I want/ To speak of a divine art in the language of the gods) (OP 1: 345). Acknowledging the inherent "danger" of his enterprise, Girodet nonetheless lays claim to poetic expression based on the elevated nature of painting itself, which he accords the divine status normally attributed to poetry alone. Thus, the erstwhile critic of critics and criticism implies that only *poetry*, the "language of the gods," can do justice to its equally sacrosanct sister art.

Le Peintre, which Girodet himself considered complete, is at once more polished and more contradictory than *Les Veillées*, in this sense presenting a more accurate portrait of the artist caught on the cusp of Neoclassicism and Romanticism. Girodet's justification of his poetic venture becomes far more developed in *Le Peintre*. Beginning with a 40-page *Discours préliminaire*, the painter-poet defends himself against his would-be critics while simultaneously asserting painting's equivalence *and* superiority to poetry, with the clear subtext of refuting painting's *inferiority* assumed by his reader or the general public. He opens the preliminary discourse with the following salvo:

> Que pensera le public à l'annonce d'un ouvrage en vers, écrit par un artiste? Avant même de le lire, ne condemnera-t-il pas et l'auteur et le livre; l'auteur, comme s'étant témérairement hasardé dans une carrière dont les études habituelles de son art semblaient devoir l'éloigner; le livre, comme une pro-

duction en quelque sorte étrangère au sol cultivé par Minerve, et ne dira-t-il pas que, dès lors, il ne peut satisfaire complètement ni les artistes ni les littéraires? (OP 1: 5)
(What will the public think at the announcement of a work in verse, written by an artist? Before even reading it, won't they condemn both the author and the book; the author for having recklessly ventured into a career from which his usual studies for his art would seem to have necessarily distanced him; the book, as a production in some way alien from the soil cultivated by Minerva, and won't they say that, consequently, it can satisfy neither artists nor authors entirely?)

Clarifying the stance he had taken in *Les Veillées*, Girodet indicates that the danger inherent in such an intergeneric endeavor is primarily one of public disapproval, for the public, while accepting writers' evaluations of painting, did not conceive painters to be capable of writing books, even about painting. Girodet will try to undermine these assumptions by demonstrating the painter's erudition and the essential grounds of intersection between the two arts, but it is important to recognize the framework within which he is working and against which he is rebelling. For although *Le Peintre* is a highly personal and self-professedly autobiographical work,[41] it nonetheless is overtly didactic as well. Girodet hoped in his verse to effectuate a new vision of the artist that transcended the limitations of genre as they were conceived and enforced by the public, critics and artists themselves in early nineteenth-century France.

Initially, Girodet focuses on the shared goals, inspiration and *language* of painting and poetry, for he insists that poetry "paints" images before the mind's eye that the painter renders on the canvas for external contemplation. This "mutual exchange" allows visual art to transcend its concrete form and embrace the realm of abstract ideas generally associated with words: "Painting, like poetry, arises from metaphysical conceptions. Both inhabit the diaphanous palace of allegory; both can also wield the whip of satire or dress up in the mask of Momus."[42] Girodet claims a place for painting in the poetic realm of metaphysical ideas, allegory, satire, criticism and allusion, which represent the elevation of painting to a more prestigious and powerful position. These "theoretical" concepts constituted the core of his "poetic" aesthetic for painting as well as the locus of critical resistance on the part of both critics and artists to Girodet's ambitious, literary canvases.

As Girodet continues his discussion of the imbrication of poetry and painting, his lexicon begins to betray some of the fundamental tensions between the two genres that he attempts to elide. Insisting on the inevitable

borrowing between the sister arts, he contends, "How could they not often be tempted to express themselves in the language of the neighboring countries where they go to exchange the inspirations of their genius?"[43] Even as Girodet attempts to render the intergeneric exchange natural and necessary, his vocabulary reveals an inherent territoriality with images of national border crossings that would have been particularly resonant in the decades surrounding Napoleon's imperial conquests. Further, his metaphor echoes the formulation put forth in Lessing's *Laocoön*, a text with which Girodet was doubtless familiar. In a chapter devoted to Homeric description, Lessing specifically discusses the "intrusion of the poet into the domain of the painter" and the "intrusion of the painter into the domain of the poet," an encroachment that entails overstepping each one's generic limitations in representing time and space. Lessing insists, "But as two equitable and friendly neighbors do not permit the one to take unbecoming liberties in the heart of the other's domain, yet on their extreme frontiers practice a mutual forbearance by which both sides make peaceful compensation for those slight aggressions which, in haste and from force of circumstance, that one finds himself compelled to make on the other's privilege: so also with painting and poetry."[44] The spatial metaphor, transforming painting and poetry into neighboring territories, contiguous but discrete, turns specifically on the images of boundaries that at once forbid and invite transgression. For both Lessing and Girodet there is similarly a linguistic metaphor at play, turning on the idea of different countries with different languages. Lessing specifically discourages these "unbecoming liberties," but Girodet posits forays onto foreign turf as intrinsic to art itself. While recognizing the boundaries of genre and the dangers inherent in crossing them, Girodet's formulation includes "those slight aggressions" as a fundamental component of intergeneric relations.

As the *discours préliminaire* proceeds, it becomes clear that Girodet seeks at once to borrow the poet's language and to better him in its application, and the metaphor of invasion is realized in his bellicose approach to the sister art. Dismissing all previous works penned by poets on painting and sculpture as uniformly dull, Girodet declares war on his poetic predecessors. He intones "It would have thus been necessary, from the outset, to engage in a dangerous battle with writers whose reputation, as poets, was solidly established." Moving from style to substance, he asserts that his rival poets "had spoken of painting without having the incontestable right to that authority. . . . They were not painters; consequently they could not be fully versed in artistic practice."[45] Mirroring the opening sentence where a

hypothetical "public" denied the painter the authority to write poetry, due to his lack of training, Girodet here denies the poet the same authority, based on exactly the same criterion. In this case, the painter possesses the superior knowledge and experience, and he is singularly endowed with the "right" to write about his art. As in *La Critique des critiques*, Girodet's theory of the sister arts reads in one direction: while the painter is allowed to write poetry [about painting], the poet is expressly forbidden from the same exercise.

The poem itself, six lengthy cantos of some 3,000 lines of verse, traces a young painter's education and artistic development. The first four cantos chronicle the narrator's artistic formation, first through his formal training in France and Italy, then in a whirlwind tour of Europe. The reader witnesses the young artist's response to the history, landscape and artworks of Greece, the Mediterranean, Egypt, Jerusalem, Scotland, North America and finally home to France. The eponymous painter's experiences closely mirror Girodet's, and *Le Peintre* looks to experience and culture as formative forces in the production and fertilization of the artistic sensibility. The last two cantos, the most personal and powerful, deal with the joys and sorrows of the life of a painter, both in terms of the narrator's own experience and that of great artists of the past, in yet another attempt to legitimize the contemporary artist through the borrowed patina of history. *Le Peintre* stresses the *personality* of the poet, and his inner life, examining him as an individual whose growth and experiences—concrete, intellectual and even imaginary—are integral to his creative production and thus of vital interest to a reader. As Neil MacGregor has pointed out, "As a document of the co-existence of classic and romantic notions of the artist, *Le Peintre* is of the highest value."[46] MacGregor's brief article concentrates on Girodet's stylistic and thematic borrowings from contemporary Romantic sources, highlighting Girodet's aspirations to write a "fashionable poem" ("*Le Peintre* may not be good, but it's chic" [28]). In the final pages of this chapter, however, I will focus on Girodet's more original quest to define painting and the painter in competitive dialogue with poetry, foregrounding the ongoing struggle for domination between word and image.

From the outset of his poem, Girodet links art and desire, attributing to painting the power to seduce an audience through its imitation of life. Anticipating the theme of Pygmalion, which will echo throughout this poem, Girodet locates painting's powerful attraction (*charme puissant*) in its capacity to tempt the viewer, through a skillful combination of truth and falsehood, into falling in love with the image. Appealing at once to the

senses, the emotions and the intellect, painting, as concrete representation, has a seductive quality that poetry lacks. Here Girodet reflects Leonardo's *paragone* and his contention,

> So much greater is the power of a painting over a man's mind that he may be enchanted and enraptured by a painting that does not represent any living woman. It previously happened to me that I made a picture representing a holy subject, which was bought by someone who loved it and who wished to remove the attributes of divinity in order that he might kiss it without guilt. But finally his conscience overcame his sighs and lust, and he was forced to banish it from his house.[47]

In this audacious assertion, the Renaissance master announced his rivalry with the Godhead, for his image invites an idolatrous worship that displaces the real for the ideal, and the spiritual for the carnal. These themes will resonate both in Girodet's work and in Balzac's interpretation of his work, where the artwork as fetish will be a central issue. For Girodet, however, Leonardo represents a heroic predecessor engaged in similar battles and parallel rivalries, and later in *Le Peintre*, the narrator muses: "Et l'élégant Vinci, favori de l'Amour,/ Savant peintre, poète et galant troubadour,/ Dans les nobles beautés que son pinceau fit naître,/ Rivalisait Pétrarque et surpassait son maître" (And the elegant da Vinci, Love's favorite,/ Learned painter, poet and gallant troubadour,/ In the noble beauties that his paintbrush created,/ Rivaled Petrarch and surpassed his master) (OP 1: 61). Leonardo's status as "peintre, poète et troubadour," and his position as rival to Petrarch indicate that Girodet was as inspired by his artistic predecessor's *paragone* as by his paintings, and the Renaissance treatise serves as a key intertext in several of the cantos.

Thus, as he traces the history of painting itself, Girodet incorporates the theme of love, painting and power, in keeping with Leonardo's paradigm. Turning to ancient myth, he attributes painting's birth to physical absence and Cupid's machinations. Dibutades, her hand guided by that of the god, traces her lover's profile on the wall before he leaves for war: "Séparée à regret de l'objet de ses feux,/ A cette esquisse encore elle portait ses voeux,/ L'adorait en silence, et l'image fidèle/ Recevait les serments adressés au modèle!" (Regretfully separated from the object of her ardor,/ To this sketch she directed her desires,/ She adored it in silence, and the faithful image/ Received the vows addressed to the model) (OP1: 48). Both the production and the consumption of the image are driven by love and desire, as art fixes transitory reality into an "image fidèle" that is pleas-

ing in its double-valenced "fidelity"—that is, in its physical resemblance to
the original and its unwavering faithfulness. Where living models/lovers
inevitably change (leave, age, die), art always remains the same. As in
Leonardo's tale, the likeness becomes a surrogate for the subject of repre-
sentation and the signifier replaces the signified as object of adoration, its
symbolic value subsumed in the simulacrum. Art's power, then, lies at once
in its ability to seduce and bring pleasure to its viewer, and further in its
capacity to transcend the limitations of nature by giving eternal life both
to the subject and the artist, rendering immutable that which is by defini-
tion transient. While this is by no means a new argument, Girodet's inter-
pretation of this timeworn claim for painting's power and his continuing
insistence on the theme of rivalry provide insight into his aesthetic. Again
reflecting Leonardo's anecdote in the *paragone*, Girodet exclaims:

> O triomphe d'un art rival de la nature!
> Celeste illusion, ravissante imposture!
> Des amants séparés par toi sont réunis;
> Tu rends le fils au père, et le père à son fils;
> D'une épouse un époux plaint le trépas funeste:
> Il n'a pas tout perdu, son image lui reste;
> Il croit la voir encore, encore lui parler;
> De son oeil qui se trouble il sent des pleurs couler;
> Il bénit et l'artiste et l'heureuse magie
> Qui rend à ce qu'il pleure une seconde vie. (OP 1: 48-49)
> (O triumph of an art that rivals nature!
> Divine illusion, delightful imposture!
> You reunite separated lovers;
> You give the son back to the father and the father to his son;
> A husband who laments the death of his wife
> Has not lost everything, for her image remains;
> He believes that he still sees her, still speaks to her;
> From his confused eye he feels the tears flow;
> He blesses both the artist and the happy magic
> That gives a second life to her for whom he weeps.)

The author posits the superiority of art and its illusions to reality, and the
power of art to create and surpass life, a belief that characterizes the fun-
damental fantasy motivating the myth of Pygmalion and its many inter-
pretations.

Throughout his life Girodet actively pursued the latest developments in
art, science, philosophy and literature. His paintings and poetry present a
veritable catalogue of postrevolutionary *nouveautés*, from punning wordplay

in the *Nouvelle Danaé* to the mystical imagery and primitive legend in *Ossian* and the proto-Romantic portraits of Chateaubriand, Belley and Atala. Eager to be on the cutting edge, Girodet embraced the popular theories of Johann-Kasper Lavater (1741–1801), the Swiss physiognomist whose *Physiognomische Fragmente* (1775–78) was translated into French in 1781–1803. Lavater's theory of physiognomy, which remained influential well into the nineteenth century, delineated a correspondence between the exterior appearance of an individual and the inner being. For Girodet and later Balzac, Lavater's formulations provided a theoretical foundation for their own conceptions of art, stressing the importance of observation and the idea that one might "read" a face in order to understand the inner workings of the soul. Thus, in the *Chant second* Girodet demonstrates the painter's superiority in Lavaterian terms and points to the concept of a visual language of expression, both wielded and interpreted by the painter.

Rather than imitating the natural world directly, Girodet maintains that each artist recombines its parts into a new and original whole that reflects a higher beauty. Anticipating Delacroix's famous observation, "Nature is only a dictionary," quoted and explicated at length by Baudelaire,[48] Girodet asserts the idea of a natural language that the artist does not transcribe directly, but rather selectively quotes, arranging the components according to his own meaning. The painter's expressive vocabulary and his syntax arise both from his observation and interpretation of the visual data available to him in his encounters with the world, and here Girodet establishes the importance of Lavater's theory to the artist. He explains, "Du savant Lavater, disciple ingénieux,/ Le peintre observe aussi, d'un regard curieux,/ Le maintien, la couleur, la forme du visage;/ Distingue un sot d'un fat, un insensé d'un sage" (Ingenious disciple of the learned Lavater,/ The painter also observes, with a curious gaze,/ The attitude, color and form of the face;/ Distinguishing a fool from a fop, a madman from wise man) (OP 1: 101). The painter is skillful interpreter of the visual discourse of the human body, and he translates these signifiers into his paintings. Establishing the superiority of the artist's eye, Girodet insists that he can perceive, and reveal, what others might miss:

> Son oeil, mieux qu'un autre oeil, sous de sinistres traits
> Voit le crime, pensif, méditer ses forfaits;
> Il soulève des coeurs le voile impénétrable,
> Lit son arrêt écrit sur le front coupable,
> Et découvre bientôt, sous un masque trompeur,
> Les travers de l'esprit, les faiblesses du coeur. (OP 1:101)

(His eye, better than another eye, beneath sinister features
Sees crime meditating its evil deeds;
He lifts the impenetrable veil from these hearts,
Reads his sentence written on the guilty brow,
And soon discovers, beneath a deceitful mask,
The deviations of the mind and the frailties of the heart.)

Girodet's lexicon of seeing, exposing, reading and discovering hidden truths with a penetrating and analytic gaze emphasizes the painter's role as visionary, that is one who can see behind appearances to inner realities, while presenting the visual experience of faces as a language to be deciphered. The various conformations and expressions of the human body thus provide clues to the invisible inner world of the soul, and the painter arranges these signs in such a way as to communicate his meaning, while teaching his viewer how to read the world. Sight is equated with insight and the *meaning* of the complex system of signs that constitutes the visible world is accessible only to those astute observers, such as *le peintre*, tutored in this language that looks beyond surfaces to what is hidden.

Girodet's proto-Romantic interest in the interior world and the individual's fundamental *caractère* stands in contrast to the Neoclassical obsession with *les passions*, a codified system of expressions that exhibited specific emotional reactions to set situations, the immediate rather than permanent inner being. Yet his fascination with Lavater's theories also highlights the painter's desire to expand the purview of vision, allowing it to penetrate beyond the surface of things into the mysterious depths of the soul, beyond the ephemera of appearances to essences. In an effort to elevate painting in the estimation of the contemporary French reader, Girodet, like Leonardo before him, raises sight to an almost mystical level, putting it on par with the intellect, and thus, once again, in direct competition with words for expressive and didactic superiority.

Finally, the two most telling episodes in the poem derive from a pair of Greek myths on the power of the artist: Apelles and Campaspe, and Pygmalion and Galatea. The first recounts the triangulated tale of love, art and power between Alexander the Great, his mistress and his favorite painter, Apelles.[49] As Girodet recounts the episode, Alexander, "conqueror of Asia and the master of the world," weary from the exertions of battle, finds peace in the arms of the concubine, Campaspe. Infatuated with her beauty, he calls Apelles, to whom he explains,

Je t'offre, lui dit-il, le plus parfait modèle
Que jamais puissent voir et la terre et les cieux,

Digne de tes pinceaux, d'Alexandre et des dieux:
Exprime son regard, son céleste sourire;
Que ton tableau, comme elle, excite mon délire.
Si ton art peut atteindre à rendre sa beauté,
Tu peux, tu dois compter sur l'immortalité. (OP 1: 169)
(I offer you, he said, the most perfect model
That the earth and the skies have ever seen,
Worthy of your brushes, of Alexander and the gods:
Convey her gaze, her celestial smile;
Let your painting excite my desire as she herself does.
If your art can succeed at rendering her beauty,
You can, you must count on immortality.)

The painted image will reflect the perfection of the model, and will serve not only to inflame the passion of the real woman's lover, but also to establish the fame and immortality of the artist. The initial triangulation, where Alexander offers Campaspe to Apelles, so that he might reproduce her beauty for both of their benefit, prefigures the relational structure of Poussin/Gillette/Frenhofer in Balzac's *Le Chef-d'oeuvre inconnu*, where the living woman/model/lover is a token of exchange between the two men. As in the earlier scene with Dibutades, there is a fundamental belief in the equivalence between art and life, as the painted image is imbued with the same attractions as the loved one.

Alexander leaves and Campaspe approaches the artist, who is so overwhelmed by her beauty that he cannot apply brush to canvas. But love inspires his courage and his art, and he is transported to the realm of the gods as he paints Campaspe. In a description that anticipates the Pygmalion episode to follow, love creates not only a work of great beauty, but one that is infused with life: "Isolé, chaque trait est plein de volupté;/ . . . Et cette flamme, au ciel par le peintre ravie,/ Y fait éclore l'âme et circuler la vie" (Alone, each feature is full of voluptuousness;/ . . . And this flame, which the painter has stolen from heaven,/ Gives birth to the soul and makes life circulate there) (OP 1: 170). The infatuated artist creates a masterpiece that transcends its existence as art, pulsing with life itself. Art surpasses the beauty of reality, and Campaspe herself demands, "Peintre chéri du ciel, par quels heureux secrets/ Peux-tu me rendre ici plus belle que moi-même?" (Painter dear to the gods, by what happy secrets/ Are you able to make me more beautiful here than myself?) (OP 1: 171). The artist confesses that his love has inspired the sublime image, but he further admits the futility of his passion, for "Ton amour pour le roi me défend l'espérance" (Your love for the king forbids me hope). Reinserting art into the realm of the political,

Girodet pits the artist against the king, and it is the artist who wins the love of Campaspe, for she reflects: "L'amant qui m'a su rendre aussi belle, à mes yeux,/ Plus que tout autre amant est digne de mes voeux./ [. . .] je sens que mon coeur/ Loin de l'éclat du trône a choisi son vainqueur" (The lover who was able to render me this beautiful in my own eyes,/ Is more worthy than any other of my troth/ [. . .] I feel that my heart/ Far from the magnificence of the throne has chosen its conqueror) (OP 1: 171). Alexander enters the studio, unnoticed by the two lovers, and witnesses their passionate embrace. Torn with astonishment, jealousy and rage, he stands silently watching them, the most powerful man in the world reduced to an impotent voyeur. When he has finally mastered his own passion, he approaches the lovers, his fury conquered by the beauty of Apelles's painting, which in a reversal of his initial offer to the artist, now stands as a tribute to "votre amour et ma gloire" (your love and my glory). He assures them that he will be generous, for in fact he has lost nothing: "Campaspe vit pour moi dans ce portrait fidèle;/ Pour prix de la copie, accepte le modèle./ Je veux que la beauté couronne le talent,/ Peintre illustre!" (Campaspe lives for me in this faithful portrait;/ For the price of the copy, accept the model./ I want beauty to crown talent,/ Illustrious painter!) (OP 1: 172). The painting serves as substitute for the real woman, thus rivaling her beauty with that of the artist's inspired manufacture. Alexander, as enlightened ruler, embraces the artist as his equal, crowning him with the gift of Campaspe in exchange for the portrait.

Girodet's choice of Apelles is significant both in terms of his project to elevate the status of the artist, and also in terms of a larger political dialogue regarding state sponsorship of the arts in the early nineteenth century. As Richard Wrigley explains, "The precedent of Alexander's admiration for Apelles had special significance under the Consulate and Empire, when France was ruled by a head of state who actively encouraged the arts as a means of promoting his own glorification. When Consul Bonaparte visited the Salon in 1802 he was apostrophized as an inspiration to France's artists, who were a veritable generation of Apelles to his Alexander."[50] Girodet, who had eagerly courted Napoleon's favor at the beginning of his rule, had never succeeded in securing many commissions. When he did, as in the series of 36 identical portraits of the emperor for the courts of France, he found their formulaic requirements stultifying, irremediably at odds with his conception of the role of the artist's originality. Thus, the painter/poet's use of the popular image of the Greek king must be read *against* the common association established between Napoleon and Alexander, offering instead a new model for the trope. Hav-

ing failed to flourish professionally under the Empire, Girodet nursed great hopes of belatedly rising to the forefront of his generation under the Restoration. The painter made several overtures to Louis XVIII, who sought to establish himself as a patron of the arts through regular visits to the Salon, and this section of *Le Peintre* stands as a petition for the Bourbon king's favor. To some extent, Girodet's machinations worked: Louis XVIII invited the artist to show him the as yet unhung *Pygmalion* in 1819 and in every newspaper report of the interview there is explicit reference to Apelles and Alexander. This fantasy of royal approbation, artistic power and prestige reveals Girodet's own dream of glory under a new political regime, and constitutes his poetic appeal to the new king, himself eager for public approbation, to take on the magnanimous role of the Greek ruler.

In keeping with the political orientation of Apelles, the following episode in *Le Peintre*, Pygmalion, begins with a Winckelmannian meditation on the role of the Greek state in nurturing artists and the arts. Closely following Ovid's version of the tale, Girodet tells of Pygmalion's withdrawal from society as he devotes himself to art. Diverging from tradition, Girodet then recounts how the sculptor has erected a belvedere at the summit of his palace, a temple to Venus entirely decorated by his own works. In referring to his *palais*, Girodet indicates that his Pygmalion is a prince, rather than a simple artisan, once again placing the painter atop the social hierarchy (as with Endymion, *chez* Noël) and linking the artist with politics and power.

Like the hero of Ovid's tale, Girodet's Pygmalion has rejected real women for the fantasy of art: "fuyant le joug de l'hyménée,/ Et confiant aux arts sa noble destinée,/ Pygmalion rêva la céleste beauté/ Qui lui dut et la vie et l'immortalité" (fleeing the yoke of marriage,/ And entrusting his noble destiny to the arts,/ Pygmalion dreamed of the celestial beauty/ Which owed to him her life and immortality). Conflating art, love and religion throughout this dense passage, Girodet indicates that Pygmalion's art, and his passion, are inspired by Venus in every sense of the word: "Animé par un dieu qui l'enflamme et le presse,/ A peine il en conçoit l'image enchanteresse,/ Son ciseau créateur en reproduit les traits:/ C'est Vénus elle-même avec tous ses attraits" (Animated by a god who excites and impels him,/ No sooner does he conceive the enchanting image,/ Then his inventive chisel produces its features:/ It is Venus herself with all of her charms). If the artist's inspiration is god-given, as indicated in *Endymion* as well, the work of art stands as a tribute to that power, while transcending the limitations of mortal beauty. Pygmalion, seduced by his own creation, believes that the statue, more beautiful than any living woman ("Nulle fille

des dieux, nulle aimable mortelle/ Jamais de tant d'appas ne reçut l'heureux
don" [No daughter of the gods, no adorable mortal/ Ever received the
happy gift of such charms]), is alive. Following Ovid's text, Girodet reflects
that artist's initial self-deception, then, making the same transition from
infatuation to physical love as his predecessors, Girodet outlines Pyg-
malion's idolatrous, forbidden passion for the ivory maiden:

> Sa main, de son idole effleurant le contour,
> S'en éloigne par crainte, y revient par amour,
> Tremble de l'offenser; mais sa bouche plus tendre
> Lui dérobe un baiser qu'elle ne peut comprendre.
> Il la pare avec soin de voiles précieux,
> Tels que ceux qu'on destine aux images des dieux,
> Ou couronne son front des dons brillants de Flore.
> Tout lui sied, et, sans voile, elle est plus belle encore;
> Chaque moment accroît le trouble de ses sens,
> Et déjà, de l'amour il connaît les tourments. (OP 1: 175)
> (His hand, stroking the contours of his idol,
> Withdraws from fear, and returns from love,
> Trembling at the thought of offending her; but his tender lips
> Steal from her a kiss that she cannot understand.
> He dresses her with care in precious veils,
> Like those meant for images of the gods,
> Or crowns her head with the brilliant gifts of Flore.
> Everything suits her, and, without the veil she is even more beautiful;
> Each moment increases the confusion of his senses,
> And he already knows the torments of love.)

Not daring to ask for his heart's true desire, Pygmalion prays to Venus, in
a close replication of Ovid's verse, for "une épouse aussi belle/Que celle
dont mes mains ont formé le modèle" (a wife as beautiful/ As the one I have
modeled with my hands) (OP 1: 176) and once again Venus understands
the artist's true meaning and grants his wish. Here, however, Girodet adds
his own dramatic touch that combines echoes of *Ossian* with the effects of
a stage performance. Introducing the image of an electric spark, then
cupid's divine light, as the symbols for animation, he explains,

> Trois fois, comme l'éclair de la nue électrique,
> S'élève de l'autel la flamme prophétique,
> Présage fortuné des faveurs de Cypris.
> Soudain, d'un vol léger, sur l'écharpe d'Iris,
> L'amour descend du ciel que sa trace illumine;

L'air s'épure aux rayons de sa clarté divine;
En vain le marbre oppose à leur vive chaleur
Sa roideur inflexible et sa dure froideur,
Le dieu malicieux se rit de l'impossible:
Il paraît, le bloc cède, et le marbre est sensible. (OP 1: 176)
(Three times, like the electric flash of a lightning cloud,
The prophetic flame rises from the altar,
Fortunate sign of the favors of Cypris.
Suddenly, in a nimble flight, on a rainbow,
Love descends from the heavens, lighting the sky in his wake;
The air is purified by the rays of divine light;
In vain, the marble resists their ardent warmth
With its inflexible rigidity and its hard chill,
The malicious god laughs at the futility:
He appears, the block yields and the marble is sensate.)

Girodet has added an unexpected intermediary in the person of the cupid, present in many paintings of Pygmalion, but rarely in its literary accounts. Shifting the focus away from Pygmalion's genius to his position as chosen one of the gods, Girodet's introduction of cupid as the force orchestrating the statue's animation further links art and love while removing the artist from the realm of culpability.

As he moves to Galatea's animation, Girodet includes contemporary scientific *nouveautés*, attributing the spark of life to an ethereal fluid (*un fluide éthéré*) emerging from cupid's flames and penetrating the stone of the sacred idol. Exploiting the potential of language's linear and developmental nature, the poet narrates the gradual movement of life through her veins, in a blason that significantly skips her head. The *fluide éthéré* enters the stone, "s'en empare, y circule et court de veine en veine:/ L'idole enfin respire, et, de sa douce haleine,/ Elle rend le zéphyre amoureux et jaloux./ De son sein attendri glissant à ses genoux,/ La divine vapeur sur ses pieds vient s'épandre,/ Et du socle isolé va la faire descendre" (takes possession of it, circulates and flows from vein to vein;/ The idol finally breathes, and, with her sweet breath,/ She makes the zephyr amorous and jealous./ From her now tender breast gliding to her knees,/ The divine vapor has just spread to her feet,/ And is going to make her descend from her lonely pedestal) (OP 1: 176-77). But if the divine vapors emanated by cupid can animate her body, only the love of the artist can animate her soul, and in a scene reminiscent of Rousseau's *Pygmalion*, the artist is associated with loftier ambitions than the more sensual cupid. The now animated statue, a living, breathing body, remains thus far devoid of spiritual vitality: "Mais

son âme naissante, encore dans le sommeil,/ Du souffle de l'amour attend son doux réveil;/ C'est à lui d'animer son regard près d'éclore;/ D'achever ce soupir qui tient captif encore,/ Dans son coeur sans désir l'instinct de la pudeur./ Par degrés son front perd sa muette pâleur,/ Et va trahir le dieu qui lui donna la vie" (But her nascent soul, still slumbering,/ Waits for the breath of love to awaken her,/ In her heart, no desire, only the instinct of modesty./ By degrees her brow loses its silent pallor,/ And is going to reveal the god who gave her life) (OP 1: 177). While the gods orchestrate the physical animation of the statue, it is the artist's love that brings her soul to life, a metaphor for the ultimate creative power of the artist. Finally returning the narrative gaze to Pygmalion and his own reaction to his answered prayer, Girodet similarly portrays the movement of the artist's soul, mirroring the changes taking place in his creation. At once drunk with pleasure and stunned with disbelief, Pygmalion experiences the gamut of emotion that, in keeping with Lavater, may be read on his face and in his eyes: "Son teint se colorer des roses de l'aurore,/ Le souris du bonheur sur les lèvres éclore,/ Et son regard timide, incertain, languissant,/ Contempler tour-à-tour le ciel et son amant" (His complexion turns the color of roses at dawn,/ The smile of happiness blooms on his lips,/ And his bashful gaze, uncertain, pining,/ Moves between the heavens and his beloved) (OP 1: 177).

The mythic figures of Apelles and Pygmalion and their narratives of art, love, creation and the artist's relationship to his model in *Le Peintre*, serve as crucial metaphors for Girodet's vision of art and the artist within society. A higher, transcendent truth, Girodet's art takes its inspiration from the gods and holds a more elevated position in the cosmology than even life itself. If poetry had always been *la langue des dieux*, while painting the earthbound stepsister devoid of even a goddess or a muse, Girodet has attempted to use the language of the gods in his poetry to establish the equally divine status of painting, taking great pains to illustrate the painter's proximity to the gods in both his power and production. In the final canto, Girodet returns to the themes of artistic inspiration and the role of art in the larger world. The artist is defined as a spiritual creature whose creation is a product not of his hand and his eye, but of his soul, reiterating the idea that Apelles's and Pygmalion's sublime productions arose from the depth of their emotion. Like the author, the painter thus portrays his innermost thoughts, hopes and desires in his art, which is a vehicle not merely of depiction, but expression, and thus, by extension, inspiration for an audience. Art, as Girodet explains, exerts such a power over its audience that it can inspire virtue, heroism and, as illustrated above, love. Finally, the *differ-*

ences between painting and literature in their modes of representation, which Girodet has elided throughout the six cantos, are brought to bear at the end of the poem to assert painting's ultimate expository superiority. While continuing to assert that painting is a language, Girodet maintains that it is more effective than verbal communication because of the universality of its sign system. If art's ultimate goal is to lead humanity toward higher aspirations, painting is the more effective genre for it requires no previous knowledge of its syntax or vocabulary. Using a natural sign system, painting's visual language is accessible to both the erudite and the illiterate, for its images appeal directly to the soul. The painter/poet contends, "Les beaux-arts ont lié tous les peuples entre eux;/ La peinture surtout, universel langage:/ L'homme civilisé, l'homme inculte et sauvage,/ Se laissent amollir à ses traits pénétrants;/ Elle plaît à tout âge, en tous lieux, en tous temps" (The fine arts have linked all peoples together;/ Painting above all, the universal language:/ The cultivated man and the savage alike,/ Find themselves moved by its penetrating qualities;/ It pleases in every era, in every place, at all times) (OP 1: 192). Painting transcends difference—be it national, educational or temporal—presenting universal truths in a universal language, and the painter of genius, who plays such a crucial role in civilization and culture, will ultimately take his place on high, side by side with the divinities.

Closing with the life of Raphael, a Romantic figure whose genius and early death appealed to Girodet's own self-image, the poet posits one final time the apotheosis of the artist, whose posthumous glory stands as testimony to his universal importance. *La Gloire*, whose promise encouraged the *peintre* to continue his labors despite the envy of rivals and vituperation of critics, has the last word in *Le Peintre*. As an allegorical figure addressing Raphael's mourners, she counsels them to dry their tears, for history will continue to revere him:"L'univers et les temps maintiendront sa mémoire./ Oui! de mon noble éclat toujours environné,/ Des peintres le plus grand, par ma main couronné,/ Dieu des arts, et rival du dieu de l'harmonie,/ Va cueillir dans les cieux les palmes du génie" (The universe and time will maintain his memory./ Yes, my noble renown will always envelop/ The greatest painters, crowned by my hand,/ God of the arts, and rival of the god of harmony,/ Come gather in the heavens the palms of genius) (OP 1: 199). Thus Girodet aligns himself with the great Renaissance painter, while claiming a place in the pantheon, redeemed by future generations who will recognize the "chefs-d'oeuvres inconnus" (a phrase that will reappear in Balzac's tale). This poetic tribute to the power of images and his assertion of the superiority of visual language, even as he exploits and

depends upon literary form, reveals the tensions perceived by the painter between the genres in the early decades of the nineteenth century. Moreover, Girodet's poem demonstrates his desire to establish the importance of painting in social, political, religious and finally aesthetic terms, in order to elevate its status and increase its "value" to a reader perceived as hostile to its intellectual and representational merits. *Le Peintre* expresses far greater concerns than Girodet's own individual struggles and gives voice to the complex anxieties of identity and creativity that artists collectively confronted in the emergent capitalist culture of early nineteenth-century France.

The success of Girodet's endeavor will never be known, for *Le Peintre* was not published during his lifetime. Its posthumous appearance, within the context of his collected works and letters, juxtaposed with Coupin's biographical essay, notes and annotations, brought with it associations and implications that prevented a straightforward reception. Yet the general response to the very *concept* of the painter's poetry, by readers and critics from the nineteenth century to the present day, has been overwhelmingly negative and dismissive,[51] revealing a lingering anxiety over the transgression of generic boundaries that will be rendered concrete in the critical reception of Girodet's most overtly literary, and thus most competitive painting, *Pygmalion et Galatée*.

Chapter 3 ～

PYGMALION, THE PATRON, POLITICS AND THE PRESS: A PORTRAIT OF THE ARTIST IN RESTORATION FRANCE

Pygmalion and the Patron: The Art of the Fetish

Girodet remained an important figure on the artistic scene under the Empire. His works from 1806-1819 reflect popular currents in art: a scene of the Emperor's heroic conquest (*Napoleon Accepting the Keys of Vienna* [1808]), Orientalist fantasies (*The Revolt at Cairo* [1810], *Mustafa Sussen of Tunis* [1819]), and literary scenes and portraits (most notably *Les Funérailles d'Atala* and a portrait of Chateaubriand, both of 1808). Yet, despite a handful of commissions, Girodet never succeeded in winning Napoleon's favor, nor was he temperamentally suited to the exigencies of the Emperor's patronage. Abandoning his imperial court commission after only 26 of the 36 identical portraits were completed, Girodet complained about the insufficiency of the state's compensation and was unwilling to subordinate his own views to those of the ruler. Girodet's wealth allowed him an independence that made it possible for him to paint what he wanted when he wanted. Consequently, his production, smaller and more idiosyncratic than that of his contemporaries, failed fully to attain the critical prestige or popularity that he longed for.

Thus, although he remained a prominent public figure and his work was well received, Girodet never again achieved the adulation accorded to him for *Le Sommeil d'Endymion*. He continued to own his triumphant *académie* and displayed it at every possible opportunity, declining to sell it to numer-

ous eager buyers. Indeed it was the fame and unavailability of *Endymion* that brought about Girodet's last important commission and his final attempt to establish himself as France's premier painter. Giovanni Battista Sommariva (1760–1826), the most important patron and collector of French art in the early nineteenth century, had tried from 1809 onward to procure *Endymion* for the vast collection housed in his Parisian *hôtel*. Girodet's steadfast refusal led to a commission in 1812 from the powerful patron, who sought a replacement for the youthful masterpiece in what would eventually become Girodet's *Pygmalion et Galatée*.

The fate of Girodet's final Salon painting is intimately tied to its patron. Sommariva, an Italian-born "diplomat," began his shady career as a barber's assistant, was later trained as a lawyer and made his fortune as Napoleon's appointed head of the Cisalpine Republic (1800–1802). Universally regarded as opportunistic and unscrupulous by those who knew him well, Sommariva was an ambitious social climber and shameless parvenu who sought refuge in France when the political tides turned in Italy. Arriving in Paris in 1806, Sommariva forged a new persona: shedding a wife and gaining a title, he reinvented himself as a patron of the arts. Amassing an enormous collection of paintings and sculptures to draw attention away from the disreputable sources of his fortune, the Italian arriviste also exploited art "as an instrument of social prestige."[1] Sommariva's career typifies the new atmosphere of social mobility in Napoleonic France, where self-made men, beneficiaries of political alliances and financial *agiotage*, ascended to power and subsequently sought legitimacy through the acquisition of cultural artifacts. One of the first nineteenth-century patrons to start building a collection on the prerevolutionary scale, Sommariva's tastes ran to eroto-mythological works by the leading artists of the period, including David, Girodet, Prud'hon, Guérin, Gérard and Canova. His holdings were so large that they were divided between his Parisian galleries in the rue Basse-des-Remparts and a villa on Lake Como acquired during his tenure in Milan, both of which were open to the public.

Sommariva's munificence made him a popular figure with both contemporary French artists, who enjoyed his support, and *amateurs*, who enjoyed access to his galleries. The xenophobic Parisian press paid him the ultimate compliment of considering him one of their own, insisting that, despite his Italian birth he "belonged to France in his tastes and affections."[2] Sommariva's connoisseurship, however, was by no means purely philanthropic: his personal letters reveal the unsentimental vision of a businessman who considered art in terms of financial investment. Sommariva was rare in his willingness to sponsor works before they were completed, yet

this too was approached in terms of a business endeavor, as he played an active role in overseeing the conception and production of his investment. Recognizing artists' shaky financial position at the outset of the century, Sommariva exploited the power of patronage to his own ends. Yet despite his efforts at controlling the artistic process, he nonetheless achieved a level of intimacy with his many commissioned painters, including Girodet, who managed to retain a positive relationship with the collector throughout the arduous process of conceiving and completing the *Pygmalion*.

Sommariva forged his closest artistic alliance with Antonio Canova (1757-1822), the most influential sculptor of the Neoclassical period. The miraculous "lifelike" quality of Canova's sensuous Classicized nudes received much attention during the first third of the century, and prompted connoisseurs and critics alike to indulge in baroque fantasies of infatuation with the statues. As one contemporary commentator was to observe, "His female figures above all are made to inspire in the spectator the desire to see the graceful fable of Pygmalion come true."[3] Sommariva considered his many Canovas the centerpiece of his collection and expressed an obsessive, fetishistic fascination with the statues that shares much with Ovid's mythological tale. In a series of letters of 1812-13, written to Canova as he awaited the completion and delivery of the statue, *Terpsichore,* Sommariva began referring to the sculpted muse as *mia Sposa* (my wife) and there are at least ten other references to the *Terpsichore* as *mia Sposa* during this period.[4] Sommariva calls the statue Canova's "daughter" on a variety of occasions and in keeping with the wedding fantasy, began planning a "nuptial feast" to which he would invite David, Gérard, Prud'hon and Girodet, who would be able to appreciate her graceful splendor. Once in his possession, *Terpsichore* occupied the place of honor in his bedroom, as he explains "She is already settled precisely into her place in my bed. All those who have had the opportunity to admire her in her nuptial bed appreciate her even more than at the museum exhibition."[5] Like Pygmalion, Sommariva places the statue on a bed and indulges in the sexual fantasy that it is not a work of art but rather a real woman—a wife, a daughter, a lover—whose perfect beauty and grace surpass mundane reality and will satisfy him in ways that others could not. The consistency of Sommariva's diction throughout several years' worth of letters indicates that the marriage metaphor and its subtext of conjugal relations was more than a fatuous turn of phrase, reflecting a deeply felt fantasy that transformed the marble statue into an overdetermined sexual fetish.

If the *Terpsichore* bore the weight of Sommariva's sexual fantasies, Canova's even more renowned *Magdalene* held a comparable place in his

collection as a religious fetish with inescapable sexual overtones. Considered Canova's masterpiece, the *Magdalene* brought visitors from near and far to Sommariva's galleries, where it was displayed in "a small shrine, half chapel, half boudoir."[6] Built specifically for Canova's *Magdalene*, the shrine was hidden behind a silken curtain. When the visitor penetrated the secret sanctum, he or she entered a room covered in gray silk drapery and furnished with purple appointments; the sculpted Magdalene was posed in the center, illuminated by an alabaster lamp, with a mirror behind her to expose all sides. This temple to the repentant prostitute simultaneously celebrated her beauty, suffering and submission, while the visual syntax of the gray silk, violet upholstery and alabaster lighting functioned as dueling evocations of church and brothel. In a firsthand account of a visit to Sommariva's galleries, Thomas Dibdin highlights the "surprise and admiration" felt upon entering the room and seeing the statue, emotions that, by his own admission, arise as much from the "studied, artificial" effects of Sommariva's orchestrated presentation as from the spiritual representation of a religious figure.[7] If she is worshiped in this Parisian shrine, it is as much for her beauty as it is for her symbolic nature, and in this sense Canova's *Magdalene* becomes an idolatrous figure, a fetish confusing a representation of the divine with the powers of the divine itself.

Finally, Sommariva's attitude toward the art that he possessed embodied overt commodity fetishism. The patron imbued the material objects with the projected consciousness of a real person, seeing them as an extension of himself, his wealth and power. Initially, Sommariva used the paintings and sculptures as personal surrogates in his relationship with the French public, and his correspondence reflects a desperate desire to display each of his purchases and commissions at the Salon, which had become a vehicle for self-promotion for wealthy new collectors. Sommariva's fortune allowed him to become a creator of sorts, for, as Marx explains, money "converts my wishes from something in the realm of imagination, translates them from their mediated, imagined or desired existence into their *sensuous, actual* existence—from imagination to life, from imagined being into real being. In effecting this mediation, [money] is the *truly creative* power."[8] As Sommariva's letters demonstrate, the collector indeed used his money to commission the fulfillment of imagined fantasies into sensuous existence in works of art that represented both the realization of the ideal and the realization of his power to possess these objects embued with projected life. Sommariva, fully identified with his commodified collection, continued his attempt to shape his public persona by actively pursuing the reproduction and circulation of his images. Not content to open his homes to the pub-

lic, the Italian patron commissioned engravings of nearly all of his works, each inscribed with a dedication to its owner, so that the images he bought might be bought by others throughout Europe, marked with the visible imprint of their patron. Extending the mania for the replication of art as object even further, Sommariva commissioned a set of miniatures of his paintings. Carrying them with him on his travels, the patron could show the world what he possessed, and the artworks served at once as the concrete realization of his fantasies, a symbol of his wealth and a personal proxy.

Thus the work of art *chez* Sommariva, and the Canova statues of female figures that he owned in particular, represent the confluence of a variety of fetishisms that emblematize an early nineteenth-century approach to art, collecting and the female body. In keeping with the most basic definition of fetish, they function as substitutes for something else—something that is simultaneously present and absent, admitted and denied—while serving as icons of displaced anxiety, deferred desire and symbols of control. The idealized image of the female body, at once a representation and "real" in the mind of the viewer, exists as a screen for his projected fantasies; as a circulating material representation, it serves as a surrogate for the owner, his power, wealth and fantasies. In an era of unpredictability, Sommariva's hybrid form of fetishism represents an effort to shape and control the instabilities of class, social status, wealth and gender that so troubled the consciousness of an entire nation. Fear of the unknown is combated by substituting the fantastic for the threatening truth, and Sommariva's collection tapped into larger anxieties experienced by the French public and recognized by some of its more prescient critics. In 1814, the *Journal des arts* observed that painters and their production were the new objects of worship, but "None received universal praise like the famous sculptor Canova, whose *Muse* and *Terpsychore* could have prolonged the sway of Idolatry among the ancients."[9] The figure of Pygmalion, so closely associated with Canova's art and with his spectators' responses to it, became a central metaphor for this idealized, eroticized approach to art and the fantasy of its animation. Both its adherents and its critics saw in the privileging of representation over reality the dangerous specters of fetishism and idolatry.[10]

Girodet's Pygmalion: Gender, Genre and the Politics of Representation

When Sommariva and Girodet finally agreed on an image of Pygmalion and Galatea, the patron envisioned a direct tribute to Canova's genius. There is nothing, however, in the painting or in any of Girodet's own writ-

ings to indicate that the artist had Canova in his own mind as his referent.[11] Indeed, for the competitive and egotistical Girodet to have spent the better part of seven years painting a tribute to *someone else's* genius seems unlikely at best, and it is far more probable that the artist let the patron believe what he wanted, while following his own personal vision.

Girodet's epic seven-year effort to produce the canvas for Sommariva reveals at once the artist's desperate desire to create a new and important masterpiece, and his personal investment in the subject. From 1813 until November 1819 Girodet painted and repainted the canvas myriad times in uncertain pursuit of perfection. As Coupin recalls, "It is impossible to imagine the number of beautiful things that he successively covered up when making this painting,"[12] while the critic Miel commented, "Girodet worked slowly, with a sort of mystery, obliterating beautiful things that did not please him."[13] The painter himself admitted the difficulties he was having in a number of letters, often referring to the fact that he had started it over several times and could not seem to finish it.[14] Nor did his anxiety decrease as the canvas neared completion. In a letter written shortly before he exhibited the painting in 1819, he complained: "I am still extremely busy with a painting that has occupied me for a long time, and I have begun it over and over again without success, never knowing whether I will be happier with the next effort."[15] The mystery alluded to in Miel's comments above was Girodet's typical modus operandi. From his earliest work on the *Endymion* the painter had always endeavored to keep his subjects and their progress a secret until he could unveil them in a state of near perfection, a compulsion noted by his peers and public with varying degrees of awe and amusement.

David frequently used Girodet as an example to other students of how *not* to live their lives. As Delécluze recalls, the master painter warned "Look at Girodet, he has been working like a galley slave for five years in the depths of his studio, without anyone seeing a thing. He is like a woman who is in labor forever, without ever giving birth."[16] Girodet's fellow painters perceived his withdrawal and devotion to his canvases, to the exclusion of all else, to be both antisocial and nonproductive, for as David's metaphor indicates, these painful and protracted labors rarely bore fruit, while the artist appeared to be more caught up in the process than the product. The maternal metaphor, equating childbirth with the production of the work of art, gained increasing currency in the nineteenth century, as Romantic creation was linked to suffering, pain and tears in an organic process of conception, gestation, labor and delivery.[17] Yet for David and Girodet, both of whom relied heavily on this trope to talk about the lat-

ter's work, the maternal metaphor has different valences. For Girodet, who tied genius to virility, the image of the work of art as the artist's offspring reflects at once the godlike status of artist as creator who can bring forth life itself, and a sublimation of the male sexual drive into an elevated form of chaste [pro]creativity. For David, the metaphor takes on negative implications in relation to Girodet's work, pointing not to the artist's genius, but to his impotence and "feminine" overprotectiveness of his works. As in the earlier reference ("Il est comme les lions, celui-là, il se cache pour faire des petits"), the image evokes the physical nature of creation, emphasizing the agonies—the "degrading" animal nature—of labor, and not its sublime and spiritual result. Further, lurking within David's frequent use of this image in reference to Girodet is the specter of fetishization and the unspoken belief that the painter had begun to believe his own fictions, investing his creations with an imaginary, potentially dangerous, life of their own.

In light of Girodet's reticence about his works in progress, a painting by his student, François-Louis Dejuinne (1786-1844), of Girodet at work on *Pygmalion et Galatée* stands as testimony to the exceptional nature of this canvas. Commissioned by Sommariva, the original is now lost and all that remains are an enamel copy (also commissioned by Sommariva)[18] [figure 3.1] and a preliminary drawing of the subject by Dejuinne. The portrait of artist and patron reveals Sommariva's active role in the painting's production and his remarkably intimate relationship with the thorny Girodet.[19] The scene is set at night, and while the atelier is shrouded in darkness, Girodet and his work are illuminated by the moon and by a large lamp that dissects both Dejuinne's canvas and Girodet's. While the atmosphere evokes the mystery and magical transformation thematized in *Pygmalion* there is also an element of realism, for Girodet painted almost exclusively at night by artificial light, in an effort to reproduce the luminous moonlit effects of the *Endymion* in his subsequent work. The earlier canvas hangs in the shadows above Girodet's head, a physical manifestation of its omnipresence in the artist's consciousness in this *mise-en-abîme* of artistic creation. Yet the moon, the conspicuously *absent* source of light in *Endymion,* is also the symbolic representation of Diana, who is thus made metaphorically present in this image of passion and animation.

Indeed, until the very end of his career, Girodet conceived and executed many of his most important compositions in dialogue with his 1791 canvas. *Endymion* and *Pygmalion* stand in inverse relation: where one is an allegory of death, the other is an allegory of life; where in the former the supine male form is the source of female desire, in the latter the erect female form is the source of male desire. Endymion is transformed from

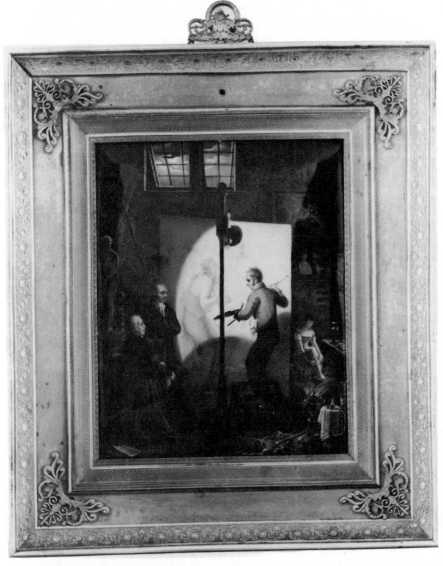

Figure 3.1. Adéle Chavassieu, enamel copy after François Dejuinne's *Portrait de Girodet peignant Pygmalion devant M. de Sommariva*. 1822. 19 x 15.5 cm. Galleria d'Arte Moderna, Milan. Dépôt de la Pinacoteca di Brera. By permission of the Minister of Cultural Affairs, Milan.

mortal to immortal, Galatea is transformed from immortal [art] to mortal, each by the forces of a divinity, represented by an impish cupid. The naked and sensuous forms of both Endymion and Galatea are the unconscious objects of desiring gazes that they cannot reciprocate, and each embodies an ideal. Each painting is moreover an allegory of art, one falling at the beginning of Girodet's career, the other at the very end, and each employs the female form, or its absence, as a crucial means of enunciating an aesthetic tied both to art and to cultural politics. In Dejuinne's canvas, the presence of the pair of models—the statue and the woman—on either side of Girodet's painting in progress reflects the artist's dual sources of inspiration: the ideal and the real. Tellingly, Girodet turns his back on the real model, engaged in the pedestrian activity of putting on her stockings and illuminated by an ordinary table lamp, as he looks to the shadowy, moonlit perfection of the naked Venus de Medici. In a painting of multiple triangulations, only the three men establish eye contact with one another, while the female glance is modestly downturned (Galatea and the model) or vacant and unreciprocated (Venus).

The painting's structure as a *mise-en-abîme* posits a series of contrasts between the fictitious artist and the real one, playfully exposing Girodet's own myth-making project. While *Pygmalion et Galatée* eschews the *décor* of atelier for an idealized temple, Dejuinne's portrait presents a realistic picture of Girodet's own cluttered studio. Where Girodet's Pygmalion contemplates his creation without any sign of his physical labors, Dejuinne's Girodet is shown at work, wielding the tools of his trade. Although both Pygmalion and Girodet derive their inspiration from Venus in this pair of paintings, the sculptor's source is the divine goddess herself, while the painter's source is a concrete representation of the goddess, as his art derives not from an original, but from a copy. Pygmalion and Galatea are spotlighted in Dejuinne's picture-within-a-picture, but the cupid, who unites the two lovers, is strategically obscured by the pole of the custom-made lamp and Girodet replaces the cherub as the intermediary between the sculptor and his statue. Yet as he turns toward the statue of Venus with raised paintbrush, Girodet gazes directly at Sommariva, who literally and figuratively stands as the intermediary between the artist and his inspiration. Behind Girodet, a small brazier sends off smoke, mirroring the burning censer at Galatea's feet in the painting, while the violin lying on the floor in the foreground echoes Pygmalion's lyre as a sign for the visual artists' lyric inspiration. Even the complementary profiles of Pygmalion and Girodet, with their dark curls, bent legs and raised hands on either side

of Galatea, their mutual creation, mark Dejuinne's conflation of the two painted artists.

Dejuinne's dialogue with his master's work in progress highlights the sexually charged nature of Girodet's identification with his painting. For if Girodet's *Pygmalion* emblematizes the elevated aesthetic of chaste contemplation, Dejeuinne shows an undisguised eroticism on the part of the painter who creates the animated statue. His head juxtaposed with her breast, his left arm, palette and brushes obscuring her groin, Girodet advances upon Galatea as if he is about to embrace her, while the legs of the hidden Amor thrust phallically toward Galatea's slightly splayed legs, an extension of the artist's hidden desires. Indeed the image is punctuated by phallic imagery in the lamppost, helmets, brushes, maulstick and even palette, while the folds of the cloth spilling forth from his pocket evoke both male and female anatomy. The painter's flushed cheek and disheveled hair indicate not only the frenzy of creation, but also a state of sexual excitement, yet tellingly, he averts his gaze, unable to look at the object of his desire, much like the modest Galatea herself.

From its inception in late 1812 to its tortured completion in 1819, Girodet saw the *Pygmalion et Galatée* [figure 3.2] as a final chance to enunciate a new aesthetic and achieve the acclaim that had eluded him, while finally forging a place for himself as France's premier painter. Begun under Napoleon's Empire, the *Pygmalion* was completed during the Bourbon Restoration, and the shifting regimes brought with them swings in aesthetics that shaped the reception of Girodet's allegorical painting. By 1816, the competing schools of Davidian Neoclassicism, Prud'hon's anti-Davidian Classicism—stylized, allegorical, and sensuous, Gros's proto-Romantic Classicism, with its passion, movement and color, and the full fledged Romanticism of Géricault were all struggling for dominance. Romanticism evolved in an oppositional mode against the institutional Classicism of the *Académie*, and the battles over artistic hegemony in Restoration France, fought in the ateliers, Salons and art critical reviews, were above all ideological. Indeed despite the passionate debates between Neoclassicism and Romanticism that dominated artistic discourse of the time, paintings of both schools often shared stylistic and thematic overlap, and the true source of conflict frequently lay in political affiliation.

With David's exile in 1816, his former pupil hoped to ascend to the fore of Neoclassical painting, while establishing a better rapport with the new government. Hence, in *Pygmalion* Girodet presents a public manifesto of his own genius and renewed Classicism for the new monarchy.[20] On the

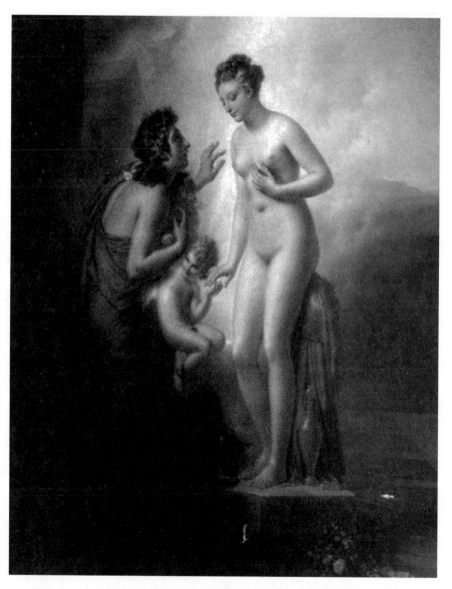

Figure 3.2. Anne-Louis Girodet-Trioson, *Pygmalion et Galatée*. 1819. Oil on canvas, 253 x 202 cm. Private Collection.

most basic level, the retrograde image glorifies the cult of the past and the *beau idéal*, in contradistinction to the "realist" tendencies of the Romantics. Appearing at the Salon of 1819 alongside Géricault's energetic *Raft of the Medusa*, Girodet's *Pygmalion et Galatée* has suffered in the comparisons of twentieth-century critics, who have interpreted the mythological canvas as the swan song of a moribund Classicism.[21] Yet for all the latter-day accusations of sterility, Girodet's idealized vision of art, the artist and woman dominated the Salon of 1819, far surpassing Géricault's image in its critical and public acclaim. The enormous outpouring of attention—both positive and negative—lavished upon this mythological canvas and the intensity of response from its supporters and opponents, testify to the highly charged politics of gender, genre, aesthetics and vision set forth in Girodet's representation of the artist and his animated statue.

Girodet's paired figures of Pygmalion and Galatée resonate with meanings beyond the Ovidian allegory. The embodiment of artistic success, Pygmalion presented an image of Girodet as he wished to be seen. Moreover, Coupin indicates that *Pygmalion* was the painting "in which he seemed to have wanted to overcome insurmountable difficulties and surpass the limits of his art."[22] Stylistically and thematically conservative, its author nonetheless conceived *Pygmalion* as original and epoch-making in its *approach* to its subject and its direct challenge to its source. In a letter to François-Xavier Fabre, Girodet explains that the principal difficulty lay in achieving "the effect of the gradation of light and shade and of the transition, as smooth as I could possibly make it, from the animated part to that which is still marble."[23] For in choosing to *show* the precise moment when Galatea surpasses her existence as art and comes to life, in attempting to introduce movement, animation and change to the static surface of the canvas, Girodet endeavors to transcend the very limitations of his medium. The painter self-consciously selects a scene that only the poet could technically recount, and in this sense, Girodet's *Pygmalion* challenges the representational power of poetry itself.

The source of Girodet's painted *Pygmalion* can be traced not only to Ovid and, as Rubin suggests, to Rousseau's *Pygmalion, scène lyrique*, but finally to his own poetic version of the myth as recounted in canto 5 of *Le Peintre*. As discussed in chapter 2, *Le Peintre* demonstrates painting's power to rival poetry and to dominate an audience through its seductive imitation of reality. From Dibutades to Apelles to Pygmalion, the artistic representation is preferred over the model because the work of art displays a permanence missing from the human lover and life. In each case, the lover willingly accepts the exchange of signifier (painting or sculpture) for sig-

nified (real person), as art, within Girodet's formulation, presents a superior reality.

While Girodet's painting and his poem follow Ovid fairly closely, his specific points of departure evince his personal interpretation of this myth of creation. The poem's Winckelmannian tribute to the glories of the Greek state's support of artists endows the nineteenth-century Pygmalion with political valences absent from Ovid, and this *engagé* orientation is echoed in the painting, which Girodet saw as a direct appeal to King Louis XVIII. The departure from Ovid that received the most critical attention was Girodet's setting of the scene in a temple, depicting the artist in the act of adoration free from any sign of his physical labors. On the most essential level, removing the artist from his atelier is consistent with Girodet's desire to insert the painter/sculptor into the realm of intellectual creation—this miracle is the result of genius, not skillful craft. But by inserting the episode within an overtly religious setting, complete with incense and offerings, Girodet conflates art, religion and the worship of beauty in an unironic evocation of his own fetishized aesthetic and Sommariva's. Complementing beauty's political import is thus its religious status, each serving to elevate society through contemplation of virtue and the divine in ways not ordinarily accessible to mere mortals. As artistic manifesto, *Pygmalion et Galatée* thus embodies the cult of beauty that Girodet had preached in lectures addressed to the *Académie* during the painting's composition, as the institution struggled to formalize resistance to the Romantics. In "De l'originalité dans les arts du dessin" (1817), Girodet presented a fragmented, often contradictory theory that nonetheless encapsulates his idiosyncratic approach to *Pygmalion*. Defining originality as the union of imagination, genius, inspiration and the imitation of nature, Girodet turns to the Greeks as the pinnacle of this inspired art, which united art and religion via the sanctity of beauty. Calling for a return to the worship of the *beau idéal*, Girodet concludes his lecture with an extended metaphor of the "feu sacré" of Classical art, tended by the artist-*cum*-priest whose duty is to reproduce "religiously . . . this ineffable beauty, the dazzling image of divinity on earth, its unshakable empire now seated forever on the debris of the shameful fallen idols who had usurped the temple and profaned its altars."[24]

Girodet concretizes the academic cult of beauty in Pygmalion's worship of Galatea, the incarnation of the *beau idéal* and the product of creative genius. Indeed if Girodet personifies beauty as a female ideal ("cette beauté vierge") in his *dissertations* and paintings, it is a highly sexualized metaphor, as is his formulation of creative genius. Girodet asserts "genius thus resem-

bles a vigorous tree whose superabundant sap plays over a profusion of veg-etation."[25] In the same vein, the production of the work of art is consis-tently described in terms of childbirth (*enfantement*) or on the occasion of failure, abortions (*de productions avortées*).[26] Galatea, a living symbol of male fertility and creativity, embodies the metaphoric offspring of the phallic genius in an image of the artist's virility that is doubly felt in his creative, [re]productive powers and his amorous passion for the statue.

Girodet's artist as phallic, fertile lover stands in deliberate contradistinc-tion to the feminized, impotent image of the contemporary Romantic hero. If the Romantic geniuses of Chateaubriand, Constant, Senancour and de Staël were melancholy, alienated and ultimately failures in life and in love, the well-read Girodet proposes an anti-Romantic formulation of virile manhood—the artist as hero, *succeeding* in life and in love. While the painter's insistence on metaphors of potency may reflect his personal expe-rience of marginalization under Napoleon's Empire, it also corresponds to the general ethos of masculine anxiety that characterizes the postrevolu-tionary period and stems from the same source as the Romantic metaphor of a male *mal du siècle*.[27] The ongoing crisis of paternal authority from the Consulate through the Restoration led to a prevalent feeling of disem-powerment among men of every class and a concomitant misogyny, grow-ing in part from the militaristic ideal of the Napoleonic regime. For the novelist in particular, writing for an increasingly female audience[28] and competing directly with popular women authors such as Mme de Staël, Sophie Gay and later Sand, these formulations of the Romantic male genius as alienated, impotent and in important ways, feminized, manifested a definitive gender crisis. Despite the 1804 institution of the repressive Napoleonic Code, the specter of potent women on the barricades, over-throwing the hierarchies of church, king and family, continued to haunt conservatives and liberals, Romantics and Neoclassicists alike in the early nineteenth century.

If René, Adolphe, Obermann, Oswald, et alia, fail to find happiness with real women, Pygmalion triumphs with an ideal one, and the shortcomings of a disappointing reality are remedied by the compensatory pleasures of imagination and creation. As Margaret Waller illustrates in *The Male Mal-ady*, the very fiction of impotence is yet another means of asserting and retaining dominance over women by coopting the "feminine" positions of passivity and victimization.[29] Girodet's anti-Romantic fiction of virility as manifested in *Pygmalion* is no less an assertion of power and mastery, sim-ply presented in a different aesthetic guise. Countering the Romantic hero's "failure to be a man," Girodet's Pygmalion is resolutely so, and while

the Romantics adopt the negatively valenced qualities of femininity, Pygmalion, as giver of life, takes on the most positive one. Girodet's artistic hero meets with spectacular success, due to his creative genius: the painter/sculptor is both sexually and generically superior to his literary counterpart. A variation on the Davidian or Napoleonic hero as virile and manly warrior, Girodet's masculine ideal exchanges the sword for the equally phallic paintbrush or chisel, trading destruction for creation. In a reprisal of his earliest enunciation of male ideality, he posits the hero as artist who manifests virility in his beauty, spirituality and creative powers.

Girodet's revisionist formulation foregrounds the question of gender and the constitution of ideal femininity in the light of male creative genius and potency, and thus the nature of Girodet's Pygmalion and Galatea (and by extension artist and art) can only be understood in terms of their mutual relations. The paradigm of creation and dependence configured by Pygmalion and Galatea, as artist and artwork, inverts the natural relations of biology and maternity. Pygmalion shows man as woman's creator: where he is the knowing and desiring subject, she is the innocent and chaste object. Girodet's ideal woman, in the person of Galatea, is on a pedestal, her perfect naked form the focus of the worshipful gaze of her creator. As a work of art, she is the product of Pygmalion's shaping hands and imagination and her sexual desirability is based solely on her physical attractions. As his creation, she has neither independent existence nor experience and her virtue, highlighted in Girodet's painting, his poem and nearly every critical review, is signaled by her downturned eyes. The object of the admiring gazes of Pygmalion and the painting's spectators, Galatea cannot return the gaze, and if *voir* = *savoir* = *pouvoir*, she is dissociated from knowledge and power, while the steady glance of the sculptor gives him direct access to both. Galatea's ideality is thus located in her beauty, her modesty, her innocence and her absolute dependence on her master. Her nude form represents the Classical perfection of the Medici Venus, but complementing that beauty is an immobility that typifies nineteenth-century heroines. As Naomi Schor contends, "the post-Revolutionary female protagonist is consistently deprived of the minimal attribute of subjecthood, which is not, or not merely, the faculty of speech, the capacity to produce signs, but rather the power of locomotion."[30] Galatea, as a gradually animating statue, is deprived of thought, speech, and movement; while her torso is pulsing with life, her feet remain of stone. Object of worship and desire, the ideal woman-qua-statue, is also an object of control, a male fantasy lacking independence, mobility and the threatening Otherness that portends emasculation.

Within the Pygmalion paradigm, from Ovid onward, Galatea's attractions stem both from her beautiful form, and from her contrast with real women, who are consistently equated with prostitutes. Female sexuality and desire thus serve as a central subtext to the myth and its retellings, in a sense that is independent from the presentation of male desire in the person of Pygmalion. For Galatea awakens a tabula rasa, "Without desire in her heart, only the instinct of modesty,"[31] and Girodet chooses the chaste moment of her initial animation as the subject of his painting, where she remains an object of a passionate gaze that she does not yet reciprocate. The female ideal is at once erotically enticing and unattainable, a simultaneous invitation and refusal of desire that perpetuates the containment of female sexuality through an ideology of innocence. Her fetishized virginity circumscribes female sexuality in "a spectacular binding or rebinding of female energy, a containment that only makes sense as a response to an equally spectacular explosion of female energy: the active participation of women in the revolution."[32] Girodet's Galatea, an idealized allegory of the feminine, defuses the threat of female potency by "voiding the feminine form of female corporeality and desire. [. . .] The allegorization of woman, a sort of degree zero of female representation, can only be brought about through a violent act of suppression of all particularities, not to mention of life."[33] In other words, the allegory of ideal femininity, based on a woman whose form is eroticized for a viewer but not for herself, is contingent upon denying her the position of independent subjecthood, either through death or not yet attained life. Female sexuality, equated with subjecthood and the threatening energies of revolution, is actively denied in an effort to consolidate the power of the dominant but ever anxious male culture.

The movement from the politics of androgyny in *Endymion* to the politics of virility in *Pygmalion* reflects the shift from an aesthetic of optimistic indeterminacy to one of urgent resistance. Girodet's initial effort to control and silence the female element by suppressing its very existence was mirrored in the institutionalized marginalization of women under Revolution and Empire. Yet by 1819 it was evident to Girodet and his fellow Frenchmen that the threatening presence of female energies, so closely linked to chaos and destruction, could not be contained simply by banishing them, officially and icongraphically, from the public sphere. With the rise of female intellectuals, authors, painters and the first stirrings of nineteenth-century feminism under the draconian Napoleonic Code, women remained resolutely present in the collective social consciousness. The image of the Galatea, a return of the repressed, reflects Girodet's acknowl-

edgment that he must incorporate and in turn subordinate the female in a more direct manner for his political and aesthetic manifesto of art to have its desired effect as beacon of the ideal future of art and society. The response of contemporary critics to the idealized and eroticized form of the Galatea, and the universal approbation of her modestly downturned gaze, stand as testimony to the accuracy of his assessment.

Pygmalion and the Critics: The Politics and Aesthetics of Reception

Representation of the female form in Girodet's work consistently reflects historical circumstance and ideologies through its strategies of containment and resistance. In 1791, the absence of the female in *Endymion* posited a Republican sphere free from the dangerous influence of female power and desire. Less than a decade later, the Neoclassical harlot of the *Nouvelle Danaé* embodied the corrupt state of social and political reality under the Directoire, while by 1819 the idealized body of Galatea stands as a political allegory for the birth of a new ideal order under the Restoration regime. The fantasy of a return to the clearly defined hierarchies of a patriarchal order is played out in this overdetermined allegory of female subordination that conflates Neoclassical aesthetics with conservative political doctrine in the image of the idealized Galatea.

Girodet's transformation from radical republican to conservative monarchist resulted from a growing disenchantment with the failed promises of the varying regimes and a nostalgia for an idealized past. For Girodet, the newly installed monarchy led by the moderate Louis XVIII represented a new venue for the artist to shop his material and theoretical wares. The Neoclassical style, once associated with liberal republican values and foment, had by 1812 taken on the fusty aura of conservative, Academic formula. But Girodet's painterly vocabulary in *Pygmalion et Galatée*, with its references to Greek and Roman statuary, ideal man- and womanhood, and mythological allegory, took on new valences following Napoleon's exile in 1814 and David's soon thereafter. During the period of *Pygmalion's* composition, Girodet began to gain a foothold in the official ranks of the new regime. In 1815 he was appointed member of the *Institut* and received the decoration of Saint Michel, and three years later the state purchased *Endymion*, the *Déluge* and *Atala* for 60,000 francs. Yet, to his frustration, Gros and Gérard received even greater honors and attention from the King. Thus, Gérard's tribute to the restored monarch, *The Entry of Henri IV into Paris*, displayed at the Salon of 1817, led not only to his promotion to the first painter to the King, but to a crushing humiliation for Girodet. Gérard's

savvy canvas, evoking parallels between Golden Age and the coming age of restored monarchy, so pleased the king that he jestingly goaded Girodet on his long-awaited *Pygmalion*. In a heavy-handed reference to the rivalry between Gérard and Girodet, Louis XVIII turned to the latter at the Salon and proclaimed, "History tells that Miltiade's trophies kept Themistocles awake at night: we have had a *Marathon*, now we expect a *Salamine*. M. Gérard is not here; I would have liked to have had the pleasure of telling him before Henri IV that I have named him first painter."[34]

Following such a public challenge, Girodet had little choice but to complete his canvas and display it at the next Salon, though he waited until the closing days to build on the anticipation of this long-awaited painting. Girodet took steps to create a positive buzz about the canvas before it was publicly shown and to establish anew his reputation as an artist of genius. As Delécluze recounts it, the notoriously secretive painter of *La Galatée* (as the painting was increasingly called) invited a select audience to his atelier (*le sanctuaire*). There, he performed an elaborate pantomime of putting the finishing touches on his canvas, seducing the gullible "belles dames de Paris" into proclaiming "that they had seen Girodet paint and that it was not surprising that the works of this painter were so perfect, since he corrected them *up until the last second*."[35] The cynical critic concluded that this *petite comédie* was the result of Girodet's own recognition of the weakness of the painting, and he was not alone in suspecting that Girodet's delays and private showings were a ruse on the part of the self-promoting painter. Countering the accusations of charlatanism, Girodet gives his most detailed account of the delays in the completion of his *Pygmalion* in an unpublished letter of response to his critics. Here he insists that he was plagued by illness and constant interruptions (including the death of Trioson in 1815). In the voice of a neutral third party maintains "If his painting was not finished at the beginning of the exposition, it was because it simply was not possible for him, despite his best efforts, to have finished it."[36] Whether motivated by the weaknesses of his work or his desperate desire to succeed, Girodet's public performance of putting the "finishing touches" on a canvas he had reworked for seven years, demonstrates how far he would go to assure that this allegory of art and genius was identified with his own artistic prowess. His willingness to "paint" for an audience reveals Girodet's acknowledgment of the power of public opinion and his dependence on word of mouth both to shape and to offset the printed word, so disparagingly dismissed in *Critique des critiques*.

Girodet's long-awaited *Pygmalion* did indeed generate an enormous outpouring of attention in the press and at the Salon, much of it politically

motivated. Géricault, whose liberal and Romantic *Raft of the Medusa* was to receive similarly biased evaluation in the press of 1819, observed to a friend, "This year, our newspaper scribblers have reached the height of ridiculousness. They judge every picture by the political spirit by which it was composed. A Liberal review will praise a certain work for its truly patriotic execution, its national touch. The same work, judged by an Ultra-Conservative, will be merely a revolutionary composition dominated by a general tint of sedition."[37] Thus the conservative press (*Le Journal des débats*, *Le Moniteur universel*) applauded *Pygmalion et Galatée*, while the liberal press and the Romantic critics voiced harsh condemnations of the canvas. In sum, four independent pamphlets were published on the *Pygmalion* alone, four poems appeared in the daily press singing the praises of the painting, and at least ten different mainstream publications devoted articles (sometimes several) to Girodet's painting in the final months of 1819. When several journals reported that enthusiastic admirers had hung a wreath and laudatory verses on the frame, the more critical press claimed that Girodet himself had orchestrated these tributes. He was moreover accused in another newspaper of authoring of one of the more dithyrambic pamphlets, prompting the painter to write a stinging letter of rebuttal. All in all, *l'esprit de parti* dominated the reception of the *Pygmalion*.

The king's private viewing of *Pygmalion* two days before the painting was displayed at the Salon set the initial tone for its politicized reception.[38] The "transcriptions" of the king's remarks clearly constituted an effort to establish the success of the painting before it was seen, while linking Girodet, *Pygmalion et Galatée* and the monarchy in a single image of restored glory. Where Girodet sought personal advancement, many saw the hand of the *Institut* behind the positive reception of the painting, which became an emblem of the values of Neoclassicism, academicism and monarchism.[39] Ironically, Girodet's belabored image, in which he hoped to strike a highly personal note, became a critical battleground for the political and aesthetic struggles of contemporary France. Indeed, the painter and his image were subordinated to contending ideologies and his allegory of genius and rebirth was rarely read in terms of Girodet's own talent.

The accounts of the king's visit as reported in the press presented unabashed hype for the conservative image, but also clear indications of what Girodet's painting may have meant to a contemporary viewer and how he had hoped it would be perceived.[40] For the king, as for Girodet, the well-publicized encounter served as a vehicle for self-promotion, as each used the press to circulate a consciously crafted image. Thus on 4 November, Girodet brought his canvas to the apartments of the king, who

after studying it for several minutes, cried out "dans une espèce d'enthou-siasme:'Ah! c'est superbe!,'" a far cry from David's measured response to *Ossian*. The ensuing exchange attests to the almost universal tendency to fuse Girodet and his creation, while revealing the sexual and political cur-rents underlying the image. As recorded in all three versions, the king asks the painter, "M. Girodet, n'étiez-vous pas vous-même, en présence de votre Galatée, dans la situation de Pygmalion?" (were you not yourself, in the presence of your Galatea, in Pygmalion's situation?), whereupon the painter replies, "Sire, je crois ne l'avoir jamais regardée qu'avec les yeux d'un père; mais ce dont je suis assuré, et ce que je sens bien vivement, c'est que, dans ce moment, je suis beaucoup plus heureux que Pygmalion lui-même" (Sir, I believe that I have only looked upon her with the eyes of a father; but I am sure, and I feel this very strongly, that at this moment I am much happier than Pygmalion himself). In this peculiar interchange, Girodet appears not to understand the king's question, for it seems likely that Louis XVIII is commenting on Galatea's miraculous animation. But Girodet's response focuses defensively on the sexual component of Pyg-malion's relationship with his creation, his denial of course bringing that fetishistic love to the fore. By claiming that he only looked on her with the eyes of a father, Girodet emphasizes the centrality of sight in the erotics of *Pygmalion*, while again returning to the metaphor of paternity, creation and ultimately incest, for the maker's love of his own creation (however hotly denied), like a father's passion for a daughter, carries the strong taboo of forbidden desire.

The king's subsequent comments, echoed in nearly every positive account, highlight just what Girodet hoped the painting would illustrate. Louis remarks the unmistakable "génie de l'artiste" as manifested in his exe-cution of the figure of Galatea and his miraculous transition from "la nature morte" to "la nature animée," exclaiming, "En vérité, je crois qu'elle va descendre à l'instant même de son piédestal!" (In truth, I think she is going to get down this very minute from her pedestal!). Girodet's sublime passage from stone to flesh in the body of Galatea has enabled his audience to enter into the Pygmalionesque illusion that the beautiful statue is indeed alive and will begin moving momentarily, and this fantasy will dominate nearly every contemporary review of the painting. The king goes on to praise the painter "d'avoir représenté Galatée les yeux baissés" (for having represented Galatea with her eyes lowered), and this theme will also reso-nate throughout the critical response to the image. The scripted exchange allows Louis XVIII to appear at once sensitive and enlightened, while tout-ing the lifelike qualities of Girodet's remarkable canvas, and despite the

propagandistic nature of its genesis, this dialogue foregrounds the major issues surrounding both the positive and negative response to the painting.

The king concludes his remarks with a reference to Ovid, invoking an ongoing comparison between poetry and painting in subsequent reviews. In keeping with this visual-verbal dynamic, at the end of the royal audience Girodet presents the king with his own poetic rendition of Ovid's Pygmalion, in all likelihood a version of his own lines from *Le Peintre* that so closely resemble the painting. The interview ends with Louis's declaration that he will return to see the painting again, and then, as he withdraws the monarch adds, "Bravo, M. Girodet, *ut pictura poesis erit*." The poetic nature of Girodet's canvas was one of the central points of contention in the polarized discussion of this painting, and one that crossed political lines to reveal the universal tensions between authors and artists. Like *Endymion*, *Pygmalion et Galatée* was dubbed "poétique" by its admirers. *Le Moniteur universel* maintained "the poetic genius that directed this composition has been generally recognized."[41] Emeric-David lauded "the intelligence of this poetic composition" with its "coloring as poetic as the composition,"[42] while P. A. opined "All is poetry, all is magic in this painting."[43] In the same vein, several articles and pamphlets included poems in tribute to Girodet's genius. One of the first to appear was appended to the frame of the *Pygmalion* shortly before another admirer placed a laurel wreath upon the chefd'oeuvre. As reported in the *Journal des débats*, the poem read as follows: "Peintre charmant d'Endymion/ Viens jouir des transports de la foule enchantée;/ Tout Paris, pour la Galatée/ A les yeux de Pygmalion" (Charming painter of Endymion/ Come and enjoy the ecstasy of the enchanted crowd;/ All of Paris, looks upon Galatea/ With the eyes of Pygmalion).[44] The coarse verse encapsulates the painting's mass appeal, while coining a metaphor that would be exploited again and again: that of the painting's spectators being transformed into Pygmalions. Positive reviewers exploited this seductive image of Galatea's animation, as the public of the Salon of 1819 embraced the fantasy of the ideal becoming real. They claimed that the painting exerts a magic over its audience that mirrors Galatea's magical transformation, while the premise that the spectators regard the female nude with Pygmalion's own eyes highlights the erotics of the collective gaze at this fetishized idol of perfection.

Another poetic tribute was included in P. C.'s laudatory pamphlet. The unattributed verse has two sections: the first, entitled "Pygmalion et Galatée/ Au Salon de 1819" is set to the tune "du Premier baiser d'amour," while the second is called "Au Peintre immortel." The opening section highlights the eroticism inherent in Girodet's image. The poet begins by

putting words in Pygmalion's mouth, transforming the static image into a drama that points back to its literary roots in Ovid and Rousseau. Praying to Venus to animate his creation, this poetic Pygmalion admits to being "Seduced by the object that I admire."[45] Yet moving from the image of seduction and the promise of the passion that will follow the animation, the poem shifts to the theme of rivalry ("Girodet, vainqueur de l'envie") and posits Girodet's canvas as a nationalistic victory for French art. The second section of the poem, sounding remarkably close to Girodet's own verse, is devoted to the artist's apotheosis: Galatea's mortality will bring immortality to her creator, who "no longer fears any rivals." This work reveals the dialogic nature of the painting's reception, reading the image in terms of both its literary forbears and its direct painterly competition. The themes of rivalry and competition surface again and again, whether between nations, between artists, between movements or between genres, in each case in the form of a quest for superiority and dominance.[46]

The *paragone* haunts the critical response to Girodet's *Pygmalion et Galatée* and the issue of Girodet's departures from literary "authority" frequently takes center stage, as authors negotiate the power of words versus images to recount this myth of artistic genius. The myriad rivalries of Restoration France—aesthetic, political, ideological, personal—are played out in the authors' refusal to grant the painter full access to narration. Nearly every *compte rendu* begins with the author's own retelling of Ovid's myth, revealing a pronounced rivalry with the painter and his aesthetic, and a concerted effort to assert the limitations of visual representation. Where one author insists on going back to the "original" to evaluate Girodet's fidelity to his subject,[47] another exposes Girodet's lack of originality. Gault de Saint-Germain traces a succession of predecessors from Ovid, to a representation of *Pygmalion* at the *Théâtre français* in 1775, to Lagrenée's painting inspired by the play, to Delille's verses on Pygmalion in *L'Imagination*, which he claims were inspired by Lagrenée's popular scene.[48] In elaborating this chain of representations, Gault is demonstrating the derivative nature of Classical art—a common critique of the day—but he specifically highlights intergeneric jealousy, for he claims Delille wrote his verses out of envy for Lagrenée's success. The written word is the "autorité" against which this copy must be judged, and the shortcomings of the painting are attributed to the limitations of Girodet's genre. In beginning their reviews of Girodet's *Pygmalion* with their own written versions of Pygmalion, these authors assert the ascendancy of the verbal over the visual, emphasizing the "fact" that while the author has a multitude of moments to recount, the painter has but one. Girodet's most notable failing, in these *laocoönian* for-

mulations, is his effort to portray a complex of emotions in his hero and transformation in his heroine in a single image.

Thus, Girodet's models—Ovid, Rousseau, and of course his own *Le Peintre*—were able to portray Galatea's animation as a gradual process, for the very nature of language lends itself to the theme of movement and change in ways that the static surface of a painting cannot. Indeed, where Girodet could devote 27 lines of verse to Galatea's awakening, and his poetic Pygmalion's reaction runs the full gamut of emotion, from confusion to admiration to delight, in the painting he attempts to render all of these moments in a single image, and according to many of his critics, fails miserably. Nearly every author focuses precisely on the question of *time* and comparing Girodet to Ovid, Rousseau or themselves, they insist that the painter cannot render what the poet can. Coupin, for example, observed, "In essence, the painter must unite, in the same frame, that which, in Ovid, makes a series of tableaux, he must show, in an instant, the succession of circumstances that the compose the poet's story."[49] Thus, although the painter may imitate the *appearance* of reality, it is the poet who comes closer to the *experience* of reality. The critic Kératry subtly highlights the painter's shortcomings by telling us what isn't there: "If painting could portray two instants at a time, rest assured we would see his hand tremble; in the same way, since his lips are parted we would also see his heaving chest lift the robe that covers it."[50] Landon insists that Girodet commited a crucial error in trying to portray Pygmalion's many conflicting emotions in a single image: "Less fortunate than the poet, the painter can only represent a single action, a fixed moment, and can only present in the physiognomy of one person, one sensation, one passion at a time."[51] The ambitious effort to transcend the limitations of his genre and create a "poetic painting" has weakened Girodet's work, from the point of view of the critics, who take the opportunity to enforce the boundaries between the different forms of representation. Girodet's effort to ascribe a complex of emotions to Pygmalion in a single image was construed as subversive by authors of every stripe. Although the conservative Landon would conclude that *Pygmalion et Galatée* occupied "the first rank among the modern productions of our best artists," his condemnation of Girodet's interdisciplinary ambition is as harsh as that of the most liberal Romantic critic: "He has tried to surpass the limits of his art, and at least we can be grateful for his efforts; but we must admit that he has set himself a goal that painting could never attain, and needlessly created for himself insurmountable difficulties."[52]

Emeric-David's lengthy article devoted to *Pygmalion et Galatée* in the *Moniteur universel* (15 November 1819) presents the most eloquent enunci-

ation of the simmering *paragone* surrounding this image. He too begins
with reference to the subject's literary history, citing Ovid, Saint-Lambert,
Rousseau and Buffon, while like most of his fellow critics, ignoring the
myriad painted representations of Pygmalion that graced the Salons of the
previous century. Emeric-David locates the image squarely in terms of a
dialogue with these authors and their Pygmalions, who, he claims, would
most certainly be present in the minds of most viewers. The critic
acknowledges Girodet's self-conscious challenge to poetry's hegemony and
cedes triumph to the painting. He declares "it is clear that the masters of
the art of writing who recounted the passion of Pygmalion and the beauty
of Galatea, have a rival in the art of painting."[53] Emeric-David has zeroed
in on the very heart of Girodet's intentions in identifying his desire to
outdo poetry in his portrait of Pygmalion.

The article continues in a literary vein, basing the analysis on the favor-
able comparison between Girodet's image and earlier tales, but Emeric-
David is unique in crediting him not only for his fidelity, but also for his
departures, for "following the laws of painting, often quite different from
those of the epic or drama . . . he invented while imitating."[54] Emeric-
David deconstructs the authority of the myth, insisting that Ovid's version
was inaccurate; far from a sanctified "truth" to be faithfully reproduced, the
story can only be read symbolically, as an allegory.[55] Rather than condemn-
ing Girodet's audacity, this singular critic makes a specific point of dissociat-
ing the real from the ideal. If the others critics condemned painting to the
realm of the literal and purely mimetic, Emeric-David admits the sister art
to poetry's domain of symbol and allegory, thus allowing a meaning that
lies beyond the mere facts of physical representation. Many of Girodet's
reviewers recognized these allegorical ambitions, but the invasive nature of
his foray into metaphoric significance caused most to condemn them out
of hand, equating painterly allegory with overreaching and overt failure.

Whether praised or ridiculed, *Pygmalion et Galatée* is consistently read
dialogically, its virtues and merits formulated in comparative terms with
poetry. The privileging of generic over aesthetic values and the anxiety
over the transgressive nature of Girodet's ambitious painting reflect
endemic political and sexual anxieties in postrevolutionary France. Ques-
tions of authority and conformity haunt nearly every page devoted to this
programmatic canvas, while Girodet's traversal of boundaries resonates
with a charge that far outstrips his ultimately innocuous image. As W. J. T.
Mitchell has observed, "The adulteration of the arts, of the genres, is an
incitement to the adulteration of every other domestic, political, and nat-
ural distinction,"[56] and thus it becomes evident that Girodet's efforts to

engender a hybrid form of poetic painting represented the hint of more extensive breakdowns. The laws of genre, as formulated by Lessing and his inheritors, are closely related to the "laws" of gender: "The decorum of the arts at bottom has to do with proper sex roles."[57] The breakdown of genre along the lines of gender positions poetry in the realm of the masculine attributes of intellect and expression, while painting is associated with the body, as the mute object of an evaluative gaze. Both gender and genre are to this end unstable categories that are relationally defined through ideological constructions based on polarities and exclusions. If female is to some extent "not male," painting is by the same token "not poetry," a tension illustrated in the insistently oppositional discourse of the critics of the Salon of 1819. Mitchell asserts,

> the relation of genres like poetry and painting is not a purely theoretical matter, but something like a social relationship—thus political and psychological, or (to conflate the terms) ideological. Genres are not technical definitions but acts of exclusion and appropriation which tend to reify some "significant other." The "kind" and its "nature" is inevitably grounded in a contrast with an "unkind" and its propensity for "unnatural" behavior. The relations of the arts are like those of countries, of clans, of neighbors, of members of the same family. They are thus related by sister- and brotherhood, maternity and paternity, marriage, incest and adultery; thus subject to versions of the laws, taboos, and rituals that regulated social forms of life. ("Space and Time" 112)

Indeed, Girodet's critics treat the painter's interdisciplinary aspirations—his desire to imbue ("feminine") painting with ("masculine") poetic eloquence—like the violation of a taboo. If the political aspects of this transgression are rooted in the social relations of the arts, the psychological component is located in the gendering of the genres and its reflection of the very real power relations between men and women at the turn of the nineteenth century. Thus the reviewers of *Pygmalion* refer to the painting simply as *La Galatée* and universally focus on her modesty, her nudity and her averted glance as indicators of the most successful aspects of the image. Critics laud Girodet's painted statue as an emblem of the ideal both in painting and in womanhood—that is, the passive, nonsignifying object of an evaluating masculine gaze. Finally, then, the dynamics of the desiring gaze constitutes the chief switching point between the complementary discourses of gender and genre, as the critics contend with the sexualized nude form of Galatea.

Without exception, Girodet's reviewers praise Galatea's *pudeur*, her mod-

esty and her lack of sexual awareness, and each highlights the fact that she is portrayed with downturned eyes. The ideal woman, like the ideal painting, is the beautiful and unassuming object of admiration removed from the masculine position of desiring subjectivity. Several articles locate her perfection in the fact that she is caught between the two states. One critic contends, "It is not a statue that the artist has painted, nor is it entirely a woman," while another avows "Galatea is still marble, but she is already a woman."[58] As the conflation of woman and art, Galatea's essential *lack*—her lack of essence, experience, consciousness, subjectivity, power, desire—can be read in terms of castration and displacement. It serves as a projection of the double anxiety induced by the perceived power of women and artists and of the desire to circumvent the threat they represent through the gaze that is at once "fetishistic in that it displaces fear of loss on to the aestheticized bodies of [. . .] women and voyeuristic in that it subjects those bodies to objectification and visual control."[59] Thus, while Girodet's critics praise Galatea's chastity, the descriptions of her body and her animation are highly eroticized, as the spectator/author displaces Pygmalion as her desiring viewer whose gaze consumes and controls the beautiful but impotent form.

Critics describe Galatea's nude body in terms that resonate at once with innocence and desirability—"la pureté de formes"; "sa volupté timide et décente"; "cette grâce moelleuse, souple, ondoyante" (the purity of form; her timid and chaste voluptuousness; this velvety, supple, undulating grace). The goddess is at once beautiful, seductive and modest (*belle, séduisante, pudique*) and her animation takes the form of a highly eroticized catalogue of her nude form, a *blason* that concentrates not on her face but on her body. Kératry focuses on the transition between marble and flesh in a way that allows the author and reader to linger over her naked body with verbs that mark movement in a progressive caress that the painted Pygmalion could only dream of: "The miracle of animation already runs through this beautiful body; it has made the chest palpitate; it has left its trace on the most private feminine attractions; it has descended to the legs; it is going to steal them from the stone which, bit by bit, becomes supple and takes on color."[60] In a similar fashion, Delécluze traces the eroticized glance along the animating body of the goddess in *Lycée français*,[61] while the anonymous *Notice sur la Galatée* presents the most audacious sexualized description of Galatea's body, in a passage that is redolent of seduction and projected carnality:

> Le miracle s'opère, la vie a pénétré au coeur de la statue, et se répand dans tout son beau corps. [. . .] La statue s'anime, les joues se colorent d'un incarnat léger. Le coeur a palpité, la main gauche est venue écouter ce mouve-

ment inconnu, et le sein timide cède au doigt qui l'interroge. [. . .] La com-
motion électrique s'est fait sentir. La main droite de Galatée cède, se colore
d'un feu plus vif, le genou droit ressent aussi les effets de la proximité du
Dieu, la vie y a pénétré plutôt que dans l'autre. [. . .] Ces yeux sont encore
baissés, mais ils vont s'ouvrir. Comme il sera doux, leur premier regard!
l'amour et la pudeur, le plaisir et l'innocence, vont y respirer. Déjà la bouche
sourit de ce sourire inexprimable qui convenait à cette vièrge céleste, et qui
répand une harmonie suave sur toute la composition.[62]
(The miracle occurs, life has penetrated to the heart of the statue and spreads
throughout the beautiful body. [. . .] The statue comes alive, the cheeks take
on a light rosiness. The heart has beaten, the left hand has come to hear this
unknown movement and the timid breast yields to the questioning finger.
[. . .] The electric shock has made itself felt. Galatea's right hand yields, col-
ors with a more vivid fire, the right knee also feels the effects of the prox-
imity of the God, for life has penetrated there more than in the other knee.
[. . .] These eyes are still lowered but they are going to open. How sweet
their first glance will be! Love and modesty, pleasure and innocence, will
reside there. Already the mouth is smiling that inexpressible smile that
becomes this heavenly virgin, and which spreads a soft harmony throughout
the whole composition.)

The lexicon highlights the fantasy of Galatea's impending loss of inno-
cence, which coincides with her transition from art to life. Her animation
is described in terms that also imply sexual excitement, as her heart races,
her cheeks flush and her legs give way to life, which *penetrates* her virgin
body (twice), while the repetition of *céder* (to yield) again emphasizes her
passivity. The eroticized prose asserts a male mastery over the female form
that transfers the power of the gaze outside of the frame of the picture,
from Pygmalion to the spectator-cum-author, who thus controls both the
feminine and the painterly by rendering each the object of his shaping
words and desires.

Girodet's fans and foes alike shared the Pygmalionesque fantasy of
Galatea's animation, first voiced by Louis XVIII. Even I. G., who posed the
most concerted attack on Girodet's painting, falls into the fetishizing fan-
tasy of animation. He muses, "There is nothing finer or more delicate in
outline and modeling than the neck, the chest and the shoulders; it is no
exaggeration to say that the neck is mobile and that you can see the head
move."[63] Like most other critics, I. G. tempers his praise of Galatea with
strong criticism of the painted Pygmalion who, as proxy for Girodet or the
visual artist as animating genius, is consistently attacked as a failure of
expression and execution. Thus, in a passage that typifies the response to
Girodet's sculptor, the opposition critic of *La Renommée* contends,

Il s'en faut que la figure de Pygmalion soit digne des mêmes éloges. Rien de plus froid que l'expression, de plus gêné que la pose, le dirai-je? de plus médiocre que le dessin. On ne peut regarder l'Apollon, a dit Winckelmann, sans prendre soi-même une attitude plus noble; on ne peut, sans prendre soi-même une attitude plus passionnée que celle de Pygmalion, regarder sa Galatée. J'en appelle à tous ceux qui voudront vérifier cette remarque; qu'ils se retournent, et qu'ils me disent si parmi les spectateurs il en a un seul dont la physionomie ne soit plus animé que la pantomime et la physionomie du sculpteur mourant d'amour devant le chef-d'oeuvre de son ciseau. (620) (The figure of Pygmalion should be worthy of the same praise. But nothing is colder than his expression, nothing more awkward than his pose, and shall I say it? nothing more mediocre than the drawing. Winckelmann said that you could not look at Apollo without assuming a nobler attitude yourself; you could not look at Galatea without assuming a more passionate attitude than Pygmalion. I invite all those who would like to verify this remark to return to the Salon and tell me if they see among the spectators a single physiognomy that is not more animated than the pantomime and physiognomy of the sculptor dying of love before the masterpiece of his own chisel.)

The critic transforms the spectators en masse into Pygmalions superior to Girodet's, while the painted sculptor is displaced, deemed insufficient, thus impotent, due to his own lack of expression and passion. In this reversal of created and creation, Galatea is animated and lifelike while Pygmalion is the frozen and lifeless work of art, as I. G. deflates the virile creative pretensions of the painter by reworking the composition according to his own interpretation.

In a similar manner, Gault praises Galatea and denigrates her admiring creator, who reads like an afterthought, a witness to Girodet's own creative struggles. Focusing his critique on Pygmalion's expressive shortcomings, the critic contrasts the "the protracted calm of a soul devoid of emotion" in the painted artist with "le transport de sa passion" of Rousseau's hero, whose exclamations he quotes at length.[64] If Galatea is collapsed into a feminized ideal of painting, Pygmalion is conflated with Girodet, and thus Gault's criticisms of the ancient sculptor reflect upon the painter's failures, while the questions of passion and enthusiasm point to the Romantic/Neoclassical debate. By dividing the painting into two separate discourses, one successful, one a failure, the critics are able to fetishize Galatea as both woman and simulacrum of painting itself, while expurgating her original fetishizer. Pygmalion is displaced by an adoring author who is allowed to express passion, introduce movement and assert power and control over the beautiful objectified form.

For authors of the day, Pygmalion's infatuation pointed directly to fetishism, in its nineteenth-century context of idolatry. In the *Revue ency-clopédique*, the otherwise complimentary critic comments that Galatea's beauty has inspired in her creator "an immoderate passion. Galatea has become, for him, the object of a personal religion. Since his imagination made him see in her something other than a statue, he had her transported to a magnificently decorated terrace, where he erected an altar."[65] The author's vocabulary designates Pygmalion's passion as a *culte particulier* and his placement of the scene in a temple was the source of much outraged commentary. The transition from statue to "autre chose qu'une statue"— the investment of a material object with meaning beyond its own intrinsic value—arises from the creator's imaginative projections, and if the artist is ultimately rewarded, the dangerous, idolatrous nature of the relationship between Pygmalion and Galatea is nonetheless evident. In a similar vein, Landon also focuses on the placement of Pygmalion and his statue in the temple, indicating the sculptor's own fetishistic love for his work: "It is there that Pygmalion mysteriously locked himself away with the new master-piece of his chisel, to hide it from intrusive gazes, and to give himself over, without constraint, to the illusions of a mad love."[66] Landon sees in Pyg-malion's passion illusion and madness, while his desire to shroud his creation in mystery, sheltering her from prying eyes, recalls Girodet's own manic behavior toward his works and anticipates Frenhofer's mania in *Le Chef-d'oeuvre inconnu*.

Fonvielle, a relentless opponent of Girodet's painting, attacks the premise of the myth itself:

> Quel doit être le résultat de cette passion malheureuse qui le consume pour un marbre insensible? De le rendre le plus misérable des êtres, puisque nul espoir ne peut soulager le tourment qu'il éprouve; de le dégoûter de la vie; de le rendre indifférent à tout ce qui n'est pas Galathée; de l'arracher au monde; de le consumer lentement, douloureusement, et d'imprimer sur tous ses traits un sombre désespoir qui ne pourra s'éteindre que dans la tombe.[67]
> (What must be the result of this unfortunate passion for unconscious mar-ble that consumes him? To make him the most miserable of creatures, because no hope can soothe the torment he feels. It will disgust him with life, make him indifferent to everything that is not Galatea; take him away from the world; consume him slowly, painfully and impress upon his features a somber despair that will only be extinguished in the tomb.)

Between the lines of this vehement passage Fonvielle indicts Girodet and his ambitions, for such unreasonable passion can only lead to the agony of

impossibility and futile longing, ending in madness or death. Fonvielle anticipates Balzac's interpretation of the dangers of an artist's love for his creation, while enunciating the fundamental desire of many critics to contain the desires of the visual artist, to deprive him of his fantasy of possession, and illuminate the folly of confusing the ideal (art) with the real (life).

Thus, hand in hand with the fetishistic fascination with Galatea's eroticized form goes an iconoclastic urge to destroy the false idols, or at least the idolater, and a concerted effort to keep the limits between art and life, painting and poetry, male and female, distinct and inviolable. Ultimately, the critical discourse of 1819 devoted to *Pygmalion et Galatée* negotiates the tensions between the *power of images* and the *power over images*. The former is embodied in the infatuated figure of Pygmalion who is dominated by his creation (read visual image and woman), the latter in the analytic voice of the critic who can shape or control the image/woman according to his own needs through narration. The dangerous power of mimetic representation, inherent in the visual arts but alien to language, leads to an anxiety that is closely akin to the fear of the feminine, as each portends a potential destruction through a false idol—something whose seductive power is at once inappropriate and threatening. If an idol is "simply an image which has an unwarranted, irrational power over somebody; . . . an object of worship, a repository of powers which someone has projected into it, but which in fact it does not possess," fundamental to the formulation of this concept is the idea that this image is overvalued by an *other*, and not by the narrating self. By extension, Mitchell avows:

> The rhetoric of iconoclasm is thus a rhetoric of exclusion and domination, a caricature of the other as one who is involved in irrational, obscene behavior from which (fortunately) we are exempt. The images of the idolaters are typically phallic [. . .] and thus they must be emasculated, feminized, have their tongues cut off by denying them the power of expression or eloquence. They must be declared "dumb," "mute," "empty," or "illusory."[68]

Indeed, Girodet's critics consistently portrayed Pygmalion as deluded Other and repeatedly denied him the power of expression as both surrogate for the artist himself and emblem of the idolatrous desire to transcend the limitations of representation and create life itself. The painted Galatea fares better with the critics than her fictitious creator, for her overt powerlessness, averted gaze and erotic nude vulnerability allow her viewers to assert their own specular domination without the threat of retaliation. The politics of gender intersect with the politics of genre in a critical discourse

that glorifies the passive, nonthreatening nature of Galatea as an icon of femininity and painting—a voiceless object of beauty to be looked upon and desired—while resisting and reviling the more active image of Pygmalion, as Girodet's symbol of virile, signifying artistic manhood.

Finally, the critical reception of *Pygmalion et Galatée* in the contemporary press also reflects the political and aesthetic polarities simmering between the conservative, monarchical Neoclassicists and the liberal Romantics. And just as Girodet's painting self-consciously engaged the questions of poetry, painting and ideal femininity, so too did it present a declaration of a "renewed" Neoclassical doctrine. Not surprisingly, the most enthusiastic of Girodet's critics are also opponents of Romanticism, while his opponents attack not only the painting, but also the backward-looking movement that it represents. Where the *Journal des débats* states of Girodet's masterpiece, "his is the glory of having completed the restoration of art,"[69] baldly aligning the painting and the restored monarchy, the anonymous *Notice sur la Galatée* contends that Girodet's *Galatée* is the only hope for the future of art. Although the political subtexts of these accusations of "modern" degeneration and the restoration of "traditional" taste and judgment are fairly obvious, at the heart of much of this critical palaver lies the technical debate over sketch versus finish. A cornerstone of the Romantic/ Neoclassical contention, the debate centered on the question of Classical perfection. Embraced by the *Académie*, Neoclassical *fini* virtually erased the hand of the artist and the process of creation in the quest for a polished, quasi-transparent surface. For the Romantics, the sketch, with all of its energy and imperfection, came closer to the spiritual or emotional state of the artist, while its spontaneity stood in direct contrast to the carefully studied practice of academic training. Romantic resistance to academic *fini* took the form of an aggressively energetic brushwork and the privileging of color over line, both of which draw attention to the broken and inflected surface of the canvas as the site of representation, not reality. Girodet's seven-year struggle to complete the image represents an almost ironic counterexample to the speed and spontaneity of the Romantic sketch. Thus Emeric-David intones:

> On assure que l'auteur y a travaillé longtemps, et qu'il en a repeint plusieurs fois différentes parties. Certes, à la beauté du faire, on ne le soupçonnerait pas. Ne craignons donc pas de le louer sur son courage et sur son obstination. Ces qualités sont un des attributs du génie. C'est une grande leçon que le savant auteur donne ici par son exemple aux jeunes maîtres, qui prenant la fougue pour du talent, et la précipitation pour de la facilité, multiplient

imprudemment des compositions indigestes, et corrompent eux-mêmes les
plus heureuses dispositions naturelles, par l'abus qu'ils ne craignent pas de
faire de leur savoir et de leurs moyens. (1456)
(They maintain that the author worked on it for a long time, and that he
repainted different parts several times. Indeed, given the beauty of the fac-
ture, one would never suspect it. Let us not hesitate then to praise his
courage and his obstinacy. These qualities are one of the attributes of genius.
The learned author gives an important lesson here through his example to
the young masters who, mistaking ardor for talent and speed for fluency,
imprudently churn out incoherent compositions and corrupt their most for-
tunate natural dispositions by shamelessly misusing their training and meth-
ods.)

The reliance on tried but true methods, hard work, courage and determi-
nation over facility, youth and passion, refers equally to the aesthetic debate
and the changing regimes, and in many senses the two discourses collide in
art critical journalism of the period.

Thus, I. G.'s harsh evaluation of *Pygmalion et Galatée* presents both a
Romantic attack on Neoclassical art and an assertion of the political basis
for the painting's public success. Written in the form of a comic dialogue
between Pasquin, Marferio and "l'Artiste," I. G.'s commentary on the Salon
of 1819 appeared over several months in issues of *La Renommée*, a short-
lived Romantic revue (1819-1820) founded by Benjamin Constant. In its
prospectus of 19 June 1819, the editors announced that *La Renommée* "sera
rédigée dans un esprit d'opposition" (will be drafted in a spirit of opposi-
tion). In aesthetics no less than in politics, the journal indeed took an
inflammatory, generally irreverent position, and the playful mood of these
salons only half-masked its disruptive intent. In an early entry, immediately
following the opening of the Salon, the two harlequins bemoan the decline
of French painting, much like their conservative counterparts, but here, it
is the establishment of the *Académie* that initiated the degeneration of
French art. Pasquin contends that "it is only since painters were regimented
beneath Lebrun's banner or beneath that of the artists who succeeded him
as *first painter*, that this multitude of imitators appeared, whose productions,
varying in subject but uniform in style and color, are recognized at first
glance."[70]

The central complaint of the "Lettre de l'Artiste à Pasquin et à Marfe-
rio" is Girodet's lack of originality and lack of passion, yet its point tran-
scends the failings of the painting to a larger indictment of the political
motivations behind its reception. Broadly hinting throughout that the pos-
itive press attributed to *Pygmalion* was merely propaganda, I. G. states that

the "concert of praise" was penned by "friends who were more indiscreet than intelligent,"[71] only later to attribute one of the more favorable pamphlets to Girodet himself. Citing two paragraphs from P. C.'s *Description du tableau de Pygmalion*, the critic contends "Such is the description that M. Girodet himself gives of his own painting."[72] Girodet refuted the accusation, but a note in *La Renommée* reveals the larger issues driving this attack. The note reads, "The book peddlers sell the description of the painting *Pygmalion*, which contains the most pompous elegies of M. Girodet, without any difficulty at all at the door of the museum. They sell without hindrance the *Observer at the Museum* where the praises of M. le comte de Forbin are no less sparing. However, *Harlequin at the Museum* is ruthlessly forbidden. Is it because he allowed himself a few witticisms about the works by the museum's director?"[73] Propagating the theory that the *Pygmalion* was promoted and protected by the Institut and/or the Restoration government, I. G. and fellow Romantic and liberal, antimonarchical critics read and responded to Girodet's final painting in terms of its symbolic value as a representation of the rapidly fading influence of the Neoclassical academic ideal.

Sadly, there may have been some truth to these contentions, for several of Girodet's defenders make claims for the painting primarily in contradistinction to Romanticism, in a prefiguration of his funeral oratory. Thus Landon concludes his evaluation of *Pygmalion* with this faint praise for the painter:

Au surplus, quelles que puissent être les légères imperfections que nous avons fait remarquer dans ce tableau, et même celles que nous avons dû omettre pour ne pas fatiguer nos lecteurs par des observations minutieuses, M. Girodet, en se renfermant, comme il ne cesse de le faire, dans les nobles principes de l'art; en repoussant cette manière vicieuse et négligée qui s'introduit de jour en jour dans l'école actuelle, parce qu'elle favorise l'inexpérience et la paresse de jeunes talents, trop pressés de se produire au grand jour; M. Girodet, disons-nous, acquiert un droit incontestable à l'estime et à la reconnaissance des véritables amis de la peinture.[74]

(Moreover, whatever the slight imperfections that we have noted in the painting may be, and even those which we had to omit so as not to tire our readers with minutia, M. Girodet, by confining himself, as he always has, to the elevated principles of art; by rejecting the defective and careless style that daily emerges in the contemporary school, because it favors the inexperience and laziness of the young talents who are in too much of a hurry to present themselves in public; M. Girodet, we say, acquires the incontestable right to the esteem and recognition of true friends of painting.)

Similarly, Delécluze, whose lengthy defense of the painting is one of its most vehement *louanges*, later confessed to not liking the *Pygmalion* at all, and in his biography of David proclaims it a total failure. Indeed, as Rubin has well illustrated, Delécluze's letter "au rédacteur du *Lycée français*" is primarily a defense of Neoclassicism and a well-considered attack on Romanticism, while Girodet's antique image of ideal beauty and art is ultimately the vehicle for the conservative critic's doctrine.

Finally, then, while Girodet's *Pygmalion et Galatée* has failed to obtain a place in the canon of nineteenth-century art, it nonetheless resonated with political, aesthetic and gendered significance upon its debut in 1819 in a way few other paintings have matched. Moreover, the power of its associations were such that *Pygmalion et Galatée* continued to serve as a potent symbol for a mythologized, idealist aesthetic for several decades to come. By the Salon of 1824, Girodet's *Pygmalion et Galatée* still figured strongly enough in the public's mind to invoke myriad references in the critical press, but it had been reduced to an emblem of a static and frigid Classical ideal. As Stendhal warned in his Salon, "If you do not modify the chastity of the antique, your painting will be nothing but a copy, like Girodet's *Galatea* in his painting of *Pygmalion* (in Sommariva's gallery). If you try to portray passion, the heads of your figures will be in perpetual contrast with the bodies, for the first condition of Classical sculpture is DEEP CALM, without which, for the Greeks, there was no *ideal beauty*."[75]

By 1839, upon the liquidation of Sommariva's galleries, the *Pygmalion* and the rest of the Italian expatriate's collection, were beyond passé: they were relics of a by-gone era, firmly tied to the period and politics that produced them. Thus *L'Artiste*, the Romantic journal par excellence gently mocked the impending sale of Sommariva's once admired possessions, musing that upon entering the now deserted galleries, "An indefinable odor of empire grabs you by the throat; but it is that you are, in fact, in the midst of imperial art. Mythology blinds you, ancient history haunts you. . . . Never have David, Gérard and Girodet shown themselves in such a miserable light."[76] Twenty years after its much awaited début, Girodet's final masterpiece is reduced to a "désappointement cruel," a potent symbol of the degradation of the Neoclassical troika in the age of high Romanticism: "Here is Girodet's Galatea; but someone needs to light a stove for this woman; she is trembling, she is cold, she is green. It is not blood animating marble that becomes flesh, it is flesh becoming marble."[77] Condemned to failure and death, the once-animated Galatea is a stony and frigid monument to the Classical tradition and its shortcomings, but the recurrent interest in her ambivalent form stands as tribute to the power of

this image that must be destroyed. Implicitly invoking the contemporary line versus color debate of the schools of Ingres and Delacroix, the author from *L'Artiste* contrasts the static and lifeless *Pygmalion* with a vibrant Rembrandt sketch hanging nearby: "Look below Girodet's *Pygmalion*, at this admirable little head by Rembrandt! You could not say whether it is the head of a man or a woman; but what brilliance! what life! How this beautiful brow is lit! and who would not trade this simple sketch for all the masterpieces of David?"[78] The invocation of Rembrandt resonates with Balzac's own description of Frenhofer in the pages of *L'Artiste* some eight years earlier, in *Le Chef-d'oeuvre inconnu*, a story that relates Girodet's aesthetic struggles in a way that reflects on the art of the past and present. Thus, although indisputably a product of a place and a time, Girodet's *Pygmalion et Galatée*, alternately adored and maligned, continued to play an important role in the artistic imagination well into the July Monarchy as the potent symbol of the power and dangers of the ideal and the troubling allure of confusing art and life.

On 10 December, a month after the closing of the Salon of 1824, Girodet died after a long and painful illness. Following the Salon of 1819 the painter had withdrawn to his home and his studio, focusing most of his energies on teaching and writing. Although he produced several portraits during the last five years of his life, the *Pygmalion*'s qualified success and the rapid rise of Romanticism spelled personal defeat for Girodet, who was never to achieve the glory that he longed for. In the "Eloge historique de M. Girodet," read at the *Académie Royale des Beaux-Arts* in October 1825, less than a year after the painter's death, Quatremère de Quincy adeptly summarized Girodet's career. Contending that an *éloge* can serve not only as a means of honoring the dead but also as "a sort of history lesson on the taste and spirit of each period,"[79] Quatremère makes it clear that even a mere ten months after his demise, Girodet was already considered the quintessential representation of a bygone era. Girodet's successes and failures are evaluated equally in terms of the artist's personal vicissitudes and those of his epoch, as Quatremère insists: "It would have been difficult to ignore the active influence exerted by each era on the talents that it produces; and to not reconcile certain causes with their effects, that only that relationship can explain. In confronting the artist with his century and the century with the artist, one can seize in the history of the famous painter whom we have lost, the opportunity to review the period that he illustrated."[80] Indeed Girodet's career, overshadowed today by the artists who preceded (David) and followed him (Ingres, Delacroix), stands as a revealing portrait of an age

awkwardly caught between two centuries and two movements, an age of widespread uncertainty and doubt that is reflected both in Girodet's art and its reception. And if indeed, as so many later critics have contended, one finds a faint but undeniable whiff of Romanticism in much of Girodet's work, despite his own intentions to the contrary, it only stands to further document his position as mirror of an age.

Chapter 4 ✎

ALLEGORIES OF READING: BALZAC'S *MAISON DU CHAT-QUI-PELOTE*

The Writer in Nineteenth-Century France

The revived rivalry between the sister arts emerged from the struggle for artistic identity in postrevolutionary France. The author, who had never enjoyed the same kind of institutional support as the painter had, faced different yet equally challenging dislocations in the postrevolutionary era. The *Académie française,* whose ranks were limited to the 40 *Immortels,* was principally devoted to maintaining the linguistic standard of France, while its members were authors and public figures elected at an advanced stage in their careers. Although the *Académie française* awarded prizes for literary merit, it neither trained students nor produced officially sanctioned art and had no public event comparable to the Salon. Writers of the Ancien Régime did not suffer from the social stigma that painters did,[1] often associating freely with the upper ranks of society in literary salons. Yet they nonetheless remained in a similar state of dependency, for the author, no less than the visual artist, relied on the patronage of the aristocracy for support. Michael Moriarty explains that the prior claims of literature to the status of pure, nonmercenary activity were based on the fact that "much literary production in the *Grand Siècle* took place outside of a market structure: it was practiced as an amateur activity or remunerated noncommercially by royal or aristocratic patrons. The decline of such patronage in the eighteenth century and after rendered the writer more directly dependent on the market."[2] Indeed, until the nineteenth century, few authors actually lived on the direct proceeds from their writings; the handful of books producing a living wage were generally pornographic or political tracts. Even the most admired authors of the Enlightenment could not support themselves through their publications,

and relied on the gifts of patrons to survive. As James Smith Allen demonstrates, "to earn a livelihood, the *lumières*, for example, did not have to sell so much as be admired by the right people, or failing that, attend another occupation insuring the income that writing alone normally could not provide. Even Voltaire did not live by his pen; he earned most of his money from properties, banking transactions, commodity speculations, as well as a royal pension as a gentleman of the bedchamber to Louis XV."[3] By the turn of the century, with the decline in patronage and the rise of the capitalist marketplace, literature, no less than painting, became firmly ensconced in the realm of commodity.

Steadily increasing literacy rates[4] and innovations in printing technology made it possible for more and more authors to earn a living from their craft. The industrialization of book production—cheaper paper, faster presses and less expensive means of producing the text—contributed to lowering the unit cost per book, and by midcentury the introduction of the *roman à quatre sous* (three-penny novel) helped to expand the book-owning public down the social and economic scale to include artisans and petty bourgeois.[5] The booming new market of journals, newspapers and reviews proved to be of even greater importance to nineteenth-century author, as it provided a venue for articles, fiction, and, beginning under the July Monarchy, the *roman-feuilleton* (serial novel). From 1811 to 1846 the number of dailies published in Paris jumped from 11 to 26 while the total number of subscribers grew from 56,000 to 200,000.[6] During the same period the "journal of ideas" came into its own, while hundreds of periodicals devoted to culture, politics, women's interests and satire emerged, all needing authors, critics and illustrators to fill their pages.

The expanding literary market became a magnet for ambitious youths from the provinces, who flocked to Paris in the 1830s and after, in hopes of launching lucrative careers.[7] In "L'Homme de lettres," a *physiologie* published in *Les Français peints par eux-mêmes (The French painted by themselves)*, Regnault comments on the proliferation of authors in the Paris of the July Monarchy and the competition that ensued:

> Il n'y a pas, dans la société, de classe si nombreuse, si variée, si composée que celle des hommes de lettres: il n'y a pas de métier où il y ait tant de concur-rents, pas de camp où il y a tant de rivaux. Poètes, historiens, philosophes, romanciers, dramaturges, journalistes, publicistes, feuilletonnistes, vaudevil-listes, tous se pressent, se poussent, se heurtent, se coudoient, se foulent, s'écrasent. Malheur à celui qui n'a pas la voix puissante! Car elle ira se per-dre au milieu des bruits confus de la tempête littéraire. La multitude s'en va toujours grossissant, toujours se recrutant.[8]

(There is no class in our society as numerous, as diverse, as mixed as that of the man of letters: there is no profession where there is so much competition, no camp where there are so many rivals. Poets, historians, philosophers, novelists, playwrights, journalists, publicists, serialists, vaudevillians, all crowd each other, push each other, clash with each other, elbow each other, torment each other, crush each other. Woe to him who lacks a powerful voice! Because it will be lost in the midst of the confused commotion of the literary tempest. The multitude keeps on growing, ever recruiting new members.)

The *physiologiste* attributes the swelling ranks of authors to the mass exodus of ambitious *provinciaux* to Paris, but also to an unprecedented elasticity of terms. He complains, "The least essay makes a writer, the least rhyme makes a poem. . . . Challenge the title of man of letters to the most imbecilic man of independent means, and he will think it enough to prove you wrong that he goes and dreams up a pastoral poem by the light of the moon or by the banks of a stream."[9] In an effort to distinguish the untrained masses of *hommes de lettres* from veritable artists, Regnault reduces them to commercial producers: "it is no longer the temple of the muses that should be opened to poets, it is the temple of the stock exchange; it is the court of commerce where they want to become vindicated at all costs, in order to carry on a trade in their verses and brokerage of their inspirations."[10] The entry of books and journals into the realm of popular commodity transformed writing into a mode of production, and by 1841, 36 percent of the authors in France were supporting themselves solely by means of their writing.[11] But despite Sainte-Beuve's condemnation of "la littérature industrielle,"[12] the average *journalier* only earned some 750 francs a year, and the author becoming wealthy from his literary production was the exception, not the rule. Indeed, for every Balzac, Sue or Scribe were a hundred *débutants* with no market value. Regnault trenchantly noted, "an unknown talent has no venal value; [. . .] the price of intellect varies like that of industrial stocks."[13] As reading became an industry, "the old book printer gave way to the modern publisher, a man who conceived of himself as a businessman and an investment gambler, able to sense popular demands and to gauge bestseller possibilities. For the commercial publisher the literary work was only the beginning. Like any other product, it had to be marketed in such a way as to insure a return on the investment."[14]

Rising literacy rates, an expanded market for the printed word, and publishers with an eye toward profits affected what postrevolutionary authors wrote, and for whom. Literature now became available to almost every level of society, much as painting had, via the Salon during the previous century, and the new mass market shaped literary production in unforeseen

hu and Gabriel Weisberg maintain that the very fact that the
had access to the media and to literature had a significant
entire cultural scene of the 1830s and '40s, for it "eliminated
ine between high and folk culture, creating instead a popular
culture that encompassed a social continuum ranging from the privileged
class of landlords and urban capitalists to the petty bourgeois and upper
crust of the laboring class (artisans, prosperous farmers, etc.)."[15] Now
French men and women from widely differing social strata could share the
same literary experience, just as they viewed the same paintings and sculp-
tures at the Salon, a "democratization" of culture that was reflected both
positively and negatively in Romantic art.

As the bourgeoisie strengthened its hold on French culture and a new
mass culture/market emerged, the very delineations between painting and
literature began to collapse. Thus, the genres began to conflate in actual
practice, and more importantly, in popular perception and experience. Chu
and Weisberg document "a new fluidity of boundaries between cultural
forms (painting, graphic arts, literature, drama, music)" as a direct result of
the developing notion of popular culture:

> Mayeux was a cartoon character, as well as a pseudonym of numerous satir-
> ical writers and a figure on the Parisian stage. Walter Scott's novels were read,
> performed on stage, sung in the opera, and depicted in Salon paintings. The
> same social types that are described in the novels by Balzac are depicted in
> Charlet's prints. July Monarchy painters write (Delacroix) and writers paint
> (Victor Hugo). In essence, there is a growing tendency in the 1830s and
> 1840s, to relate the visual and the verbal. (8)

The new urgency to link word and image arose more from commercial
than artistic exigencies: the increased recognition factor and thus sales
potential motivated the mixing of the various art forms far more than any
theoretical belief in a *fraternité des arts*. A play or a painting based on a pop-
ular novel was sure to attract interested crowds, while fiction incorporating
popular "types" from the printed media often shared similar success. Nev-
ertheless, the increasing porosity of generic boundaries engendered rivalry
and anxiety among the sister arts, increased profits notwithstanding.

The illustrated book, which reemerged in the 1820s and '30s, was
among the most deliberately motivated of these intergeneric "border cross-
ings," promoted as a means of attracting new readers and appealing to the
buyer in a highly competitive market. The introduction of new techniques
such as wood-engraving, steel-engraving and lithography during the July

Monarchy made the incorporation of images within the texts far more economical than had been previously possible, allowing publishers to advertise "livres de luxe à bon marché" (luxury books for cheap).[16] Where earlier illustrations had been printed on separate pages, the wood-engraved vignette of the 1830s was integrated directly into the text without a border, "creating a fluid relationship between the visual and the verbal."[17] The vignette, closely associated with Romanticism, was an important selling point for publishers of the many *nouveautés littéraires* competing for readership under the July Monarchy. Ségolène Le Men indicates that the presence of a vignette on the title page or as the frontispiece of a book "symbolized the meeting of art and literature, and was linked to the idea of the sister arts developed by the Romantic circles."[18]

Yet, these economically driven couplings only exacerbated the tensions and competition haunting the concept of the sister arts. For the author, the illustration interpolated directly within the text could be seen not only as a supplement to his tale, but also as a displacement, preempting the writer's descriptive powers while supplanting the reader's imaginative participation in the story. Just as the author as critic became intermediary between a painting and the public, so too did the illustrator mediate between text and public, providing them with his own interpretation of a scene or character. For many authors, reading was an act of viewing or envisioning, and they consequently relied on detailed descriptions to give the impression of "reality," openly calling themselves "painters in words" and encouraging readers to participate actively in the synthesis of images. The concrete form of an illustration on the page interrupted this compact between author and reader, usurping some of the author's own power and authority. Thus, the dependence on the sister art to increase the sales of a book reaped resentment as well as profit. While the illustrator frequently felt the onus of the subsidiary role, he was occasionally given precedence over the author in advertising copy, again in hopes of increased sales. Finally, illustrations represented a series of translations that distanced the artist from his own production: the image in the text was the visual artist's interpretation of the author's tale, interpreted in turn by the engraver. While the art of engraving was both technical and precise, the hand of the artist, his intention and his immediate relationship with his audience were disrupted on a number of levels in what Benjamin so aptly dubbed "the age of mechanical reproduction."[19]

L'Artiste

The juxtaposition of words and images reached its apogee in the illustrated journals of the July Monarchy, where text and pictures vied for the reader's attention in an unprecedented relationship of equality. The proliferation of magazines like *La Silhouette, La Mode, Le Charivari, La Caricature*, etc., testified to the public's appetite for illustrated periodicals and the publishers' and artists' willingness to meet this desire. The tensions between the visual and verbal, the role of illustration and the vignette, and the struggle of the nineteenth-century artist to define his role and his art were laid out most cogently in the pages *L'Artiste*, the revue where Balzac first published *Le Chef-d'oeuvre inconnu*. Established by Achille Ricourt, the first issue of *L'Artiste* appeared on 1 February 1831. In the course of its 73-year run the journal bore witness to artistic and intellectual life in Paris during the nineteenth century, through works by Delacroix, Devéria, Delaroche, Decamps, Gavarni, Sand, Musset, Chateaubriand, Hugo (who contributed both drawings and poetry), Baudelaire, Gautier, the Goncourts, Sue, Huysmans and Balzac.[20] As a journal devoted equally to word and image, *L'Artiste* provided a forum for both the painter and the poet in their roles as creators. As a compendium of art and criticism, the weekly *revue* included *salons*, book reviews, theater reviews, theoretical treatises and aesthetic commentary alongside engravings of paintings, original images and original fiction. Although later associated with Romanticism, the editors at the outset of its history envisioned one of its principle goals as providing "a tribune for artists where, by turns, they can defend their own doctrines and refute those of their adversaries."[21] Thus, *L'Artiste* of the early 1830s was very consciously a forum for the spirited debate between Classicism and Romanticism, played out in fiction, criticism, letters and editorials. Yet other important polemics also found voice in the pages of *L'Artiste*, most notably the contention over what defined an artist and his role in society during the 1830s, and the repressed rivalry between painters and poets for expressive domination.

The definition of the artist was a central topic of investigation in *L'Artiste* from its very inception, for it was precisely at this moment (ca. 1830) that *artiste* "acquired a new breadth of meaning, designating not only painter and sculptor but also writer and composer."[22] Jules Janin's seminal "Être artiste!" of 1831, presents an emblematic discussion of the concept of *artiste*, aimed at clearing up the confusion of this elastic term for artists and audience alike.[23] While the first few pages of his article define art in rhapsodic Romantic terms "Art is life! Art is a gift of the soul in a variety

of forms . . . ,"[24] the second half takes a bold step toward expanding the working definition of the artist in a more concrete sense. Janin claims there are two kinds of artists: "The man who knows and judges, and the man who creates. The first is the fortunate artist, audience to all the efforts, applauding all the successes; the second is the laborious artist, an actor involved in this noble struggle of the arts, full of great hopes, and enjoying the future instead of the present."[25] In a single move, Janin has transformed the audience into artists and included the *critic* as such: anticipating Wilde by more than half a century, he has placed the judge on equal footing with the creator. In elevating criticism to the level of art itself, Janin strikes a blow for the legitimacy of the critic and his craft, in response to the painters' crusade against art criticism that had escalated during the Restoration. As Robert Lethbridge has demonstrated, painters became increasing, albeit reluctantly, dependent upon authors "to complete the communicative exchange with the spectator" for "prior to the availability of colour reproductions, the visual could only be translated or traduced, in written invitations to visualize."[26] By the 1830s the proliferation of texts about art was reaching a monumental scale, especially once the Salon became an annual event in 1831. The position of dependence and perceived inferiority on the part of the painter led to resentment, "anxieties about the appropriation of the visual by the verbal"[27] and ultimately what Bourdieu has called "a war for liberation which the painters had to wage in order to win their autonomy and affirm the irreducibility of the pictorial, artistic work to all types of discourse."[28]

"Des Critiques en matières d'art," an article by Eugène Delacroix that appeared in *Revue de Paris* in 1829, provides an eloquent illustration of this very war to which Bourdieu alludes. In the spirit of Girodet's "Critique des critiques," Delacroix takes up the pen to protest the power of the critics and in an opening sally delineates a territorial battle between artists and critics. He contends, "les gens du métier contestent aux faiseurs de théories le droit de s'escrimer ainsi sur leur terrain et à leur dépens. . . . Le pauvre artiste, exposé tout nu avec son ouvrage, attend avec une vive anxiété les arrêts de ce peuple qui a la fureur de juger" (professional artists dispute the right of theory-makers to skirmish on their territory and at their expense. . . . The poor artist, exposed naked with his work, waits anxiously for these people who have such a madness for judging to cease and desist).[29] Stung by the "plume dont le fiel brûle jusqu'aux os" (pen whose bitterness burns right to the bone), artists dream of a revenge where they might rise up and "rendraient sottises pour sottises sur ce sujet si pauvre en véritables résultats" (return insult for insult on this fruitless subject). But

ultimately Delacroix laments, "la lutte n'est guère possible. Les armes man-
queront toujours pour cette sotte guerre" (the battle is scarcely possible. We
will always lack the weapons for this ridiculous war). For visual artists at the
dawn of the July Monarchy, the *plume* (pen) is felt to be mightier than the
pinceau (paintbrush). Blaming the critics for the reign of mediocrity,
Delacroix denounces the stranglehold on taste held by shortsighted hacks,
unable to understand or appreciate new forms of beauty. As he finishes his
brief essay, Delacroix addresses himself to his fellow artists and to the pub-
lic, for indeed, the battle between artists and critics is finally a battle for the
public. Simultaneously affirming and critiquing the far-reaching power of
the critics, he concludes: "Ces dragons vigilants sont là pour vous avertir,
vous public, comment vous devez jouir; vous, musiciens, peintres et poètes,
pour vous diriger sur la scène, au moyen de fils dont ils tiennent le bout"
(These vigilant dragons are there to inform you, public, as to what you
should enjoy; you, musicians, painters and poets, to direct you on the stage
like puppets, by means of the strings they hold in their hands).

Janin's article in *L'Artiste* two years later takes an opposing position to
that voiced by the Romantic painter. By indicating that the critic was as
much of an artist as the creator he was evaluating, and moreover, that he
was a *happy* artist, while the creator was *laborieux*, Janin fuels the fires of
intergeneric antagonisms while further increasing the power of word over
image. The "Prince of Critics" articulates what art critics had long been
asserting and painters explicitly resisting: that the description, evocation or
evaluation of a work of art could be the equivalent of art itself. This equiv-
alence will be played out in the pages of *L'Artiste*, where criticism and
original art appear side by side and are treated identically, a review by Delé-
cluze or Viel-Castel holding no less weight than an engraving after
Delacroix or Devéria, or a story by Hoffmann or Balzac.

Yet, Janin goes on to explain that the journal exists for both critic *and*
artist, and if the critic is artist, so too may the artist become critic: "For the
man who judges, judgments to convey, for the man who creates, engrav-
ings to reproduce his creations, for both a journal to write; a journal where
they can frankly state their most intimate thoughts."[30] In a posthumous
affirmation of Girodet's ambition, *L'Artiste* is distinguished by the number
of articles, letters and treatises written by visual artists themselves. The very
first volume (February-July 1831) includes pieces authored by Devéria,
Johannot and Delacroix. Delacroix's letter to the editors engages in elegant
theoretical discourse, while Devéria writes a straightforward plea to the
critics to be kinder to painters. In a similar vein, the illustrator Alfred
Johannot penned "Du point de vue dans la critique." In this brief but

antagonistic piece, the painter/author mounts a striking attack on contemporary critics by usurping the linguistic metaphor. He claims that the critics err greatly when they judge artists in comparison to one another or group them in schools, for every artist has his own means of expression, a personal language complete with "what is called style, rhythm, idiom in literature. [. . .] Painting is like languages in this way; we always prefer using the mother tongue to render our most intimate impressions."[31] By turning his images into a language, Johannot echoes the generic crossing of boundaries enacted when the critic tries to evoke images with words. While this trope—the language of images—dates back to Diderot, it gained general currency during the middle third of the nineteenth century and figures significantly in Balzac's own competition with painters. Here, as elsewhere, it is emblematic of the barely concealed rivalry simmering between the sister arts for expressive superiority.

The idea of competition was as fundamental to this review as the vision of collectivity embraced in its title. Indeed, the efforts to expand the definition of the term *artiste* served to escalate, rather than ameliorate artistic anxieties and uncertainties, sparking further attempts to assert territoriality among the various genres. Nonetheless, the blurring of boundaries between painting, literature and music remained a cornerstone of *L'Artiste*'s philosophy, a position summarized by V. Schoelcher in an article on the Salon of 1831:

> par ce mot d'artistes ainsi pris au général, je n'entends pas seulement les peintres, mais aussi les poètes, les littérateurs, les musiciens, les savants, qui, chacun dans leur sphère, ont une égale mission à remplir, car tous les arts se touchent et se lient par une affinité spirituelle, qu'il est donné aux organisations délicates de comprendre, et c'est de leur concours vers un même but que peuvent sortir les bienfaits qu'ils doivent au monde.[32]
>
> (by this word artist thus taken in general, I do not simply mean painters, but also poets, authors, musicians, scholars, who, each in his own sphere, has an equal mission to fulfill, for all the arts adjoin and are linked by a spiritual affinity, which delicate constitutions understand, and it is from their struggle toward a single goal that the benefits that they owe to the world may emerge.)

Even as Schoelcher reflects the idealist ideology of *L'Artiste*—a collectivity of arts, all working together toward the same goals in their individual ways, the last phrase of this passage introduces potential conflict in the word *concours*. Signaling at once collaboration and competition, *concours* encapsulates the tension between these two opposing terms that drives both the theory and practice of art under the July Monarchy. Despite its

efforts to forge a more universal definition of the artist and to promote an atmosphere of solidarity and fraternity among the sister arts, the pages of *L'Artiste* are characterized by strong undercurrents of contention that emblematize the state of the arts in nineteenth-century France, relations that will find ample expression in Balzac's tales of art and artists of the 1830s.

Balzac and Physiology: Reading the Visual World

Critics from Balzac's day to our own have documented the central role played by painting and painters in *La Comédie humaine*.[33] In the chapters to follow, however, I will investigate the *meanings* and *motivations* behind Balzac's use of painting and the figure of the artist from 1829-31, when he was establishing his own voice and reputation as an author.[34] I will focus on the generally ignored fact that during this period (and later as well), Balzac's painters are artistic, social and psychological *failures*. If his much-analyzed use of pictorial allusion (primarily to Old Masters) is generally a form of validation, his depiction of depictors is quite the opposite. Balzac had little formal knowledge about painting or aesthetic theory, and confessed in 1849: "I love to hunt down paintings and laboriously cobble together my *little museum*, but unfortunately I do not know much about art."[35] Thus, although he amassed a collection of paintings, furniture and objets d'art, he never considered himself a true connoisseur, nor did he develop the art critical acumen of many contemporary authors such as Stendhal, Baudelaire or Gautier. His tastes ran to the conservative canvases of Raphael, Leonardo, Titian and Rembrandt, while his modern artist of choice was Girodet, who figured prominently both in his private collection and in the *Comédie humaine*, where he is mentioned no fewer than 20 times.[36]

Balzac's initial fascination with the painter surfaced in 1819, the year he took up residence in the rue Lesdiguières to try his hand at writing. In a letter to his sister Laure, the 20-year-old author muses upon the difficulties he is having in beginning *Cromwell*, a five-act verse tragedy. For his opening scene between the king and queen, he knows only that "It must be sublime throughout, in the genre of Girodet's *Atala* in painting."[37] Prints of Girodet's *Atala* circulated widely at the time, but it is also possible that Balzac had seen the painter's copy of the canvas exhibited in 1814-15, when his family was living in the Marais. His desire to reproduce the tragic and "sublime" effect of this literary painting indicates Balzac's early orientation toward a Classically based Romantic aesthetic in painting. The young

author's reference to Girodet in the autumn of 1819 is not surprising, for the painter's name was splashed across the pages of nearly every journal,[38] as all of Paris eagerly awaited the long delayed presentation of *Pygmalion et Galatée*. Thus, in October 1819 Balzac wrote to his aesthetic mentor, Dablin, and inquired "If Girodet puts his *Endymion* in the exposition, could you please get me a ticket for the day when it is not supposed to be crowded. I will go in the morning and no one will see me."[39] Although there is no further mention in his correspondence, given Balzac's interest in Girodet and the feverish pitch of publicity surrounding the painting, it is likely that the young author joined the throngs to see *Pygmalion et Galatée* in the final days of the Salon of 1819. At the very least we can be sure that he read and heard about the controversial canvas from Dablin, on whom he counted for oral reports of the exposition.[40]

Dablin, a trusted friend of the family, *quincailleur* and art collector whose tastes were formed during the Empire,[41] introduced Balzac to the world of art and was formative in shaping his young protégé's taste along the lines of his own. His collection included paintings by Fragonard, Greuze, Dou, works after Raphael and Giorgione, two Prud'hons, and a collection of more than 300 miniatures. Among Dablin's friends was Forster, who engraved Girodet's *Endymion* in 1820, and thus, while the painting was indeed not displayed at the Salon of 1819 as Balzac had hoped, he had access to a reproduction of the image early in his career. Similarly, even if Balzac missed the exposition of *Pygmalion et Galatée* in 1819, his correspondence the following year indicates that he was actively pursuing entry to Sommariva's galleries, where he would have been able to contemplate the mythological canvas at leisure.[42] Girodet's initial masterpiece and his last attempt to repeat its success play iconic roles in several of Balzac's stories of the 1830s. As friend and biographer Théophile Gautier commented, "His favorite painter was Girodet. Some of his first stories bear the marks of this backward taste for which we teased him, but he accepted our jokes with good grace."[43]

Balzac's spotty artistic education continued throughout the 1820s, through his varied experiences as editor, publisher and author. His first (disastrous) publishing venture, a set of illustrated works by La Fontaine and Molière, brought Balzac into contact with Achille Devéria (1800-1857), who provided the illustrations for this pair of collected works in 1825-26. Devéria, who would later become an important contributing illustrator at *La Silhouette, L'Artiste, La Caricature* and *La Mode*, introduced Balzac to the world of contemporary artists and illustrators; a devoted student of Girodet's, Devéria also regaled Balzac with tales of life in the recently

deceased painter's atelier. Although trained as a painter, Achille Devéria's fame derived from his 3,000 lithographic prints and the illustrations for more than 300 books that he produced, personifying the newly legitimized professional illustrator who began to thrive under the July Monarchy.[44] As publishers relied increasingly on images to sell their wares, a career as an illustrator presented a more financially secure alternative to the uncertainty of life as a painter, and a number of artists divided their time between painting and illustration in order to make ends meet. Illustrated books were collaborative products where words and images (theoretically) held equal weight, and Balzac's early experience in the literary marketplace taught him the importance of illustrations in selling books. For Balzac, Devéria represented a classically trained artist who followed the demands of the market, subordinating his interest in easel painting for the quicker and more profitable "modern" arts of lithographic portraiture and illustration geared to a specific contemporary venue and audience.

By 1830-31, Balzac had also become closely associated with some of the most influential caricaturists of his day, including Gavarni, Grandville and Daumier, with whom he collaborated in periodicals. An important tool of social commentary and criticism during the July Monarchy, caricature reflected many of the political, artistic, gender- and class-related tensions that characterized the age. Presenting its critique in easily deciphered images, caricature exploits the comic tools of exaggeration and deformation of the familiar and recognizable.[45] Yet owing to its deformative quality, caricature relies on interpretation or translation for its humor to signify, displaying a "literary" or "writerly" quality that depends on the active participation of an audience. Balzac's interest in caricature was multifold. Attracted by an art that both depicted and mocked the society of his day, he was also drawn to a form that presented its signs for a "reader" to interpret, composing and comparing eidetic images within the imagination to come to meanings implied, but not enunciated, by the signifiers.

Balzac's stories, articles and reviews appeared in the pages of *La Silhouette, La Caricature, La Mode, Le Charivari* and other periodicals of the era, side by side with the drawings of Gavarni, Grandville, Traviès, et alia. In keeping with the reciprocal nature of word and image in the illustrated press of the time, the caricaturists illustrated Balzac's articles and Balzac provided text for their drawings in his many laudatory reviews of their *albums*. Thus, in an article in *La Silhouette* (15 April 1830), Balzac sang the praises of Grandville's *Voyage pour l'éternité: Album funéraire* by bringing the six satirical images to life with his own literary equivalences in a series of verbal caricatures that draw out Grandville's own social criticisms while

also subtly displacing them. In this early evaluation of the power and relevance of caricature, Balzac's insists on the reader's participation in the experience of the set of images, posing much of his exposition as questions and imperatives ("Where do you think you are going in following this amazing, heavenly creature. . . . What do you think you see in the person of this fat boy, chubby, prosaic. . . ," etc.).[46] Balzac exploits an inclusive and accusatory *vous* of direct address throughout the piece, leaving the reader little distance to separate herself from the insistent voice of the narrator or from Grandville's pointed commentary on death. Focusing on the philosophical nature of Grandville's work, Balzac brings forth "la spirituelle moralité" of these "tableaux comiques." For Balzac, the best caricature presents a moral lesson within its mockery, an aim he will embrace in his own work from 1830 on.

Closely linked to caricature, *physiologies* similarly focused on contemporary society through the vehicle of comically exaggerated portraits of Parisian "types." Addressing nineteenth-century Parisians' unquenchable desire to consume images of themselves, the *physiologies* were plentiful (some 76 different titles appearing in 1841 alone) and inexpensive, generally costing about a franc (while a book cost at least 3 F 50), and thus meant to appeal to a large segment of society. Their consistent size and format marked the commodified tomes as products intended for mass consumption.[47] The meticulously detailed *physiologies* presented verbal and visual portraits of the vast array of social types constituting contemporary France in an attempt to render the increasingly alienating Parisian landscape comprehensible to its expanding population. Mass migration from the provinces to the capital had resulted in a "crisis of socialization" that the *physiologies* sought both to reflect and address, mapping "the signs and signals, the employments and amusements, the dangers and blunders . . . within this mysterious world of social signs."[48] Taking the scientific systems of classification as professed by Buffon, Cuvier, Lavater, Gall and even Saint-Simon, as their model, the *physiologies* both exploited and mocked their ambitious pretensions. In an age that strove to codify every aspect of life, the *physiologies* engaged in a direct dialogue with the popular guidebooks, *Hygiènes*, *Traités* and *Codes*. Providing readers with a neat classification of their friends, neighbors and the faceless, nameless Others, the *physiologies* simultaneously poked fun at the very concept of such absolute insights through word play, puns and exaggerated reliance on a parodic scientific vocabulary. The playful nature of many *physiologies* is demonstrated by the definition of the form in the *Physiologie des physiologies*: "*Physiologie,* this word is composed of two Greek words whose meaning is henceforth this: Volume in-

18, composed of 124 pages and an unlimited number of vignettes, tailpieces, nonsense and babblings [*logos*] for the use of foolish people [*phusis*]."[49]

Although the *physiologies* reached their peak of popularity in 1840-42, the form can be traced back to the end of the Restoration and the early years of the July Monarchy. The early *physiologies* generally took the form of articles appearing in the same journals that boasted the works of the caricaturists. Although Balzac's *Physiologie du mariage* of 1829 has been identified as "the direct model for the genre,"[50] the author's shorter pieces, such as "L'Epicier," published in *La Silhouette* in April 1830 and later included in the quintessential collection of *physionomies*, *Les Français peints par eux-mêmes,* are paradigmatic in their focused, satirical classifications of the habits, customs and manners of Parisian stereotypes.[51] Balzac's long-standing interest in *physiologies* emerged from his desire to catalogue France, its inhabitants and their *habitudes*, but also from his fascination with J. C. Lavater's theory that the visible world presented a system of signs somewhat akin to language. Indeed *physiologie* initially stemmed from the science of living organisms and their parts, while playing off of an homophony with *physiognomy*, Lavater's pseudoscientific method of reading the exterior human form to divine an inner essence. Balzac has been called "the most explicitly physiognomical of the many European novelists from 1800 to 1850"[52] and his passion for Lavater is documented throughout *La Comédie humaine.* In *Physiologie du mariage* (1829), he contends,

> La *Physiognomie* de Lavater a créé une véritable science. Elle a pris place enfin parmi les connaissances humaines. . . . Les habitudes du corps, l'écriture, le son de la voix, les manières, ont plus d'une fois éclairée la femme qui aime, le diplomate qui trompe, l'adminstrateur habile ou le souverain obligés de démêler d'un coup d'oeil l'amour, la trahaison ou le mérite inconnus. L'homme dont l'âme agit avec force est comme un pauvre ver luisant qui, à son insu, laisse échapper la lumière par tous ses pores.[53]
>
> (Lavater's *Physiognomie* created a true science. It took its place among the human sciences. . . . An individual's personal habits, handwriting, the sound of his voice, his manners, have more than once enlightened the woman who loves, the diplomat who deceives, the clever administrator or the sovereign, each of whom must distinguish in a glance the secret love, betrayal or merit that had been hidden. Man, whose mind is always active, is like a poor glow-worm who unconsciously emits light from all his pores.)

The contention that one could analyze the human face, body, comportment and manners and uncover inner truths, despite the individual's efforts to hide or dissemble, was enormously compelling and Lavater's *Physiog-*

nomische fragmente (1775-78) remained a popular source of reference well into the second half of the nineteenth century.[54] Physiognomy's privileging of sight as the path to meaning appealed to many artists, including Girodet, but for Balzac the *linguistic* nature of Lavater's systematic approach to the world, where every physical detail could function as a signifier, provided its fundamental attraction. Lavater's physiognomy denotes for Balzac a way of *reading* the language of the world and the text of the body, a twofold process that requires both recognition and interpretation of the signs. In keeping with Balzac's elitist orientation, not everyone is adept at such translations of physical signifiers into meaning. If his journalistic *physiologies* are object lessons in how to read the faces and figures of fellow Parisians, Balzac's stories from the same period (1829-31) present illustrations of how *not* to read the world, or the dangers of accepting what is seen at face value. Consequently, although physiognomy and its frivolous offspring, *physiologie*, would seem to elevate the visual world above the domain of words, for Balzac the inverse is true, as he relies on metaphors of language, text, reading and interpreting to define the visual world as a complex sign system.

But, if the world of the *physiologies* remains patently *lisible*, or "readerly" in Barthes's sense, then Balzac's universe is "writerly" or *scriptible*, a production rather than a product depending on the active participation of a reader to synthesize meaning.[55] The language of the standard *physiologies* is ultimately a language of images, where, once versed in the system of one-to-one equivalence, to see is to understand is to know, and in these texts, sprinkled liberally with illustrations (some 30 to 60 per hundred pages of print), the visual dominates the verbal.[56] Reflecting what they perceived as the order of the world, the *physiologies* privilege the sense of sight. Conversely, the language of Balzac's physiognomy and *physiologie* in *La Comédie humaine*, highlights the *gulf* between seeing and knowing, which can only be bridged by interpreting, an activity more closely linked to verbal than visual experience. And if sight is a central metaphor *chez* Balzac, the observer, especially if he is a painter, will often be blind to what he "sees," unable to decipher a world whose semiotic nature makes it more readily accessible to a man of words—the author/narrator himself—than to a man of images. While Balzac's works are thus filled with highly detailed verbal "portraits" of the physical traits, manners and milieux of his characters, in keeping with Lavater's principles, they present a stark contrast to painted or drawn portraits in their presentation and intended perception or consumption.

Central to the aesthetic aims of the *Comédie humaine,* the difference

between merely seeing and really "reading" the world is most clearly demonstrated by a series of artists whose painted portraits reflect their own fantasies while remaining at odds with an accurate image of the real world. These stories, produced from 1829-31, when Balzac was in intimate contact with artists and illustrators, reflect an unspoken level of competition with the visual artist and a desire to demonstrate the superiority of the author in painting a picture that reveals the world in all of its complexities. While the visual, external image may hold the key to inner truth, for Balzac the reproduction and interpretation of that image, and the access to these elevated insights, is the purview of the written word.

La Maison du chat-qui-pelote: Visible and Invisible Difference

The *Comédie humaine* set forth to portray every aspect of French society— its many social castes, professions and "types" in their respective milieux— so it is not surprising that the figure of the visual artist appears among the myriad characters that populate Balzac's universe. Nor is it surprising, given his interest in Lavater and contemporary *physiologie*, that Balzac turns to the metaphor of painting in his *Avant-propos* for the 1842 publication of *La Comédie humaine*. Balzac describes his task in recording "l'inventaire des vices et des vertus" of his day as one that consists "en rassemblant les principaux faits des passions, en peignant les caractères, en choisissant les événements principaux de la Société, en composant des types par la réunion des traits de plusieurs caractères homogènes . . ." (in assembling the principal realities of the passions, in painting the personalities, in choosing the principal events of Society, in portraying types by combining the traits of several similar characters . . .). The author insists that "un écrivain pouvait devenir un peintre plus ou moins fidèle, plus ou moins heureux, patient ou courageux des types humains" (a writer could become a painter, more or less faithful, more or less successful, patient or courageous, of human types) (1: 11). Later in his introduction he explains "Ce n'était pas une petite tâche que de peindre les deux ou trois mille figures saillantes d'une époque. . . . Ce nombre de figures, de caractères, cette multitude d'existences exigeaient des cadres, et, qu'on me pardonne cette expression, des galeries" (It was no small task to paint the two or three thousand remarkable figures of an era. . . . This number of figures, of characters, this multitude of existences needed frames, and, if you will pardon me the expression, galleries) (1: 18). But if the *Comédie humaine* is, in its author's own words, "cette vaste peinture de la société" (this enormous painting of society) where "les ravages de la vie sont peints" (the ravages of life are painted) no less than "la Vie

elle-même est peinte" (Life itself is painted) (1: 19), painting itself does not hold a privileged position in the narrative. In conjunction with the many failed and corrupted painters and sculptors in its vast landscape, it is associated almost exclusively with illusion, danger and death. The marked disparity between Balzac's trope of the author as painter/story as painting and his narrative treatment of artists and art reveals a complex and conflictual attitude toward visual representation and his fellow artists that is central to Balzac's definition of his own art and the "realist" approach to the world.

Some 12 years before publishing his *Avant-propos*, Balzac composed a preface for the first edition of *Scènes de la vie privée* that foregrounds the same interest in sight and insight. Here he claims that the stories in this collection, which includes *La Maison du chat-qui-pelote*, *La Vendetta* and *Le Bal de Sceaux*, are intended to serve as an education to young women in the realities of life, love and marriage. Playing on the visual metaphors of the exposure and veiling of his paintings of manners, Balzac defines his didactic goals:

Il existe sans doute des mères auxquelles une éducation exempte de préjugés n'a ravi aucune des grâces de la femme, en leur donnant une instruction solide sans nulle pédanterie. Mettront-elles ces leçons sous les yeux de leurs jeunes filles? . . . L'auteur a osé l'espérer. Il s'est flatté que les bonnes esprits ne lui reprocheraient point d'avoir parfois présenté le tableau vrai de moeurs que les familles ensevelissent aujourd'hui dans l'ombre et que l'observateur a quelquefois de la peine à deviner. Il a songé qu'il a bien moins d'imprudence à marquer d'une branche de saule les passages dangereux de la vie, comme font les mariniers pour les sables de la Loire, qu'à les laisser ignorer à des yeux inexpérimentés. (1: 1172-73)

(There probably exist some mothers for whom an education free from prejudice has not robbed them of feminine graces, giving them instead a solid instruction without pedantry. Will they place these lessons before the eyes of their young daughters? . . . The author has dared to hope so. He hoped that these fine minds would not reproach him for having occasionally presented the true painting of manners that families today bury in shadow and that the observer sometimes has difficulty discerning. He thought that it was less imprudent to mark with a willow branch life's dangerous passages, as bargemen mark the sands of the Loire, than to let them remain unseen by inexperienced eyes.)

Balzac's lessons will enter through the *eyes* of his audience and the author implies that his *tableau vrai de moeurs* will teach his reader how to *see* what had been hidden from view. The tales are, he insists, based firmly in a real-

ity that protective parents have tried to hide. Anticipating criticism, he claims, in an early enunciation of his "realism," "In publishing this work, [the author] merely conveys back to the world what the world has shown him."[57] Yet in trying to reveal veiled truths to his readers, Balzac claims his narratives will themselves be hidden. Relying once again on visual tropes he reflects, "Would it be possible that, having tried faithfully to paint the events that follow or precede a marriage, his book would be refused to young people destined one day to appear on the social scene? Would it be then a crime to have lifted the curtain for them, to show them the stage that they must one day embellish?"[58] Balzac's efforts to reveal precisely what society seeks to obscure identifies his endeavor as a counter-discourse, more closely akin to *physiologie* or caricature than traditional portraiture. As defined by Richard Terdiman, counter-discourse "sought to disturb the easy reproduction and reception of dominant discourse . . . to unmask the *fetish character* of modern forms of social domination."[59] By presenting a vision of society not as it wished to be seen, but as it "really was," and rendering the "natural" at once denaturalized and alien, Balzac attempted to map the unspoken realms of power and ideology, exposing both their functioning and corruption. But if Balzac's counter-discourse takes primary aim at the dominant discourse of French bourgeois society, in this set of stories from the early 1830s, the dominant artistic ideology is also under attack, as he seeks to subvert the naturalized association of painting with mimetic "realism" and the contemporary conflation of sight with knowledge and power. As indicated in the preface to *Scènes de la vie privée* and in the *Avant-propos* to the *Comédie humaine*, Balzac will abrogate the painter's powers of representation with his own "painting," while simultaneously exposing the artist's blindness and the author's insights.

La Maison du chat-qui-pelote (1829), the earliest of Balzac's *Scènes de la vie privée*, serves as a foundational text for the author's social and artistic counter-discourses. A cautionary tale of the dangers of marrying outside of one's class, *La Maison du chat-qui-pelote* also presents an emblematic image of the artist, in the persona of Théodore de Sommervieux, as a Romantic and dangerous figure whose difficulties reconciling art and life lead to the destruction of his innocent wife. The opening scene of the novella lays the groundwork for the entire tale in a manner that recalls the visual vocabularies of physiognomy and *physiologie* with both parodic and serious intent. Relying on the metaphor of translation, Balzac begins the tale by evoking the eponymous storefront as "one of those delightful houses which allow historians to reconstruct old Paris by analogy. The

menacing walls of this ramshackle building seemed to have been decorated with hieroglyphs. What other name could the *flâneur* give to the Xs and Vs that the horizontal or diagonal timbers traced on the façade, outlined by little parallel cracks in the plaster?"[60] The façade of the Maison du chat-qui-pelote, alternately standing as an analogy and a hieroglyph, is a surface that must be interpreted. Its signs—like the letters x and v traced by the half-timbers and cracked plaster—present a language that is symbolic, pointing beyond itself to something else, and polyvalent, for indeed x and v may be interpreted as letters or roman numerals. This introductory insistence on the linguistic nature of visual experience encapsulates a paradigm for reading both *Maisons du chat-qui-pelote*—that is the building within the tale and the tale itself[61]—that will be important in the delineation of Sommervieux's character as well. For as the narrator's focus shifts from the shop to its observer, he will construct a distinct economy of vision that will shape the inscribed reader's interpretation of Balzac's own set of symbolic signifiers.

Sommervieux first appears as an unidentified "jeune homme" examining the storefront from across the street "avec un enthousiasme d'archéologue." In keeping with the evocation of "historiens" and "hiéroglyphes" in the preceding paragraph, it would seem that this observer, with his archaeological orientation, might be well equipped to decipher the code of the façade before him. But, as Balzac adds, "In truth, this relic of the sixteenth-century bourgeoisie offered more than one problem for the observer to resolve,"[62] problems that the reader, guided by an all-seeing narrator, will be able to resolve, but Sommervieux will not. As the young man gazes upon the ancient building, his eyes stop at the windows on each floor, looking for a way, literally and figuratively, to penetrate the façade. But behind each window, offering the hope of entry, are shutters or curtains, barring it. The third floor windows, which are of particular interest to the spectator, "had little panes of glass so green that, without his excellent sight, the young man would not have been able to perceive the blue-checked cloth curtains that hid the mysteries of this apartment from outsider's eyes."[63] Ironically, the spectator's "excellent" vision allows him to see only more barriers between himself and the interior of the house. What prohibits his visual penetration is cloth—both what the family sells (and defines them as commercial and bourgeois) and what he paints on, hence the eventual screen for the projection of his own fantasies.

Thus our introduction to Sommervieux, only later identified as a painter and an aristocrat, is mediated through "sa contemplation sans résultat" (fruitless contemplation) (1: 40), and his initial image is as one who

looks but cannot see. Balzac introduces painting, in turn, through commerce, via the odd sign hanging in front of the Guillaume's establishment, in which a gentleman and a cat play at *pelote*, batting back and forth a ball made, once again, of cloth. The image of the cat playing racquetball begs interpretation, but in a prefiguration of the praxis of uncommunicability that dominates this tale, there may be no meaning at all behind the frivolous scene. The narrator contends "Drawing, colors, accessories, all was treated in a way to make you believe that the artist had wanted to mock the merchant and the passers-by."[64] Shifting his focus to its function as emblem rather than aesthetic object, the narrator adds, "these signs, whose etymology seems strange to more than one Parisian merchant, are dead paintings of once living scenes with which our crafty ancestors had succeeded in luring customers into their stores."[65] Signifiers severed from their original signifieds, the signs all over Parisian storefronts are now empty symbols that continue to be used to attract curious customers who, like the owners, remain unaware of what the sign *means*. As art becomes a function of commerce, devoid of reference or signification, it stands as a symbol of death—a *tableau mort*—in contrast to the living scenes (*tableaux vivants*) it replaces. The dénouement of the tale is prefigured in this initial portrait of the *Maison du chat-qui-pelote* that, in a Lavaterian mode, reflects the lives of its inhabitants.

The painted sign, as physical artifact, shows further manifestations of its instability, signaling a breakdown between signifier and signified. Time has altered the image in ways that mock the artist's intentions, severing the representation from its original. Balzac's narrator observes: "In altering this artless painting, time had made it even more grotesque through some uncertain features that must have made conscientious *flâneurs* uncomfortable. Thus the cat's tabby tail had been cut up in such a way that one could mistake it for a spectator, so thick, long and bushy were the tails of our ancestors' cats."[66] The phallic tail—thick, long and bushy—is severed from the body in a symbolic castration that turns the tail-qua-penis into an Other, a spectator watching the grotesque game between the emasculated cat and the aristocrat. Unlike the written work of art, painting or sculpture may fall victim to time's physical destruction, losing its power as it is transformed into an image at odds with its original composition. These changes are the source of anxiety for the *flâneur*, the denizen of the Parisian boulevards who played a crucial role in the *physiologies* as able reader of the city's inscribed text. Balzac defined the *flâneur artiste* as an active consumer of the urban landscape who is "a writer as well as a reader of the urban text."[67] No mere stroller, the *flâneur* is an interpreter of the myriad signs and sym-

bols that bombard the Parisian in his daily perambulations around the city. His semiotic relationship with the visible world, which further ties him to an author ("La flânerie est le caractère distinctif du véritable homme de lettres"), allows the *flâneur* to read impending castration in the *Maison du chat-qui-pelote* by interpreting the otherwise impenetrable sign (and thus be rendered anxious). Sommervieux, on the other hand, remains unable to transcend the surface for hidden meanings. When he first sees the sign of the cat and racquet, "un sourire involontaire se dessinait alors sur ses lèvres" (an involuntary smile drew itself upon his lips) and later he laughs gaily at the image. From the very beginning Balzac creates an implicit contrast between the painter and the *flâneur*, indicating Sommervieux's initial blindness through his incongruence with the more adept Parisian *physiologiste*.

Turning finally to the figure of the spectator himself, Balzac transforms Sommervieux into the spectacle, and the erstwhile observer now becomes the object of the reader's gaze. Sommervieux's face, body, clothes and comportment present a code to be deciphered, and the narrator leads the readers to interpretations, based on appearances, that immediately set them apart from the unanalytic characters in the novella. Beginning with his clothes, the stranger is identified as someone who "avait aussi ses singularités." Demonstrating the art of reading both a novel and the world, the narrator signals that the details of his vestment reveal inner qualities: the spectator's mud–flecked silken socks are explicit signs of his impatience and his wealth. By extension, his elegant clothes stand in contrast to the muddy street and bourgeois commercialism of the scene, letting the reader know that he is not of this milieu. His fashionable wrap, "pleated in the style of ancient robes," reveals the observer's Neoclassical bent. In a similar vein, his long dark curls "indicated a hairstyle à la Caracella, which had become fashionable as much because of the School of David as because of the mania for Greek and Roman style that characterized the first years of this century."[68] The reference to the School of David is the first of many indications of the profession of this *inconnu*, while linking him directly with Girodet and the Romantic Neoclassicists of the Directory and Empire.

Indeed, if the initial description of his clothes points to an idealized Classical orientation, the physiognomy of this rich and smitten *jeune homme* is imprinted with Romantic signifiers. Balzac documents:

> Une cravate ébouissante de blancheur rendait sa figure tourmentée encore plus pâle qu'elle ne l'était réellement. Le feu tour à tour sombre et pétillant que jetaient ses yeux noirs s'harmoniait avec les contours bizarres de son visage, avec sa bouche large et sinueuse qui se contractait en souriant. Son front,

ridé par une contrariété violente, avait quelque chose de fatale. Le front n'est-il pas ce qui se trouve de plus prophétique en l'homme? Quand celui de l'inconnu exprimait la passion, les plis qui se formaient causaient une sorte d'effroi par la vigueur avec laquelle ils se prononçaient; mais lorsqu'il reprenait son calme, si facile à troubler, il y respirait une grâce lumineuse qui rendait attrayante cette physionomie où la joie, la douleur, l'amour, la colère, le dédain éclataient d'une manière si communicative que l'homme le plus froid en devait être impressionné. (1: 42)

(A dazzlingly white cravat made his anxious face appear even paler than it really was. The fire that flashed in his dark eyes, by turns gloomy and sparkling, harmonized with the strange contours of his face, with his large, sinuous mouth that straightened out when he smiled. His brow, furrowed with violent vexation, had a stamp of doom. Isn't the forehead the most prophetic feature of a man? When that of the unknown spectator expressed passion, it formed furrows that were frightening in the vehemence with which they were expressed; but when he regained his composure, so easy to disturb, a luminous grace lit his brow, making attractive this physiognomy where joy, sorrow, love, anger and disdain were manifested in such a communicative way that the coldest man had to be impressed by it.)

The author's straightforward physiological reading of Sommervieux's face highlights his artistic temperament in an unmistakable image of the Romantic creator: acute pallor, fiery eyes, expressive mouth and passionate demeanor that reveal both beauty and violence. Anticipating the unhappy conclusion of this artist's tale, the narrator indicates the prophetic qualities of these features, which tell us all we need to know about his character and his ultimate fate. Although Balzac is relying on contemporary clichés, there is much of Girodet's own face in this portrait of the artist as a young man, which recalls a self-portrait from the same period in which the story is set [figure 4.1]. In both images, the artist is portrayed with a pale and expressive visage; a large brow hovers over a distinctly sinuous mouth while the dark eyes communicate a somber, conflicted intensity. Yet if the language "pronounced" by Sommervieux's patently artistic countenance "communicates" its message to a reader through a detailed portrait, it is a portrait of the artist by the author, where the emphasis falls on linguistic representation. The model for art is found in how we interpret the painter, not in how the painter interprets the world.

The dynamics of the gaze thus prove to be important initial markers in Balzac's tale, and the lengthy opening scene, more cinematic than narrative, shows the reader what lies before Sommervieux unperceived. When the voyeur's vigilance is finally rewarded, and a young woman appears in the

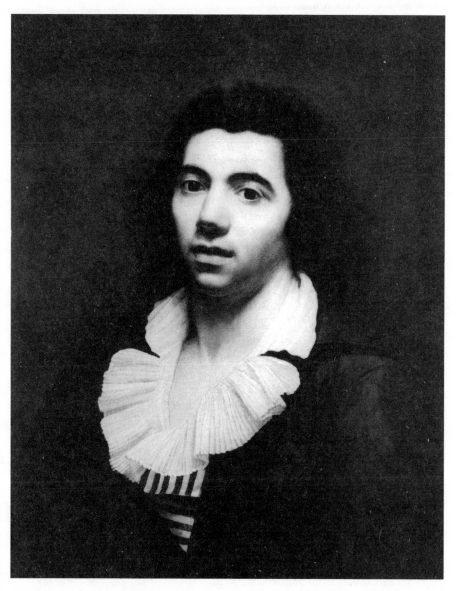

Figure 4.1. Anne-Louis Girodet-Trioson, *Self-Portrait*. c. 1814. St. Petersburg, The State Hermitage Museum.

frame of the third-floor window, Balzac presents his reader with another self-consciously painted portrait, this time through the filter of the infatuated artist's consciousness:

> La figure d'une jeune fille, fraîche comme un de ces blancs calices qui fleurissent au sein des eaux, se montra couronnée d'une ruche en mousseline froissée qui donnait à sa tête un air d'innocence admirable. Quoique couverts d'une étoffe brune, son cou, ses épaules s'apercevaient, grâce à de légers interstices ménagés par les mouvements du sommeil. Aucune expression de contrainte n'altérait ni l'ingénuité de ce visage, ni le calme de ces yeux immortalisés par avance dans les sublimes compositions de Raphaël: c'était la même grâce, la même tranquillité de ces vierges devenues proverbiales. (1: 43)
>
> (The face of a young girl appeared, fresh as one of the white flowers that bloom on the breast of the waters, crowned by a frill of rumpled muslin that gave her head an air of admirable innocence. Although covered in brown fabric, her neck and shoulders could be discerned, thanks to little gaps made as she moved in her sleep. No expression of awkwardness marred the guilelessness of this face, nor the calm of the eyes already immortalized in Raphael's sublime compositions: it was the same grace, the same tranquility of these now proverbial virgins.)

This portrait of Augustine framed in her bedroom window recalls Raphael's virgins, but also Girodet's *Etude de vierge*, shown at the Salon of 1812 to great acclaim.[69] Augustine's fresh innocence and calm, otherworldly demeanor, her position in the window and the brown shawl covering her shoulders all echo Girodet's drawing, while the reference to Raphael invokes Balzac's own parallel between the two artists: "A Virgin by Raphael vied for poetry with a sketch by Girodet."[70] The idealized image relies on Romantic metaphors of flowers that underline his insistence on her virginity, but remains vague, leaving her features to the reader's imagination. As Augustine hastily withdraws from view, the window slams down behind her and "la croisée redescendit avec cette rapidité qui, de nos jours, a valu un nom odieux à cette naïve invention de nos ancêtres, et la vision disparut" (the window sash fell with the rapidity which, in our day, has earned a hateful name for this naive invention our ancestors, and the vision disappeared) (1: 43). Balzac's sly reference to the *fenêtre à guillotine* recalls the *découpage* of the cat's tail, repeating the image of castration of the works of art that converge in/on the Maison du chat-qui-pelote and presaging the end of the story. For indeed, when the "vision" disappears, and Som-

mervieux is confronted with the reality of Augustine as a real woman and not a work of art, destruction will ensue.

The final introductory scene mediated through the dynamics of the gaze takes place when Augustine's father, the *bon bourgeois* M. Guillaume, emerges from his home and place of business and spots Sommervieux across the street. As the merchant watches the aristocrat watching his *maison*, he assumes "that this threatening figure wanted to rob the till of the Chat-qui-pelote."[71] What at first seems to be a comic misreading of the situation, reflecting the bourgeois's cupidity, has a greater truth than initially meets the eye, for Sommervieux will rob Guillaume and his wife of their daughter, a finer treasure than any till could hold. When the oldest apprentice emerges, he follows the gaze of the stranger to Augustine's window as well, meriting a look of annoyance from his employer. The apprentice's anxiety reveals his own feelings for his master's daughter, and the specular standoff between the father and the two suitors is brought to a close only when the stranger hails a cab and drives off. This introduction of most of the major characters in the novella has taken place, in the course of seven pages, without a single word exchanged between individuals. The elaborate pantomime demonstrates the language of gesture, appearance and physiognomy while creating a dichotomy between what the characters involved in the scene perceive and what the narrator allows his reader to see. The visual world of appearances communicates volumes, but not to the uninitiated, and it is only when images are translated into *words* that they transcend pure experience into signification. The narrator's act of interpretation allows the undifferentiated mass of ocular input to be sorted into meaningful data, while providing a paradigm for the reader's own approach to the text of this visually oriented tale. From the very outset we are warned that seeing is not necessarily understanding.

Abandoning the misty filter of the lover, Balzac provides us with a second look at Augustine, revealing the vulgarities that Sommervieux is unable to perceive. Usurping the painter's brush, Balzac sketches a realistic, if cynical, portrait of his heroine: "Augustine was small, or, to paint her more accurately, tiny. Gracious and full of candor, a man of the world would have had little to reproach this charming creature for, save some shabby gestures or certain vulgar postures, and sometimes a lack of ease. Her silent and impassive face expressed the fleeting melancholy that overtakes all those young girls too weak to dare to resist their mothers."[72] One of the central tenets of *Scènes de la vie privée* is that girls know only as much as they have been exposed to. Augustine and her sister Viriginie are products of a commer-

cial bourgeois upbringing, "accustomed to hearing nothing but miserably mercantile arguments and calculations."[73] Although Augustine's exposure has been limited, her aspirations are not, and Balzac delineates a stark dichotomy between her Romantic soul and her bourgeois existence. Anticipating Emma Bovary, Augustine reads Romantic novels, lapses into reveries and suffers from a longing to transcend the reality that she knows. Unaware of the limitations of her own intelligence, circumscribed by her education and environment, Augustine is a victim of the fatal clash between the real and the ideal, whose longing for the unknown will destroy her.

Next, the narrator shifts his focus to the stranger's own *formation* and what led him to fall in love with Augustine. Ironically, it is a glimpse of the humble Maison du chat-qui-pelote at dusk, transformed by the painter's Romantic imagination into a Dutch genre scene, that seduces the well-born artist. Since Balzac has already described the family and their meals in detail, the readers may contrast in their own minds the contradictory images: one, a realist portrait of bourgeois life ca. 1812, in all of its petty idiosyncrasies, the other a romanticized vision of the family and their milieu mediated through the historicizing lens of Dutch painting. Nightfall has obscured his view, and the artist enjoys the effects of chiaroscuro, a device that promotes mystery rather than accuracy.

Finally the *inconnu* is identified as a painter, Théodore de Sommervieux, whose name echoes Sommariva, Girodet's infamous patron, and whose career also shares a marked degree of overlap with that of *Endymion*'s creator. A winner of the Prix de Rome, Sommervieux has recently returned to Paris, "His soul nourished by poetry, his eyes filled with Raphael and Michelangelo."[74] Several months before *La Maison du chat-qui-pelote* was composed in October 1829, Girodet's *Oeuvres posthumes* had appeared, complete with Coupin's extensive biographical essay, Girodet's correspondence, translations, theoretical writings and his poems, *Le Peintre* and *Les Veillées*. Balzac clearly demonstrates his familiarity with the two volumes here and in other stories of the period. The reasons *why* he chose Girodet both as a favorite painter and as model for the flawed artist will only become apparent upon examination of the tales and Balzac's own conflictual relationship with the visual arts. Through his connections with Devéria and the Duchesse d'Abrantès, Girodet's friend and Balzac's mistress, the author gained access to intimate details of the painter/poet's life, allowing him insight into Girodet's artistic struggles and an added patina of realism in his portrayal of the artistic life.[75]

Like Pygmalion, Sommervieux has rejected real women for the fantasy of the painted virgin. When he falls in love with Augustine, his passion is

based on her resemblance to a work of art: "From the rapture stamped on his exalted soul by the unposed scene he was contemplating, he moved naturally toward a deep admiration for the main figure. Augustine appeared pensive and ate nothing; the lamp was arranged in such a way that light fell entirely upon her face, her head and shoulders seemed to move in a brilliant circle that sharply highlighted the contours of her head and illuminated it in an almost supernatural manner."[76] He becomes infatuated with an image that he himself has produced; she is a *figure principale*, rather than a girl. Sommervieux's Augustine is so far removed from reality that the very act of eating would destroy the illusion, and her movement seems illusory, like Galatea's animation. Unable to eat or sleep, Sommervieux translates the image that is consuming him from his imagination to canvas. Yet, as Balzac is quick to point out, the memory that he transposes has little relation to what was really there: "Le lendemain, il entra dans son atelier pour n'en sortir qu'après avoir déposé sur une toile la magie de cette scène dont le souvenir l'avait en quelque sorte fanatisé. Sa félicité fut incomplète tant qu'il ne posséda pas un fidèle portrait de son idole" (The next day he entered his studio and did not leave until he had fixed upon a canvas the magic of this scene whose memory had in a way fanatasized him. His bliss was incomplete as long as he did not possess a faithful portrait of his idol) (1: 53). Playing on the proximity between *fantaisie* and *fanatisé* (fantasy and fanaticized), Balzac highlights the fetishistic nature of Sommervieux's relationship to this *idole*, an image that becomes overinvested with personal meaning entirely at odds with reality. Like so many Pygmalions before him, Sommervieux has fallen in love with the product of his own imagination, but in a variation on the theme, the artistic fantasy is translated back into reality, allowing him to view a living woman as a work of art, instead of the reverse.

Sommervieux's connection to Girodet is established when Balzac identifies the real Neoclassical painter as the fictitious painter's friend and mentor, including him as a character in the story. Sommervieux has withdrawn from society, giving himself over entirely to his obsession, and it is not until Girodet asks him what he will be sending to the impending Salon that he is summoned from his solipsistic dream. Upon seeing Sommervieux's genre scene of the Chat-qui-pelote and Augustine's portrait, Girodet grasps his friend's situation. He embraces Sommervieux "unable to find words. His emotions could not be rendered as he perceived them, from soul to soul."[77] Rendered speechless by the author, the ever-eloquent Girodet intuits that Sommervieux is in love. He counsels Sommervieux to hoard his masterpieces, protecting them from an unappreciative public, and advises his protégé, "faisons plutôt des vers, et traduisons les Anciens! il y a plus de gloire

à en attendre, que de nos malheureux toiles" (let's make poetry instead, and translate the Ancients! There is more glory to be found there than from our miserable canvases) (1: 54). The passage resonates with Girodet's personal obsessions—his vanity, his secretive nature, his fear of rejection and his poetic ambitions—standing witness to Balzac's intimate knowledge of the painter's life and art while forging a clear link between Sommervieux and the author of *Endymion*. As the fictitious Girodet explains, their images are not meant for public consumption, they are "des écrans, des paravents" (screens) onto which the artist's emotions and fantasies have been projected. Like Frenhofer to come, Balzac's Girodet advocates a protective, fetishistic approach to the artwork that is not meant as a form of communication with an audience, but rather as a personal expression by and for the artist alone. His exhortation to abandon "nos malheureux toiles" for the *gloire* of poetry and translation invokes Girodet's own career and the original title of Balzac's story, *Gloire et malheur*, as well. Girodet indicates here that painting is associated with unhappiness, poetry with glory, and Balzac's tale of the artist and his craft bear out this opposition in the ultimate triumph of the author and his narrative over the painter. Despite Girodet's warnings, Sommervieux displays his paintings at the Salon to great popular acclaim. In an evocation of Girodet's *Pygmalion*, the narrator notes, "As for the portrait, there are few artists who do not still remember this animated canvas on which the public, who are sometimes discerning as a group, conferred a crown which Girodet himself hung on the frame,"[78] recalling the controversial canvas of 1819 both in its "lifelike" attribution and in the laurel wreath placed on its frame by Girodet himself.

If Théodore fell in love with an image, Augustine follows suit, for she reciprocates his passion only when she sees the painting at the Salon, and recognizes the painter as her mysterious voyeur. Art thus stands as an intermediary between the lovers, but to negative effect, for it reflects a fantasy at several removes from the reality presented by the narrator and cannot bring happiness to either. Augustine's cousin, Mme Roguin, a self-identified Romantic, takes it upon herself to join the star-crossed lovers, flattered by Sommervieux's attentions ("This morning he gave me my portrait made by the hand of the master. It is worth at least six thousand francs") and her own fantasies of the "rôle d'une petite-maîtresse." The notary's wife intercedes on behalf of the lovers, protesting to Guillaume, "I come in Noah's ark, like the dove with the olive branch. I read that allegory in *Le Génie du christianisme*."[79] The ridiculous Roguin, a parodic bourgeoise caricature, invokes through her reference to this Romantic manifesto, Chateaubriand and *Atala*, both subjects of Girodet's brush. Once a meeting has been effec-

tuated between the aristocratic artist and the bourgeois family, the disso-
nance between the two spheres and their respective languages makes their
incompatibility evident to all but those involved, blinded as they are by
Romantic fantasy and self-interest. Guillaume, ever practical, can only see
painting in terms of its use-value and painters are reduced to "des meure-
de-faim" (starving wretches). When Lebas, the oldest apprentice, assures
him that the paintings might help sell more cloth, Augustine's father is not
convinced, and "This observation did not prevent art and thought from
being condemned once again at the tribunal of Trade."[80]

Balzac's focus shifts from visual to verbal languages, as the author
demonstrates that the same word can evoke entirely different meanings for
two individuals, each of whose understanding is shaped by his own expe-
rience.[81] Thus, when Théodore presents his painted scene of the Maison
du chat-qui-pelote to the family, Lebas admires his execution of drapery in
the image. The artist modestly admits "Les draperies font toujours très bien
[. . .] Nous serions trop heureux, nous autres artistes modernes, d'atteindre
à la perfection de la draperie antique" (Draperies are always effective [. . .]
We modern artists would only be too happy to attain to the perfection of
ancient drapery). In a comic turn fundamental to the aesthetic of the
malentendu that characterizes the tale, the clothmaker leaps in: "Vous aimez
donc la draperie [. . .] Eh bien, sarpejeu! touchez-là, mon jeune ami.
Puisque vous estimez le commerce, nous nous entendrons" (So you like
drapery [. . .] Well then, by jove, let's shake on it, my young friend. Since
you value commerce, we will understand each other) (1: 70). By the same
token, when the smitten Augustine asks her other suitor, Lebas, what he
thinks of painting, the apprentice responds "je connais un maître peintre
en bâtiment, M. Loudois, qui a des écus" (I know a master house painter,
M. Loudois, who has made some money) (1: 65). Where the commercially
oriented merchants read the world in terms of the real and concrete, Som-
mervieux sees it exclusively in terms of art and representation: what is for
one a beautiful painting is for the other a useless means to "gâter de bonnes
toiles" (spoil good canvas) (1: 71). Yet, the misunderstandings go unper-
ceived by the characters who are unable to interpret any linguistic register
outside their own consciousnesses. Augustine loves Théodore "without
perceiving any of the differences between herself and him."[82] Her failure
to "read" her lover is evident when Mme Guillaume, with the help of her
besicles (spectacles), spots Sommervieux hidden behind a pillar at church,
watching and worshipping his "madone" with idolatrous fervor, and in turn
catches her daughter following the mass in a prayer book held upside
down. Similarly, in the wake of the conversation with his future in-laws,

Sommervieux is so blinded by love that he too cannot see the chasm that separates their worldviews. The narrator's metaphor, "The blindfold that covered the young artist's eyes was so thick that he found his future in-laws amiable,"[83] highlights the image of cloth as the barrier between the two worlds, while emphasizing the painter's patent incapacity to see.

La Maison du chat-qui-pelote presents the dangers of transgressing boundaries through the ill-fated marriage of Augustine and Théodore, while reflecting simultaneously upon the consequences of breaching social and artistic hierarchies. For indeed, if Sommervieux comes from a world of images, Augustine comes from a world of words, and the merging of these two incompatible spheres results in the negation of both. For Balzac, beginning his literary career at a moment when word and image were united as never before, the naturalized relationship between the two realms was potentially pernicious. Consequently, Augustine and Sommervieux's ill-fated marriage of bourgeois and nobility encodes the equally inauspicious union of words and images: if the failure of the marriage demonstrates that art and commerce should remain separate, then so, by extension, should words and images. Girodet, as advocate of the painter's rights to poetic expression, stands as symbol for the aesthetic of generic transgression and its negative consequences. Moreover, if the blurring of boundaries between the social and aesthetic realms is endorsed by the Romantic Mme Roguin, then the narrator, in pointing out the irreconcilable differences between them, stands for an aesthetic deliberately at odds with Roguinian Romanticism—that is, a nascent Balzacian Realism.

Once united, the couple's blissful infatuation is quickly halted when Augustine conceives their first child: the death knell for love in nineteenth-century novels. In shifting from virgin to expectant mother, Augustine leaves the realm of the ideal for the real; in becoming corporeal and human, she shatters her husband's fantasy. Waking up to his own illusion, "Theodore could not ignore the evidence of a cruel truth: his wife was not sensitive to poetry, she did not inhabit his sphere, she did not follow him in all of his caprices, his improvisations, his joys and his sorrows; she existed in the earthbound realm of the real world, while he had his head in the clouds."[84] As both husband and wife become increasingly aware of the irremediable gap between their temperaments and sensibilities, "ces sentiments secrets mirent entre les deux époux un voile qui devait s'épaisser de jour en jour" (these secret feelings placed between the couple a veil that became thicker each day) (1: 76). The veil that blinded them to their differences now serves as a barrier between them; perceived by both as it thickens daily, it continues to prevent them from truly "seeing" the other.

Mme Guillaume represents the voice of reason, for she sees what her daughter cannot. With a perspicacity entirely missing from the Romantic protagonists, she queries, "Have you ever seen a man [. . .] who puts statues to bed beneath muslin sheets and has his windows closed during the day to work by lamplight?",[85] revealing once again the link between Sommervieux, Pygmalion and Girodet.

Once the baby arrives, Sommervieux takes up with the Duchesse de Carigliano, a figure who has been linked to Balzac's own mistress, the Duchess d'Abrantès.[86] Despairing of her husband's lost affections, Augustine pays the Duchesse a visit, seeking lessons in the artifice that is entirely foreign to her. Confronting the complex linguistic register spoken by the Duchesse de Carigliano's possessions and bearing, "She tried to guess the nature of her rival from the scattered objects; but there was something as impenetrable there in the disorder as in the symmetry, and for the naive Augustine, they were sealed letters."[87] Augustine cannot "read" the visual signifiers, which present a foreign language of images that lie beyond the parameters of her literal, word-based world. The Duchesse, stretched out on her couch like a sultaness, is at one with her ornate surroundings. Like Augustine, she too is a work of art, but one that she herself has consciously composed:

> Au fond de ce frais boudoir, elle vit la duchesse voluptueusement couchée sur un ottomane en velours vert placée au centre d'une espèce de demi-cercle dessiné par les plis moelleux d'une mousseline tendue sur un fond jaune. Des ornements de bronze doré, disposés avec un goût exquis, rehaussaient encore cette espèce de dais sous lequel la duchesse était posée comme une statue antique. La couleur foncée du velours ne lui laissait perdre aucun moyen de séduction. Un demi-jour, ami de sa beauté, semblait être plutôt un reflet qu'une lumière. Quelques fleurs rares élevaient leurs têtes embaumées au-dessus des vases de Sèvres les plus riches. (1: 86)
> (At the end of this cool boudoir, she saw the duchess lying voluptuously on a green velvet ottoman placed in the middle of a sort of semi-circle defined by the soft folds of muslin stretched over a yellow lining. Gilded bronze ornaments, placed with exquisite taste, further enhanced this sort of dais under which the duchess was posed like an antique statue. The deep color of the velvet availed her of every means of seduction. The twilight, that friend of beauty, seemed more of a reflection than a light. Some rare flowers raised their perfumed heads from the richest Sèvres vases.)

The elaborate portrait of the Duchesse de Carigliano presents an important contrast to the unseen portrait of Augustine. Identified as a *tableau*, she

presents herself as such, and the narrator emphasizes her self-conscious attention to the lighting, color, composition and background of her own posed self-portrait. Unlike Théodore's images of Augustine and the *Chat-qui-pelote*, this painting of the Duchesse is not at odds with reality, it *is* reality, as structured and created by the subject herself. If Augustine was introduced as one of Raphael's virgins, the object of an idealizing imagination, the voluptuous Duchesse seems to have emerged from a contemporary canvas. Elevated on a pedestal, surrounded by decadent classical markers of wealth and sensuality, Sommervieux's lover evokes Mme Récamier reclining in her gauzy gowns upon couches in portraits by David, Gérard, Dejuinne, et alia. This vivid image is a collaborative effort between the Duchesse and her spectator, and the author provides us with a far more detailed "work of art" than the painter did. Augustine's portrait remained mired in the realm of generalities and personal impressions nearly impossible to visualize; once painted it is never described. Yet while Balzac's reader is presented with a clear image in words, Augustine is at a loss before the real image.

The Duchesse is at once the most apparently artificial character in *La Maison du chat-qui-pelote* and the most insightful one, for she is able to distinguish between illusion and reality and successfully negotiate between the realms. Taking pity on her lover's abandoned wife, she explains Augustine's error in marrying an artist: "We must admire men of genius, and enjoy them like a performance, but live with them! never. No, no. It is like trying to take pleasure in watching the machinery backstage at the Opera, instead of sitting in a box and savoring the brilliant illusions."[88] The Duchesse transforms the artist into the spectacle to be enjoyed and discarded; as creators of illusion they cannot be taken at their word anymore than an opera, a painting or a novel should be taken as real or "true." Defining marriage in terms of power, not passion, she counsels the innocent Augustine to resist the tyranny of love in order to *régner* (reign), a woman's tools consisting in her abilities to "dissimuler, calculer, devenir fausse, se faire un caractère artificiel . . ." (1: 89). The Duchesse carefully distinguishes between love and marriage, illusion and reality, emphasizing that women's power arises not from any real status or strength they might have, but from the *appearance* of power—"Notre pouvoir est tout factice" (Our power is a grand illusion) (1: 90). The lesson to the innocent bride is that she must learn to control appearances, deriving power from her understanding and manipulation of the difference between artifice and reality.

The Duchesse's words shock the naïve Augustine; her actions open her eyes to her husband's corruption. Leading her to a private chamber, the

Duchesse de Carigliano shows Augustine her own portrait as Mlle Guillaume that Sommervieux has given to his mistress. This literal and metaphoric betrayal of his wife stands as symbol of the ultimate violation, as the former fetish is offered up on the altar of the new object of adoration as a many layered sacrifice. The painted image has been throughout the story a public token, first mediating the meeting of Sommervieux and his love, and ultimately her family, through its exposition at the Salon, then presented to the Duchesse who next gives it back to Augustine, who will in turn show it to Sommervieux, with sinister results. This portrait of Augustine—a simulacrum of the private woman that circulates publicly— posits the opposition of the real versus the ideal while illustrating the power of the latter over the former, for indeed the image precedes its original everywhere—at the Salon, at the Duchesse's, and even in death. The disturbing scene in the Duchesse's *cabinet* juxtaposing "l'original devant la copie" (1: 91) portends the destruction of both. For while the aristocratic realist can tread the fine line between the two realms, the more romantically idealistic Sommervieux and his wife will not be able to support the confrontation of truth and illusion.

Thus, when Augustine follows the Duchesse de Carigliano's advice, it backfires disastrously. Presented with the painting that his wife has brought home, "the artist stood motionless as a rock, and his eyes moved alternately between Augustine and the accusatory canvas."[89] The painter is enraged by the forced comparison of his wife and her image; the movement of his eyes between woman and simulacrum, real and ideal, highlights his terrifying confrontation with his own illusion. Sommervieux is turned to stone by the sight of his wife and her image, a pair of Medusas embodying the visible signs of difference and thus the implied threat of castration. One of the three Gorgons, Medusa was so hideous that whoever looked upon her turned to stone, but as Freud interprets the myth, Medusa's head is a figure of sexual difference, representing the projected specter of the mother's [fantasized] castrated genitals. As Charles Bernheimer explains, "Medusa is the [male] look fascinated by its [female] otherness in the mirror. It is the emblem of the failure of Narcissus's specular self-love, suggesting that his identity is monstrously mutilated."[90] For Sommervieux, the painted image of Augustine represented an ideal projection of his fantasies and desires that erased the difference between [male] self and [female] other. When forced to face the dissimilarity between his fantasy (the painting) and reality (his wife), Sommervieux is quite literally *petrified*, as the repressed recognition of difference figures forth the image of castration, a sign that had hovered before him, unseen, throughout the text. Balzac's story is the tale

of unacknowledged differences and their dangers, taking the form of class difference (aristocrat vs. bourgeois), professional difference (artist vs. merchant) and generic difference (words vs. images) that are equally reducible to gender difference: male vs. female. The Duchesse de Carigliano can view the painting of Augustine and the model herself with equanimity, for as a pragmatic realist she has long recognized the differential nature of reality and the relations between men and women. While dissimilar from Augustine in nearly every respect, she shares and acknowledges her existence as other-than-male.

The penis and the repressed fantasy of female castration, intimately tied to fetishism, thus serve as a central metaphor for the multilayered question of separation and difference around which Balzac's cautionary tale is structured. As Elizabeth Grosz contends, "The phallus is the 'signifier of signifiers,' the term that defines each subject's access to the symbolic order. It is emblematic of the structure of language, the gap dividing language from the real, which enables the signifier to slide over the signified and makes the polyvalence and play of language possible."[91] The phallus, as signifier of difference, represents the recognition of the gap between signified and signifier and language's symbolic nature, so at odds with the direct, mimetic nature of painting. The elision of sexual difference, in the refusal to recognize woman as Other, here emblematizes a further elision of linguistic difference between sign and meaning, and a steadfast desire, as seen in Augustine and Théodore, to take the world at face value. The author's emphasis in *La Maison du chat-qui-pelote* on the polyvalent nature of language, in the many *malentendus* that punctuate the narrative, highlights the multiplicity of meanings attributable to a single word (thus the gap between signified and signifier). Moreover, the characters' incapacity to transcend the literal and translate signs into multifaceted signification signals a naïve relationship to language entirely at odds with the narration's playful indeterminacy. While Augustine may partake of the world of words and Sommervieux the world of images, each is impeded in his or her relationship to that world by this literal-minded approach that sees in signs—whether visual or verbal—an absolute equivalence with the referent that refuses to acknowledge the gap that is difference. Grosz adds, "The gap is the founding trace constituting the unconscious as such through repression of the signifier of incestuous desire. When the veil is lifted there is only the Medusa, women's castrated genitals, lacking, incomplete, horrifying (for men). Salome's dance, like striptease, can seduce only when at least one veil remains, alluring yet hiding the *nothing* of women's sex. The fetish thus plays the role of the veil, both outlining and yet covering over women's

castration."[92] In *La Maison du chat-qui-pelote*, the portrait, as fetish, can only function as erasure of difference as long as the fantasy of equivalence between signifier (painting) and signified (Augustine) can be maintained. When the confrontation between the real (woman) and the ideal (portrait) destroys this illusion by exposing inevitable gaps and fissures, the veil between Augustine and Sommervieux that masks the differences between them indeed reveals a petrifying Medusa.

Unable to accept the dichotomy between representation and reality, Sommervieux destroys both. Turned to stone by the revelation of repressed difference, his wife's entreaties leave him cold. Balzac's final portrait of the artist is an overwhelmingly negative one, for he exposes both Sommervieux's artistic and personal shortcomings. The "tortures of the artist's wounded vanity"[93] lead him to seek revenge on the Duchesse in a manner closely resembling Girodet's own attack on Mlle Lange in his *Danaé*. The artist proclaims, "I will avenge myself . . . she will die of shame: I will paint her! yes, I will represent her as Messalina leaving Claudius's palace at night."[94] Sommervieux's desire to use art as a weapon continues the conflation of representation and reality, for the Duchesse de Carigliano *is* an adulterous Messalina, much as Girodet's portrait of Mlle Lange reflected a literal truth. Balzac's version of this notorious episode from Girodet's career was doubtless shaped by his own mistress's memoirs, for the Duchesse d'Abrantès recounts the episode in the very volume Balzac was helping her write and edit in 1829, as he wrote *La Maison du chat-qui-pelote*. In keeping with d'Abrantès's reaction to Girodet's impetuous actions of 1799 ("il était passionné, irascible . . . il eut tort" [he was passionate, irascible . . . he was wrong]), Sommervieux is portrayed as shallow, vain and unfaithful, motivated by ego and self-interest. Even as his wife implores him in "une voix mourante" (a dying voice) he proclaims "Je la tuerai" (I will kill her). Although he is referring to his treacherous mistress, the unrecognized polyvalence of language is such that his words are true in respect to another "la"—Augustine and her surrogate, the painting. In his fury, all women become interchangeable for Sommervieux, and in last ditch effort to eliminate difference, the artist destroys the accusing image in a scene of violence that recalls Girodet's desecration of the original portrait of Lange. The scene of Sommervieux's "démence" (madness) is indeed so horrible that the narrator refuses to recount it, and limits himself to the results, allowing the reader's imagination to fill in the gaps. The next morning, when Mme Guillaume stops by to visit her daughter she finds a disheveled and tear-stained Augustine "contemplating the fragments of a torn canvas and the broken pieces of a large gilded frame scattered on the floor."[95] The

painted image of Augustine, a fetish replacing the real woman in Som-
mervieux's affections, is in the end a surrogate both for his wife—the orig-
inal subject—and for his mistress, to whom the image has been given. Like
a word or a coin, this circulating signifier takes on different values, even for
its creator, but the painter cannot recognize the polyvalent nature of the
sign, even as he destroys it. And while the Duchesse will survive, Augustine
will not, as she is destroyed by art and an artist she failed to understand.

Balzac's opening tale of the *Comédie humaine* thus presents an undeni-
ably negative portrait of the artist and of the dangers of visual representa-
tion, which threaten to destroy the real by privileging the ideal. This early
but emblematic approach to painters and painting reflects Balzac's effort to
establish his authorial presence on the changing literary scene. In "La toile
déchirée," Franc Schuerewegen explains, "the narrative is in reality con-
structed at the expense of a pictorial *failure*, an incapacity to represent
which comes as a condition of the possibility of the production of the
story. . . . the Balzacian painting must be erased, even annihilated to the
profit of the production of the narrative."[96] Defining himself in con-
tradistinction to the failures of painting, Balzac posits a counter-discourse
to the reigning hierarchy of representation as formulated in the equiva-
lence between seeing and knowing promoted by the physiologies—a dis-
course in which he himself participated. By showing how the painter
cannot see what the author can, and by demonstrating the complex nature
of our experience of the visual world as closely modeled on the act of
reading, *interpreting* and *translating* signs into meaning, Balzac subverts the
straightforward assumption of *voir* = *savoir*. Sommervieux's inability to per-
ceive difference, his fetishizing desire to substitute representation for real-
ity, is portrayed as the ultimate blindness, creating an art that destroys both
itself and life. The perception of the many layers of difference between
class, art, commerce and gender are all reflected in the differences between
words and images, thus accessible to the reader of Balzac's tale, but not to
the painter or to his audience. Sommervieux's ultimate disillusionment and
his forced recognition of a difference between the real and the ideal may
take the form of a symbolic confrontation with castration, but it is not a
literal castration. In keeping with Balzac's own linguistic structures, it is
rather a symbolic recognition both of lack and difference, "castration as a
differential process of substitution, subverting, on the contrary, literality as
such."[97] Shoshana Felman has linked class struggle and gender struggle in
Balzac, seeing common to both "the very structure of *division* from which
they spring, as well as the principle of *hierarchy* that, in both cases, organizes

the division as an authoritative *order*."[98] In *La Maison du chat-qui-pelote, Sarrasine* and *Le Chef-d'oeuvre inconnu* the *generic* struggle between painting and literature must be added to the formulation, for indeed in each of these tales the author demonstrates the *division* between painting and prose, establishing new hierarchies based on the superiority of words over images.

Chapter 5 ∾

SARRASINE:
GENDER, GENRE AND THE
FEMALE READER

Women Readers and Women Writers of the July Monarchy

B alzac's debt to the female reader of the July Monarchy has become a critical commonplace.[1] Middle- and upper-class women who had the leisure time to read and the disposable income to purchase or borrow books and periodicals had become an influential force in nine-teenth-century literary production. Famously attuned to the workings of the marketplace, Balzac was keenly aware of the power of the female read-ership, noting that "a *woman's novel* is a much better speculation on fame than a manly work."[2] Yet, Balzac's misogyny, betrayed both in his fiction and in his correspondence, is equally renowned. Although his readers appreciated the plethora of complex female characters that populate his stories and novels, one is hard pressed to find a single sympathetic heroine in *La Comédie humaine* who is neither a villainess nor a victim. Owen Heathcote notes the fundamental "duality and duplicity of women"[3] in Balzac's oeuvre, where a dominant theme is adultery and betrayal perpe-trated on or by women. Despite Balzac's reputation as a harsh critic of the institution of marriage, his fiction proposes implicit support for the status quo, and his first major publication, *Physiologie du mariage* (1829) presents nothing less than a breviary of postrevolutionary strategies to "remettre les femmes à leur place."[4]

Balzac's desire to "put women in their place" was a politically and aes-thetically motivated response to the return of women to the public sphere. In a clear echo of 1789, the conservative Bourbon monarchy was over-thrown by a revolution in which women once again played an active and visible role, as emblematized by Delacroix's iconic *Liberty on the Barricades*.[5] By 1830, the maternalist "hearth and home" politics of Empire and

Restoration gave way to an era of increased female activism in both the intellectual and political spheres. The women's emancipation movement, along with Saint-Simonism and Fourier's utopianism, proposed images of sexual freedom based on female equality that contributed to widespread anxiety regarding gender roles and social structures. Richard Bolster observes, "Thus it seems that class war was joined by a war between the sexes, and these are the two new themes that came to enrich the novel as it was reborn after 1830."[6] Unprecedented numbers of female authors entered the literary marketplace, most notably in the periodical press, and the period from 1830-1848 saw as many female writers as the entire eighteenth century.[7] For the handful of nineteenth-century women authors read today—Mme de Staël, George Sand, Claire de Duras, Marceline Desbordes-Valmore, Flora Tristan—were countless others enjoying equal popularity in their own day, including Sophie Cottin, Hortense Allart, Delphine Gay, Anaïs Ségalas, Amable Tatsu, Louise Ackermann, et alia. Individually and collectively, these *femmes auteurs* presented direct competition to their male counterparts, generating tensions, jealousies and rivalries that took the form of Bolster's "guerre des sexes" on a variety of levels.

For male authors, the proliferation of *femmes auteurs* emblematized the threatening dissolution of sexual and professional hierarchies while further demonstrating the loss of prestige that art had suffered, first in its commodification, and now as a *female* domain. Christine Planté explains,

> la femme intellectuelle, artiste ou émancipée compromet à la fois la perpetuation de l'espèce et les traits les plus stables et les plus valorisants de l'image du créateur. Les masques s'échangent, les rôles se brouillent, les hiérarchies s'effondrent. [. . .] Pour rester hommes à des places d'hommes, il faut renvoyer les femmes à leurs rôles, au nom d'une infériorité démontrée avec une violence à la mesure du danger, violence qui prouvera du même coup la fermeté virile, un instant mise en doute, de celui qui y recourt.[8]
> (the female intellectual, artist or emancipated woman compromised at once the perpetuation of the species and the most stable and valorizing features of the image of the creator. [. . .] To remain men in men's positions, women must be returned to their roles, in the name of an inferiority demonstrated with a violence commensurate with the danger, a violence that will prove at the same time the manly resolve, momentarily put into question, of he who has recourse to it.)

The more concrete threat of financial competition accompanied the perceived assault on literature's status. Women wrote primarily to support themselves and their families, and most *femmes auteurs* of the 1830s avoided

openly feminist themes in order to appeal to the widest possible audience. Yet, as Michèle Sarde notes, "For a woman to write and be published already constituted a subversive provocation, and she was immediately treated as a bluestocking and charged with the crime of feminine treason. As soon as a woman 'wants to emulate a man, she is a monkey,' wrote Joseph de Maistre in 1808 and Barbey d'Aurevilly echoes 'Women who write are no longer women. They are men—at least would-be men—and failures at it!'"[9] Thus, the proliferation of female authors and readers during the July Monarchy provoked strong resistance from the patriarchal order, promulgated in negative images of *intellectuelles*, *bas-bleus* and *femmes auteurs* and their injurious effects on literature and society. Rapidly, the *femme auteur* became an operative cultural stereotype rife with ideological projections and fantasies informed by a threatened virility and an unspoken fear of emasculation at the hands of these "unnatural" women.

The renewed female presence in literature and politics resulted in a spate of parodic images of women in the guise of men, often *en travestie*, and men feminized by their masculine wives—feeding and diapering babies or cleaning the house in skirtlike robes while their pen-wielding wives toil away on their manuscripts or attend political meetings. Grandville's illustration from *Scènes de la vie privée et publique des animaux* [figure 5.1] portrays the *femme auteur* as a magpie, playing off of the pun of *la femme de plume* (feather/pen) and the meaningless jabbering of the shrill bird. The caption reads "J'espère prouver un jour qu'entre les mains d'une pie intelligente, une plume n'a pas moins de valeur que dans les griffes d'un loup ou les pattes d'un renard" (I hope one day to prove that a pen in the hands of an intelligent magpie has no less value than in the claws of a wolf or the paws of a fox), in an unambiguous attack on the pretensions of the "fair sex" to intellectual equality. Her feminine duties cast aside—as symbolized by an overturned pot and a mouse nibbling at her discarded knitting—this female author stares off into space, contemplating her next line, pen in one hand, smoking cigar in the other. The phallic pen, cigarette, knitting needles and above all the dagger hanging from her belt and pointing at her crotch, vividly illustrate the masculine and emasculating force of the *femme auteur*. The Farnese Heracles, stooping above the yawning mouth of the overturned urn, his genitals obscured by a woman's fan, designates the castrating nature of this artistic usurpation: the embodiment of Classical art dwarfed and rendered impotent by this unnatural creature.

For Balzac, the emergence of the *femme auteur* and the "grande émancipation femelle de 1830" represented a dangerous threat to society, the family and the male author himself. His familiarity with literary women was

Figure 5.1. J.-J. Grandville, Illustration from *Scènes de la vie privée et publique des animaux*. 1842.

extensive, beginning with his own beloved sister Laure. Although she claimed she wrote only for herself, Laure published for years under the name *Lélio*, only after her brother's death daring to sign her works with the name Balzac.[10] Balzac's close ties to the Duchesse d'Abrantès from the mid-1820s until the late 1830s further brought him into contact with literary women and their world at her salon, and it was during this period that he forged his lifelong friendship with Sand. D'Abrantès, who wrote under the name of Constance Aubert, contributed frequently to women's periodicals and was outspoken in her efforts to disprove the misogynistic assumption that "les femmes auteurs ne sont plus femmes" (women authors are no longer women).[11] She avowed "I simply maintain that women have strong souls, courageous hearts, patriotic virtues, and I maintain that they can do anything that a man can do through the force and strength of will,"[12] contentions that her young lover would try to disprove in his own writings. Although he maintained friendships and even a long-term love affair with intellectual women, Balzac was categorically dismissive of their literary efforts. As he confided to Mme Hanska, "I quite like it when a woman writes and studies, but she must, as you have done, have the courage to burn her works."[13] Even the greatest women authors of his century were not exempt from his condescension, and for Balzac "Mme de Staël, George Sand, the princess Belgiojoso were admirable and dangerous monstrosities."[14]

Balzac was particularly competitive with his friend Sand, coining the phrase "sandisme" to denote "a sort of 'sentimental leprosy' that spoils women by giving them pretensions to moral superiority and literary genius."[15] Sand's unconventional lifestyle and cross-dressing flaunted the conventions of marriage and femininity that Balzac embraced, but above all she posed a double threat in her gender reversals and public success. Balzac intoned to Mme Hanska, "She is a boy, she is an artist, she is great, generous, devoted, *chaste*, she has the great characteristics of a man, *ergo* she is not a woman."[16] Sand served as a negative model for several of his intellectual heroines in the *Comédie humaine*, most notably in *Béatrix* (1838-45), a *roman à clé* that Mme Hanska found "so transparent as to be in very bad taste."[17] Readers recognized the author of *Indiana* in the "hermaphroditic" *femme auteur* Félicité des Touches, "fille audacieuse et perverse," whose androgynous pseudonym (Camille Maupin), dress and comportment pointed directly to George Sand (née Aurore Dupin). Echoing Balzac's thoughts on Sand, his fictitious Béatrix says of Félicité, "You have something of the man in you, you act like them, nothing stops you, and if you do not have all of their advantages, your mind works like theirs, and you

share their scorn for us."[18] For Balzac, the *femme auteur* is indeed a man, or at the very least, not a woman.

The end of the Restoration and the onset of the July Monarchy was a period of profound instability, and the social and political crises that led up to the July Revolution did not abate with the installation of the Orleanist king. From 1830–1840 tensions and rivalries between right and left dominated the Chamber of Deputies, where ministries averaged less than a year in duration. Legitimists clamored to oust the "usurper" from his throne, and no fewer than ten attempts were made on the king's life. France entered into war with Algeria while republican agitation was becoming an increasing threat on the home front. A series of riots and insurrections erupted across the nation, the most dramatic of which was the Lyon uprising of 1831 where 15,000 striking workers were "suppressed" by the National Guard, resulting in over 600 casualties. Class conflict grew increasingly tense at every level of the French society. The old aristocracy, petty bourgeoisie and peasants were equally alienated by the bourgeois monarchy, and continually at odds with prosperous upper bourgeoisie, now perceived to be the dominant social and political class. Widespread cholera epidemics in 1832 further added to the sense of unease during an era that was touted as one of peace and prosperity.

The general sense of unrest in France around 1830 found expression in artistic images of gender "instabilities" that reflected the psychic dislocations of a generation in perpetual crisis. As Romantic male authors appropriated "feminine" qualities (vulnerability, sensitivity, passivity) for their heroes, real and fictitious female authors adopted—or were assigned—a "virilized" persona defined in terms of failed femininity and/or the emasculation of attendant men. As women entered the artistic equation in unprecedented number, gender-based metaphors for creativity took on new nuances that reflect the shifting dialectic between "masculine" and "feminine" in nineteenth-century French art and culture.[19] As noted above, "impotence" was a popular trope during the Restoration and July Monarchy, when the phrases *impuissance, défaillance, stérilité, manque de virilité* dominated discourses on art, politics and society. Chateaubriand labeled his own era "une époque de stérilité," and Barrault, a Saint-Simonian, decried the fact that "Irrefutable evidence of man's impotence is bursting forth everywhere."[20] But where the Romantics themselves celebrated this image of exhaustion and decadence (their ongoing production belying its literal truth), opponents of the movement used the metaphor of sterility to denounce Romantic art itself as empty, exhausted and emasculated.

Thus, in an effort to distinguish his voice from the Romantic and female

authors populating the pages of the popular press, Balzac proclaimed his creation "un acte viril" that "would excite riots in a republic where the critiques penned by eunuchs have long forbidden the invention of any form, genre or action whatsoever."[21] If practitioners and critics alike linked Romanticism with impotence, renewal lay in rebirth. Balzac's accusation, "The century is like a perpetually pregnant woman who never gives birth,"[22] harkens back to David's criticism of Girodet while highlighting the fundamental tensions between production and impotence motivating these metaphors of birth and miscarriage. Yet the trope of art as childbirth had always been based on a paradoxical image of exclusively male fertility and procreation. Once women entered the artistic scene in significant numbers and aspired to the status of genius themselves, artists such as Balzac felt impelled to reassert both artistic "birth" and genius as exclusively male domains.[23]

From Aristotle onward, western culture defined genius as a distinctly male form of mental strength. The link between artistic genius and male fertility emerged from the stoic conception of *logos spermatikos* and was later confirmed in Tissot's *De la santé des gens de lettres* (1766) where "the animating nervous fluid that produces genius is made analogous to the male semen," beliefs that made female genius an impossibility.[24] Where women's "limited" energies were devoted to the physical production of children, male energies, infinitely more protean and "potent," were seen to be capable of the quasi-divine act of creating art. However, with the onset of Romanticism and its cult of sensibility, genius became associated with traditionally "female" qualities; as Christine Battersby notes, "On the one hand—even before Freud—the driving force of genius was described in terms of *male* sexual energies. On the other hand, the genius was supposed to be *like a woman*: in tune with his emotions, sensitive, inspired—guided by instinctual forces that welled up from beyond the limits of rational consciousness."[25] This androgynous model of genius, wherein the physically male artist possessed psychic qualities of "femaleness," was at once influential and disquieting. Ironically, the androgyny read only one way: a physically female artist with psychically male characteristics was not a genius, but a monster or a freak. Indeed, Battersby adds, "The Romantics' muddling of the old categories of 'female', 'feminine' and 'male' did not fundamentally disturb the old sexual hierarchies—and produced, at best, a male ambivalence towards female authorship."[26]

Thus, in spite of the integration of female characteristics within the Romantic definition of genius, it continued to be considered an exclusively male attribute, as artists and aestheticians made concerted efforts to

distinguish between creation and reproduction. In *Des Artistes*, a series of three articles appearing in *La Silhouette* in early 1830, Balzac attempted new definitions of art, the artist and genius. He describes the genesis of the work of art in terms of the familiar childbirth metaphor:

> Un soir, au milieu de la rue, un matin en se levant ou au sein d'une joyeuse orgie, il arrive qu'un charbon ardent touche ce crâne, ces mains, cette langue; tout à coup, un mot réveille les idées; elles naissent, grandissent, fermentent. Une tragédie, un tableau, une statue, une comédie, montrent leurs poignards, leurs couleurs, leurs contours, leurs lazzis. C'est une vision, aussi passagère, aussi brève que la vie et la mort; c'est profond comme un précipice, sublime comme un bruisement de la mer; c'est un groupe digne de Pygmalion, une femme dont la possession tuerait même le coeur de Satan; c'est une situation à faire rire un pulmonique expirant; le travail est là, tenant tous les fourneaux allumés; le silence, la solitude ouvrent leurs trésors; rien n'est impossible. Enfin, c'est l'extase de la conception voilant les déchirantes douleurs de l'enfantement. (OD 1: 353)
>
> (One evening, in the middle of the street, a morning upon arising or in the midst of a joyous orgy, it may happen that a live coal touches this brain, these hands, this tongue; suddenly a word awakens ideas, they are born, grow, ferment. A tragedy, a painting, a statue, a comedy, show their daggers, their colors, their contours, their buffooneries. It is a vision as fleeting and brief as life and death; it is deep like a precipice, sublime like the roaring of the sea; it is a group worthy of Pygmalion, a woman whose possession would even be the death of Satan; it is a situation that would make a dying consumptive laugh; the work is there, keeping all of the furnaces ablaze; silence, solitude open their treasuries; nothing is impossible. Finally, it is the ecstasy of conception veiling the excruciating pains of childbirth.)

Balzac's narrative of artistic inspiration deconstructs the creative process, separating conception from execution. Playing on the polyvalent meanings of *conception*, Balzac employs the sexualized metaphor for the act of creation that was so central to Girodet's own definition of art and genius. Like the painter of *Endymion*, the young author transforms the work of art into a child conceived in *jouissance* and delivered (or aborted) by the male artist in agony. Although the passage provides a vivid illustration of the male artist's appropriation of female reproduction as masculine creative genius, Balzac's particular spin on the trope reveals fundamental aspects of his theory of art. For where inspiration/conception is likened to an orgasmic moment of ecstasy, the translation of the interior vision into an externalized work of art constitutes the *travail* that makes the artist (like the laboring woman) suffer. For Balzac, the painful movement from the ideal to the

real separates the genius proper from the *génie avorté*. Artistic conception is fraught with danger for Balzac's artist, for he may easily tumble from the precipice or drown in the roaring sea, unable to move beyond the pleasure of the idea to the realization of the idea in concrete artistic terms. Only the artist of genius will be able to traverse these difficulties and deliver the work of art; all others will be doomed to a perpetual and fruitless labor that produces only suffering, while the image remains stillborn within the imagination.[27]

The childbirth metaphor, central to Balzac's formulation of artistic creation, was frequently linked to miscarriage and aborted effort in the case of insufficient genius. And if, as Frappier-Mazur contends, "In Balzac's work, maternity applies to creation," it is always a *male* maternity, for she adds, "if one surveys the characters for whom the childbirth metaphor is used to describe intellectual and artistic creation, one finds that they do not include one single woman."[28] Working at once within and against the Romantic paradigms of genius, art and creation, Balzac appropriates images of impotence, androgyny, childbirth and miscarriage to enunciate his own aesthetic response to the perceived threat of female artists and the very real crises of gender and representation. For it is important to note that, although the Romantic era did indeed witness the proliferation of images of powerful "masculine" women and weak "effeminate" men, these artistic and literary representations came closer to reflecting shifting ideologies and personal anxieties than the "real" status of gender relations. The undeniable presence of women in the political and aesthetic realms did not ultimately produce an "empowerment" of women under the July Monarchy. It did, however, bring about awareness of the instability of gender and the potential for sexual revolution that led to a corresponding desire to reinscribe boundaries, to redefine the limits of femininity and to expose the dangers posed by the penetration of women into the masculine realms of art, representation and politics.

Sarrasine: Les Deux Portraits

Sarrasine, one of Balzac's earliest tales, is also among his most famous and frequently analyzed. As Per Nykrog has recently pointed out, however, most of the recent critical palaver on this story has focused less on Balzac than on Barthes, as *S/Z* has displaced *Sarrasine* as subject of scholarly attention.[29] Barthes's groundbreaking study provides many insights into Balzac's tale and into Barthes's own methodological systems, yet inevitably elides alternative readings that I hope to elicit here. Given the story's metaficti-

tious structure, what might *Sarrasine*, a tale of failed artists and gender con-fusion, tell us about Balzac's own narrative strategies and aesthetic position vis-à-vis gender, genre and genius? What might castration, eunuchs and cross-dressing have implied for Balzac and his contemporary readers, in relation to a male and an ostensibly "female" artist? And finally, what does this double layered tale of art, representation and seduction tell us about Balzac's own struggle to define the artist and his role in contemporary France and to claim his own position as a successful author?

Originally published in 1830, *Sarrasine* first appeared in two install-ments, each with a title deleted in the 1844 Furne edition. The first chap-ter, published in the *Revue de Paris* of 21 November, was entitled "Les Deux Portraits," the second, appearing a week later, was designated "Une Passion d'artiste." While the relevance of the second is obvious, the first title is less so, for there is only one real portrait per se in the tale: the pivotal image of La Zambinella in the guise of Adonis as painted by Girodet after Sarrasine's statue. Yet upon close examination, *Sarrasine* presents a series of portraits, or *pairs* of portraits, that must be read comparatively, the contrasts between the images giving rise to the dialectic meaning of Balzac's mysterious tale. Initially one can juxtapose the visual portraits (Sarrasine's statue and Girodet's painting) with one another and with the verbal portraits pre-sented by the author. As in so many of Balzac's competitive *portraits des artistes*, the tensions between artists, words and images constitute a central facet of the author's definition of his own narrative art. But the very struc-ture of the tale, with its parallel scenes of infatuation and failed seduction, invites ever more comparisons between pairs of artists (Sarrasine/the nar-rator; Sarrasine/Balzac; Balzac/the narrator; Zambinella/Marianina; Zam-binella/the narrator), and between the objects of their intended seduction (La Zambinella/Mme de Rochefide; Mme de Rochefide/Sarrasine; Mme de Rochefide/the reader). These contrapuntal portraits provide further illumination as to the meanings proposed by Balzac's insistent doublings and *encadrements*. Indeed, the very structure itself of a tale within a tale pro-vides two discrete images—one set in Paris ca.1830, the other in Rome ca. 1760—whose similarities and differences lie at the heart of Balzac's *conte fantastique*.

The comparative/competitive context of *Sarrasine* is further established in its early versions by the inclusion of an epigraph, querying, "Croyez-vous que l'Allemagne ait seule le privilège d'être absurde et fantastique?" (Do you think that Germany has the exclusive right to be absurd and fan-tastic?). The reference to Germany and the fantastic evokes E. T. A. Hoff-mann, the master of the genre who was enjoying a vogue during this

period in France, and, in a more general sense, the essence of Romanticism itself, a movement that came to France in part via Mme de Staël's *De l'Allemagne* (1813).[30] The very form of the interrogatory epigraph asks the reader to compare the as yet unread story to the German fantastic, and by extension, to read in terms of and against Romanticism, as the author asserts the French right to this genre while taking it in a new and unique direction.

Balzac opens his tale with the observations of a first person narrator at a Parisian ball. An "unseen seer,"[31] this unnamed character is caught between two worlds and fully engaged in neither: "Seated in a window recess and hidden behind the sinuous folds of a silk curtain, I was able to contemplate at my leisure the garden of the mansion where I was spending the evening. The trees . . . vaguely resembled ghosts who were badly wrapped in their shrouds, a colossal image of the famous *dance of the dead.* Then, turning to the other side I could admire the dance of the living! a splendid salon, with its gold and silver walls . . ."[32] As he looks through the *embrasure* at the frozen, spectral garden and the lively, vibrant ball, the framed images are presented as works of art that the narrator denotes as "deux tableaux si disparates" (6: 1044). In a neat reversal that asserts the *difference* between author's voice and the narrator's, Balzac presents the narrator himself as a work of art. Sitting within the window's *embrasure*, he is framed by the very frames through which he sees these two worlds, in a portrait perceived only by the reader; the two scenes that his narrative foregrounds provide the background *décor* for his own framed image. Thus, the central theme of *encadrement* (framing) is announced in the opening paragraph as a way of bringing the very idea of art to the fore in a *mise-en-abîme* of enclosed images and gazes. If the narrator recounts the story of the evening *chez* Lanty and in turn the story of himself telling the story of Sarrasine, it is Balzac who tells us the story of the narrator recounting both these tales. This third level of distancing, so often forgotten in the interpretation of *Sarrasine*, is as critical as the enclosed frames.

From his privileged position behind the scenes of the ball, the narrator reproduces conversations he overhears and we begin to learn things that words can communicate but vision cannot—history, connections and hidden truths. The fête takes place at the Lanty *hôtel*, recently acquired from the maréchal de Carigliano, and thus the (unidentified) site of Sommervieux's trysts with the Duchesse de Carigliano and Augustine's disillusioning confrontation with her own portrait some 15 years earlier. The Lanty family are depicted by their guests as mysterious and nefarious, as the narrator explains "Nobody knew what country the Lanty family came

from, nor from what commerce, plunder, piracy or inheritance their for-
tune, estimated at several millions, derived."[33] As Crow has pointed out,
there are significant grounds of intersection between the Lanty family and
Sommariva, as they share Italian surnames, enormous fortunes from uniden-
tified sources and what Parisians assume to be shady pasts.[34] Sources of
gossip, both Sommariva and the Lantys use their money to establish legit-
imacy within the Parisian élite, who happily prostitute themselves at the
palaces of these opulent outsiders. The unattributed open-ended questions,
"Etaient-ce des bohémiens? étaient-ce des filibustiers?" (Were they gypsies?
were they filibusters?) (6: 1045) enlist the reader's active participation in the
story. From the outset, Balzac establishes the narrative as a quest for
answers, both highlighting and seeking to resolve the gaps between appear-
ance and reality, while at the same time undermining the narrator's omni-
science.

The first member of the Lanty family to come under the narrator's
direct scrutiny, is Marianina, whose youth and beauty link the exotic and
the erotic in a typical Romantic formulation: "Who would not have mar-
ried Marianina, a girl of 16 whose beauty embodied the fabulous fantasies
of Eastern poets? Like the daughter of the sultan in the story of *The Magic
Lamp*, she should have remained veiled."[35] Mediating life through art, the
narrator sees Marianina through an orientalist filter, her beauty deriving its
meaning from poetry and fable. In keeping with this exotic context, he
maintains that hers is a beauty that should have remained veiled, as the hid-
den carries a more powerful sexual charge than the readily apparent. But
underlying this desire is also the disastrous outcome of the story, for it is
only thanks to veils and illusion that Sarrasine falls in love with La Zam-
binella. Similarly, if Marianina had indeed remained veiled from the gaze
of the narrator and his friend, then the truth of emasculation itself would
have remained obscured. Thus, the tension between the seen and the
unseen is initially figured in the image of the veiled beauty bodied forth
by Aladdin's magic lamp. Invoked by a lamp of wishes, not illumination,
the veil provides the screen for fantasy, not insight or understanding.

Following the evocation of Marianina, the narrator shifts his gaze to her
mother, Mme Lanty, one of Balzac's infamous *femmes de trente ans*. More
lovely at 36 than she was at 21, she is also more powerful and threatening,
and the narrator generalizes the type, contending,

> Leur visage est une âme passionnée, il étincelle; chaque trait y brille d'intel-
> ligence; chaque pore possède un éclat particulier, surtout aux lumières. Leurs
> yeux séduisants attirent, refusent, parlent ou se taisent; leur démarche est

innocemment savante; leur voix déploie les mélodieuses richesses des tons les plus coquettement doux et tendres . . . pour ces sortes de femmes, un homme doit savoir, comme M de Jaucourt, ne pas crier quand, en se cachant au fond d'un cabinet, la femme de chambre lui brise deux doigts dans la jointure d'une porte. Aimer ces puissantes sirènes, n'est-ce pas jouer sa vie? (6: 1045–46)

(Their face is a passionate soul, it sparkles; each feature shines with intelligence; each pore has a special brilliance, especially when illuminated. Their seductive eyes attract, refuse, speak or remain mute; their gait is innocently knowing; their voice deploys the melodious riches of the most coquettishly sweet and tender tones . . . for these sorts of women, a man must know, like M. de Jaucourt, how not to cry out when he hides in the depths of the closet and the chambermaid breaks two of his fingers as she closes the door. Isn't loving these powerful sirens gambling one's very life?)

In contrast to the image of the veiled virgin, this portrait of the older and experienced women is neither romanticized nor idealized, for it is based on the observation of life, not the fantasy of art. As in *La Maison du chat-qui-pelote*, Balzac presents a typology based on a careful reading and interpretation of the visual language of the faces, voices and bearing of these "women of thirty," and highlights the inherent danger. The anecdote of the lover's broken fingers anticipates the theme of castration, while also recalling the images of amputation in the opening scene of the earlier tale. These *deux portraits* of Marianina and her mother posit opposing female types, while also setting up different ways of seeing or "reading" *la femme*. One, heavily influenced by projected desire, will be that of Sarrasine, the artist who sees what he wants to see, unable to interpret the visual signifiers (much like Sommervieux before him), the second, based on a more linguistic model, looking behind the surface for the meaning of appearances.

Mme de Lanty's son, Filippo, places the entire family under the sign of the feminine— "The beauty, fortune, intelligence and graces of these two children came exclusively from their mother,"[36] and like his sister is marked as a Romantic figure of fantasy. Yet his beauty holds an early key to the family's mysterious Otherness, for Balzac adds that Filippo, "To say it all in a single word . . . was a living image of Antinous."[37] Antinous, Hadrian's beautiful lover who drowned in the Nile, pairs the themes of same sex attraction and death. A popular subject of Classical sculpture, Antinous became a standard of male pulchritude, and one of the most famous images was found in the excavation of Hadrian's villa at Tivoli. This relief formed the centerpiece of the collection of Cardinal Albani, revealed to

be the possessor of the statue of Sarrasine at the end of this tale. The image of Filippo as Antinous, left for the reader to interpret, presents an important component of the Lanty family legacy, narratively prefiguring (or chronologically echoing) his great-uncle's image as crafted by Sarrasine. But these links are suggested, not explained, leaving the reader to construct the connections and compare the contrasting portraits.

Balzac elaborates the literary, Romantic qualities of the Lantys as he compares the mysterious family to a poem by Byron, "whose difficulties were translated differently by each person in fashionable society: a sublime and obscure song from stanza to stanza."[38] Like Hoffmann's *conte fantastique*, Byron's poetry was a Romantic prototype, and the Lanty family, feminine, fantastic and exotic, embodies many qualities of this artistic movement. The passage indicates that the Lantys resemble a work of art: like a poem, they must be interpreted, for meaning does not lie on the surface, but rather, as in a musical composition, in the complex relations between the parts. Repeating the connection, the paragraph ends with a reference to the Gothic works of Radcliffe, as he concludes "the enigmatic story of the Lanty household presented a perpetual source of curiosity, rather like one of Anne Radcliffe's novels,"[39] again linking the family with mystery, the fantastic, and here, a female artist.

These references to Byron and Radcliffe, unmistakable harbingers of Romanticism, frame a paragraph devoted to a most *unromantic* theme—money—as Balzac establishes his own orientation. Painting a portrait of this foreign family and the society that welcomes them, Balzac reflects on the power of lucre in contemporary Paris: "There, even bloodstained or filthy money betrays nothing and represents all. As long as high society knows the amount of your fortune, you are classed among those who are your equals, and nobody asks to see your titles of nobility, because everybody knows how little they cost!"[40] Money in the Paris of the late Restoration is at once more powerful and mysterious than any fiction, shaping lives and relations in ways that are even more frightening than the gothic ghosts of tales past. Seeking to reinvent the English and German supernatural, Balzac indicates the real source of the terror in his tale. The Lantys' wealth, the subject of speculation in this paragraph introduced by Byron and concluded by Radcliffe, derives from their mutilated uncle, whose castration was motivated by the greed of his protector. Ultimately, then, society produces weirder creatures than the otherworld ever could, and what induces the gothic frisson in Balzac's tale are the real and very human emotions of greed, deception, passion, lust and fear.

The narrator sinks into a reverie echoing his mood at the beginning of

the tale. Meditating on the oppositional nature of the world, he sees it in terms of "de noir et de blanc, de vie et de mort" (black and white, life and death) and importantly, the real and fantastic, for the pair of scenes before him are the product of "Ma folle imagination autant que mes yeux" (My mad imagination as much as my eyes). As Barthes so well illustrates, the novel is dominated by binaries that will be exploded by the introduction of the ambiguous third term, the castrato, neither male nor female, fully dead nor fully alive. Thus the narrator's insistence on the tidy but reductive vision of the world in terms of antitheses, "ces deux côtés de la médaille humaine" (the two sides of the human coin) (6: 1050), will be debunked, for Balzac will prove there must always be a third term within the equation, just as the *deux portraits* that populate the tale must always dialectically lead to a synthetic third. The image of the two sides of a coin, eternally separated but inseparable, anticipates Saussure's definition of *signifié* and *signifiant* as two sides of a piece of paper, complementary parts of a whole that remain discrete, but it is their relationship that generates the meaning of that unity, the sign.

Awakened from his daydreams by the laugh of a young woman, the narrator confronts an image that personifies his thoughts: "la pensée en demi-deuil qui se roulait dans ma cervelle en était sortie, elle se trouvait devant moi, personnifiée, vivante, elle avait jailli comme Minerve de la tête de Jupiter, grande et forte, elle avait tout à la fois cent ans et vingt-deux, elle était vivante et morte" (the thought in half-mourning that was turning over and over in my mind had emerged and appeared before me, personified, living. It had sprung forth like Minerva from Jupiter's head, tall and strong, it was at once a hundred years old and 22, alive and dead) (6: 1050). The haunting specter is the Lanty's ancient uncle, but in a demonstration of the power of language to shape reality, *he* is transformed into *she*, as the pronoun for *la pensée* is *elle*, and here words reveal more than images. The initial description of the *vieillard* (old man) highlights his contradictory nature in a way that will only become relevant in retrospect, while every locution insists upon his existence as a work of art. Emphasizing his inexplicable nature, the narrator contends, "Il semblait être sorti de dessous terre" (He seemed to have emerged from the underground) (6: 1050), recalling Frénilly's widely quoted observation regarding Sommariva, "il sortait de dessous terre,"[41] and forging yet another link between the Lanty family and Girodet's patron.

What has drawn this *petit vieillard* from his room is Marianina's performance of a cavatina from Rossini's *Tancredi*. The old man is entirely absorbed in the song, and "his almost somnambulistic preoccupation was so

focused upon things that he was in the middle of the crowd without per-
ceiving the crowd."[42] Like the narrator, he is lost in a dream world, even in
the midst of the boisterous gathering, and once again Balzac creates an
artist who is so caught up in an interior vision that he cannot see what lies
before him. The unidentified *vieillard* emerges next to a woman who is, at
first, also unidentified. Yet, after highlighting the beauty, youth and fresh-
ness of this young woman, who seems to embody life and femininity, the
narrator draws a paradoxical parallel. He muses, "They were there, before
me, both together, united and so close,"[43] linking the lovely and lively
danseuse with her decrepit and moribund neighbor in a way that seems to
transcend their mere physical proximity. Like the many unanswered ques-
tions posed by this narrative, the grounds of intersection between these
seemingly antithetical creatures will only become clear at the end, upon the
retrospective comparison of yet another pair of contrasting portraits.

The young woman, whom the narrator has escorted to the ball, is
amused and frightened by the old man, her revulsion vying with curiosity.
As she turns her gaze upon this "créature sans nom dans le langage humain,"
we get the first detailed description of that which supposedly lies beyond
words, through the double filter of the narrator's and the *jeune femme's*
observation. The "portrait" of the *vieillard* constitutes one of Balzac's
famous "set-pieces," a highly evocative description that inundates the
reader with physical and metaphysical details that must be synthesized into
some kind of coherent whole. This narrative technique represents, in these
early tales, the author's preliminary attempts to establish his own power of
representation while posing a direct challenge to the painter's art, which is
consistently rendered illusory. Jean Molino maintains that Balzac's portrait
of the singer presents a bravura passage in which Balzac tries to rival the
art of painting, citing the author's insistence on relief, color, light and shade
in the description.[44] But beyond a direct rivalry with painting, Balzac seeks
to undermine its representational authority, constructing a verbal portrait
that is more *truthful* and "realistic" than a visual image. The accumulation
of signifiers in Balzac's word paintings posits a linguistic paradigm for the
proper consumption of the image, as seen above in *La Maison du chat-qui-
pelote*. Within Balzac's descriptions, the body becomes a semiotic vehicle
that must be *read* for its import to emerge fully.

Beginning with his emaciated body, Balzac's overdetermined descrip-
tion reveals the emptiness lurking behind the mysterious old man's fragile
features—"Son excessive maigreur, la délicatesse de ses membres, prou-
vaient que ses proportions étaient toujours restées sveltes. Il portait une
culotte de soie noire, qui flottait autour de ses cuisses décharnées en

décrivant des plis comme une voile abattue. [. . .] Vous eussiez dit de deux os mis en croix sur une tombe" (His excessive thinness, the delicacy of his limbs, indicated that his proportions had always been slender. He was wearing black silk breeches which floated about his emaciated thighs in folds like an empty sail. [. . .] You would have said they were two bones crossed on a tomb) (6: 1051). The evocation of death and the void is a premonition of the essential lack at the heart of this castrato, but further stands in direct contrast to the painted portrait of Zambinella hanging in an adjoining room, which presents him intact. For if we return to Girodet's *Endymion,* modeled directly after this portrait (within the fictional world of the tale), the beautiful youth's idealized body fully is equipped with shadowed, yet identifiable genitalia. The verbal portrait can show the discerning reader what the visual portrait does not, and indeed it is *vous* who perceives the sepulchral cross beneath the baggy clothes. The polyvalent image of *voile* (veil and sail), serving a central role in the descriptions of Marianina and her uncle, is stripped away by the penetrating gaze, exposing both vitiation and horror. The narrator explains, "A feeling of deep horror for humanity gripped the heart when a fatal glance revealed the marks left by decrepitude on this fragile machine"[45]—an unveiling that the author and his reader may effectuate, but the visual artists and their respective audiences cannot.

Moving from his body to his clothes, Balzac's description sets into relief the tension between decrepitude and luxury, surface and structure: his elaborately embroidered vest, dazzling linen and lace jabot, bejeweled with a priceless diamond, present a stark contrast to the decaying body they decorate. Ironically, both the emptiness and the wealth are products of the same phenomenon—Zambinella's castration—which has created a hidden void that is masked by all that money can buy. Yet it is precisely this contradiction between lack and plenitude that emblematizes the essence of the *vieillard,* for he adds "Ce luxe suranné, ce trésor intrinsèque et sans goût, faisaient encore mieux ressortir la figure de cet être bizarre. Le cadre était digne du portrait" (This superannuated luxury, this intrinsic and tasteless treasure, made the face of this bizarre creature stand out even more. The frame fit the portrait) (6: 1052). Returning to the image of portrait and frame, Balzac makes it impossible for his reader to miss his point: he is presenting us with a work of art to be read as such, while the relationship between *cadre* and *portrait* is one of interdependence and mutual reflection, a concept that will pertain to all the frames and portraits throughout.

Thus the outdated luxury of the mysterious old man's garb frames a face whose hollow contours constitute one of the more haunting passages

as a piece of art
—object-like.

in the novella: "This dark visage was angular and sunken in every sense. The chin was sunken; the temples were sunken, the eyes were lost in yellowish sockets."[46] While this pitiable creature is at once horrifying and unnatural, Balzac's prose indicates that it is not a supernatural unnatural: the product of art, artifice, and ultimately money, it is rather a Realist unnatural. In this dense paragraph Balzac creates a network of meaning that links artifice, painting, femininity and death. The *vieillard's* heavily made-up face is itself "son masque"—a canvas covered in pigment that conveys not the impression of reality but of artificiality. He is "une peinture très bien exécutée" (a well executed painting), yet it is an art that obscures rather than exposes the truth, for his makeup and wig hide an ever more hideous ruin beneath. If his body is the product of artifice, it is by extension feminized. The desire for beautiful accoutrements—"the golden earrings . . . the rings glittering with fabulous stones . . . a watch chain that sparkled like the diamonds in a necklace at a woman's throat"[47]—is attributed to "la coquetterie féminine." Finally, he is "une idole japonaise"—a feminine and foreign object of misplaced or overinvested worship—that is in turn likened to a corpse's skull. "Silencieuse, immobile autant qu'une statue," the feminine and artificial man is reduced to an inanimate work of art, a representation of death rather than life ("une tête de mort") exuding the musty smell of long-abandoned gowns. Every aspect of the description points to a tension between a feminine surface (*maquillage*, jewelry, cast-off dresses) and a masculine structure irremediably at odds, creating a composite image of false representation that implies a living death. Anticipating the effect of Sarrasine's fetishizing gaze, Balzac's description demonstrates the fatal consequences of transforming life into art.

Following this extensive portrait, the narrator emphasizes the contrast between the hideous old man and the beautiful young woman who stands beside him. Overcoming her horror, she reaches out to touch him, to see if he is really alive, and the ensuing chaos—the old man's shriek and his family's protective descent upon him—drives the errant couple into a boudoir, where they retreat from the party in shame. Alone in the room, the narrator accuses his friend of madness, but the ensuing scenario, "— Mais, reprit-elle après un moment de silence *pendant lequel je l'admirai*, est-ce ma faute?" (But, she replied after a moment's silence *during which I gazed at her admiringly*, is it my fault?) (6: 1053; my emphasis), reveals parallels between the narrator and his own subsequent subject of discourse. The aside that designates his admiring glance at the silent image sets up a chain of desire and even idolatry that aligns the narrator with Sarrasine, and thus with blindness and failure. For the impetuous *jeune femme* is the object of

the narrator's silent and admiring gaze in the same way that Zambinella was the object of the sculptor's gaze, and in turn, in the same way that Zambinella, in the guise of Adonis, is soon to be the object of the ingénue's gaze. In each case the gazer falls prey to projected desires that obscure accurate perception. Thus, in a key juxtaposition of portraits, Balzac presents the painting that will, in the final paragraphs of the tale, be identified as the portrait of Zambinella in his youth.

As is typical of Balzac's approach to painting, the image is barely described, and in stark contrast to the elaborate evocation of the *vieillard*, the reader has little sense of the painted body. The tableau nonetheless remains central to his meaning as a visual artifact: while the *response* of the viewers to the painting is significant, the specifics of its content are repressed, leaving the written "portrait" more vivid and "visual" than the painted one. The Lantys have enshrined the painting of Adonis stretched out upon a lion's skin in a boudoir replete with blue satin wall coverings and an alabaster lamp. An object of reverential contemplation, the fictitious painting and its setting offer an obvious evocation of Sommariva's galleries and his presentation of Canova's *Magdalene*, references familiar to Balzac's Parisian readership.[48] Like the *Magdalene*, this is a portrait of someone who has prostituted himself, while the presentation highlights the fetishism of its owners and viewers who transform the work of art into an idolatrous object of worship. Even the narrator falls victim to the power of this evocative image, for in his attribution of the painting ("cette merveille") to "quelque pinceau surnaturel" (some supernatural paintbrush) he embraces the illusions of which he accused others and is transformed into a Romantic viewer. The painting is attributed to Girodet ("It is due to Girodet's talents . . . that painter so dear to the poets")[49] in all but the final version of 1844 and clearly evokes *Endymion*, with its graceful contours, luminous surface and exquisite androgynous male figure stretched out on an animal skin. However, Balzac transforms the subject of the fictitious canvas into Adonis, a beautiful youth best known as Venus's beloved. The product of the incestuous union of Cinyras and his daughter Myrrha, Adonis was the direct descendent of Pygmalion and Galatea, an important intertext of this tale of a sculptor's misguided love and closely linked to the paired references to Girodet and Sommariva. In this Ovidian myth of love, destruction and violence, the virile young hunter is gored in the groin by a wild boar, his emasculation and death prefiguring the end of Balzac's own tale.

The shifting mythological reference is one of several transformations Balzac effectuates on Girodet's epoch-making canvas, for the very nature of the ephebic nude and its reception had undergone enormous changes in

the 40 years between the completion of *Endymion* and its fictionalized consumption in *Sarrasine*. Where the male nude in general, and Endymion in particular, had been signifiers of a heroic ideal in the Revolutionary period, this construction of masculinity had passed into history, and in 1830 the perfect, androgynous beauty becomes a signifier for impotence. If *Endymion* appeared at a moment when the dominant discourse sought to effectuate a masculinization of the public sphere and a marginalization of the feminine, *Sarrasine* is set at the moment of the reemergence of the female in the public sphere and consciously seeks to portray this social dynamic. Thus, where Girodet's image was painted in terms of male–male relations, Balzac's tale is written in terms of male-female relations, with a specific eye cast toward a female audience; indeed the inscribed viewer of *Endymion* is, in the tale of 1830, a woman. Although the homoerotic gaze of the Amor upon the sleeping shepherd is reenacted in Sarrasine's unrecognized attraction for the castrated singer, the primary gaze upon the painting itself is female, in a deliberate reversal of traditional structures of viewing, and the implied corollaries of power and knowledge. Balzac's reconfiguration of the active male subject/passive female object dichotomy endows the woman with the Consciousness usually tied to vision within Cartesian logic. The clothed female viewer inspecting the canvas stands as a potential "maker of meaning," while the naked male object of her gaze is the "bearer of meaning," within the visual economy of the story.[50] In this sense, the "ambiguities in gender occasioned by male ephebic bodies"[51] do not disappear, they are simply translated to another register. The androgynous male nude, as castrated object of a female phallic gaze, demonstrates the ongoing reconfiguration of gender and the body in nineteenth-century culture and representation.[52] The painted image is as polyvalent as words, depending on the context and the spectator for its coded meaning. The deconstruction of the traditional order of gendered viewing will be an integral part of Balzac's deconstruction of the generic hierarchies of art based on representation, power and knowledge as the correlatives of sight.

The dynamics of the gaze are thus shaped both by the erotics of desire and the drive for knowledge and control, all of which are inextricably linked. Yet Balzac's aesthetic agenda in *Sarrasine* seeks to undermine the assumed access to power and knowledge via sight by highlighting the deformative nature of sexual desire on perception. Thus, the initial response of the *jeune femme* to this painted Adonis reflects the idealizing filter employed by the artist and his audience, for, upon viewing "the exquisite grace of the contours, the pose, the color, the hair, everything in fact," she proclaims "Does such a perfect being exist?" Then, "after the kind of

examination she would have given a rival," she adds, "'He is too beautiful for a man.'"[53] Balzac delineates his reversal of the usual structure of scopic regimes by underlining the erotic nature of her gaze upon the passive nude form of the hunter. Yet even as she takes on the subject position, the *jeune femme* is object of the admiring gaze of the narrator and the reader. While the painted Adonis, soon to be emasculated by the avenging boar, is feminized by his beauty, the desiring, gazing woman only partially assumes a male position of phallic authority, for knowledge remains elusive. Her subject position is constantly threatened by her object position and by her own desire, as the very power of this beautiful but misleading image ultimately casts everyone associated with it under the sign of the impotent and the feminized. In *Sarrasine*, vision and painting can only lead to varieties of falsehood and failure.

In a chain of unreciprocated desire, the *jeune femme* admires the painted Adonis while the narrator admires her, but each sees the painting as a *rival*. Where she experiences the jealousy of gender, he feels the jealousy of genre, as the Adonis/Endymion becomes the site of the conflation of two equally potent rivalries—male/female and painting/poetry. Stung by his female friend's admiration for this painted figure, the narrator laments, "Oh! how I then felt the pangs of that jealousy in which a poet had vainly tried to make me believe! the jealousy of engravings, paintings, statues, where artists exaggerate human beauty following the doctrine that makes them idealize everything."[54] Giving voice to the competition between authors and painters, Balzac foregrounds the sexual nature of the rivalry, for it focuses on the seduction of a female audience, and the narrator will respond to the power of the image with his own powerful story. The intergeneric tensions center on the realms of words versus images, which are mediated through the destabilization of the authority of the gaze. The audience in question, the young society woman, has already revealed her repulsion with the real and infatuation with the ideal in her responses to Zambinella in person and in pigment, but the narrator will try to seduce her away from illusion with a more compelling vision of the truth.

In an initial attempt to defuse the powerful hold of the portrait "dû au talent de Girodet," the narrator highlights its distance from reality. Although it is a portrait, by definition a likeness of a specific individual, "this great painter never saw the original, and your admiration will perhaps be less ardent when you realize that this *académie* was executed after a statue of a woman."[55] The entrancing image is based on art, not life, and thus Balzac and his narrator indicate that, although painting may be able to promote the *fiction* of reality in its naturalistic form of representation, it is no more

real than any other fiction. As a work of art based on art, Girodet's portrait stands as a *mise-en-abîme* of the entire story. For indeed, Sarrasine's statue of Zambinella as a woman is also based on the singer's art, not his true life, setting up a chain of representations based on fantasy, artifice and illusion culminating in Girodet's *Endymion*, painted after Sarrasine's *Zambinella*. Only the storyteller can show us the original behind the replications.

Yet the narrator is "Oublié pour un portrait" (Forgotten for a painting), and truth notwithstanding, beauty and visual representation hold a powerful sway over an audience. Anticipating Sarrasine's own Pygmalion complex, the *jeune femme* prefers the representation to a real man, and falls in love with a perfect and impossible beauty that is more appealing than reality itself. For an author attempting to appeal to an audience, painting posed the threat of obsolescence in a market that sought pleasing images of itself over more truthful portrayals of reality. Thus, in this tale of contrastive portraits of artists Balzac also inscribes contrastive portraits of audiences, in hopes of providing a positive paradigm of a good reader of texts and images through the counterexamples of the bad readers that populate *Sarrasine*.

Moving again from art to life, the narrator and his female companion shift their attention to Marianina and the *vieillard*; unseen seers, they witness the old man give the young girl a ring, which she slips over a gloved finger, and then disappear behind a hidden door. The mystifying "marriage" of youthful beauty and decrepitude prompts the young woman to try and interpret what she has just seen, posing a series of questions— "What does this mean? . . . Is it her husband? . . . Where am I?"[56] —that the reader herself might ask. The narrator's facetious answer ("you, madame, who are exalted and who, so sensitive to the most imperceptible feelings, know how to cultivate the most delicate sentiments in a man's heart without bruising it, without breaking it at the outset, you who pity heartache, and who join the wit of a Parisienne with the passionate soul worthy of Italy or Spain . . .")[57] illuminates his own feelings for the young woman but sheds no light on the scene she has witnessed. Half teasing, half bitter, the narrator's words expose the polyvalence of meaning, for it is clear that this ironic speech means the opposite of what it says. The response of the *jeune femme*, "Oh! you fashion me to your own taste. What singular tyranny! You don't want me to be *myself*,"[58] casts the narrator in the role of Pygmalion, yet another artist/lover trying to transform a woman into his own fantasy. Despite her pique, the young woman's curiosity is aroused by the events unfolding before her, and the infatuated narrator promises to tell her all that she wants to know, but only in exchange for a more private rendezvous.

The amorous narrator's decision to use art—the narration of a tale—to seduce his reluctant mistress reflects his competition with the painter, whose image has displaced him in his mistress's eyes, while also revealing a vision of the work of art as capable of "mobilizing the forces of desire."[59] Balzac too hopes to seduce his own female reader by demonstrating the higher value of narration vis-à-vis painting, as the two art forms compete for a single market. But if the narrator competes with painting by trying to replicate its illusions, Balzac seeks to distance his own art from that of the visual artist while underlining the dangerous nature of artistic deception and the irremediable gap between art and life. The contrasts between the author of *Sarrasine* and the author of the framed narrative of Sarrasine illuminate Balzac's own didactic intentions in this metafictitious tale.

The imperious *jeune femme* initially rebuffs the narrator's offer, for she wants to hear his tale immediately. As male and female protagonists struggle for control over knowledge, seduction and desire, the narrator reveals an attitude toward his audience that is at once attracted, scornful and frustrated ("You are more capricious, a thousand times more whimsical . . . than my imagination").[60] As initially published, the first half of the story ended with this angry denunciation, leaving the reader, like the *jeune femme*, waiting for the revelations, while the narrator and Balzac retain the ultimate control, in that they possess that which their audience desires: knowledge. The technique of suspense, indigenous to the tradition of gothic horror tales that Balzac is writing in and against, thus defines a relationship between narrator and narratee based on revelation and obfuscation that places the narrator in the position of mastery, and this rapport will be undermined at story's end, when the roles will be reversed. But the interpolated tale at the heart of *Sarrasine*, based on the interchange between a male narrator and his astute female audience, demonstrates important aspects of Balzac's own relationship to his female readership, both in terms of his own goals and what he prescribed as the role of that audience.

Sarrasine: Une Passion d'artiste

"Une Passion d'artiste," the second half of the story to appear in the *Revue de Paris*, shifts from the public realm of the ball to the private realm of the young woman's *salon* where the couple sit before a fire. The opening sentence invokes an intimate, sexually charged relationship between the male narrator and his female audience that further hints at the power structure through their physical positions—"she seated on a low sofa; me on some cushions, almost at her feet, with my eyes beneath hers."[61] Despite his supe-

Feet as phallic

rior knowledge, the narrator claims a subordinated position at her feet, beneath her watchful eye. Sarrasine's story, as told by the narrator, is set in the mid-eighteenth century and presents a portrait of the artist as a young man in terms that closely follow Romantic formulae for artistic genius: he is volatile, nonconformist, passionate and violent, at odds with paternal authority and the status quo.[62] Sarrasine is a slave to his talent, which surfaces at a very young age. While others learn their lessons at his Jesuit school, Sarrasine conflates art and religion; he "sketched the reverend father . . . Instead of singing the praises of the Lord at church, he amused himself during the services by whittling away on a pew; or when he had stolen some piece of wood, he would carve a figure of a saint."[63] Sarrasine's representations reflect a close correlation between art and eroticism ("he always left behind rude sketches whose licentious character distressed the youngest priests")[64] and he is ultimately expelled from his parochial school for having crafted a priapic figure of Christ out of wood—a transgression that indicates both the sculptor's impiety and fetishism, which, as the convergence of art, eroticism and misdirected worship, will indeed be his downfall.

Disowned by his father, Sarrasine emigrates to Paris where he joins the studio of the Neoclassical sculptor Bouchardon. The sculptor's "génie sauvage" is sublimated as Sarrasine immerses himself in his art: "As fanatical about his art as Canova before him, he rose at dawn, remained in his studio from morning till night, and lived only with his muse."[65] Art replaces life for Sarrasine, and the reference to Canova, icon of fetishized statues, provides yet another connection to Sommariva and Girodet, for not only was Canova rumored to be the subject of *Pygmalion et Galatée*, he created a sculpture of *Endymion* in 1819-22. Art, eroticism and fetishism are linked even before Sarrasine falls in love with La Zambinella, for during his apprenticeship in Paris "He had no other mistress but Sculpture and Clotilde, one of the celebrities of the Opera."[66] The interchangeability of sculpture and women, reflected in the structure of the sentence, provides an indication of Sarrasine's attitude toward both, while even his real mistress is associated with art, as a denizen of *l'Opéra*.

Sarrasine leaves Paris for the artist's obligatory stint in Rome, and in "B/G" Crow traces Sarrasine's adventures in Rome directly to Balzac's reading of Coupin's edition of the *Oeuvres posthumes* published the previous year. Crow suggests that Balzac's incorporation of Girodet's artistic production and personal experience into the fictitious world of *Sarrasine* constitutes "a meditation—translated to the register of sexual desire—on the historical situation in which a set of beliefs about painting was passing

away, bringing its own death through a narcissistic fixation on a vanished moment of past perfection."[67] Yet, what remains to be established is what this passage in *painting* implied for Balzac, as an *author*; why he felt compelled to chart this passage in such violent and overdetermined terms; why he chose to portray this movement away from a fixation on past perfection in the convoluted form that he did; why *Girodet* specifically; and finally, and perhaps most provocatively, why is the aesthetic transition translated to the "register of *sexual desire*" and gender confusion?

Balzac's interpretation of Girodet, painting and the complex interplay between art, representation, eroticism and historical moment[s] is manifested in the figure of Sarrasine. Rome, with its romanticized Classical associations of past glory, has induced in Sarrasine "the state of ecstasy that took hold of all young imaginations at the sight of the queen of ruins."[68] The ecstasy is only heightened by the sensuality of the theatrical experience when he first visits the opera. Seduced by the spectacle, Sarrasine experiences a sublime transport that fuses the aesthetic and the sexual. In a truly Romantic formulation, he listens and sees through the filter of his soul. Yet, from the very outset the narrator emphasizes the illusory nature of Sarrasine's experience, for he is at the *theater*, the very realm of fiction and deception. La Zambinella's introduction is couched in terms that highlight both theatricality and illusion: "The lights, the enthusiasm of the crowd, the illusion of the staging, the glamour of attire that, at this time was quite alluring, all conspired in favor of this woman."[69] If the lighting, costumes and milieu conspire to delude the audience, the narrator colludes as well, hiding the most central illusion—the gender of the singer—behind a feminine signifier, and thus the reader is initially as deluded as Sarrasine. Alerted to the theatricality, the reader is warned to look behind appearances, but only when Sarrasine's misprision is revealed do our own assumptions become exposed, and the narrative signposts become retrospectively apparent. What appearances hide, words can unveil, but only when they too are analyzed.

Sarrasine's desire shapes his admiring gaze and transforms the singer into an icon of perfection. The description of La Zambinella, presented through the filter of Sarrasine's passionate projections, renders the singer an object of aesthetic contemplation—she is evaluated in terms of line, color, contour, configuration as a painting or statue might be. Her beauty and perfection make La Zambinella into a Galatea-like object of worship; the sculptor sees her as a statue modeled after Venus to be revered and adored. Sarrasine's reflection, "C'était plus qu'une femme, c'était un chef-d'oeuvre!" (She was more than a woman, she was a masterpiece!) elevates art

above women and like Pygmalion, he falls passionately in love with this "work of art" that is, in a very basic sense, his own creation. In a twist on Ovid's tale, the narrator adds "Sarrasine dévorait des yeux la statue de Pygmalion, pour lui descendue de son piédestal" (Sarrasine's eyes devoured the statue of Pygmalion, for him descended from its pedestal) (6: 1061), for here the real person is turned into an inanimate object only to be animated again by the miraculous powers of imagination and desire. The irony of her artistic perfection is the human mutilation that lies beneath the surface and the radical disjunction between appearance and reality undermines the visual artist's claims to representational superiority. As Balzac will increasingly make evident, words, in their nonrepresentational mutability, can be more "real" and more "truthful" than images, for "truth" and "reality" lie hidden behind the surfaces of the material world.

Sarrasine's aesthetic and emotional transports bring about an orgasmic ecstasy in the artist, yet the description points to a kind of madness. For the smitten sculptor, La Zambinella's song "was a delirium . . . he was moved by an impulse of madness, a kind of frenzy." He is "complètement ivre," while the power of her presence is "almost diabolical." Yet all of these emotions that reveal his disturbed state "take place in a sphere inaccessible to human observation" as Balzac undermines the epistemology of sight as knowledge at every possible level. Vision is instead both selective and inaccurate— "He was so completely intoxicated that he no longer saw the theater, the spectators, the actors, nor did he hear the music. Moreover, there was no distance between himself and Zambinella, he owned her, and his eyes, riveted upon her, possessed her."[70] The erotics of the gaze can lead to a fantasy of possession that is purely imaginary. Balzac's description of the artist's response to the performance is redolent with sexual imagery, while revealing a measure of danger, sickness and insanity in the orgasmic catharsis. The erotic frenzy, followed by melancholy and emptiness, is tied to suffering rather than satisfaction, while his dreamlike state on the steps of a church foregrounds his idolatrous, sexualized worship of a secular work of art. The metaphoric intercourse between La Zambinella and Sarrasine prefigures the gender reversals and confusions that will dominate the rest of the tale. For here, the male protagonist is the passive party who is made love to by the active feminine voice that rolls up and down his body and soul, attacking his very being, leaving him weak, enervated and ultimately feminized in the mode of a Romantic artist.

Returning home, Sarrasine draws his beloved from memory, and like Pygmalion, "lui parlait, la suppliait" (spoke to her, implored her), believing in the reality of his own creation. The sculptor enacts what Mieke Bal has

identified as "the typical conflation of representation and object which comes with the eroticization of viewing. [. . .] The work of representation itself is ignored, so that the work of art disappears behind its object. [. . .] What is *not* seen is that which is perceived: the work."[71] Desire blinds the viewer to the constructed nature of what he sees and the breakdown between seeing and perception leads to the severing of seeing from knowledge, as vision becomes simply another act of creation. Thus, in the case of Balzac's infatuated visual artist, the very nature of his representation comes into question. When Sarrasine confuses the representation of La Zambinella with the singer herself, art replaces reality and the lexicon stresses the hallucinatory nature of the images, which are products of inwardly generated fantasies at odds with external reality.

The tension between inner and outer reality comes to the fore when the narrator's friend interrupts the story of Sarrasine's nascent infatuation, reminding Balzac's readers that this is a double layered narrative of seduction and illusion. For the first time in *Sarrasine*, the young woman is identified by name—she is Mme de Rochefide, and this revelation informs us that she is a married *aristocrate* who is contemplating adultery, while the story that we are reading is the narrator's own vehicle for seduction. As she exclaims, "I still don't see Marianina and her little old man,"[72] Mme de Rochefide raises the critical question of the connection between this narrative of eighteenth-century Rome and the scene in nineteenth-century Paris she had witnessed the day before. Unlike Sarrasine, Mme de Rochefide has retained an awareness of representation and frame; her search for connections between the two stories stands in pointed contrast to the eighteenth-century sculptor's fetishizing gaze. As a narratee who remains aware of her position outside of the work of art as a structuring presence, Mme de Rochefide thus serves as a model for Balzac's own reader, who must similarly remain aware of the fictitious or representational nature of both of these interrelated narratives. In this sense, the female *destinataire* of the narrator's fireside chat becomes a "focalizer," that is "an agent in the work who represents vision, and thereby offers positions of viewing to the real reader."[73] As a narrative of visual and verbal art, *Sarrasine* presents two focalizers: the fetishizing sculptor who views art as life, conflating representation and reality, and Mme de Rochefide, who retains an awareness of the distance between the two, as she tries to *see* the connections between her own experience in the real world and the images she is consuming.

Mme de Rochefide's desire to go beyond the surface in pursuit of the unseen and unspoken meaning is what will differentiate a good Balzacian reader of art and of the world from a bad one. Mme de Rochefide strives

to interpret what she hears, participating intellectually in the story and distancing herself from the delusional Sarrasine, while her question seeks to wrest control from her narrator. He, in turn, complains "All you see is him, I cried out impatiently, like an author whose theatrical effect is being spoiled."[74] The narrator here affiliates himself directly with an author, requiring the reader of *Sarrasine* to contrast him with the author who has created the entire tale, while his reference to theatrical effect indicates his desire to use illusion and unveiling as part of his artistic strategy. If, as Barthes contends, narrative is a striptease, the narrator's power lies in the deferral of the ultimate exposure of that which is hidden; unlike visual representation, narrative seduction lies in the process rather than the product. Where Balzac's inscribed narrator defers "showing" his audience the veiled truth in order to mobilize desire, Balzac defers the exposure of the "truth" in order to deconstruct the equivalence of "seeing" and "knowing." If the desire to see and to know are ultimately erotically driven, in the case of *Sarrasine* the significance lies in the recognition of these formulations of power and symbolic meaning as subjective and flexible constructions of desire.

The exchange between narrator and narratee centers on vision ("Mais je ne *vois* encore ni Marianina ni son petit vieillard," . . . "Vous ne *voyez* que lui"), reflecting the tensions between the visual and verbal representations in this tale, while reminding us of Mme de Rochefide's infatuation with the portrait that prompted the narration of this retaliatory tale. *Voir* suggests both physical seeing and metaphysical understanding, and the polyvalent nature of words and images lies (unrecognized) at the heart of this exchange. For the narrator's bitter response is in its own way ironic. While on the surface functioning as a rebuff to her continuing fascination, it also indicates the truth, for indeed, although she does not yet realize it, all that she does "see" in this story is the *vieillard*, simply in an earlier incarnation that she cannot "see" (recognize or understand). Thus, we are doubly reminded of the many layers of linguistic meaning, the uncertainty of appearances, and the potential lacunae between seeing and understanding.

As Sarrasine prepares for his first rendezvous with his beloved, "he adorned himself like a young girl about to appear before her first lover."[75] Just as Adonis and Mme de Rochefide exchange positions within the gendered hierarchy of the gaze, the artist takes on attributes of femininity as he heads off to meet the woman who will eventually be exposed to be a man. Upon arriving at his mysterious destination, he is disappointed to find himself in a crowded, well-lit parlor, as he "had hoped for a badly lit room, with his mistress seated by a fire."[76] Sarrasine had wished to avoid illumi-

nation, preferring a darkened screen for the projection of his fantasies to the bright lights of truth. When he approaches La Zambinella, she is stretched out on a couch, and the sculptor is immediately aroused by the sight of her little foot: "Oh, how his heart beat when he spied a dainty foot, shod in those mules which, allow me to say, madame, used to give to women's feet such a coquettish and voluptuous look that I do not know how men were able to resist them."[77] The foot, the fetish par excellence, will reappear in Frenhofer's *La Belle Noiseuse* as a central signifying synecdoche, and its function as a substitute penis cannot be overlooked in this tale of castration and its attendant anxieties. But as important as Sarrasine's fetishistic attraction to the foot/phallus of this woman/man, is the narrator's own identification with that desire, for he too cannot resist this fetishized fragment of the body that promises a false presence, an assurance of "wholeness" that is nothing more than projected desire. The narrator, despite his extradiegetic position of knowledge and power, shares many of Sarrasine's own illusions and fantasies, and the story's full significance will lie in the intersection of these two fictitious artists and their creations.

Here and throughout, the dialogue between the ignorant lover and the dissembling beloved functions at two levels, for even as she tells him the truth, he interprets her words as mere artifice. Indeed the series of exchanges in which Sarrasine proclaims his love and La Zambinella protests her inability to return his affections read as a near parody of bad Romantic dialogue, with the significant twist that the clichés are not mere convention, but true. The opera singer's seemingly empty and overused phrases reveal a truth that the sculptor and the reader are initially inured to. In the carriage on the way to Frascati, she declaims:

Oh! vous ne m'aimeriez pas comme je voudrais être aimée. [. . .] Sans but de passion vulgaire, purement. J'abhore les hommes encore plus peut-être que je ne hais les femmes. J'ai besoin de me réfugier dans l'amitié. Le monde est désert pour moi. Je suis une créature maudite, condamnée à comprendre le bonheur, à le sentir, à le désirer, et, comme tant d'autres, forcée à le voir me fuir à toute heure. Souvenez-vous, seigneur, que je ne vous ai pas trompé. Je vous défends de m'aimer. (6: 1069)

(Oh! you would not love me the way I want to be loved [. . .] Purely, without the ends of vulgar passion. I hate men even more perhaps than I hate women. I need to take refuge in friendship. The world is deserted for me. I am an accursed creature, condemned to understand happiness, to feel it, desire it, and, like so many others, forced to see it continually escape me. Remember, sir, that I have not deceived you. I forbid you to love me.)

La Zambinella's speech highlights Romantic conventions of suffering, impossible love and a life condemned to misery and isolation—conventions that the reader and Sarrasine interpret as formulaic exaggeration. The polyvalent nature of language, always open to a multiplicity of meanings, implicitly complements the singer's own polymorphic identity. Sarrasine stubbornly refuses to see and hear the truth, dismissing La Zambinella's pseudo-confession— "Si je n'étais pas une femme?" (And if I weren't a woman?)—out of hand. His retort carries the heavy irony of Balzac's own dismissal of the visual artist's perceptual acuity: "Crois-tu pouvoir tromper l'oeil d'un artiste?" (Do you think you can fool the eye of an artist?) (6: 1069).

In Balzac's Realist universe, the Romantic cliché is thus rendered real and referential rather than hyperbolic and abstract. Like Sarrasine, La Zambinella's art is her life: "The stage where you saw me, that applause, that music, that glory to which I have been condemned, that is my life, I have no other."[78] For Balzac, this confusion of the two spheres leads to physical and spiritual death, for art should reflect life, not replace it, and both Sarrasine and La Zambinella fall victim to this Romantic obsession. The central image of castration becomes a metaphor for the feminizing tendencies of Romanticism, as the signifiers marking the castrato's deformation are also intimately tied to contemporary formulations of artistic genius and heroism. Indeed, "the delicacy of this weak and enervated soul . . . the irrational whims, instinctive worries, unexpected boldness, blusters and delicious delicacy of emotion,"[79] could as easily have been describing René, Adolphe and Oswald as La Zambinella. Similarly, the singer's talent and mien combine "feminine" aspects often associated with male Romantic heroes ("tristesse . . . mélancolie . . . découragement . . . passion" [6: 1070]) that make the revelation of her original sex logical within Balzac's own narrative agenda, while the disclosure of a castrated male body lurking beneath the veiled form of a female artist is fully in keeping with contemporary misogynist discourse of the 1830s. The anxiety that a female artist would neuter and/or render impotent the males around her, so clearly manifested in popular caricatures, appears in Balzac's tale as well, where Sarrasine is himself figuratively castrated by his exposure to this unnatural creature, in her undeniable "monstruosité." Ironically, the sculptor reflects that he would be repulsed by a more "masculine" woman—"je détesterais une femme forte, une Sapho, courageuse, pleine d'enérgie, de passion" (6: 1071)—the stereotype of the *femme artiste* à la Corinne or Félicité des Touches. It is in fact a "feminine" *man* who embodies his ideal *woman*, whose art is the product of her delicate conformation in ways that he cannot see.

Sarrasine's ultimate disillusionment comes when he attends a concert at the ambassador's residence and sees La Zambinella dressed as a man. Refusing to believe his own eyes, he rejects reality and clings to illusion, and it is only when the Prince Chigi *tells* him that *she* is a *he* that he begins to grasp the truth, as words communicate what vision cannot. The Prince claims "credit" for the "gift" of Zambinella's voice, and his interpretation of castration as an endowment rather than a subtraction implies that, like Sarrasine, he sees the singer not in terms of life but of art. The Lantys' wealth, the jewels, *hôtel* and glittering splendor are analepticly accounted for, as art and capital are united in the figure of the castrated and thus impotent artist, an image that reflected Balzac's vision of the contemporary artist as much as that of the artist of the Ancien Régime.

The effect of this revelation of truth upon the respective art of Sarrasine and Zambinella is entirely destructive, for in each case art was based on sustained illusion. Realizing that the sculptor has discovered her secret, Zambinella sits down trembling and refuses to sing another note. And in a final scene between the two artists, when Zambinella is kidnapped by Sarrasine's artist friends, the sculptor attempts to destroy his own creation—the statue—when confronted with the horror of the original. Mirroring the malignant juxtaposition of model and portrait in *La Maison du chat-qui-pelote*, the scene in Sarrasine's studio reads as a negative inversion of Pygmalion's ecstatic moment of wish fulfillment. Where Galatea comes to life for the ancient sculptor, here the artist must confront the shattering discrepancies between art, life and his own illusions. The juxtaposition of the real and the ideal leads inevitably, *chez* Balzac, to the destruction of both, and despite his original intention to kill the singer, Sarrasine decides that Zambinella is living a life worse than death. Yet her living death is contagious, infecting the entire world with sterility by association, and Sarrasine laments "I will always think of this imaginary woman when seeing a real woman . . . you have emptied the earth of women for me. . . . No more love! I am dead to all pleasure, to all human emotion."[80] Substituting one [wo]man for all women, Sarrasine continues to privilege the imaginary over the real, a confusion that kills him first emotionally, then physically. Turning his rage on the statue that reflects his now debunked fantasy, he hurls his hammer at the marble image in order to destroy it, but ironically, he misses. When he brandishes his knife at the singer, her shrieks alert Cardinal Cicognara's men, who murder Sarrasine in the name of Zambinella's protector. Thankful for an end to his intolerable suffering, the sculptor succumbs to three phallic thrusts from a stiletto, and the castrato is whisked away by the Cardinal and his men.

In the end, though the artist has perished, his representation lives on, albeit in a different form, and it is finally through the painting of Endymion/Adonis that the connections between the two levels of diegesis are made apparent. For when Mme de Rochefide wonders what is the connection between the story she has just heard and the *petit vieillard,* the narrator recounts the genesis of the painted image by way of explanation. He expounds, "Madame, Cardinal Cicognara became master of Zambinella's statue and had it executed in marble. Today it is in the Albani museum. The Lanty family came across it there in 1791. They asked Girodet to copy it and this portrait that showed you Zambinella at 20 an instant after having seen him at one hundred, later served him as model for his *Endymion* whose type you might have recognized in the Adonis."[81] The painting, in all of its seductive splendor, comes to stand for a false aesthetic of illusion, blindness and corruption, irremediably at odds with reality. The mythological subject remains at several removes from life, as it is art modeled after art modeled after art and projected fantasy, and while the contemplation of its loveliness brought pleasure to its spectator, the revelation of its actual subject brings only disgust. Girodet's painting of a beautiful youth, an image of impossible androgynous perfection, served as a symbolic embodiment of the poetic dreams of the new, all-male Republic, and later as model for the idealized Classical-Romantic painting in the early decades of the nineteenth century, centering on erotic mythological subjects. Balzac deconstructs this original optimistic orientation of *Endymion,* and reconstrues it as the embodiment of the idealizing, mythologizing tendencies of the Romantics, who embraced and were inspired by this fantastic image. The androgynous Greek shepherd is transformed into the portrait at two removes of a eunuch, his original physical perfection metamorphosed into a haunting image of masked mutilation. Girodet's artistic dream of an art created and consumed by virile men no longer holds in postrevolutionary France, and by 1830, Balzac's subject and audience are gendered female. For if "the female spectator is socially and culturally structured as an absence in nineteenth-century French art,"[82] the Realist author insistently inserts female viewer, reinscribing the elided Diana, not from any feminist sympathy, but rather to highlight the failures of his aesthetic rivals. If the ghastly image of Zambinella/*le vieillard* stands as a parody of the feminizing tendencies of Romanticism, in a more serious vein this castration reflects Balzac's vision of the ultimate impotence of Romanticism and its idealizing tendencies, where Sarrasine's Pygmalionesque conflation of art and life bastardizes both.

As he struggles to announce his own Realist aesthetic, Balzac wages bat-

tle against Romanticism for aesthetic hegemony. At the same time, Balzac seeks to unseat painting and visual representation from their positions as arbiters of the "real," a rivalry played out in his continuing attacks on the figure of the visual artist in his tales of this period. By demonstrating the breakdown between what the visual artist perceives and reproduces and what is really there (case in point being La Zambinella), Balzac asserts the superiority of word over image, for the unstable and polyvalent nature of the world is far more accurately reflected by language than by images, both of which demand interpretation. *Sarrasine* deconstructs the representational pretensions of the visual arts, whose apparent mimetic fidelity to the "real" world falsify it by creating the illusion that it is stable and knowable, and that "what you see is what you get." As Balzac's tale breaks down the equivalence of *voir* and *savoir*, *pouvoir* is removed from the equation as well. Indeed it is the visual artist who is rendered blind by his passion, and this inability to see and to know leads directly to his impotence, procuring *puissance* and production for the author of the tale, who retains the ultimate power of insight into language, art, representation and reality, in all of their instabilities.

The rivalries between word and image, Romanticism and Realism, the "real" and the ideal at the heart of *Sarrasine* are most clearly evoked in the contrastive pairs of "portraits" signaled above. The dialectical tensions between these portraits produce Balzac's meaning, as they show, rather than tell, what the author intends, allowing the reader to play an active role in the synthesis of meaning. The narrator is at once the most shadowy and most pivotal character in *Sarrasine*, and it is through his contrastive portraits with Sarrasine, as infatuated artists, and with Mme de Rochefide, as consumers of art, that Balzac's own narrative goals become apparent.

Although his story is meant to expose Sarrasine's blindness, the narrator ultimately shares the sculptor's fetishizing tendencies, and remains unable to perceive the true nature of the object of his intentions. Like La Zambinella, the narrator uses his art—the story—to seduce, but like the singer he ultimately only induces revulsion in his audience, for Mme de Rochefide, like Sarrasine, turns away from passion and love, seeing in them only illusion and deception. The narrator, like the protagonists in his tale, is also rendered impotent, and his naïve contention in the last lines of the story, "On n'y fait plus ces malheureuses créatures" (They no longer make these unhappy creatures there) (6: 1075), is belied by his own emasculated state at the hands of his powerful female *destinataire*. As author of the story, Balzac thus diverges in his goals from those of his inscribed narrator, for rather than trying to seduce his reader with Romantic fantasies, he exposes

her to a "truth" that reflects the relative nature of words and images while alerting her to the deceptive nature of the world. Art is a vehicle for truth rather than illusion, which will ultimately empower rather than castrate. After learning of the *vieillard's* origin, Mme de Rochefide is able to translate the lesson to the corruption of society and to protect herself from the narrator, and thus becomes an ideal reader. Mme de Rochefide is won over from painting to narrative, but rather than seduced she is edified. Where [Girodet's] image led her down the path of fantasy, words bring her back to reality; although she is revolted by what she has learned, she is also, if only fleetingly, empowered with knowledge.

Sarrasine thus stands as a defining moment in Balzac's formulation of Realism and the ultimate power of the *author* who can empower his audience through a confrontation with the "real," while the illusions of the ideal, associated with Romanticism and painting, lead to failure and impotence. Mme de Rochefide's impassioned final speech presents a vivid illustration of what Balzac's female readership loved in the author—a biting recognition of the status of women in the corrupt world of nineteenth-century France, and the noble withdrawal of the wronged woman from the world. Finally, though, Balzac's pessimistic worldview and misogyny cannot be denied. If at the end of *Sarrasine* Mme de Rochefide appears to be a powerful and enlightened figure, eschewing seduction for an elevated renunciation of society, several years later she will reappear in *Béatrix* (1838), as the spiteful friend of the *femme artiste,* Félicité des Touches. In a bizarre Sarrasine redux, Béatrix de Rochefide runs off to Italy with Conti, the opera singer, only to be abandoned and lead a life of intrigue, corruption and infidelity. But while the lesson did not perhaps linger, Mme de Rochefide, as the ultimate hero of *Sarrasine*, temporarily embodies a positive paradigm of the Realist reader, presenting Balzac's initial acknowledgment of the importance of the female audience and his direct appeal to her to beware the seductive powers of the other artists competing for her attention.

Chapter 6 ～

LE CHEF-D'OEUVRE INCONNU: PYGMALION DENIED

The Artist, his Model and the Atelier in the Nineteenth-Century Imagination

Le Chef-d'oeuvre inconnu (*The Unknown Masterpiece*) holds a unique place within Balzac's oeuvre as a tale that has continually transcended its temporal and generic boundaries for painters, authors and critics alike. Set in seventeenth-century Paris, this allegory of failed genius was recognized upon its 1831 publication as a commentary on the aesthetic battles of its day, while artists of the twentieth century—Picasso, Cézanne, de Kooning— found in its hero, Frenhofer, an avatar of the modern.[1] *Le Chef-d'oeuvre inconnu* struck a vital chord in a large number of authors as well, for Henry James, the Goncourts, Zola and Wilde all composed their own versions of the tale. The appeal lingers today: an updated cinematic version, Jacques Rivette's *La Belle Noiseuse*, won the Grand Prix at Cannes in 1991, while contemporary critics continue to wrestle with the implications of Frenhofer's painting.[2] For Balzac himself, the tale held iconic significance and *Le Chef-d'oeuvre inconnu* underwent an unprecedented series of reworkings following its "pre-original" appearance in *L'Artiste* (July-August 1831). He transformed the story, with minor alterations, into a *conte philsophique* in September 1831, and submitted it to a substantial metamorphosis in 1837, increasing its length by a third and adding a definitive ending to Frenhofer's fantasy. Even some 16 years after its initial appearance Balzac was still tinkering with *Le Chef-d'oeuvre inconnu* and in 1847 he included the story in *Le Provincial à Paris* under a new title, *Gillette*.[3]

Much attention has centered on the question of influence and on the sources of Frenhofer's aesthetic as elaborated in the 1837 additions to the narrative. Beginning in Balzac's day and continuing into our own, critics

have devoted countless pages to locating the origins of Frenhofer's speeches, and Diderot, Gautier and Delacroix are most often cited as the possible "contributors" to the tale.[4] But, while acknowledging the possibility that Frenhofer's added theorizing may have been inspired by a third party, it must be stressed that *Le Chef-d'oeuvre inconnu* does not emerge from an inexplicable aesthetic vacuum. This story of artists and their models reflects themes and concerns expressed in the pages of the very journals in which Balzac was publishing, as it engages in explicit dialogue with the popular genre scenes of artists at work that were found at every Salon from 1804 to 1886.

Balzac's fictional treatment of the artist in his atelier presents a prototype of what would become a popular nineteenth-century literary topos, growing in direct response to the self-promotional efforts of the sister art. With the concomitant questionings of the artist's role in society and a new fascination with the "personality" of genius, scenes of artists in the studio had gained popularity with painters and public alike in the early decades of the century. By the 1820s there were often as many as ten canvases portraying artists at work at every Salon, increasing to almost 20 in the decades to follow.[5] Focusing on the glory of painters of the past, these Romantic, idealizing canvases portrayed anecdotal scenes from the lives of Gothic and Renaissance artists in hopes of sharing their social and artistic prestige—felt to be at an all time low in contemporary France. These narrative episodes from the biographies of Leonardo, Michelangelo, Raphael, Titian, Tasso and other renowned French and Italian artists, fell under the heading of the *style troubadour*. Also known as the *genre anecdotique* or *historique*, this nostalgic approach enjoyed enormous popularity among private patrons thanks to their smaller scale and highly detailed, finished Dutch manner in the style of Metsu, Terborch and Jan Steen. Troubadour painting's orientation toward a "modern" and "national" past reflected a Romantic bent, as well as an awareness of the aesthetic preferences of the increasingly powerful domestic consumer no longer interested in Classical subjects or *grandes machines*. Practitioners of this historical style included many of Girodet's former students such as Devéria, Dejuinne and Coupin de la Couperie, brother of Girodet's biographer, and indeed Troubadour painting reflects Girodet's predilection for a highly polished, finely detailed surface suffused with light and saturated color—considerations distinctly at odds with the freer brushstrokes and open handling of mainstream Romanticism (à la Delacroix).

Troubadour painting, like Romanticism itself, took part in a "radical reinvention of the past" that "drew parallels between the great figures of

history and their successors in the contemporary arena."[6] The Troubadour portraits of painters of the past sought to confer upon painters of the present the fantasized prestige and patronage of their predecessors. Typically, many are deathbed scenes such as Bergeret's *Honneurs rendus à Raphaël après sa mort* (Salon of 1806), which celebrate the painter's social prestige and patronage far more than his personal genius. Surrounded by princes of the state and the church, the dead painter's glory derives more from the status of his mourners than from his artistic production. Equally popular were scenes set in the atelier where, in an updated version of Apelles and Alexander, the artist presents his work to the king, pope or other prestigious spectators. Commanding the respect and admiration of the highest social echelons, the painter is portrayed on equal footing with his audience. Bergeret's *Charles V and Titian* (Salon of 1808), Marlet's *Raphaël et Léon X* (Salon of 1812), Ansiaux's *Poussin introduced by Richelieu to Louis XVIII* (1817), Jacquand's *Marie de Médicis visitant l'atelier de Rubens* and Eugène Devéria's *Le Puget présentant le groupe de Milon de Crotone à Louis XIV* (1832) all explicitly link art and power, as the authority of the painted image and its creator vie with that of the seated princes.[7] These idealized paintings of painters posited an implicit contrast between past and present in an effort to present new paradigms to potential patrons while effacing the often miserable or degrading aspects of artistic life in the postrevolutionary era.

Artists drew these episodes from the myriad biographies and "lives of the painters" that proliferated during the first half of the nineteenth century, often penned by art critics eager to capitalize on the public's burgeoning fascination with art, artists and genius.[8] By 1830 popular interest in the hagiography of painters was so great that journals such as *L'Artiste* and *Le Magasin pittoresque* regularly included critical accounts of the lives and works of the Old Masters in a form readily accessible both to lay readers and contemporary artists looking for source material. The sentimental, narrativizing Troubadour images came "certainly much closer to the novel than to history,"[9] for the Romantic painters relied heavily on postclassical and contemporary literature for inspiration, turning frequently to Dante, Shakespeare, Goethe, Scott and Byron for their canvases. The paintings of painters mined literary sources and even techniques in order to establish the "personality" of the artist via anecdote and narrative episode, bringing to life often obscure historical artistic figures in hopes of further stimulating public interest in art while promulgating the Romantic "cult of genius."

These idealized images of artists coupled with flattering portraits of patrons and the glory of patronage represented a thinly disguised attempt to curry the favor of an elusive and unfamiliar audience whose mistrust of

artists was profoundly troubling. Haskell asserts that "if one had to sum up all these pictures under a single heading one could say that they represented a sort of counter-attack on the whole tradition, never more flourishing than during the nineteenth century, which represented painters as disreputable bohemians, quarrelsome and crippled by poverty."[10] This "tradition," disseminated primarily by authors, manifested the postrevolutionary *paragone,* fueled by the competition for the bourgeois audience. Contemporary authors had little interest in encouraging a glorified image of the painter's nobility and territorial resentment grew as painters "borrowed" authors' subjects and techniques to public acclaim and profit. In short, a battle ensued over the generation of the image of artistic genius and its dark converse, *le génie avorté.* Balzac's *Le Chef-d'oeuvre inconnu* represents one author's response to contemporary painters' efforts to construct a public image of the artist based on fantasies of the past rather than the realities of the present. This *conte fantastique* subverts the idealizing project of the Romantic artists as it demonizes the painter of purported "genius," substituting the author as the true source of artistic creation.

Complementing the public image of the painter in his atelier, surrounded by admiring patrons and princes, is the more intimate image of the artist with his model. Although the male nude had dominated both training and painting throughout the history of the *Académie,* the female nude came to eclipse the male figure in the postrevolutionary era.[11] The prohibition of the undraped female figure at the *Académie* stemmed from the desire to shield male students from exposure to "immoral influences" and avoid the "unhealthy" configuration of young males collectively examining and representing the naked female form. This enforced "chastity" liminalized the study of the nude female form by relegating it to the private studio, an intimate setting far more sexually charged than the public space of the academic atelier. The popular image of the artist and his female model in painted and literary representation thus exploited the erotic charge associated with this dynamic. Rococo representations of the topos, typified by Fragonard's *Le Début du modèle* (1770), play off of the sexual vulnerability of the exposed model, draped on a couch or bed, in the phallic presence of the fully dressed artist.[12]

Nineteenth-century artists struggled to transcend this archetypal image of artistic "liberté de moeurs," with its emphasis on the physical, rather than conceptual nature of painting. Thus, in postrevolutionary images of the artist and his model, such as Ingres's portrait of *Raphaël et la Fornarina* (1814) [figure 6.1], the painter's lover and model is fully dressed, her open

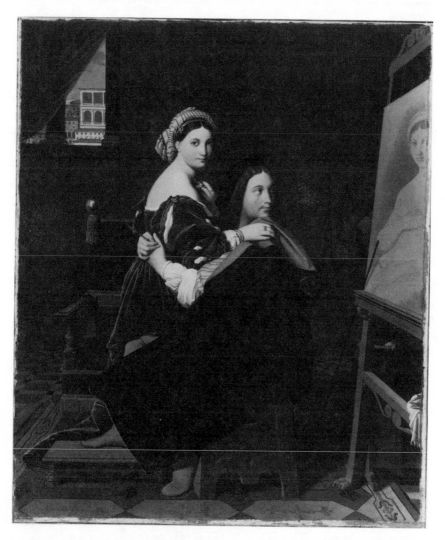

Figure 6.1. J.-A.-D. Ingres, *Raphaël et la Fornarina*. 1814. Oil on canvas, 64.77 x 53.34 cm. Courtesy of the Fogg Art Museum, Harvard University Art Museums, Bequest of Grenville L. Winthrop. © President and Fellows of Harvard College, Harvard University. Photo: Katya Kallsen.

gaze and pacific demeanor evoking paradigms of beauty and purity rather than eroticism. While embracing the baker's daughter who perches on his lap, the Renaissance master gazes at his own canvas where her image is sketched, thus indicating his preference of the ideal over the real—a theme that will be central to *Le Chef-d'oeuvre inconnu*, for which this image serves as an intertext. Eroticism is repressed, but not entirely effaced from the image, for although the model is clothed, her image is not, and the painted Fornarina on the easel exposes a nude breast cupped by her right arm while her left hand points provocatively at her lap. The small paintbrush with the brilliant red tip clutched by the painter as he holds the model and the mahlstick jutting up toward her naked bosom indicate the sexual tension of the atelier and the intimate relationship between artist and model. But here, the sensual dynamic is channeled through the painted image, which becomes the repository for the artists' (both Raphael's and Ingres's) fantasies and desires. In the background sits a third image of the artist's model/lover in a shadowy tondo, easily identified as the renowned *Madonna della sedia*. The replication of images of La Fornarina in three different incarnations—real woman, Madonna and courtesan—highlights what Patrick O'Donovan has identified as "the ambiguity of beauty—part sacred, part erotic, part substance, part image—as it figures in painting and in stories about painting."[13]

Exploiting Raphael's well-known relationship with La Fornarina as both model and lover, Ingres's image exposes the artist's transgression of boundaries between art and life, while revealing a crucial dialectic between virgin and courtesan that characterizes nineteenth-century approaches to the female figure/model. Closely associated with the prostitute, for indeed she was paid to take off her clothes and perform a male fantasy, the model was nonetheless capable of representing ideal innocence as easily as venal seduction, thanks to the transformative powers of the artist's imagination.[14] Ingres's painting, a tribute to the artist's ability to shape perception, presents the full range of these alternative realities in a single image. La Fornarina and the (window)-framed image of the real world occupy one side of the canvas, while the other is shared by the competing but complementary images of her, mediated by the figure of the artist who is placed between the two spheres. Finally, as Ingres mythologizes the artist's creative power and authority, his *own* portrait of La Fornarina dominates the composition, while Raphael's pair of paintings remain secondary, and there is a subtle competitive edge to this tribute for representational dominance.

The mythology of the model as courtesan dates back to classical history,

and the earliest prototypes of the artist's model—Lais, Phyrne, Campaspe—were identified in terms of their sexual relations with the artist. The image persisted from ancient Greece to the Renaissance and well into the nineteenth century,[15] and even today there is a public fascination with the personal relations between artist and model (i.e., Picasso and his many wives/lovers/models, Wyeth and the Helga series, etc.). It was not, however, until the nineteenth century that the model became established as a *type* in France. Marie Lathers contends, "It would not be an exaggeration to assert that the nineteenth century invented the female model as an individual who could be identified and whose history could be written . . . [for] the shift from the male to female body as focus of life drawing and referent of legitimate art, joined by a 'democratization' of the artist's profession and the resulting rise of public ateliers and academies, opened a vacancy in the conventional roster of atelier figures that only the professional model could fill."[16] The nineteenth-century model, generally an urban working-class girl, was categorized by the 1830s as the *grisette*, "independent, adventurous and obliging." If this female profession achieved tangential legitimacy from its increasingly commonplace nature, in another sense it remained both marginal and suspect, for "what could never be forgotten by bourgeois culture was the fact that the majority of female models posing in the nineteenth century stood naked before the (most often male) artists who hired them."[17]

The model's body represented the confluence of sex, desire, art and money, and as such became a loaded symbol for the myriad anxieties surrounding art and representation for both creators and consumers in nineteenth-century France. The metaphor of prostitution, so closely tied to the iconic figure of the model, was also increasingly applied to the artist's own activity, as he sold his body of work to the highest bidder. The bourgeoisie's ambivalence toward artists and their world—one part fascination, one part repulsion—was echoed by the artists' own hostility toward the audience upon whom they relied, as the laws of the marketplace asserted their forces upon creative production. The commodification of art and the commodification of sex, both of which were reaching a crescendo in postrevolutionary capitalist culture, generated parallel dislocations and malaise as the once elevated spheres of love and art became equated with money. While Charles Bernheimer and Hollis Clayson have documented the growth of prostitution in nineteenth-century France,[18] the artist often felt himself to be (or was portrayed as being) in a similar professional relationship with his audience. The alienated relationship between artist and audience, brought together by desire and money, coalesces in the image of the *grisette*, a female

body representing the uneasy mating of the real and the ideal through the exchange of capital.[19]

The anxieties surrounding the commodification of art and the body in nineteenth-century France thus converged in the figure of artist's model. The painted nude carried its own associations and meanings that were similarly the products of social and artistic ideologies. Historically, the painted or sculpted nude in Western art has been "the central subject of art," coming to stand for art itself.[20] Marcia Pointon contends that the nude is "a form of rhetoric" functioning within the "grammar of representation" and thus must be interpreted as a signifying entity within a larger structure of meaning. Pointon identifies "the figure of the woman, and particularly the nude, as a sign for male creativity. Women can thus be understood in representation to signify not only the objectified female body that constitutes Art but also the very creativity through which it comes about and which is male."[21] Courbet captures this symbolic imbrication of art and the female body in his programmatic *L'Atelier du peintre* (*allégorie réelle*) (1855), where the nude model hovers attentively behind the artist who is working on a landscape.

In postrevolutionary France, as male artists sought to assert both gender and generic superiority, the female nude represented a symbol of creative mastery and "a way of encoding male cerebral processes."[22] Yet, as the female nude embodies the male genius's power of creation *ex nihilo*, the generative force behind this creativity lies in "the assertion of the artist's sexual domination."[23] Indeed, Carol Duncan argues, "More than any other theme, the nude could demonstrate that art originates in and is sustained by male erotic energy. This is why so many 'seminal' works of the period are nudes. When an artist had some new or major artistic statement to make, when he wanted to authenticate to himself or others his identity as an artist, or when he wanted to get back to 'basics' he turned to the nude."[24] The female body is emptied of meaning outside of the economy of male desire, and the threatening power of her sexuality and individuality—all the more apparent in the course of the nineteenth century—is neutralized within the rhetoric of representation. Lynda Nead confirms that in the majority of nudes "women are portrayed as powerless and vulnerable, given meaning only through the creative force and potency of the male."[25] Pointon concurs, asserting that the female body "is evacuated of other meaning in order to achieve this almost heraldic effect"[26] of the artist's status as artist. The female nude as signifier of male creativity and dominance reflects the traditional structures of male/active/subject,

female/passive/object present in the dynamic of the gaze as posited by Mulvey and others, while further locating "the origin of art itself in male desire."[27] Yet this desire for a woman who is his own creation, and the eroticization of the act of painting partakes of the idealizing pattern of Pygmalion paradigm. Its popularity in the nineteenth century stands as testimonial to an increasing sense of discontent with the "real," especially as it pertains to women and desire.

The painted female nude and the living female model stood as complementary embodiments of nineteenth-century ideologies of art and gender, while clearly manifesting the inherent tensions between the real and the ideal in representation and sexual relations. The painted body became a switching point for the desire of the creator and his male audience: an idealized image of female passivity, purity and/or availability that displaced the reality of the working girl assuming poses for cash, as well as the more threatening specter of better-off women petitioning for political and sexual equality. Finally, beneath these obvious juxtapositions of the real and the ideal lies an unresolved tension between mind and matter that is fundamental to the eroticization of art and to the *paragone*. The metaphysics of art and the formulations of genius during this period embraced the ideological associations of woman-nature-body and man-culture-mind. Nead explains "The term 'male' is associated with the higher faculties of creativity and rational mental processes, while the 'female' is associated with the biological mechanisms of reproduction. Thus in western metaphysics, form (the male) is preferred over matter (the female); mind and spirit are privileged over body and substance."[28] Although painters had, since the Renaissance, endeavored to claim a place within the pantheon of intellectual rather than physical arts, the eroticization of painting and the construction of desire as an emblem of artistic activity served to feminize it, by bringing it back to the realm of the body. If the nineteenth-century painter hoped to allegorize his genius through the representation of the ideal female form, highlighting his cerebral prowess and creative potency, the nineteenth-century author insistently read these creative productions in terms of their materiality, as fetishized *reproductions* of a desirable body, rather than elevated intellectual creations. These very tensions between the real woman and her painted image, between the conception and the execution of art, between the potency of genius and the impotence of mere fantasy, are central to *Le Chef-d'oeuvre inconnu*, reflecting Balzac's acute awareness of the conflicts and crises shaping artistic and gender relations in the France of the July Monarchy.

"Pygmalion et sa statue ne sont plus une fable pour moi":[29] *Le Chef-d'oeuvre inconnu*

Originally subtitled *Conte fantastique, Le Chef-d'oeuvre inconnu,* like *Sarrasine,* evoked the gothic tradition of Hoffmann's popular tales in a parable of the visual arts that reflected just as self-consciously on the art of narration.[30] But where *Sarrasine* was set in the ballrooms and parlors of late-Restoration France, *Le Chef-d'oeuvre inconnu* takes place in the early seventeenth century. The motivations behind Balzac's choice lie at once in the contemporary vogue for history and in the political and artistic intersections between the two periods. Henri IV, the first Bourbon king, ascended to the throne in the 1589, expanding France's European power base while solidifying the absolute monarchy. A popular subject among Romantic and Troubadour artists,[31] Henri IV brought an end to civil war and enjoyed the adoration of the masses, and thus stood as a symbol of legitimacy and consensus building for the Restoration audience. Balzac's tale, however, is set two years *after* Henri IV's assassination in 1610, during the regency of Marie de Medici, a period of conflict that saw the outbreak of the Thirty Years War and the bitter alienation of Marie and her son Louis XIII. Thus 1612, like 1831, represented the demise of a Bourbon monarchy per se (as an Italian-born regent and her cronies briefly held the country's reins) and the aftermath of political turmoil. By setting his allegorical tale during a period where France was led by a woman (whose name will play a key role in his narrative), Balzac reflects the perceived ascendancy of female power in the France of the July Monarchy and the implied effeminacy of the bourgeois Orleanist king, Louis Philippe.

Dubbed the *Grand siècle,* the seventeenth century was considered France's golden age of artistic perfection. The graceful forms and Greco-Roman subjects of Racine, Corneille and Poussin emblematized the pinnacle of aesthetic achievement in their linear rationality and Classical ideal. Yet the *âge d'or* did not truly begin until 1640, and thus Balzac's tale of 1612 takes place in the moment preceding the onset of an age of artistic possibility and perfection. In Troubadour painting, history served as a shorthand method of introducing the "elevated" values of a romanticized past into the commercialized present, while providing viewers with positive images of artists and patrons that might serve as modern paradigms. Contrasts between past and present are central to the functioning of these historical paintings, yet the implied commentary is gentle, idealizing and even wistful. Balzac's use of history in *Le Chef-d'oeuvre inconnu* is more

pointed, for the encoded relationship between past and present reflects negatively on both in a rejection of romantic historicization for a more "realist" vision of art, representation, patronage and prostitution across the ages. Universalizing the difficulties confronted by the artist, Balzac allows the tension between the seventeenth and nineteenth centuries to generate meaning both through similarity and difference in a story that functions on two levels: the social construction and deconstruction of the artist and his work, and the more transcendent question of the artist's own relationship with his creation.

The opening scene presents an unidentified young man on the threshold of initiation. Emphasizing his youth and his poverty, the narrator evokes a Romantic image of the bohemian artist. Pacing back and forth before a house in the rue des Grands-Augustins, the hero displays "the hesitation of a lover who doesn't dare present himself at his first mistress's house, however easy she might be."[32] Conflating art and love, Balzac invokes the age-old image of art as mistress, while the implications of her easy virtue resonate with Pygmalion's preoccupation with prostitution. The reader soon learns that the youth is at the door of François Porbus (1569-1622), a Dutch court portraitist considered an important precursor of the Troubadours and "Henri IV's painter, abandoned for Rubens by Marie de Medici."[33] This invocation of Rubens, the Baroque master of expressive color and fleshy nudes stands in proleptic opposition to Poussin's rational, linear, ascetic aesthetic in terms that mirror the tensions between the schools of Delacroix and Ingres in Balzac's own day. However, unlike the popular Troubadour paintings of the period, Balzac's story does not portray the glories of a monarch's respect for a painter, but instead the dismissal of the "homme de génie" by the fickle female ruler. This image of disjunction between art and the power structure reflects the experience of the nineteenth-century artist while pulling painters off of their self-constructed historical pedestals. Balzac rejects the sentimentalized Romantic vision for a proto-Realist view of the world and human relations.

The young man's timidity before the unopened door of this "master," whom he approaches like a "mistress," anticipates the homosocial/sexual tensions that will arise in the ateliers of Porbus and Frenhofer. The three artists enter into a triangulated relationship that precludes the women who are ostensibly the focus of their attentions, recalling the uneasy dynamic of David's studio. The neophyte is likened to a young girl in his innocence, passion and "that undefinable modesty that people destined for glory know how to shed in the exercise of their art, just as pretty women shed theirs

in the stratagem of flirtation."[34] Shifting to a metaphor of artistic virginity, Balzac introduces the sexualization of art to his extended trope. *Pudeur,* linking shyness and shame, derives directly from *pudendum,* and is almost inevitably erotic in its connotations. As the budding artist is feminized, the author compares art to the peekaboo antics of *coquetterie,* while the artist's production is likened to the body of a beautiful woman—modestly hidden at first, but later displayed with confidence when the doubts driving modesty have been dispelled. *Pudeur,* exposure and the dueling bodies of women and art are central to the drama of *Le Chef-d'oeuvre inconnu* and constitute the very nature of entry into the world of the Balzacian visual artist.

In a shift of focus closely resembling the introduction of Sommervieux in *La Maison du chat-qui-pelote,* the narration moves from description of the artist and his actions to an evocation of his observations. In both stories the author privileges the filter of the inscribed spectator's vision, as the artist-heroes stand before the house of a desired "mistress." Yet, where Sommervieux was a flawed observer, the *jeune homme* in the *Chef-d'oeuvre inconnu* is soon to be identified as Poussin, the greatest of all French painters, and his will be an insightful gaze, at least most of the time. Augustine's opening "portrait," painted in Sommervieux's romanticizing imagination, stood in stark contrast to the reality that the more earthbound narrator revealed. The image of Frenhofer, who arrives on Porbus's doorstep soon after Poussin, is no less self-consciously a portrait, but unites, rather than distances, the vision of painter and narrator. Balzac's "pre-emptive" portrait asserts the primacy of words to evoke images and characters. The passage begins, "Imaginez un front chauve, bombé, proéminent, retombant en saillie sur un petit nez écrasé, retroussé du bout comme celui de Rabelais ou de Socrate; une bouche rieuse et ridée, un menton court, fièrement relevé, garni d'une barbe grise taillée en pointe . . ." (Imagine a bald, rounded, protuberant forehead jutting out like a ledge over a crushed little nose, turned up at the end like Rabelais's or Socrates's; a laughing and wrinkled mouth, a short chin, proudly raised and decorated with a pointy gray beard . . .). The description continues on and on, accumulating a dense surface of details that reveal the contradictory and fantastic nature of this mysterious stranger, at once philosophical and ribald, troubled and merry, wealthy and wasted. The artist's face and body must be read, interpreted, by the viewer, who in this case is the reader, and our powers of imagination are enlisted via the imperative "Imaginez," which is followed in the paragraph by "Mettez . . . entourez-la . . . jetez . . . " (10: 415).

These direct commands highlight the participatory role of the reader in

the synthesis of an image of the painter while drawing our attention to the progressive nature of prose, which develops an image over time rather than in space. Like writing, reading is a *process*, but in the collaborative efforts of author and reader, a vivid, even lifelike image may emerge, for he adds, "vous eussiez dit une toile de Rembrandt marchant silencieusement et sans cadre" (you would have said a Rembrandt canvas walking silently outside its frame). The work of art come to life and emerging from the frame is exactly what Frenhofer dreams of and cannot achieve, while there is a distinct contrast between this minutely detailed description and Frenhofer's own technique, which "appears slack and seems to lack precision."[35] Aligning himself first with Poussin, through the narrative focalization, and then with Rembrandt, Balzac posits a proleptic contrast between his own powers of visual representation and the failures of his fictitious painter. Yet in this troubled tale of art and its limitations, he is quick to admit that even his is "an imperfect image of this character to whom the weak light of the stairway lent a fantastic appearance."[36] Thus, Balzac indicates that an image is an *image* and, whether painted or described, will always be imperfect, falling short of the reality of lived experience. From the beginning, the author signals the gaps between words and reality, acknowledging the shortfall between the description of Frenhofer and what one would have seen on the spot, whereas his protagonists will seek the fantasy of a perfect representation. This tale of representation and its limitations is as much about words as it is about images, driven by a desire to define both the artist and his production in terms of and against the model of linguistic expression. While we may never "see" Catherine Lescault, we will retain a vivid "portrait" of her portraitist, the Maître Frenhofer. Although even this is an admittedly flawed image, it represents the triumph of the author over the painter for representational superiority, as the very concept of "representation" per se is redefined.

The trinity of artists—Poussin, Porbus and Frenhofer—represents the three ages of man, and the story is structured upon a series of triangulated relations that are inherently in flux. This sense of change and instability coincides with Balzac's definition of life, irremediably at odds with the static forms of painting and sculpture. As the trio enters Porbus's atelier, Balzac launches into another highly detailed description. Cataloguing the ephemera and tools of the trade that imbue his tale with a "realistic" atmosphere, the author challenges contemporary Troubadour images of the artist's studio. In contrast to the sanitized version of the artist's studio evident in Ingres's *Raphaël et la Fornarina*, Balzac emphasizes the chaotic nature

of the workplace, with upended stools, paint boxes, plaster casts and unfin-
ished sketches strewn everywhere upon the floors, tables and shelves. The
scene highlights fragmentation and process. The "heap of broken images"
in the atelier—fractured torsos of antique goddesses, cast off studies and
preliminary *ébauches*—contribute to the "realism" of the scene, but also to
a deconstruction of the work of visual art, usually seen in a polished state
of completion hanging upon the wall of a gallery or salon. The cluttered
studio, with its skylight, armor, statues, casts of Classical figures and a side-
board full of curios, vividly recalls Girodet's own atelier, as portrayed in
Dejuinne's portrait of the artist at work on Pygmalion [figure 3.1].[37] Balzac
may certainly have heard descriptions from Devéria and others, while
Dejuinne's painting and the miniature after it were displayed at the Salon
of 1822 and later at Sommariva's gallery, making this image of Girodet at
work readily available to the author during the period of his own artistic
development. The general disposition of the studio and the scene of the
three men gathered around a canvas that follows in Balzac's tale indicate
that Dejuinne's portrait may be taken as a visual intertext whose relevance
is tied to Balzac's fascination with Girodet and the image of Pygmalion in
its mythic as well as generic implications.

The three men gather around Porbus's *Marie égyptienne*, a painting
whose subject and provenance are central to Balzac's artistic allegory.
Painted for Marie de Médicis and subsequently sold "aux jours de sa mis-
ère," *Marie égyptienne* thematizes the connections between art, money and
prostitution. The legendary saint, in a variation on Mary Magdalene, was
an Alexandrian harlot who, after experiencing a vision, renounced sin and
retired naked to the desert as a repentant convert. Unable to pay the fare
to cross from Egypt to the Holy Land, she offered herself to the boatman
in a final sacrifice of her *pudeur*. Porbus's painting, which portrays the saint
preparing to pay her passage on the boat, doubly encodes the image of
bodies for sale. For just as Marie the Egyptian prepares to prostitute herself
one final time, Marie de Medici sold the painting, and in the pre-original
(*L'Artiste*) version of *Le Chef-d'oeuvre inconnu* the author elaborates on the
destiny of the painting that circulates, like money and prostitutes, through
a series of hands. Balzac's narrator explained:

> Ce chef-d'oeuvre, destiné à Marie de Médicis, fut par elle vendu à Cologne,
> aux jours de sa misère; et, lors de notre invasion en Allemagne (1806), un
> capitaine d'artillerie la sauva d'une destruction imminente, en la mettant
> dans son porte-manteau. C'était un protecteur des arts qui aimait mieux
> prendre que voler. Ses soldats avaient déjà fait des moustaches à la sainte pro-

tectrice des filles repenties, et allaient, ivres et sacrilèges, tirer à la cible sur la pauvre sainte, qui, même en peinture, devait obéir à sa destinée. Aujourd'hui cette magnifique toile est au château de la Grenadière, près de Saint-Cyr, et appartient à M. de Lansay.[38]

(This masterpiece, destined for Marie de Medici, was sold by the queen in Cologne, during her days of poverty; and, at the time of our invasion of Germany (1806), an artillery captain saved it from imminent destruction by putting it in his valise. He was a protector of the arts who preferred taking to stealing. His soldiers had already drawn mustaches on the patron saint of repentant girls, and, drunk and sacrilegious, were going to use the poor saint for target practice, she who even in painting had to obey her destiny. Today this magnificent painting is at the château de la Grenadière near Saint-Cyr, and belongs to M. de Lansay.)

While the elaboration of the provenance imparts "reality" to a fictitious composition, this passage emphasizes the painting's existence as an object that is traded, transported, defaced and otherwise defiled. Frenhofer offers to buy Marie de Medici's *Marie égyptienne* from its painter, for "ten gold crowns more than the queen paid."[39] Confirming the wealth of the *homme mystérieux*, this bid for the painted harlot sets up a network of exchange of art, money and women that characterizes the rest of the narrative and reveals the contemporary preoccupation with the commodification of art and the prostitution of the artist. Balzac, who agreed to write this story in 1831 in order to raise cash,[40] was intimately acquainted with the equivalence of artistic production and hard currency: three years earlier he had raged against "that prostitution of thought they call *publication*."[41] The thematic link between painting/painters and prostitution reflects Balzac's own anxieties as an artist in an era of high capitalism, but also reveals fundamental concerns and competition regarding visual representation and the fetishization of the work of art.

After having offered to buy the saint, Frenhofer launches into a critique of the image, complaining "elle ne vit pas" (she doesn't live) (10: 416). Even in its broadest sense, the metaphor of a painting being "lifeless" is a catachresis, for a painting can never *live*, and Frenhofer's aesthetic demand is based on the impossible. Soon, moreover, it will become evident that the elder artist seeks life in its literal meaning, believing it possible for a canvas to live and breathe. In the first of several sections added to the later editions of *Le Chef-d'oeuvre inconnu*, Frenhofer embarks on a heady disquisition on the principles of painting. Emphasizing color and light over line and drawing, his words share much with those of Diderot, Delacroix and the Romantic school rising to prominence in the 1820s and '30s. Yet

224 ～ Pen vs. Paintbrush

specifics aside, the painter voices a Promethean desire to "avoir dérobé le secret de Dieu" (have stolen God's secret) (10: 416) that can only lead to punishment from the jealous divinity. In a similar transgression of boundaries, he compares the painter's work to that of a poet, warning "Il ne suffit pas pour être grand poète de savoir à fond la syntaxe et de ne pas faire de fautes de langue!" (To be a great poet it is not enough to know your syntax thoroughly and not make grammatical errors!) (10: 416). Both of these images of overreaching—of a painter trying at once to be a god and a poet—will resonate throughout the story in Frenhofer's ambitious quest and his ultimate failure. Beyond line and color, with their encoded references to Romanticism and Classicism, this *génie avorté*'s flaws lie less in his style than in his substance.

Frenhofer's criticisms of Porbus's *Marie égyptienne* reflect the tone and content of many of Diderot's *Salons* that had become influential in the course of the 1830s and '40s.[42] Yet behind his complaints that the painting lacks dimensionality, lies the disappointed fantasy of animation. A latter-day Pygmalion, Frenhofer laments "I would find it impossible to believe that this beautiful body is animated by the warm breath of life. It seems to me if I put my hand on this firmly rounded breast I would find it as cold as marble."[43] Like Ovid's sculptor, Frenhofer sexualizes the represented body, longing to caress it, only to be betrayed by the sensation of cold stone rather than warm flesh. Focusing on the Egyptian's breast, the source of life and of erotic arousal, he intones, "No, my friend, blood does not flow beneath this ivory skin, the purple dew of life does not swell the veins entwined in a web beneath the transparent amber of the temples and chest."[44] The references to marble and ivory, as well as the fantasy that the image might breathe, point to Galatea, while his desire for the sainted prostitute is a redux of Sommariva's fetishizing approach to Canova's statues. Although Frenhofer recognizes that Marie is not "alive," he expects that it is *possible*, and his most basic aesthetic criterion is neither color nor line, but life—that which is *impossible* in the work of art.

The tension between art, life and death is played out on the fractured surface of the painted female body. Frenhofer observes:

Cette place palpite, mais cette autre est immobile; la vie et la mort luttent dans chaque morceau: ici c'est une femme, là une statue, plus loin un cadavre. Ta création est incomplète. Tu n'as pas pu souffler qu'une portion de ton âme à ton oeuvre chérie. Le flambeau de Prométhée s'est éteint plus d'une fois dans tes mains, et beaucoup d'endroits de ton tableau n'ont pas été

touchés par la flamme céleste. [. . .] Il y a de la vérité ici, dit le vieillard en montrant la poitrine de la sainte.— [. . .] Mais là, fit-il en revenant au milieu de la gorge, tout est faux. (10: 417-18)

(This place palpitates, but over here it is immobile; life and death battle in each fragment: here it is a woman, there a statue, elsewhere a cadaver. Your creation is incomplete. You were only able to breathe a portion of your soul into your beloved work. Prometheus's torch was extinguished more than once in your hands and many parts of your painting were not touched by the celestial flame. [. . .] There is truth here, said the old man indicating the saint's chest. [. . .] But here, he said, returning to the middle of her bosom, everything is false.)

The painted figure of Marie the Egyptian becomes the signifier of Porbus's creative genius and its shortfalls, a creation whose lack of life stands as testimony to an artistic impotence for the fetishizing Frenhofer. Her body is fragmented into disparate pieces that openly clash, presenting life and death, motion and immobility, truth and falsehood in a single form. In a story shaped around triads, *Marie égyptienne* is at once a woman, a statue and a cadaver, prefiguring an identical fate for *La Belle Noiseuse*, and in this story of Pygmalionesque fantasy the statue stands as an intermediary stage in the struggle between life and death. The Promethean desire to confer life upon inanimate matter literalizes the claims and fantasies of artists throughout the ages, but in Balzac's tale it is further complicated by its application to a painted female form and the insistence on the sexual fantasy at the heart of the painters' metaphor.

Moving to the central issue of the aesthetic debate, Frenhofer responds to Porbus's claim that the failed *poitrine* of his saint had been based on his scrupulous study of nature, with an explosive "La mission de l'art n'est pas de copier la nature, mais de l'exprimer! Tu n'es pas un vil copiste, mais un poète!" (Art's mission is not to copy nature but to express it! You are not a paltry copier, but a poet!) (10: 418). Where Porbus attests "there are real effects in nature that are not believable on canvas," Frenhofer ambitiously proclaims "We must seize the spirit, the soul, the physiognomy of things and beings."[45] Embracing a proto-Romantic aesthetic, Frenhofer seeks to transcend art's mimetic nature for an expressive truth, while his claim to poetry also resonates with nineteenth-century theories of the sister arts. Frenhofer longs to reproduce the spark of life itself. However, if he sees himself as a poet, what he seeks to express seems to lie beyond words. Porbus's Marie remains a contradiction centering around an unnamable absence: "C'est cela, et ce n'est pas cela. Qu'y manque-t-il? Un rien, mais

ce rien est tout. Vous avez l'apparence de la vie, mais vous n'exprimez pas son trop-plein qui déborde, ce je ne sais quoi qui est l'âme peut-être et qui flotte nuageusement sur l'enveloppe . . ." (It is that, and it is not that. What is it lacking? A nothing, but this nothing is everything. You have the appearance of life, but you do not express its overflowing excess, that *je ne sais quoi* which is perhaps the soul and which floats hazily on the surface) (10: 419). While the "lack" of the female nude points to castration anxiety (played out in the phallic foot emerging from Frenhofer's own canvas), the impossibility of articulating that which will complete his "poetry" is also significant on a less psychological plane. Reduced to the empty signifiers "cela," "rien," "tout" and "je ne sais quoi," Frenhofer is an expressive artist who cannot express himself and whose words, like his painting, float amorphously, like so many clouds. The painter who asks painting to replicate life, while aspiring to the expressive heights of poetry, is condemned to meaninglessness.

Frenhofer offers to introduce the neophyte, now identified as Poussin, "aux plus intimes arcanes de l'art" by showing what was needed to complete the painted saint. The scene that follows, closely resembling the composition and erotic energy of Dejuinne's group portrait of Girodet, Sommariva and Breguet in the atelier, demonstrates the sexually charged relationship between the artist and his production. As the two younger painters look on, Frenhofer goes to work:

Le petit vieillard retroussa ses manches avec un mouvement de brusquerie convulsive, passa son pouce dans la palette diaprée et chargée de tons que Porbus lui tendait; il lui arracha des mains plutôt qu'il ne les prit une poignée de brosses de tout dimensions, et sa barbe taillée en pointe se remua soudain par des efforts menaçants d'une amoureuse fantaisie. [. . .] Puis il trempait avec une vivacité fébrile la pointe de la brosse dans les différents tas de couleurs dont il parcourait quelquefois la gamme entière plus rapidement qu'un organiste de cathédrale ne parcourt l'étendue de son clavier à l'*O Filii* de Pâques. (10: 421)

(The little old man pulled up his sleeves with a convulsive abruptness and placed his thumb in the palette, dappled and loaded with tones, that Porbus handed him; he snatched from his hands, no sooner than he had picked them up, a handful of brushes of every size, and his pointy beard suddenly bobbed up and down from the threatening efforts of an amorous fantasy [. . .] Then, with a feverish intensity, he dipped the tip of his brush in the different spots of color, sometimes running down the entire gamut more quickly than an organist at a cathedral runs the scales of his keyboard for the *O Filii* at Easter.)

Balzac portrays the act of painting as an orgasmic performance where the phallic paintbrush is the vehicle of a fetishistic fantasy of love and creation, as threatening as it is all encompassing. Frenhofer's thrusting *pinceau*, feverishly penetrating the paint and then the canvas, seeks to bring life to the painted body, resurrecting the dead through his own passion (as signaled by the reference to Easter). The metaphor is neither new nor particularly shocking: Renoir claimed to paint "with my prick" while Vlaminck asserted "I try to paint with my heart and my loins." In keeping with Frenhofer's definition of art as "la véritable lutte . . . de longs combats," Kandinsky described the artistic process in terms of a gendered struggle for domination with explicit overtones of rape: "I learned to battle with the canvas, to come to know it as a being resisting my wish (dream), and to bend it forcibly to this wish. At first it stands there like a pure chaste virgin . . . and then comes the willful brush which first here, then there, gradually conquers it with all the energy peculiar to it, like a European colonist."[46] Correlative to this metaphor of phallic domination is the image of the canvas/female body as a bare surface waiting to be inscribed with meaning by the signifying patriarchal phallus/paintbrush.

Frenhofer's battle to dominate the canvas and the female body bears witness to his own struggle for meaning. But for the misguided painter, this desired signification will only arise from the animation of pigment into flesh and the transformation of the metaphor of creation into a more literal birth, a meaning Balzac will deny him. Where his orgiastic union with Porbus's prostitute will indeed improve the painting, the process reveals the fetishizing self-deception inherent in this artistic trope. Here, as throughout the story, Balzac eschews *ekphrasis*, shifting our attention from the painting to the process. Although he gives his readers no real sense of the composition of *Marie égyptienne*, the author clearly evokes Frenhofer's frenzied labors: as sweat beads his brow, he attacks the canvas with convulsive ardor. Sexual imagery conflates with an image of demonic possession as Balzac exposes the maniacal nature of Frenhofer's investment in his art. Georges Didi-Huberman sees in Frenhofer's action a fragmentation of self, for in the act of painting he loses himself in both a metaphoric and psychological sense: "Frenhofer-as-painter is only a poor body put in motion by the evil genie himself . . . when Frenhofer paints, it is not he, but a demon who acts through his hands, moves them . . . Divided subject, thus confused subject, indistinct."[47] Pleased with the result of his labors, Frenhofer declares "This is still not as good as my Catherine Lescault," introducing the name of his own painted lover and the theme of rivalry between women. At one remove from reality, he inspects the painting through a mirror, "which in

inverting the image presents it as if it had been painted by another, thus enabling a 'gaze which is at once that of a stranger and a father.'"[48] This final twist on Frenhofer's fantastic relationship to the canvas reveals the painter's narcissism and the incestuous desire to believe in the reality of his own fantasy. As "sujet divisé" Frenhofer will eventually give way to the "folie de doute,"[49] driven by the divided attitude exposed by his antics with the mirror: that is, his simultaneous acknowledgment and denial that art is a human creation that cannot come alive and cannot desire him back. The mirror offers him a framed image that can cut off the edges of the canvas or frame, thus enabling him to deny its existence as one-dimensional representation in pigment on cloth.

Having finished his "touch-up" of Porbus's painted prostitute, Frenhofer offers to buy Poussin's drawing of her—again establishing the connection between art and harlots, both being for sale. He leads Poussin and Porbus back to his own atelier where they come upon Mabuse's *Adam*, another central image in Balzac's narrative. Jan Gossaert (ca.1478-1532), known as Mabuse, was renowned for the lifelike fidelity of his portraits and for his fictional pupil, Frenhofer, Mabuse alone held the secret to imparting life to art. Frenhofer explains that his master painted *Adam* in order to pay off a debt that had landed him in prison, and thus the image represents yet another link in the chain of exchange of art for money. Significantly, the painting in the story refers to a real canvas, Mabuse's *Adam and Eve*, but truncates the female referent and shifts the focus to the moment of creation. The dangerous nature of the artist's quest is highlighted when Poussin exclaims "Tudieu! je suis donc chez le dieu de la peinture" (Good heavens! I am with the god of painting) (10: 423), a compliment Frenhofer acknowledges complacently, for indeed, he strives to be a godlike giver of life.

Until this point, Frenhofer has evidenced his idolatrous relationship with art primarily in his theorizing, while his sexual investment in the act of painting itself was demonstrated in Porbus's atelier. But it is only when Porbus requests that Frenhofer show them his "*maîtresse,*" that the full extent of the mad fantasy begins to reveal itself. Like Girodet, Frenhofer refuses to show anyone his painting until it is perfect, which in this case means alive: "Show my work, cried the old man, profoundly moved. No, no, I must keep on perfecting it. Yesterday, toward evening, he said, I thought I had finished. Her eyes seemed moist to me, her skin was stirring. The tresses of her hair were moving. She was breathing!"[50] For Frenhofer, as for Pygmalion, the work of art/mistress may potentially come alive, and

if in Ovid's tale this animation is a gift of the gods, for Balzac's artist it will be the result of a perfected technique, as he hones light, color, shadow and relief to transform pigment into a living, breathing person.

As he pontificates on his methods, explaining how he has reached this (unseen) level of lifelike beauty, Frenhofer makes one of his more forward-looking proclamations: "drawing does not exist! . . . Line is the means by which man understands the effect of light on objects; but there are no lines in nature where everything is whole: it is in modeling that one draws, that is to say, that one separates things from their setting, the distribution of light alone gives a body its appearance."[51] Critics and artists have read Frenhofer's words in terms of their remarkable insight into the artistic philosophy of the future, for indeed they anticipate Impressionism by some 30 years. But from a literary point of view, the abolition of line is the abolition of legibility and discourse or plot. Theoretically, line in both art forms is associated with rationality and order, a means by which to make the chaos of nature accessible to the human mind. As Frenhofer's "poetic" painting seeks to do away with line, it ironically enters the realm of incomprehensibility, at least for a nineteenth-century Realist author. The painter's description of his technique in the first chapter of *Le Chef-d'oeuvre inconnu* will come back in the second chapter, when his mysterious portrait is finally revealed, as precisely the source of his illegibility and non-sense. Frenhofer boasts "Aussi, n'ai-je pas arrêté les linéaments, j'ai répandu sur les contours un nuage de demi-teintes blondes et chaudes qui font que l'on ne saurait précisément poser le doigt sur la place où les contours se rencontrent avec les fonds" (Therefore, I abandoned the outlines, I spread a haze of warm blond half-tints across the contours so that you cannot put your finger on precisely where the contours meet the background) (10: 425). This demolition of boundaries and lack of definition will result in a painting that cannot be deciphered, even by an artist who will someday be considered France's finest. The "nuage de demi-teintes blondes et chaudes" prefigures the "brouillard sans forme" (formless fog) that buries the over-painted figure of Catherine Lescault. Frenhofer's passion for his painting goes hand-in-hand with his theory, his rejection of line and thus with his failure, for as Nead points out, "Masculinity is seen as a matter of unregulated instinct, potentially anarchic and incoherent; but the discipline of drawing and the contained form of the female nude—his culture and femininity—give order to this wild expressiveness of male sexuality."[52] For Balzac, who struggled to sublimate the sexual drive into his work, Frenhofer represents the artist who is unable to regulate his instinct, summon-

ing forth instead the anarchy of unfettered male sexuality directed at, not through, his creations. His painting, free from the discipline of line, which produces order and meaning, figures forth the artistic chaos that ensues.

If Frenhofer's aesthetic agenda is at odds with Balzac's own, his self-questioning is not, and the mad genius's doubt universalizes the painter, who muses, "I have doubts . . . I doubt my work!"[53] In many ways, Frenhofer is every artist, haunted by uncertainty yet longing to surpass the limitations of his medium, but as the passage continues, he begins once again to invoke Girodet's particular battle with form, representation and the impossibility of closure. Returning from the clouds of his theorizing, the wealthy painter admits "Voilà dix ans, jeune homme, que je travaille; mais que sont dix petites années quand il s'agit de lutter avec la nature? Nous ignorons le temps qu'employa le seigneur Pygmalion pour faire la seule statue qui ait marché!" (I have been working on this for ten years, young man; but what are ten little years when one is engaged in a battle with nature? We have no idea how long it took Pygmalion to make the only statue that ever walked!) (10: 425). The reference to Pygmalion confirms Frenhofer's model while also invoking Girodet's own embattled canvas, on which he labored in secrecy for seven years. The tale thus turns on the double intertext of myth and reality, literature and painting, success and failure. Following this confession, the painter falls into a deep reverie, while playing mechanically with his knife. Withdrawn into his inner world, Frenhofer no longer sees or hears his guests, but the knife in his hand signals the violence and ultimate castration associated with this desire to translate Pygmalion's mythological success into a reality.

Frenhofer's aesthetic quest finally moves from the abstract to the concrete, and emerging from his daydreams he laments the lack of a perfect model for his masterpiece. Once again, his success depends on the impossible dream:

> Mais où est-elle vivante, dit-il en s'interrompant, cette introuvable Vénus des anciens, si souvent cherchée, et dont nous rencontrons à peine quelques beautés éparses? Oh! pour voir un moment, une seule fois, la nature divine complète, l'idéal enfin, je donnerais toute ma fortune, mais j'irai chercher dans tes limbes, beauté céleste! Comme Orphée, je descendrai dans l'enfer de l'art pour en ramener la vie. (10: 426)
>
> (But where does she exist, he interrupted himself, this lost Venus of the ancients, so often sought, and only rarely found today in scattered examples of just some of her beauties. Oh! I would give my whole fortune to see for a moment, just once, this exquisite life in its entirety, the ideal in short, but I will go search for you in limbo, perfect beauty! Like Orpheus, I will descend into the hell of art to bring you back to life.)

Frenhofer's search for the ideal woman in the real world is inevitably
doomed to failure, doubly so because he seeks an antique ideal in a mod-
ern world. This fusion of a Romantic sensibility with a Classical ideal is the
source of one of the many contradictions apparent in Frenhofer's words
(and in Girodet's art), and stands directly at odds with Balzac's own aes-
thetic predilections, which were entirely oriented toward the modern.[54]
Frenhofer's search for Venus in seventeenth-century Paris is for Balzac a
futile quest that blinds him to the beauties of contemporary reality, leading
him, like Orpheus, into the underworld. In comparing himself to Ovid's
lyric poet, Frenhofer foresees his own doom, for Orpheus's descent into
Hades to retrieve Euridyce did not succeed in bringing her back to life.
Indeed, Euridyce disappeared forever, and Orpheus was later torn to pieces,
and thus Frenhofer's metaphor refers to a myth of failure and destruction
through fragmentation.

Frenhofer, like Sommervieux and Sarrasine, disappears into his own
inner world, oblivious to all that surrounds him, leaving Porbus and Poussin
virtually alone in the studio. Porbus thus takes the opportunity to tell the
neophyte painter more about Frenhofer's past, his relationship with Mabuse
and his philosophy of art. The mysterious painter's wealth, central to so
many of his exchanges with his fellow artists, recalls Girodet's own fortune,
often blamed for his lack of productivity. Frenhofer's education as Mabuse's
pupil was based on an exchange of knowledge for money: "Frenhofer sac-
rificed the greatest part of his fortune to satisfy Mabuse's desires; in
exchange Mabuse bequeathed him the secret of relief, the power to give
to his figures this extraordinary life, this flower of nature, our eternal
despair."[55] Both art and its secrets are for sale, but beyond the apparent
commentary on commodification, the trope of exchange plays an even
more complex role in Balzac's tale. Boasting of Mabuse's incredible *trompe
l'oeil* skills, Porbus tells Poussin of the time Frenhofer's bibacious master,
"ayant vendu et bu" (having sold and drunk) the *damas à fleurs* he was sup-
posed to wear for a royal reception, painted a paper robe to replace the
original. His handicraft was so beautiful and so convincing that Charles-
Quint stopped to compliment him, only to discover his deception. The
anecdote's many intertexts, including Zeuxis and the grapes and a playful
reversal of the Emperor's New Clothes, all point to art's *illusion* and its
power to deceive an audience, where an appearance may be substituted for
a reality. Mabuse's trick illustrates the ease with which the signifier may be
confused with the signified, based purely on resemblance. Frenhofer will
embrace this aesthetic of substitution, both in his desire to exchange
money for art and in his effort to allow art to replace life, for at the heart

of the Pygmalion fantasy is the yearning to substitute the ideal for the real, the artist's creation for a living woman.

Porbus takes the occasion of his friend's reverie to refute his aesthetic ravings to the young Poussin, reasserting the importance of line as well as color in the work of art. Speaking as the voice of rationality he explains, "our art, like nature, is composed of an infinite number of elements: drawing provides a skeleton, color gives it life, but life without the skeleton is more incomplete than the skeleton without life."[56] Porbus likens art to a body whose life depends on form or structure, thus undermining Frenhofer's claims to creating life while abolishing line. A formless mass of color without a shape, *La Belle Noiseuse* will ultimately fail because it lacks the structure to signify "woman." Yet Porbus's message lies beyond the tensions between line and color, as he observes, "si le raisonnement et la poésie se querellent avec les brosses, on arrive au doute comme le bonhomme, qui est aussi fou que peintre. Peintre sublime, il a eu le malheur de naître riche, ce qui lui a permis de divaguer. Ne l'imitez pas! Travaillez! les peintres ne doivent méditer que les brosses à la main" (when reason and poetry come into conflict with your brushes, you end up doubting yourself, like our good fellow who is as much a madman as he is a painter. Sublime painter, he had the misfortune to be born rich, which allowed him to stray. Do not imitate him! Work! painters should only meditate with their paintbrushes in hand) (10: 427). His last words recall David's injunctions to his own students not to imitate Girodet who, like Frenhofer, was both wealthy and poetically inclined, and whose doubts caused a general paralysis that inhibited his artistic production. Porbus's theory, like Balzac's own, stresses the importance of *work* and the interdependence of conception and execution. Balzac cautions against poetic painting, indicating the dangers of artists' forays into the heady realm of theorizing. Crossing the boundary from painting's realm of observation to poetry's realm of ratiocination leads not to life but to madness.

Counterbalancing the triad of male artists is a trio of female models: Marie égyptienne, Catherine Lescault and Poussin's mistress, Gillette, the only living woman among them. Although *Gillette* is the title of the first chapter of the tale, she does not appear until the very last pages of this section; *Catherine Lescault*, title character of the second chapter, does not appear at all. Presented as a *type,* Gillette embodies a compendium of clichés of the mistress/model. Balzac's description highlights her beauty, goodness, sacrifice and suffering, and like her many mythic forebears, she subordinates her own happiness to the whims of genius. But as Gillette becomes more developed as a character, her emerging portrait creates a

sharp contrast with the non-image of Catherine Lescault, who is mentioned once as the model for *La Belle Noiseuse*, but never as anything more than a reference. By structuring his story, via the signposts of the titles, around these two women, one living, the other painted, Balzac shows how *his* art can portray what the painter's cannot. For ultimately the only "legible" portrait of either model will not be in paint, but in words.

The erotics of the artistic gazes—vacillating between the living woman and the painted artifact—illustrate the dangerous imbrications of art and life in *Le Chef-d'oeuvre inconnu*, as misdirected love becomes a pivotal marker for failure. Balzac transforms the opening image of "art as mistress" into a more profound conundrum as the artist-as-lover-of-art competes with, and ultimately defeats, the artist-as-lover-of-woman, while the two registers cannot simultaneously coexist. For Poussin, the tension is manifested in the alternation between his love for Gillette and his artistic ambition, contaminated by Frenhofer's heady speeches: he can see her *either* as a woman whom he loves *or* as a model, but not both at once. Gillette comments on the first time she posed for him: "your eyes are no longer saying anything to me. You aren't thinking about me any more, yet you are still looking at me."[57] The gaze of the artist transforms the female model into object, as art eclipses reality. Gillette recognizes the disjunction between art and love, and when Poussin asks her to pose for Frenhofer she astutely observes, were that to happen, "you wouldn't love me any more." Nevertheless, Poussin convinces his mistress to sit for the old *maître*, promising that "he will only be able to see the woman in you." When she finally consents he embraces her, "no longer seeing anything but his art,"[58] illustrating the hierarchical privileging of art over life and the artist's shift from loving her as a woman to seeing her as an object, a vehicle for his own creation.

Mutually exclusive, love and art cannot coexist in the atelier, and Balzac ended the first section of the story with Gillette's double recognition that "He doesn't love me anymore!" while she too "thought she already loved the painter less, surmising that he was less admirable than she had believed."[59] Much like Ingres's portrayal of Raphael and La Fornarina, Balzac's image of the artist in his studio, with his model/mistress on his knee, centers on an emotional and specular triangulation between the real woman, the painted woman and the artist. For the fictitious Poussin, as for the painted Ingres, both lovers and creators, the representation ultimately takes precedence in their hearts and in their eyes over the reality on which it was based. Love for a representation rather than a reality is of course the idolatrous path of Pygmalion and Frenhofer, who prefer the simulacrum to the model, and the second half of *Le Chef-d'oeuvre inconnu* will offer a vivid

illustration of the danger of this substitution. Like Ingres, Balzac will exert his own artistic domination by portraying the model in more vivid and lifelike terms than the painted image that absorbs the artist of the past, and both nineteenth-century artists assert their own superior powers of representation over their predecessors.

As Lathers has noted, "the artist's model is the referent in nature whose existence guarantees the success of the work of art. As the intermediary term between artist and image, she also provides the bond necessary to the functioning of this dyad and guarantees the interaction within the sign between signifier and signified will not be perceived as arbitrary."[60] The interaction between model and image, signifier and signified, becomes especially problematic in Frenhofer's creation, as the signifier takes precedence over, and even negates, the signified, leaving a blank at the heart of the painting's signification. The contrast between Poussin's and Frenhofer's relationship to art, representation and the model occupies center stage in the second half of the story, entitled "Catherine Lescault." Overwhelmed with doubts, Frenhofer has sunk into a depression, and considers a trip to the east to find a perfect odalisque, in order to assure himself that he can better reality with his own ideal woman. Porbus proposes a more immediate solution: Poussin will let his lover model for Frenhofer if Frenhofer lets Poussin and Porbus see his mysterious canvas. In an almost comic reversal of Poussin's willingness to offer up Gillette to the eyes of the master, Frenhofer refuses to let anyone see his *painting*. Echoing Pygmalion and Sommariva he exclaims, "montrer ma créature, mon épouse? déchirer le voile dont j'ai chastement couvert mon bonheur? Mais ce serait une horrible prostitution!" (show my creature, my wife? rip the veil that has chastely concealed my happiness? But that would be a horrible prostitution!) (10: 431). The theme of prostitution is brought to the fore in the exchange of women by their lovers, but if the painter's model was frequently associated with the prostitute, Frenhofer sees his painted woman as a paragon of virtue who "would blush if other eyes than my own lingered upon her."[61] In earlier versions of the tale, Catherine Lescault, whose name invokes Prévost's archetypal prostitute, had been identified as "une belle courtisane appelée *la Belle Noiseuse*" (10: 1424), highlighting Frenhofer's powerful Pygmalionesque fantasy that transforms the real courtesan into an ideal virgin. Yet the need to veil his love from outside eyes betrays his divided attitude. Frenhofer's fanatical protection of his canvas pays tribute to her (imaginary) chastity while signaling a repressed awareness of the madness of his obsessive passion, which, like Sarrasine's, will be destroyed when the veil is torn away and the truth behind the representation is exposed.

The substitution of a painted woman for a real wife, recalling both Pygmalion and Sommariva with his *Terpsichore*, reveals the fetishistic nature of Frenhofer's fantasy. He considers his ten years of labor on *Catherine Lescault* in terms of a marriage, while she is at once his creation and his possession: "I have been living with this woman for ten years. She is mine, mine alone. She loves me. Didn't she smile at me with every brush stroke that I gave her?"[62] Like Pygmalion, Frenhofer engages in an imaginary sexual relationship with this ideal "woman," but if painting is an act of sexual intercourse, it is purely onanistic, for indeed the pleasure is all his, despite his fantasies to the contrary. Like a god, he has given her both body and soul ("she has a soul, the soul that I gave her"), but Frenhofer's words reveal the fundamental contradiction of his fantasy: the conflict between the rhetoric of the passage and its conceptual meaning.[63]

Frenhofer's paradoxical desire to highlight and negate the very nature of Catherine Lescault as his own creation is exposed in the rhetorical aporia of his formulations. The infatuated painter has become both producer and consumer of his own artistic product, taking on the problematic position of desiring subject for the object of his creation that excludes any other audience. In his maniacal diatribe, Frenhofer vacillates between the fantasy of a living woman, based on the physical nature of his representation, and the assertion of the metaphysical nature of his art: "Ma peinture n'est pas une peinture, c'est un sentiment, une passion!" Comparing his painting to poetry, Frenhofer nonetheless lingers on its corporality, emphasizing virginity and nudity even as he asserts its elevated or abstract nature. As he repeats the popular trope of art as creation—his wife-*qua*-lover was "*née dans mon atelier*" (*born* in my studio)—Frenhofer simultaneously denies and affirms its existence as art. This oxymoronic "painting that is not a painting" is moreover "an exception in our art; it is not a canvas, it is a woman! a woman with whom I cry, I laugh, I chat and think. Do you want me suddenly to abandon ten years of happiness as one discards a coat? Should I suddenly cease to be father, lover and God? This woman is not a creature, she is a creation."[64] Frenhofer takes the metaphor of artistic paternity and renders it literal, while the juxtaposition of the three terms—father, lover and God—encapsulates the full panoply of dangers the artist runs in this Pygmalionesque fantasy. Flirting with the double taboo of incest and Promethean overreaching, Frenhofer's passion is an idolatrous combination of love and religion where the creator worships and desires his own creation. The final phrase was originally configured in the reverse order—"Cette femme n'est pas une création, c'est une créature"—but this exchange of terms in the later versions allows Balzac to highlight the

artist's privileging of the work of art over a living creature, while emphasizing his role in her production. Frenhofer's *Pygmalionisme* seeks not simply to imitate life but to replace it entirely, creating a solipsistic universe that depends exclusively on his desire, but it is a reality based in unreality and irresolvable contradiction.

Thus the proposed exchange of women reflects the painters' inverted hierarchy of art and life, where the painted woman is accorded *l'âme* and *la pudeur* that are denied to Gillette, the only living woman in the tale. The female figures in *Le Chef-d'oeuvre inconnu* are individually and collectively commodified, their value arising from their circulation among men. The woman as commodity-prostitute-artwork becomes the site of a confluence of fetishisms converging on her body/form, while reflecting the social relations between men and their fantasies of substitution, possession and control. In keeping with the Marxist chiasmus of double alienation, Gillette and Catherine Lescault represent the quintessential embodiment of commodity fetishism, where "people and things exchange semblances: social relations take on the character of object relations and commodities assume the active agency of people."[65] This dehumanizing principle of substitution lies at the heart of Frenhofer's epistemology, and yet, if art and women are equally fetishized in his universe, Catherine Lescault is exempted from this systematic vision as the ultimate iconic fetish, elevated above the real into the realm of the ideal object of projected meaning and desire. Although Frenhofer considers art in terms of value and exchange, promising he will give Poussin any of his treasures before he will show him his painting, he ends with the prophetic declaration that he would destroy his *own* work were it to be sullied by another's gaze. Frenhofer's words expose what is for Balzac the most problematic aspect of the painter's convoluted relationship with his own creation. He exclaims "I will have the strength to burn my Catherine at my dying breath; but subject her to the gaze of a man, a painter? no, no! The next day I would kill whoever sullied her with his glance."[66] The irony of a painter who protects his paintings from the eyes of viewers, insinuated in the title *Le Chef-d'oeuvre inconnu*, cannot be ignored. For in an art with no audience, removed from the realm of the socially communicative act, the erotics become masturbatory and antithetical to life. The gaze of the other, the lifeblood of the painter's art, is considered a violation by the scopophilic Frenhofer. Threatening his friend Porbus, the idolater promises "I would kill you instantly, my friend, if you didn't bow to her on bended knee! Do you want me to submit my idol to the cold looks and stupid critiques of imbeciles?"[67]

When Poussin and his mistress arrive at Frenhofer's house, Gillette, stand-

ing before the appraising gazes of the three painters, is evaluated in terms of a painting. The reifying stares of her audience immobilize the living model, transforming her into a work of art. If Catherine Lescault struck the pose of a harem girl, Gillette assumes the attitude of a virgin sacrifice on the auction block in the eyes of these three men, each "woman" the passive, subservient object of a dominating, colonizing gaze. As Gillette experiences the violation of the collective gaze of the artists, she is overcome with *pudeur*. Her downcast gaze and modest blush recall Girodet's Galatea, who similarly expressed a mixture of shame and reticence upon realizing that she was being looked at, although where Galatea was a work of art metamorphosing into a living woman, Gillette is a woman being transfigured by the objectifying gaze into a work of art.

The tension between women and art reaches a crescendo in the final scenes of the tale as the negotiations are finally concluded for the exchange of the two "lovers." Gillette recognizes that posing for Frenhofer presents little personal risk, for in the old painter's eyes she is "pas plus qu'une femme" (nothing more than a woman) (10: 434), a signifier empty of meaning to Frenhofer, and as she quickly learns, to her lover as well. As she turns to Poussin, she finds him absorbed in the contemplation of a painting and realizes, "Il ne m'a jamais regardée ainsi" (He has never looked at me that way). Here, as in so many of Balzac's tales of art and artists, the gaze reveals the truth of relations, and Gillette has the clarity of vision to see that she is not *seen* by the painters, all of whom are blinded to the beauty of the living woman by their fetishistic infatuation with the ideality of art. The young painter sacrifices his mistress upon the altar of Frenhofer's mysterious atelier, heretofore off limits to all. The cult of painting, the pursuit of its arcana and the worship of its icons are deliberately presented by the author as a supernatural religion, and if Frenhofer is the high priest, the dénouement of the tale will expose the idolatrous and fetishistic nature of this heretical devotion.

The sacrificial maiden is admitted into the artist's secret chambers as Poussin and Porbus, the would-be initiates, stand outside the closed door, listening as Gillette disrobes and poses for the Master. The unseen scene carries a palpable sexual charge as it unfolds in the imaginations of the two painters, while "The young man had his hand on the hilt of his sword" in a phallic gesture that responds to Frenhofer's eroticized handling of the paintbrush. Finally satisfied, Frenhofer summons Poussin and Porbus into his inner sanctum, joyously proclaiming "My work is perfect, and now I can show it with pride. No painter, paintbrushes, colors, canvas and light will ever create a rival to *Catherine Lescault*."[68] The theme of rivalry is announced

yet again, as value is dialectically determined only in comparison with something else. Although Frenhofer maintains that no *painting* or *painter* will be able to rival his *Belle-Noiseuse*, the underlying competition at the heart of *Le Chef-d'oeuvre inconnu* lies between words and images. In the poignant paragraphs to follow, Balzac will insure that there is in fact no image of Catherine Lescault at all, thus precluding a true rivalry and asserting the dominance of the word in the struggle for representational superiority.

At the story's dénouement—the revelation of *La Belle Noiseuse*—Balzac exposes the void behind Frenhofer's heady words in a scene that encapsulates the fundamental crisis of representation. As Poussin approaches the canvas he is convinced that the old man is tricking them with his "prétendu tableau," for he claims "All I see there is a confused accumulation of colors contained by a multitude of bizarre lines that form a wall of paint."[69] Frenhofer's portrait exists as a "muraille de peinture" that buries the image and prevents the spectator's access through the accumulation of sensuous signifiers that finally negates its own referentiality. Frenhofer's ecstatic assertion "Où est l'art? perdu, disparu!" (Where is the art? lost, disappeared!) takes on a heavy irony as Porbus and Poussin admit that they see nothing on the canvas, and the *rien* (nothing) that was missing from *Marie égyptienne* is indeed all that can be found in *Catherine Lescault*. But upon closer examination:

> ils aperçurent dans un coin de la toile le bout d'un pied nu qui sortait de ce chaos de couleurs, de tons, de nuances indécises, espèce de brouillard sans forme; mais un pied délicieux, un pied vivant! Ils restèrent pétrifiés d'admiration devant ce fragment échappé à une incroyable, à une lente et progressive destruction. Ce pied apparaissaient là comme le torse de quelque Vénus en marbre de Paros qui surgirait parmi les décombres d'une ville incendiée. (10: 436)
>
> (in corner of the canvas they caught sight of the fragment of a bare foot that emerged from the chaos of colors, tones and blurred hues, a sort of formless fog; but it was a delicious foot, a living foot! They remained petrified with admiration before this fragment that had escaped from an incredible, slow and progressive destruction. This foot appeared there like the torso of some Venus in Parian marble rising from the ruins of a burned city.)

Balzac's description of the incomprehensible canvas at once denies the painting any representational content and illustrates, in the tradition of the *paragone*, precisely why it is *painters* and not authors who fall into this dangerous fetishization of the work of art that leads to its very destruction. *La Belle Noiseuse* is depicted with a vocabulary that highlights an impasto lay-

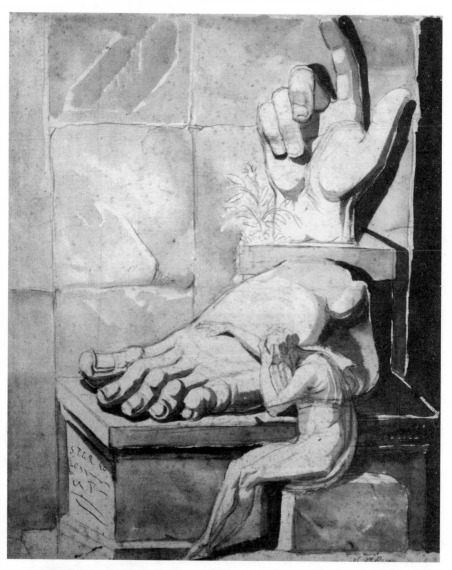

Figure 6.2. Henry Fuseli, *The Artist Overwhelmed by the Grandeur of Ancient Ruins*. 1778-79. Red chalk and sepia wash. 42 x 35.2 cm. Zurich, Kunsthaus. Photo: Giraudon/Art Resource, New York.

ering of pigment that impedes all communication. This lexicon of depth and structure, emphasizing the concrete monumentality of the work of visual art is intimately tied to its fetishistic quality and indecipherability. While *nothing* in Balzac's description enables the reader to visualize *Catherine Lescault*, what we are most acutely aware of in this description is the existence of the painting as *thing*, a static surface of superimposed color and form. Where added touches in a verbal description can be successively processed into a synthetic picture, while meaning comes from forward movement and progress, the constant revisions of *La Belle Noiseuse* led only to a "lente et progressive destruction." Although Porbus ultimately realizes "il y a une femme là-dessous" (there is a woman under there), all that is left of her is the perfect, "delicious," lifelike foot, that, returning to the Pygmalion paradigm, remains like a statue of Venus phallically projecting from the ruins of a sacrificial holocaust. This image of life suffocated beneath the concrete accumulation of sensuous materiality metonymically reflects the destruction of human life wrought by the worship of the painting as object.

The foot, the sexual fetish par excellence, petrifies the two observers who, like Sommervieux in *La Maison du chat-qui-pelote*, are frozen in horror as they confront the specter of castration and the maternal phallus.[70] This trope of substitution—the foot for the phallus—ties closely to the series of symbolic exchanges throughout the text. However, the fractured foot also reflects an aesthetic of fragmentation closely tied to the emergent modernity Balzac struggled to capture in his works. In Fuseli's paradigmatic image of the shattered continuum between past and present, *The Artist Overwhelmed by the Grandeur of Antique Ruins* (1778-79) [figure 6.2], the artist sits, head in hands, next to an enormous sculpted foot and hand that dwarf him both physically and psychologically. These pieces of the past, disconnected and oppressive, signify a lost totality that can no longer be reconstituted, their exaggerated scale and lack of connection to a coherent whole marking their obsolescence. The "modern" artist confronting these shards of the antique world is, like Frenhofer, self-blinded, covering his eyes and unable to embrace the loss that this fragmentation implies. Yet, where the shattered giants of the past are immobilized, the modern artist, though suffering, is portrayed whole, signaling Fuseli's hope that he might manufacture a new aesthetic that integrates these pieces of disjuncture into a new hybrid of past and present.

The disembodied heads of the king and the aristocrats lingered as potent symbols of the severing of past and present in the Romantic imagination, yet Géricault's still lifes of fragmented limbs from 1818-19 [figure

Figure 6.3. Theodore Géricault, *Body Parts*. Oil on canvas, 37 x 46 cm. Musée des Beaux-Arts, Rouen. Photo: Giraudon/Art Resource, New York.

6.3] encapsulate an alternative aesthetic of modern fragmentation. Linda Nochlin contends that Géricault's severed arms and legs represent the shattering of the coherence of the body that is then "reconjoined at the will of the artist in arrangements both horrific and elegant. . . . The mood of these works shockingly combines the objectivity of science—the cool, clinical observation of the dissecting table—with the paroxysm of romantic melodrama."[71] These fragments of the human body evoke "a loss of wholeness, a shattering of connection, a destruction or disintegration of permanent value that is so universally felt in the nineteenth century as to be often identified with modernity itself."[72] Like the Romantic painter, Balzac incorporates the fragment into a new aesthetic whole whose meaning arises from the tension between fragmentation and totality, drawing attention to the artist's role in the synthesis of meaning from the disparate parts of our shattered experiences and relations. Géricault's conjunction of a scientific and Romantic vision, like Balzac's uneasy marriage of Realism and the fantastic, illustrates the hybrid nature of this nascent aesthetic uniting objective and subjective praxises cobbled together by painters and authors in the early decades of the nineteenth century.

The isolated and disconnected *foot* that reappears in each of these images—Fuseli's nostalgic Neoclassical lament, Géricault's disturbing Romantic metaphor and Balzac's proto-Realist manifesto—implies a rhetorical meaning at the heart of this synecdoche. The psychosexual connection of foot and phallus, and the correlative implications of impotence, castration and difference point to the artists' experience of modernity as a Bloomian battle with the giants of the past and an unstable present in the postrevolutionary capitalist marketplace. The foot severed from the body signifies immobility and stasis, as the very base of the corpus—its support and foundation—is removed, and thus neither part of the shattered whole can function properly, verticality and forward motion being necessarily precluded. If *avoir pied* implies the ability to keep one's head above water on a firm footing, *perdre pied* indicates the opposite, with overtones of confusion, loss of control and being out of one's depth. This signifier of uncertainty and icon of fragmentation reflects the artist's recognition of his own disjunction with the past and with society, as well as the crisis of representation facing the nineteenth-century creator.

Yet the fragmented foot of the *Chef-d'oeuvre inconnu* is embedded in a *painting* and helps to generate the author's assertion of the visual artist's ultimate failure. Fragmentation and synthesis, as markers of modernity and resistance, are also fundamental to the differences between the experience of words and images. Balzac, as an author, is obligated to break down the

world into component pieces via language, the subsequent "wholeness" of his narratives arising from the dialectic between text and reader. Frenhofer's fragmentation is unrecognized and thus irreparable, for the visual artist never sees the partial nature of his representation. The superiority of the author's art lies then in its acknowledgment of the fractured nature of perception and experience, while the painter's efforts to present a static totality as the mimesis of "reality" is a falsification of both art and life, and ends in a meaningless jumble of superimposed signifiers that negate each other. This critical tension between the part and the whole is manifested in Frenhofer's failure and the narrator's success in creating a coherent work of art that can both recognize and transcend fragmentation, at least momentarily, through the active participation of an audience who can recompose what is necessarily decomposed in the process of representation.

The stupefied looks of his spectators spawns yet another theoretical diatribe, as the painter explains his technique and his process, unaware of the indecipherability of his image. Poussin admits that the master "est encore plus poète que peintre" (is still more of a poet than a painter) (10: 437), but Frenhofer's "poetry," his infatuation with theory, language and endless description is revealed to be nothing more than empty words severed from meaning, much like the painted foot is severed from the body of his imaginary mistress.[73] Balzac condemns the painter who ventures into the realm of ideas, words, poetry and criticism (as Girodet and his followers had done) to the realm of fetishizing failure. The breakdown in the painter's image of the relationship between signified and signifier, brought about by Frenhofer's desire to conflate them, severs his "language" from referentiality, emptying his image of signification for anyone but himself. Like the Romantic painters of Balzac's day who mined literature for their Troubadour tableaux and tried their hands at writing, Frenhofer transgresses the generic boundaries between word and image, he is "more poet than painter," but it is a combination that is, within Balzac's universe, fatally flawed.

The conclusion of *Le Chef-d'oeuvre inconnu*, an inverse mirror of the introduction, represents Frenhofer's counterinitiation at the hands of Poussin. When the old painter overhears the neophyte declare "qu'il n'y a rien sur sa toile" (there is nothing on his canvas), he responds first with accusations, and then, when confronted with Porbus's implicit confirmation ("Voyez"), momentarily acknowledges the enormity of his mistake. As he regards his painting with the new eyes of a spectator rather than a creator he begins to tremble, for he too sees "Rien, rien! . . . Je suis donc un imbécile, un fou!" (Nothing, nothing! I am an imbecile then, a madman!)

(10: 438). The mad painter soon became a leitmotif in nineteenth-century fiction, serving as a potent symbol of "the affinities between art and madness"[74] for authors seeking to project their own aesthetic anxieties upon an artistic Other and to establish generic superiority. Indeed, Frenhofer's madness stems precisely from his alienation from the "real" and his espousal of an interior vision that excludes both reality per se and the access of any kind of audience. His hallucinated relationship with his own creation, at once the source and manifestation of Frenhofer's *folie*, fetishism and failure, is intimately tied to the very nature of his art. For it is the visual and concrete form of painterly representation that allows the artist and his audience to confuse the sign and the signified, a confusion unlikely to occur within the nonrepresentational sign system of literature. The extent of his madness is such that Frenhofer quickly abandons his recognition of the real for a return to the ideal. In a passage that resonates with Girodet's own self-protective accusations, the old idolater cries out at his visitors "you are jealous and want to make me think that she is ruined so that you can steal her! Me, I see her! he cried, she is tremendously beautiful."[75] Even after the revelation that the "perfect" Catherine is in fact "nothing," her creator still accords her the loving protection of a cherished object and she remains the focus of the collective gaze/desire of the three painters, while the living Gillette remains forgotten in a corner of the room.

Gillette, the "unseen seer" throughout this final episode, has seen too much, and while Frenhofer's love for his mistress remains unshaken, Gillette's love for Poussin has been demolished by his vain sacrifice of the real for an impossible ideal. The forgotten woman has the last word in the pre-original version of the tale, her scorn for the painter standing as the ultimate indictment of the collective fantasy espoused by Poussin, Porbus and Frenhofer that art might come to life. In response to the uncomprehending Poussin's query as to why she is crying, Gillette explodes "Tue-moi!" (Kill me!) (10: 438). The end result of Frenhofer's Promethean quest is not to create life, but to destroy it, for indeed the only living woman in the tale has been metaphorically annihilated by the painters' fascination with the simulacrum of life rather than the real thing.

The pre-original version of 1831 ends on this ringing note of condemnation, spoken by the only nonartist in the tale. While Poussin's education is complete and he is ready to enter into the world of the "real," Frenhofer still clings to his "vision" of *la Belle Noiseuse*, remaining a self-blinded adherent to the ideal. In later editions, however, Balzac adds a distinctly different ending that solidifies his own position as critic of the painter's fantasy. Balzac's dramatic finale of 1837, where Frenhofer burns all

his paintings and dies, takes the iconoclastic form of purifying holocaust, and at the end all that remains is the *author's* chef-d'oeuvre, presenting us with a representation of the tale and the painters, but also of the forgotten model. Gillette, a "real" woman who is unseen by the painters in their quest for the ideal "nothingness" of Catherine Lescault, is given "life" by the author who can distinguish between the two. If the female nude stands as allegorical representation of male creative genius, while the female model is the repressed image of the prostituted nature of art in her association with money and desire, Balzac concludes his own allegory by destroying the former and elevating the latter. The *Belle Noiseuse*, as embodiment of the painter's genius, is twice obliterated—first in the demolition of her form on the canvas, and second, when the image is finally burned. In this ritual purge, Balzac generalizes the failures of idealizing Romanticism and the fetishizing tendencies of the visual arts, both of which believe in the power of artistic genius to "create" an art that is superior to reality. In giving Gillette the last word, and in renaming the story *Gillette* toward the end of his life, Balzac brings us back to an art based in and modeled after the "real," that comes closer to the truth than the sketchy incoherence of personal fantasy.

In 1846 Balzac added three paratextual elements to his much-edited text. A dedication "A un lord," followed by a set of five lines of ellipses and the date 1845 were appended to the beginning of the story and the date 1832 was inserted at the end. The double dating signals a time lapse between when the story was (supposedly) created and when it was offered to the *dédicataire*. The reader can only conclude that the story, like Frenhofer's painting, has been reworked, that things have been added over time, and the dedication is "le résultat d'un travail de superposition textuelle."[76] Where Frenhofer's additions to his artwork led to "une lente et progressive déstruction," Balzac's emendations ostensibly improve his. Balzac's assertion of the author's power to continue to transform his art over time, highlighted by the temporal signifiers of dates juxtaposed with his text, is a final gesture in *Le Chef-d'oeuvre inconnu*'s multi-layered *paragone*. But even as Balzac attempts to solidify the position of superiority over the failed sister art, the reader cannot fail to notice that *he* has worked on his story for at least *13 years*. In fact, 16 years elapsed between the first and final incarnations of the tale, far longer even than Frenhofer or Girodet worked on their respective *Pygmalions*. The multiple versions of *Le Chef-d'oeuvre inconnu* stand tribute to Balzac's honing of his vision of the deep-seated rivalries confronting the modern artist, but also reveal a level of personal identification with Frenhofer's compulsive reworking, an investment that lends the story some of its poignancy.

Although known to subsequent generations for the speed with which he was able to churn out stories, fueled by coffee and creditors, Balzac's style came at the cost of enormous labors and endless correction. Gautier testifies that the young author "used to cover the tenth draft [of his stories] with cross-outs and corrections," convinced "by revising it two or three more times it would have been even better."[77] Like Girodet and his fictitious counterpart, Frenhofer, in 1831 Balzac was an aesthetic outsider fitting neither into the Romantic nor the Classical mold. Like the real and invented painters, Balzac sought to establish a new style in his art, at odds with the status quo, the product of an ongoing process of revision driven as much by insecurity as inspiration. While many critics have claimed that Balzac identified with Frenhofer's unrecognized genius, given the initial date of the story and the compulsive rewriting of the text, it is far more likely that Frenhofer stood for what Balzac feared he might become. His return to the tale in the late 1830s and 1840s served as means of reminding himself where he had come from and what he must strive to avoid. Indeed, as the story is transformed in its various versions, Frenhofer becomes increasingly aligned with a Romantic, idealizing style distinctly at odds with Balzac's developing Realism. The mad painter's obsession with his work, his style and perfection gives voice to an impotent Other that threatened to consume Balzac himself and needed to be destroyed. The dedication "A UN LORD," may thus be read, as Paulson suggests, as a tribute to the author's own youthful persona, Lord R'hoone, an anagrammatic pseudonym under which Balzac published in the late 1820s. The mad and ambitious painter, with his belief in the stylistic perfectability and lifelike "realism" of his own medium, serves as a psychological foil for the author, enabling Balzac to exorcise the threatening specters of the visual arts and their mimetic fidelity to the world of appearances, as well as the hidden demons of his own stylistic anxieties.

The third addition to the 1846 text—the chain of ellipses preceding the opening paragraph—presents Balzac's symbolic elaboration of his realist literary aesthetic. The author's displacement of the painter's image ultimately extends from the narrative to the paratextual level, for the deliberate "blankness" of the ellipses stands in the place of the illustrative vignette found at the beginning of much popular fiction of the day. Frenhofer's unrepresentable masterpiece stands as a void at the center of this cautionary tale, a void whose import is closely tied to the configuration of "meaningless" marks at the head of the text. The ellipses, orderly series of dots that form linear patterns on both the vertical and horizontal axes, evoke the act of reading in their march across the page, though here it is reading

nothingness. Unlike the overpainted surface of *La Belle Noiseuse*, Balzac's "image" privileges the continuity of line over color or descriptive detail, while the spaces between the dots are as important as the dots themselves. This idea of suggestive blank spaces that allow the reader to "lire entre les lignes" and play an active role in the synthesis of meaning was central to Balzac's own theory of "reader reception." Directly at odds with Frenhofer's spatial accumulation of superimposed color and form, Balzac's own literary art depends both on the forward movement in time and the supplemental efforts of his readers to interpret and make connections between the necessarily separate signifiers. Balzac's abstract "frontispiece" encapsulates for his reader the critical difference between words and images. Where the painter believed perfect mimesis could represent all and in fact portrayed nothing, the author eschews representation per se for suggestion, depending on the reader's active imaginative participation to supply what is missing and "connect the dots." For the author of *La Comédie humaine* art, whether literature or painting, was necessarily a dialogic *process*, meaning arising from the active participation of the audience in the work, and thus Frenhofer's failure to produce a viable work of art arose from a philosophical flaw—that is, his deliberate exclusion of the *destinataire*, without whom, for Balzac, art could not exist.

Balzac's Realism is defined both in terms of and against the visual model, as he lays claim to an aesthetic of fidelity to life *outside* of imagistic mimesis, with an art that resists the fetishizing objectification that the work of visual art is liable to. In response to the blurring of lines between the genres heralded by Romanticism, Balzac reinscribes boundaries, signaling the difference between the naïve "realism" of a well-painted portrait and his own ironic Realism that calls into question the very basis of perception. Balzac seeks to deconstruct the facile equivalence between seeing, knowledge and power through narratives of the visual artist and his craft that highlight the way in which desire shapes all three. Frenhofer *sees* a perfect living woman where Poussin and Porbus see nothing, and the double reading of this portrait illustrates the subjective nature of perception and the way in which the observer's desire constructs what it creates and perceives. As Michele Hannoosh explains, Balzac's Realism is based on "the refusal of certainty, that is to say, irony." It is an irony which "prevents reality from being completely controlled by the subject, narrator or author. . . . It recognizes the possibility of contradiction and even madness; at the heart of a system of knowledge it is the sign of the unknown and perhaps the unknowable."[78] Although Frenhofer's incomprehensible canvas illustrates these principles of incoherence and madness, the irony is shaped by the

author, not the painter, who remains unable to read the painting for what it is, blind to the reality of what he has produced. Frenhofer thus fails because he believes this image holds an objective truth visible to all, rather than a purely subjective truth, visible only to himself. Balzac's Realism calls into question the very relationship between appearance and reality that painting sought to promulgate and solidify. Words lend themselves to the double readings and ambiguities of irony far better than the concrete mimetic fidelity of images, at least as conceived and executed in the centuries before our own. Indeed, despite his own desire to reproduce the universe of nineteenth-century France in all of its minutia, Balzac remained aware, and hoped to render his reader aware, of the dialectic/difference between Realism and reality, refusing the equivalence between representation and reality that Frenhofer et alia so madly embraced.

In his *paragone*, Leonardo asserted that the painter was superior to the poet because he could make the viewer fall in love with a painting that was not a real woman. Balzac, asserting his own response to the *paragone*, makes the painter fall in love with his own illusion and destroys him. The realist, be he poet or painter, must keep track of the contingent nature of reality in an art that reflects the eternal tension between perceiving subject and object, or suffer the dire consequences of disillusionment and artistic failure. Ovid's myth of Pygmalion, with its conflation of creation and desire, figures forth art in the shape of an ideal woman and sets into play the metaphysics of eroticized self-referentiality and fetishization that Balzac associated with the visual arts and their fatal flaws. In keeping with the sexual metaphor that underlies all of these tales, Balzac's Realism is ultimately an act of artistic intercourse, dependent on the active participation of the perceiving intelligence of the reader to synthesize meaning, while the very act of interpretation reflects the uncertainty and subjectivity of life, rather than its superficial appearance. Conversely, Frenhofer's Realism, like that of Pygmalion and his descendents, is masturbatory in its denial of the necessity of a perceiving audience and naive in its belief in the truth of appearances, positing the possibility of an absolute reality that, as Balzac will brutally illustrate, is nothing more than an impossible fantasy. At once a cautionary tale for artists and audience alike, as well as an assertion of literature's dominance *despite* and *because of* painting's reproductive superiority, *Le Chef-d'oeuvre inconnu* presents a final refusal of the "realism" of the painted image and a stark illustration of the futility of trying to instill art, or confuse art, with life.

Notes ✎

Introduction

1. Charles Baudelaire, *Oeuvres complètes*, ed. Claude Pichois, 2 vols. (Paris: Gallimard-Pléiade, 1975–76) 2: 744.
2. A notable exception is Dario Gamboni's *La plume et le pinceau: Odilon Redon et la peinture* (Paris: Editions de Minuit, 1989), which devotes a brief final chapter to the "conflit et solidarité" of the sister arts at the fin-de-siècle. For foundational readings of the *fraternité des arts* in postclassical literature see Rensselaer W. Lee, *Ut Pictura Poesis: The Humanistic Theory of Painting* (New York: Norton, 1967); Mario Praz, *Mnemosyne: The Parallel between Literature and the Visual Arts* (Princeton: Princeton University Press, 1970); and Jean Hagstrum, *The Sister Arts: The Tradition of Literary Pictorialism and English Poetry from Dryden to Gray* (Chicago: University of Chicago Press, 1958).
3. Thomas Crow has similarly found intersections between Balzac's tales and Girodet's paintings, but has not focused on the competitive aspect of their *rapport*. See especially *Emulation: Making Artists for Revolutionary France* (New Haven: Yale University Press, 1995); and "B/G" in *Vision and Textuality*, ed. Stephen Melville and Bill Readings (Durham: Duke University Press, 1995): 296–314.
4. See, for example, Crow's *Emulation* and Abigail Solomon-Godeau, *Male Trouble: A Crisis in Representation* (London: Thames and Hudson, 1997). Other earlier works devoted to Girodet include George Levitine's *Girodet-Trioson: An Iconographical Study* (New York: Garland, 1978) and George Bernier's *Anne Louis Girodet, 1767–1824* (Paris: Damase, 1975).
5. Although the first third of the nineteenth century is notorious for its repressive stance against women's rights and freedoms (as embodied in Napoleon's *Code civil* of 1804), women gradually made small but significant gains in both painting and literature. A.S. Harris and Linda Nochlin document, "In the 1801 Salon, out of a total of 192 painters exhibiting, about

28, or 14.6 percent were women; in 1810, out of 390 painters exhibiting, about 70, or 17.9 percent, were women; in 1822, out of 475 painters exhibiting, about 67, or 14.1 percent, were women; and in 1835, out of 801 painters exhibiting, about 178, or 22.2 percent were women." *Women Artists: 1550–1950* (New York: Knopf, 1978) 46. Moreover, while women had always been visual consumers of art at the Salons, Carol Ockman has recently raised the issue of the influence of female patrons during the Consulate and Empire, claiming "there was a pictorial language during this period that was created in large part by women," *Ingres's Eroticized Bodies: Retracing the Serpentine Line* (New Haven: Yale University Press, 1995) 39. Gen Doy discusses female art critics in the early nineteenth century in her chapter "Female Spectators Find a Voice" in *Women & Visual Culture in 19th-Century France 1800–1852* (London: Leicester University Press, 1998). By a similar token, though female authors, critics and readers never gained the power or prestige of male writers, they did gain sufficient visibility and influence during this period to exert pressure on male writers in search of popular readership (see chapter 5). Indeed, in 1827 the Academician Auger counseled men to leave the novel to women since it was "almost exclusively for their use." Quoted by Cheryl A. Morgan in "Unfashionable Feminism?: Designing Women Writers in the *Journal des Femmes* (1832–1836)," in *Making the News: Modernity and the Mass Press in Nineteenth-Century France*, ed. Dean de la Motte and Jeannene M. Przyblyski (Amherst: University of Massachusetts Press, 1999) 207. For a fascinating account of the female critics' responses to Balzac see René Guise "Balzac et la presse de son temps: Le romancier devant la critique féminine," *L'Année balzacienne* n.s. 3 (1982): 77–105.

6. See James's *The Madonna of the Future* (1875) and *Roderick Hudson* (1878), Morris's Pygmalion episode in *Earthly Paradise* (1868–70), Burne-Jones's four panel series of *Pygmalion and the Image* (1875–78), Gérôme's series of Pygmalions (1880s–90s), Zola's *L'Oeuvre* (1886), Wilde's *Picture of Dorian Gray* (1890) and Ibsen's *When We Dead Awaken* (1900), for paradigmatic nineteenth-century variations on Ovid's myth.

7. Here and throughout the text I will use "genre" in its largest or taxonomic sense—that is, designating literature-*qua*-literature and painting-*qua*-painting, thus considering literature and painting as genres within the larger category of Art, per se, in keeping with nineteenth-century conceptions and formulations.

8. I use "poets" and "poetry" within the context of the *paragone* to designate authors and literature in general, following the lexicon usually employed from Leonardo on to discuss and/or oppose the sister arts. Throughout the text I will use masculine pronouns to refer to painters and authors, as the artists in question are male and the larger issues of identity and self-definition I am investigating hinge specifically on a crisis of male artistic identity.

9. Important formalist studies of word and image, following in the wake of Lessing's *Laocoön. An Essay on the Limits of Painting and Poetry*, ed. E. A. McCormick (1766; New York: Bobbs-Merrill, 1962), include Clement Greenberg's "Towards a Newer Laocoön," *Partisan Review* 7 (1940); Joseph Frank's *The Widening Gyre: Crisis and Mastery in Modern Literature* (New Brunswick: Rutgers University Press, 1963); and Murray Krieger's *Ekphrasis: The Illusion of the Natural Sign* (Baltimore: Johns Hopkins University Press, 1992).

10. Svetlana and Paul Alpers maintained, for example, "Attempts to compare the arts characteristically come to grief in forced equations between specific features. . . . The arts differ profoundly in their conditions and languages," concluding that in word/image comparisons, "Surely the game is not worth the candle," *"Ut pictura noesis?* Criticism in Literary Studies and Art History," *New Literary History* 3.3 (1972): 457–58.

11. See Caws, *The Eye in the Text: Essays on Perception, Mannerist to Modern* (Princeton: Princeton University Press, 1981); Steiner, *The Colors of Rhetoric: Problems in the Relation between Modern Literature and Painting* (Chicago: University of Chicago Press, 1982); Fried, *Absorption and Theatricality: Painting and the Beholder in the Age of Diderot* (Chicago: University of Chicago Press, 1977); Bal, *Reading 'Rembrandt': Beyond the Word-Image Opposition* (Cambridge: Cambridge University Press, 1991); and Bryson, *Word and Image: French Painting of the Ancien Régime* (Cambridge: Cambridge University Press, 1981) and *Vision and Painting: The Logic of the Gaze* (New Haven: Yale University Press, 1983).

12. Lauriane Fallay d'Este, *Le Paragone: Le Parallèle des arts* (Paris: Klincksieck, 1992) 11. D'Este defines the liberal arts as all those "qui, en vertu d'une discrimination arbitraire, faisaient intervenir les sciences, l'ordre, le raisonnement, en un mot les mathématiques" (which, by virtue of an arbitrary discrimination, bring in the sciences, order, reason, in a word, mathematics) 11.

13. See d'Este, *Le Paragone* for further discussion of Alberti's formulation.

14. Leonardo, *On Painting*, trans. and ed. Martin Kemp and Margaret Walker (New Haven: Yale University Press, 1989) 23.

15. Contemporary films such as *My Fair Lady, Mannequin* and *Pretty Woman* and Richard Powers's novel, *Galatea 2.2* (1995) all present variations on the Pygmalion theme.

16. Ovid, *Metamorphoses*, trans. Mary M. Innes (Harmondsworth: Penguin, 1955) 231. All quotations from Pygmalion will be from this edition, pp. 231–32.

17. As Jane Miller has indicated, the phrase *tori sociam* is redolent with erotic overtone and is used throughout the *Metamorphoses* to denote "bed-partner" or wife. Miller also highlights the close correlation between Pygmalion's courtship of the statue with gifts and flattery and the precepts laid down

for human lovers in Ovid's *Ars amatoria* and the *Amores*. See "Some Versions of Pygmalion" in *Ovid Renewed*, ed. Charles Martindale (Cambridge: Cambridge University Press, 1988): 205–24.

18. In Ovid's tale the statue is never in fact named, and she is not actually called *Galatée* until Thémiseul de Saint-Hyacinthe's novel, *Pygmalion*, of the 1740s. The name gained more general currency with Rousseau's version of the tale at the end of the eighteenth century and since then Galatea (in English) and Galatée/Galathée (in French) have come into general parlance to denote Pygmalion's statue. I will use Galatea/Galatée anachronistically for the sake of concision.

19. Kenneth Gross, *The Dream of the Moving Statue* (Ithaca: Cornell University Press, 1992) 75.

20. J. Hillis Miller, *Versions of Pygmalion* (Cambridge: Cambridge University Press, 1990) 4.

21. David Freedberg, *The Power of Images: Studies in the History and Theory of Response* (Chicago: University of Chicago Press, 1989) 317.

22. Within the Jewish kabbalistic tradition, the golem is a clay figure in human form that may be animated by its maker. The golem is both potentially dangerous and idolatrous, and was seen as impinging on the creative power of God.

23. The episodes of Myrrha and Cinyras, followed by Venus and Adonis, are found in Book X of the *Metamorphoses*, pp. 232–39.

24. See Theodore Ziolkowski, *Disenchanted Images* (Princeton: Princeton University Press, 1977), chapter 2, "Image as Theme: Venus and the Ring" for a thorough investigation of this motif.

25. See La Fontaine, "Le Statuaire et la statue de Jupiter" in *Fables*, Book IX, fable vi.

26. J.L. Carr, "Pygmalion and the *Philosophes*: The Animated Statue in Nineteenth-Century France," *Journal of the Warburg and Courtauld Institutes* 23.3–4 (1960): 242

27. See Carr, "Pygmalion and the *Philosophes*" 242.

28. Boureau-Deslandes's *Pygmalion ou la statue animée*, a *conte philosophique* of 1741 anticipates both Diderot's and Condillac's treatment of the subject in a narrative that closely follows Ovid's tale while attempting to demonstrate the transmutablity of matter and document the statue's progressive acquisition of sensation and thought.

29. "Un tableau pathétique des transports, de l'enthousiasme, du délire que peut exciter dans une âme sensible et passionnée l'amour des arts et de la beauté." *Correspondance littéraire, philosophique et critique, par Grimm, Diderot, etc.*, ed. Tourneux (Paris: Garnier 1875–82) 11: 139–40.

30. "J'ai craint . . . une frayeur me saisit . . . Quel tremblement! quel trouble!" Jean-Jacques Rousseau, *Pygmalion, scène lyrique* in *Oeuvres complètes* (Paris: Gallimard-Pléiade, 1964) 2: 1225–26.

31. "Il n'y a point-là d'âme ni de vie; ce n'est que de la pierre . . . mon ciseau, faible, incertain, ne reconnaît plus son guide: ces ouvrages grossiers, restés à leur timide ébauche, ne sentent plus la main qui jadis les eût animés." Rousseau, *Pygmalion* 1225.

32. "The text is dramatically structured as a dynamic system of excess and lack (*défaut*) metaphorically represented in a polarity of self and other that engenders, in its turn, a chain of (as)symetrical polarities: hold/cold, inside/outside, art/nature, life/death, male/female, heart/senses, hiding/revealing . . ." Paul de Man, *Allegories of Reading: Figural Language in Rousseau, Nietzsche, Rilke, and Proust* (New Haven: Yale University Press, 1979) 180.

33. The scene is set with a brief description of the atelier that indicates that "Dans le fond est une autre statue cachée sous un pavillon d'une étoffe légère et brillante, ornée de crépines et de guirlandes." Rousseau, *Pygmalion* 1224.

34. Louis Marin, "Le moi et les pouvoirs de l'image: Glose sur *Pygmalion, scène lyrique* (1772) de J.-J. Rousseau," *MLN* 107 (1992): 662. Marin provides an extensive gloss on the ideas of veils and veiling in Rousseau's drama.

35. "Je m'enivre d'amour-propre; je m'adore dans ce que j'ai fait . . . Non, jamais rien de si beau ne parut dans la nature; j'ai passé l'ouvrage des Dieux." Rousseau, *Pygmalion* 1226.

36. "Je crois pouvoir lui donner ma vie, et l'animer de mon âme. Ah! que Pygmalion meure pour vivre dans Galathée!" Rousseau, *Pygmalion* 1228.

37. "Que je sois toujours un autre, pour vouloir toujours être elle, pour la voir, pour l'aimer, pour en être aimé." Rousseau, *Pygmalion* 1228.

38. DeMan 177.

39. See Rousseau's *Essai sur l'origine des langues* (c.1753), Diderot's *Essai sur les sourds et muets* (1751) and Condillac's *Traité des sensations* (1754) for similar accounts of the development of language through the association of sounds and sensations.

40. "Oui, cher et charmant objet, oui, digne chef-d'oeuvre de mes mains, de mon coeur et des dieux, c'est toi, c'est toi seule: je t'ai donné tout mon être: je ne vivrai plus que par toi." Rousseau, *Pygmalion* 1231.

41. James H. Rubin, "'Pygmalion and Galatea': Girodet and Rousseau," *Burlington Magazine* CXXVII 989 (1985): 518.

42. See Hermann Schlüter, *Das Pygmalion-Symbol bei Rousseau, Hamann, Schiller* (Zurich: Juris Druck, 1968) and Hans Sckommodau, *Pygmalion bei Franzosen und Deutschen im 18. Jahrhundert* (Wiesbaden: Steiner, 1970) for further discussion of the role of the Pygmalion myth in French and German literature, and particularly the influence of Rousseau's drama on German authors.

43. Carr documents a sixteenth-century Pygmalion by Bronzino and a handful of seventeenth-century examples, including works by Niet Volght, Pieter Feddes van Harlingen and La Hire in "Pygmalion and the *Philosophes*" 244. I am greatly indebted to the librarians at the Warburg Institute for their guidance in tracing early images of Pygmalion.

44. "On peut croire que ce prince trouva le moyen de rendre sensible quelque belle personne qui avait la froideur d'une statue." Quoted in Colin B. Bailey, *The Loves of the Gods: Mythological Painting from Watteau to David* (New York: Rizzoli, 1992) 504.

45. Mechthild Schneider indicates that Boucher's *Pygmalion*, now at the Hermitage, was originally created for the *Parc du Cerf*, the secret and secluded part of Versailles where Louis XV fulfilled his erotic fantasies. See Schneider, "Pygmalion-Mythos des Schöpferischen Künstlers," *Pantheon* 45 (1987): 114.

46. Both Deshays and Fragonard were pupils in Boucher's studio and J.M. Massengale discusses the similarities between their Galateas and Boucher's in "Fragonard *Elève*: Sketching in the Studio of Boucher," *Apollo* CXII 226 (1980): 392–97. Mary D. Sheriff interprets Fragonard's *The New Model* as a reversal of Pygmalion where the artist becomes infatuated with "the real object that inspired him rather than the art object that he fabricated," *Fragonard: Art and Eroticism* (Chicago: University of Chicago Press, 1990) 200–01.

47. "Quelle innocence elle a! Elle en est à sa première pensée. Son coeur commence à s'émouvoir; mais il ne tardera pas à lui palpiter." Denis Diderot, "Falconet," in *Essais sur la peinture; Salons de 1759, 1761, 1763*, ed. Gita May and Jacques Chouillet (Paris: Hermann, 1984) 249.

48. "Quelles mains! Quelle mollesse de chair! Non, ce n'est pas du marbre. Appuyez-y votre doigt, et la matière qui a perdu sa dureté, cédera à votre impression." Diderot, *Salon de 1763* 249.

49. Ovid 232.

50. "Quels pieds! Qu'ils sont doux et délicats!" Diderot, *Salon de 1763* 249.

51. "O Falconet, comment as-tu fait pour mettre dans un morceau de pierre blanche la surprise, la joie et l'amour fondus ensemble. Emule des dieux, s'ils ont animé la statue, tu en as renouvelé le miracle en animant le statuaire. Viens que je t'embrasse; mais crains que coupable du crime de Prométhée, un vautour ne t'attende aussi." Diderot, *Salon de 1763* 250.

52. "Vrai ou faux, j'aime ce passage du marbre à l'humus, de l'humus au règne végétal, et du règne végétal au règne animal, à la chair." Diderot, *Entretien entre d'Alembert et Diderot, Le Rêve de d'Alembert, Suite de l'entretien* (Paris: Garnier-Flammarion, 1965) 41.

53. "Il a entrevu dans sa statue les premiers signes de vie. Il était alors accroupi. Il se relève lentement, jusqu'à ce qu'il puisse atteindre à la place du coeur. Il y pose légèrement le dos de sa main gauche; il cherche si le coeur bat." Diderot, *Salon de 1763* 251.

54. Ovid 232.

55. "Il me semble que ma pensée est plus neuve, plus rare et plus énergique que celle de Falconet. Mes figures seraient encore mieux groupées que les siennes. Elles se toucheraient. Je dis que Pigmalion se lèverait lentement; si les mouvements de la surprise sont promptes et rapides, ils sont ici contenus

et tempérés par la crainte, ou de se tromper, ou de mille accidents qui pourraient faire manquer le miracle. Pigmalion tiendrait son ciseau de la main droite, et le serrerait fortement. L'admiration embrasse et serre sans réflexion, ou la chose qu'elle admire, ou celle qu'elle tient." Diderot, *Salon de 1763* 251.

56. For discussion of Gautier's "Pygmalion complex" see Ross Chambers, "Gautier et le complexe de Pygmalion," *Revue de l'histoire littéraire de la France* 72.4 (1972): 641–58; and Annie Ubersfeld, "Théophile Gautier ou le regard de Pygmalion," *Romantisme* 66 (1989): 51–59. For Gautier's most sustained treatment of the Pygmalion theme, see his 1839 tale, *La Toison d'or.*

57. Théophile Gautier, *Portraits contemporains* (Paris: Charpentier, 1881) 6.

58. Miller 7.

59. Peter Brooks, *Body Work: Objects of Desire in Modern Narrative* (Cambridge: Harvard University Press, 1993) 8.

60. Sigmund Freud, *The Standard Edition of the Complete Psychological Works of Sigmund Freud*, trans. James Strachey, et al., 24 vols. (London: Hogarth Press, 1953–74) 7: 153.

61. "Divine Galathée! moins parfaite, il ne te manquerait rien." Rousseau, *Pygmalion* 1227.

62. Freedberg 344.

63. Emily Apter, *Feminizing the Fetish: Psychoanalysis and Narrative Obsession in Turn-of-the-Century France* (Ithaca: Cornell University Press, 1991) 13. See Lacan, "The Signification of the Phallus" in *Ecrits*, trans. Alan Sheridan (New York: Norton, 1977) 281–91.

64. Ann Bermingham, "The Aesthetics of Ignorance: The Accomplished Woman in the Culture of Connoisseurship," *Oxford Art Journal* 16.2 (1993): 19. See Irigaray, *The Speculum of the Other Woman* (Ithaca: Cornell University Press, 1986).

65. Karl Marx, "The Fetishism of Commodities," *Capital* (London: Dent, 1974) 1: 77.

66. Paul Wood, "Commodity," *Critical Terms for Art History*, ed. Robert Nelson and Richard Shiff (Chicago: University of Chicago Press, 1996): 263–64.

67. W.J.T. Mitchell, *Iconology: Image, Text, Ideology* (Chicago: University of Chicago Press, 1986) 190.

Chapter 1

1. See Pierre Bourdieu, *Les Règles de l'art: Genèse et structure du champ littéraire* (Paris: Seuil, 1992) for discussion of the *champ littéraire* and *habitus.*

2. Bourdieu, "The Link between Literary and Artistic Struggles," *Artistic Relations: Literature and the Visual Arts in Nineteenth-Century France*, ed. Peter Collier and Robert Lethbridge (New Haven: Yale University Press, 1994) 30.

3. The idea of ranking is taken to its comic extreme in Roger de Piles's *Bal-*

ance des peintres (1708) in which artists of the past are assigned grades from 0 to 80 based on their composition, expression, design and color. Raphael and Rubens received a 65; Poussin was given a 53, Rembrandt scored a 50, Michaelangelo 37 and Durer 31.

4. Rensselaer Lee, *Ut Pictura Poesis: The Humanistic Theory of Painting* (New York: Norton, 1967) 7.

5. Patricia Mainardi, *Art and Politics of the Second Empire: The Universal Expositions of 1855 and 1867* (New Haven: Yale University Press, 1987) 8.

6. Patricia Mainardi, *The End of the Salon: Art and the State in the Early Third Republic* (Cambridge: Cambridge University Press, 1993) 9–35.

7. Mainardi, *The End of the Salon* 11.

8. See Thomas E. Crow, *Painters and Public Life in Eighteenth-Century France* (New Haven: Yale University Press, 1985) for a discussion of the history and social impact of the Salon.

9. Hélène Zmijewska, "La Critique des Salons en France avant Diderot," *Gazette des Beaux-Arts* (1970): 125.

10. Malcolm Easton, *Artists and Writers in Paris: The Bohemian Idea 1803–1867* (London: Edward Arnold, 1964) 2.

11. For a comprehensive analysis of David's studio and especially the relations between the master and his students (notably Drouais, Girodet, Gros and Gérard) see Crow, *Emulation: Making Artists for Revolutionary France* (New Haven: Yale University Press, 1995).

12. See E. J. Delécluze, *Louis David: Son Ecole et son temps* (1855; Paris: Macula, 1983) for a firsthand account of life in David's studio.

13. Mainardi, *The End of the Salon* 14.

14. A gold medal at the Salon entailed a cash prize, but more importantly would increase a painting's market value. James Harding reports that "one patron agreed to pay 1000 francs for his portrait with a further 2000 francs to be added if the portrait was accepted by the Salon. Conversely, it was not unknown for a picture rejected by the Salon jury to be refused by the original buyer." *Artistes Pompiers: French Academic Art in the Nineteenth Century* (New York: Rizzoli, 1979) 9.

15. Bourdieu, "The Link between Literary and Artistic Struggles" 35.

16. Colin Bailey, *1789: French Art During the Revolution* (New York: Colnaghi, 1989) 231.

17. Baudelaire called Girodet and Guérin "ces maîtres, trop célébrés jadis, trop méprisés aujourd'hui." See *Oeuvres complètes*, ed. Claude Pichois, 2 vols. (Paris: Gallimard-Pléiade, 1975–76) 2: 584. Baudelaire had announced a study of "David. Guérin. Girodet" on the cover of his *Salon de 1845* "pour paraître prochainement," but the work never appeared.

18. See E. J. Delécluze, "Obsèques de Girodet" in *Journal de Delécluze 1824–1828* (Paris: Grasset, 1948) 50–62 for a firsthand account of the funeral.

19. Delécluze reports that the members of the Institut gathered to lament the "perte irréparable que l'Ecole faisait dans un moment où elle avait besoin d'un bras fort qui la retînt sur le penchant où elle est entraînée." *Journal* 62.

20. Baron Gros, one of Girodet's longstanding contemporaries, lamented "Bientôt on voudra nous faire croire qu'un morceau de toile sur lequel on a barbouillé de la couleur pendant quinze jours est un chef-d'oeuvre digne de consacrer la mémoire d'un prince." Delécluze, *Journal* 63.

21. In a 1791 letter from Rome to his adoptive father, Trioson, Girodet declared his desire to separate his work from David's, insisting "je tâche de m'éloigner de son genre le plus qu'il m'est possible." *Oeuvres posthumes de Girodet-Trioson*, ed. P.A. Coupin, 2 vols. (Paris: Renouard, 1829) 2: 392. Further reference to this work will be noted by OP with the volume and page number.

22. Bailey, *1789* 231.

23. This account, based on Girodet's own undeniably self-promoting narration of the events in his correspondence and reproduced by Coupin unquestioningly, has also been accepted by Levitine, Crow and other Girodet scholars. Although it seems possible that there may be a level of exaggeration or even fictionalizing in the painter's self-portrait as revolutionary, what is important in the account of these events is Girodet's own vision of himself as a revolutionary and political artist, while it may be the first of many examples throughout his life of Girodet's desire to shape the reception of his art and his life through his own narration.

24. "Quant à l'effet, il est purement idéal, et par conséquent très difficile à rendre. Le désir de faire quelque chose de neuf et qui ne sentît pas simplement l'ouvrier, m'a peut-être fait entreprendre au-delà de mes forces, mais, je veux éviter les plagiats" (OP 2: 387).

25. "Ce qui m'a surtout fait plaisir, c'est qu'il n'y a eu qu'une voix pour dire que je ne ressemble en rien à M. David" (OP 2: 396).

26. Thomas Crow, "Revolutionary Activism and the Cult of Male Beauty," in *Fictions of the French Revolution*, ed. Bernadette Fort (Evanston, Ill.: Northwestern University Press, 1991) 63. Crow argues here that Girodet was in fact politically engaged. See Boime, *Art in the Age of Revolution* (Chicago: University of Chicago Press, 1987) 448–51 for discussion of Girodet as an apolitical artist.

27. Girodet queried "Et la révolution académique, où en est-elle" in a letter to Gérard dated 30 June 1790 in *Lettres adressées au Baron Gérard*, 2 vols. (Paris: Quantin, 1886) 1: 143.

28. See Whitney Davis, "The Renunciation of Reaction in Girodet's *Sleep of Endymion*," *Visual Culture: Images and Interpretations*, ed. Bryson, Holly and Moxey (Hanover: Wesleyan University Press, 1994): 168–201 for an alternative interpretation to Crow's reading and a reevaluation of the politics of Girodet's sleeping figure.

29. Crow, "Revolutionary Activism" 65. Crow reads Girodet's painting in terms of the dynamics of competition and rivalry among the male students in David's studio vying for their master's attention and approbation, and draws specific links between *Endymion* and Drouais's *Dying Athlete* as well as Fabre's *Death of Abel*. He also indicates a lineage between Girodet's nude of 1791 and David's *Bara* of 1794. See also, Crow, *Emulation*.

30. In Lucian's brief but humorous dialogue Selene [Diana] responds to Aphrodite's question, "But tell me, is Endymion good-looking?" as follows: "I think he is very good looking Aphrodite, especially when he sleeps with his cloak under him on the rock, with his javelins just slipping out of his left hand as he holds them, and his right hand bent upwards round his head and framing his face makes a charming picture, while he's relaxed in sleep and breathing in the sweetest way imaginable. Then I creep down quietly on tip-toe, so as not to waken him and give him a fright, and then—but you can guess; there's no need to tell you what happens next. You must remember, I'm dying of love." *Lucian*, trans. M.D. Macleod, 8 vols. (Loeb Classical Library, Cambridge: Harvard University Press, 1961) 7: 331. See Levitine, *Girodet-Trioson: An Iconographical Study,* 126–7, for discussion.

31. The homoerotics of this painting have received much attention from contemporary scholars. See Solomon-Godeau, Ockman and Davis for discussion.

32. Steven Z. Levine, "To See or Not to See: The Myth of Diana and Actaeon in the Eighteenth Century" in *The Loves of the Gods: Mythological Painting from Watteau to David* (New York: Rizzoli, 1992) 74. Levine notes that eleven of these Salon paintings depicted Diana and Endymion.

33. Levine 23.

34. Laura Mulvey has theorized the gendered gaze as follows: "In their traditional exhibitionist role women are simultaneously looked at and displayed, with their appearance coded for strong visual and erotic impact so that they can be said to connote *to-be-looked-at-ness.*" "Visual Pleasure and Narrative Cinema," *Visual and Other Pleasures* (Bloomington: Indiana University Press, 1989): 19.

35. Madelyn Gutwirth, *The Twilight of the Goddesses: Women and Representation in the French Revolutionary Era* (New Brunswick: Rutgers University Press, 1992) 22.

36. Paraphrased by Elizabeth Fox-Genovese in "Introduction," *French Women and the Age of Enlightenment,* ed. Samia I. Spencer (Bloomington: Indiana University Press, 1984) 1.

37. Gutwirth 118.

38. Natalie Zemon Davis, *Society and Culture in Early Modern France* (Stanford: Stanford University Press, 1975).

39. Rousseau complained of "l'ascendant aux femmes sur les hommes" in *Lettre à M. d'Alembert sur les spectacles* (Paris: Garnier-Flammarion, 1967) 116.

40. "Parcourez la plupart des pièces modernes: c'est toujours une femme qui sait tout, qui apprend tout aux hommes." Rousseau, *Lettre à d'Alembert* 116.

41. "Faute de pouvoir se rendre hommes, les femmes nous rendent femmes," *Lettre à d'Alembert* 195–96. Rousseau identifies the "reversal of natural relations" on p. 117.

42. See Mary Sheriff, *The Exceptional Woman: Elisabeth Vigée-Lebrun and the Cultural Politics of Art* (Chicago: University of Chicago Press, 1996) for an exploration of the idea of the exceptional woman. For discussion of the *salon* as a "very impressive social institution in which women exercised a considerable degree of power," see Joan B. Landes, *Women and the Public Sphere in the Age of the French Revolution* (Ithaca: Cornell University Press, 1988) and Evelyn Gordon Bodek, "Salonnières and Bluestockings: Educated Obsolescence and Germinating Feminism," *Feminist Studies* 3 (1976).

43. Gutwirth 9.

44. "Il se peut que, sous le règne de Louis XV, on n'étudiait pas la peinture de cette façon, mais, les temps sont changés et la peinture aussi, Dieu merci! Je ne veux pas avoir l'air, dans mes ouvrages, d'un contemporain de Carlo Van Loo" (OP 2: 383).

45. By the time *Endymion* was displayed at the Salon of 1793 backlash against the revolutionary women had begun, with the public whipping of Théroigne de Méricourt and Olympe de Gouges's beheading. By 1795 women were officially barred from public assembly and political participation.

46. "L'idée du rayon m'a paru plus délicate et plus poétique, outre qu'elle était neuve alors" (OP 2: 340).

47. "Ainsi ce tableau n'est point, comme quelques personnes l'ont qualifié, *Diane et Endymion*, mais bien *le Sommeil d'Endymion*" (OP 2: 340).

48. Crow, *Emulation* 2.

49. Sarah Maza, *Private Lives and Public Affairs: The Causes Célèbres of Prerevolutionary France* (Berkeley: University of California Press, 1993) 172.

50. Alex Potts, "Beautiful Bodies and Dying Heroes: Images of Ideal Manhood in the French Revolution," *History Workshop Journal* 30 (Autumn 1990): 2.

51. J. J. Winckelmann, *The History of Ancient Art*, trans. G.H. Lodge, 2 vols. (London: Sampson Low, 1881) 1: 320.

52. Winckelmann, 1: 320–21. This translation has been emended based on Alex Potts's translation in "Beautiful Bodies."

53. It is important to note that immediately following Girodet's exhibition of the *Endymion*, David (and others) began to move toward a more feminized male body in their paintings, perhaps best emblematized by *The Death of Joseph Bara* (1794). See Crow, *Emulation* 172–88 for further discussion.

54. Girodet would later include in his poem *Le Peintre* (Canto 2) a description of the Apollo Belvedere based directly on Winckelann's famous passage. Coupin discusses Girodet's imitation of and rivalry with Winckelmann in *Oeuvres posthumes* xxvij–xxix.

55. Potts 6, 8.
56. Abigail Solomon-Godeau, "Male Trouble: A Crisis in Representation," *Art History* 16.2 (1993): 287.
57. See Judith Butler, *Gender Trouble: Feminism and the Subversion of Identity* (New York: Routledge, 1990) for further discussion of the constructed rather than essential nature of gender [i.e., gender as performance] and a critique of the notion of fixed gender identity.
58. See, in particular, *Emulation.*
59. See Candace Clements, "The Academy and the Other: *Les Grâces* and *Le Genre Galant* in *Eighteenth-Century Studies* 25.4 (1992): 469–94; and Jean Locquin, *La Peinture d'histoire en France de 1747 à 1785* (1912; Neuilly-sur-Seine: Arthéna, 1978).
60. In a letter from 1800 to fellow artist François Gérard, Girodet referred to himself twice as Endymion. Gérard had been a particularly close friend of Girodet's in the early part of his career and was a frequent correspondent about the ongoing status of *Endymion.* As their fame grew, relations between the former students cooled, and the letter, which seems to refer to their alienation, reads as follows: "Bélisaire est resté bien longtemps aveugle. Je dois donc le féliciter d'avoir recouvré la vue et de pouvoir enfin s'assurer qu'Endymion ne pouvait être réveillé que par le premier baiser de l'Amour. Mais je conseille à cet Amour de quitter ses ailes lorsqu'il jouera le rôle de l'Amitié. [signed] *Endymion*." (Belisaire remained blind for a long time. I must then congratulate him on recovering his sight and on being able to ascertain that Endymion could only be awakened by the first kiss of Love. But I advise this Cupid to abandon his wings when he plays the role of Friendship. [signed] *Endymion*). *Lettres adressées au Baron Gérard,* 1:180–81.
61. See, for example, Le Marquis de Valori, *Sur la mort de Girodet: Ode dédié à ses élèves* (Paris: Boucher, 1825), where in the last lines of the poem the author concludes with the following image of Girodet as both Apelles and Endymion: "Notre Apelle s'est endormi./ N'était-ce pas l'heure où Diane/ Sur un mont, loin d'un oeil profane,/ Brille plus amoureusement,/ Et vient, perçant la nuit ombreuse/ D'une vapeur mystérieuse,/ Caresser un paisible amant!" (Our Apelles has gone to sleep./ Was it not the hour when Diana/ Upon a hill, far from profane eyes/ Shone most amorously,/And came, penetrating the shadowy night/ With a mysterious vapor,/ To caress a peaceful lover!)
62. Solomon-Godeau, "Male Trouble" 294.
63. François Noël, *Dictionnaire de la fable* 2 vols. (Paris: Le Normant, 1803) 1: 475–76. Noël wrote in his preface, "I owe a great deal, in this new edition, to the friendship of the *citoyen* Girodet, who has graciously consented to contribute a great number of notes related to this interesting research." I: xxvij–xxiij. As chronicled by Coupin and in Girodet's correspondence with Trioson, the painter had had a longstanding friendship with Noël, who

helped him secure an atelier at the Louvre upon his return to France in 1795. Noël had also assisted Girodet during his travels in Italy, in his capacity as a republican minister in Venice.

64. "Fils d'Ethlius et de Chalyce, et petit-fils de Jupiter, qui l'admet dans le ciel," *Dictionnaire de la fable* 1: 475.

65. "La Lune, éprise de sa beauté, venait le visiter toutes les nuits dans une grotte du mont Latmos, et en eut cinquante filles et un fils, nommé Etolus, après quoi Endymion fut rappelé dans l'Olympe." *Dictionnaire de la fable* 1: 475–76.

66. "Ce sujet a été souvent traité par les peintres et les poètes; mais parmi les premiers, je doute qu'aucun l'ait rendu aussi poétiquement que le citoyen *Girodet*, dont les talents justifient ce début de la plus grande espérance." *Dictionnaire de la fable* 1: 476.

67. "Endymion, presque nu, et d'une beauté idéale, dort dans un bosquet; l'Amour, déguisé en Zéphyr, mais qu'on reconnaît à ses ailes de vautour et à son air malin, écarte le feuillage, et par l'intervalle qu'il laisse ouvert, un rayon de lune, où respire toute la chaleur de la passion, vient mourir sur la bouche du beau dormeur. Le reflet de la lune, et la teinte des objets et du corps d'Endymion même, ne laissent aucun doute sur l'heure de la nuit où l'action se passe, et sur la présence de la déesse. Voilà comme les artistes, peintres ou poètes, peuvent rajeunir les sujets usés de la vieille mythologie." *Dictionnaire de la fable* 1: 476.

68. James Henry Rubin, "Endymion's Dream as a Myth of Romantic Inspiration," *The Art Quarterly* n.s. 1.2 (1978): 50.

69. "To do something new that does not simply feel workmanlike" (OP 2: 387).

Chapter 2

1. Girodet's relationships with these men of letters were by no means one-sided, and all indicated a reciprocal admiration for his work. Bernardin de Saint-Pierre engaged in an active correspondence with the painter and selected him to provide illustrations for an 1806 deluxe version of *Paul et Virginie*. Chateaubriand admired Girodet's *Les Funérailles d'Atala* of 1808 and thanked him expressly for it in *Les Martyrs*, where he further attributed his description of the sleep of Eudore in this same volume to *Le Sommeil d'Endymion*. De Vigny, who was abroad for Girodet's funeral, composed an elegy, *Aux Mânes de Girodet*, in honor of his death, in which he lamented the passing of the great artist who tried to unite the sister arts.

2. "Parmi les peintres français du temps, Girodet a été incontestablement celui qui a le plus écrit." George Levitine, "*L'Ossian* de Girodet et l'actualité politique sous le Consulat," *Gazette des Beaux-Arts* (October 1956): 42.

3. Quatremère de Quincy, "Eloge historique de M. Girodet, peintre. Lue à la

séance publique de l'Académie royale des Beaux-Arts, le samedi 1er octo-
bre 1825." *Recueil de Notices historiques lues dans les séances publiques de l'A-
cadémie des Beaux-Arts à l'Institut par Quatremère de Quincy.* (Paris: Le Clère,
1834) 310.

4. Quatremère praises the "poésie de sa pinceau" (322) and claimed that
Girodet "ne quittait pas un poème qu'il ne l'eût traduit en dessin." "Eloge
historique" 323–24.

5. Delécluze recalled, "son goût pour les lettres et pour la poésie est peut-être
celui qui a contribué à lui faire perdre le plus de temps et à altérer le plus
sa santé. . . . Sa liaison avec l'abbé Delille lui a été fatale, en ce sens qu'il a
gagné de ce poète, comme tant d'autres alors, la maladie de la poésie
descriptive." *Louis David: Son Ecole et son temps.* (1855; Paris: Macula, 1983)
268; 270.

6. In fact sections of both poems had been published during Girodet's life-
time, but neither had appeared in its entirety until Coupin's edition of the
Oeuvres posthumes. In 1807 a fragment of the *Veillées* entitled *Essai poétique
sur l'École française* was included in the *Mercure de France* (29 August) and in
1819 Girodet presented verses to the king in honor of his viewing of *Pyg-
malion et Galatée* that were most likely taken directly from *Le Peintre.*

7. "Le rôle de peintre ne suffisant pas à son activité brûlante, il avait voulu
prendre rang parmi les écrivains." OP 1: xxij.

8. "Quelquefois il lutte avec les écrivains qui ont traité avant lui les sujets qui
entraient dans son cadre." OP 1: xxvij.

9. "Il rivalise de goût, de chaleur, de sentiment avec Winckelmann . . . et
Delille." OP 1: xxvij–xxxix.

10. Susan Siegfried, *The Art of Louis-Léopold Boilly: Modern Life in Napoleonic
France* (New Haven: Yale University Press, 1995) 35.

11. Carol Margot Osborne, "Pierre Didot the Elder and French Book Illustra-
tion, 1789–1822" (Diss., Stanford University, 1979) 1–2.

12. "L'artiste qui réussit dans ces sortes de dessins, ne peut être qu'un peintre
d'histoire ou un statuaire." OP 2: 343.

13. "Dans les Arts, dès que l'intérêt du gain approche, le génie s'éloigne."
Chaussard, Collection Deloynes XX (1798) 538.

14. Mercier, *Tribune publique,* October 1796. Cited in Jules and Edmond de
Goncourt, *Histoire de la société française pendant le Directoire* (1864; Paris: Gal-
limard, 1992) 204.

15. "Le Conseil avait rejeté l'exemption circonscrite dans des termes assez pré-
cis, ne trouvant pas une distinction suffisante de la profession mercantile ou
industrielle." Goncourt, *Le Directoire* 205.

16. Raymond Williams, *Culture and Society 1780–1950* (New York: Columbia
University Press, 1983) 36.

17. George Levitine, *Girodet-Trioson: An Iconographical Study* (New York: Gar-
land, 1978) 152.

18. Raymond Sée, *Le Costume de la Révolution à nos jours* (Paris: Editions de la Gazette des Beaux-Arts, 1929) 21.
19. In a letter quoted by J. Pruvost-Auzas, Lange denounced Girodet's portrait as one "qui, dit-on, n'y peut rien pour votre gloire et qui compromettrait ma réputation de beauté." In *Girodet, 1767–1824, Exposition du deuxième centenaire* (Montargis: Musée Girodet, 1967) no. 64.
20. Lange was forced to quit the stage following the scandal, and eventually retired to Italy due to an illness attributed to her grief over the affair. She did not die, however, until 1825, the year after Girodet's demise, and some 26 years after the incident.
21. See Levitine, "Girodet's *New Danaë*: The Iconography of a Scandal," *Minneapolis Institute of Fine Arts Bulletin* 58 (1969): 69–77 for a complete iconographic interpretation of the painting.
22. D'Abrantès's account of the episode is fairly consistent with the reaction of the contemporary critics, for she felt that Girodet was originally wronged ("Girodet n'avait pas tort. Il fut blessé" [Girodet was not in the wrong. He was hurt]) and it was not until he took revenge that he became the guilty party in the controversy. She narrates the painting as follows: "Il représentait l'intérieur d'un grenier. Dans un des coins était un lit à peine couvert par une méchante paillasse et une couverture percée. Sur cette paillasse était à demi couchée une jeune et jolie personne coiffée avec des plumes de paon et n'ayant pour tout vêtement qu'une tunique de gaze laissant voir des jambes d'une grosseur extraordinaire. Elle tenait cette gaze des deux mains pour recevoir une pluie de pièces d'or qui coulaient par le toit de la mansarde. Près du lit était une lampe dont la lueur brillante attirait une foule de papillons et de mouches luisantes qui tous venaient se brûler à cette lumière traîtresse. Sous le lit on voyait un énorme dindon étandant une de ses pattes à laquelle on voyait un bel anneau nuptial. Dans un coin bien obscur, on apercevait une vieille femme mise en mendiante et ressemblant parfaitement à une vieille malheureuse qui demandait l'aumone à la porte d'Orléans et qui était, disait-on, la mère de l'original du tableau coupé dont on retrouvait la parfaite ressemblance dans la Danaé du châlit, à laquelle au reste la vanité présentait un miroir. Puis il y avait encore d'autres allusions, comme une grenouille qui s'enflait tellement qu'elle crevait, et une foule de choses plaisantes que j'ai oubliées depuis que je n'ai vu ce tableau." (It presented the interior of a garret. In one of the corners was a bed barely covered with a wretched straw mattress and a tattered blanket. On this mattress reclined a pretty young woman with peacock feathers in her hair and wearing nothing but a gauze tunic that revealed extraordinarily large legs. She held the gauze in her two hands in order to receive a shower of gold coins that was flowing from the mansard roof. Near the bed was a lamp whose bright light attracted a swarm of butterflies and shining flies who all came to immolate themselves in this treacherous light. Underneath the bed

you could see an enormous turkey extending one of its claws adorned with a wedding ring. In a very dark corner you could make out an old woman dressed as a beggar who perfectly resembled a poor old woman who begged for alms at the porte d'Orleans and who was, they said, the mother of the original subject of the shredded painting, who perfectly resembled this Danaë of the bedstead gazing into her mirror. Then there were other allusions, like a frog, swollen to bursting, and a mass of amusing things that I have forgotten since I last saw the painting.) While there are some inaccuracies in her account, these may be traced more to faulty memory than to inability to understand the image. *Mémoires de Madame la Duchesse d'Abrantès* (Paris: Garnier) 55.

23. "L'esprit, M. Girodet, est l'ennemi du génie, l'esprit vous jouera quelque mauvais tour, il vous égarera." Quoted by Mario Praz in "Girodet's *Mlle Lange as Danaë*" in *Minneapolis Institute of Arts Bulletin* 58 (1969): 64.

24. Levitine, "Girodet's *New Danaë*" 74.

25. Girodet's *Description: Ossian—Les Ombres des Héros morts pour la patrie conduites par la Victoire viennent habiter l'Elysée aérien où les Ombres d'Ossian et de ses valeureux guerriers s'empressent de leur donner dans ce séjour d'immortalité et de gloire la fête de la Paix et de l'Amitié,* distributed at the Salon de 1802, is reproduced in Bernier's *Girodet 1767–1824* (Paris: Damase, 1975) 203. As was typical of Girodet, the written description was more confusing than illuminating and provided a means of identifying many of the myriad characters in the image without actually going so far as to explain their allegorical or symbolic meaning, which would have been counter to the painter's intention.

26. "Et chaque peintre allégorique/Dès qu'il a quitté ses pinceaux,/ Doit employer sa rhétorique/ Pour nous expliquer ses tableaux." *Arlequin au Museum ou critique des tableaux en vaudevilles* (Paris: Marchant, 1802) 4.

27. See Levitine, "L'Ossian de Girodet" 39–56 for an in-depth discussion of Girodet's complex political allegory and a close reading of the iconography of the painting. Once again Levitine provides the classic interpretation, to which I am indebted.

28. Sarah Burns, "Girodet-Trioson's *Ossian*: The Role of Theatrical Illusionism in a Pictorial Evocation of Otherworldly Bodies," *Gazette des Beaux-Arts* XCV (1980): 13.

29. See Barbara Maria Stafford, "Les *météores* de Girodet," *Revue de l'art* 46 (1979): 46–51 for discussion of meteorology *chez* Girodet.

30. "Ah ah! dit David, vous ne connaissez pas encore Girodet; c'est l'homme aux précautions. Il est comme les lions, celui-là, il se cache pour faire des petits." Quoted by Delécluze in *David* 265.

31. Delécluze recounts the episode as follows: "Cette scène muette, assez longue et qui sans doute parut durer un siècle à Girodet, ne put se prolonger longtemps; David rompit le silence, se mit à faire un éloge simple,

vrai et fort bien motivé de l'habilité que l'artiste avait déployé dans l'exécution difficile de l'ouvrage. A plusieurs reprises, il renouvela cet éloge en évitant de parler du fond de la composition. Enfin, un mouvement interrogatif et quelques mots de Girodet ayant provoqué une réponse positive à ce sujet, le maître dit à l'élève, avec l'accent de quelqu'un qui résume: 'Ma foi, mon bon ami, il faut que je l'avoue; *je ne m'y connais pas à cette peinture-là; non, mon cher Girodet, je ne m'y connais pas du tout.*' Arrivé dans la cour du Louvre, David . . . dit enfin à Etienne: 'Ah ça! il est fou, Girodet! . . . il est fou ou je n'entends rien à l'art de la peinture. Ce sont des personnages de cristal qu'il nous a faits là. . . . Quel dommage! Avec son beau talent, cet homme ne fera jamais que des folies. . . . il n'a pas le sens commun.'" *David* 265–66, original emphases.

32. "Ces idées ou du moins leur application est, j'ose le croire, neuve et poétique." OP 2: 278.

33. Richard Wrigley typifies critical reaction to Girodet's poetry when he asserts that the painter's "private income insulated him from the need to consider which of painting or writing might be the more profitable." *The Origins of French Art Criticism from the Ancien Régime to the Restoration* (Oxford: Oxford University Press, 1993) 227. Neil MacGregor's brief "Girodet's poem *Le Peintre*," *Oxford Art Journal* 4.1 (1981): 26–30, is the only recent work devoted to Girodet's poetry that has come to my attention.

34. In 1804 Girodet's poem written in honor of Gros's *Jaffa* was published in the *Journal des débats*.

35. Susan Siegfried, "The politicisation of art criticism in the post-revolutionary press," in *Art Criticism and its Institutions in Nineteenth-Century France*, ed. Michael R. Orwicz (Manchester: Manchester University Press, 1994): 11.

36. Siegfried, "The politicization of art criticism," 21. Also see Francis Haskell, "Art and the Language of Politics" in *Past and Present in Art and Taste* (New Haven: Yale University Press, 1987) 65–74 for further discussion of this subject, especially in relation to the adoption of political terminology (revolutionary, avant garde, reactionary, anarchist, etc.) in the language of art criticism.

37. "Beaucoup de gens aujourd'hui s'affichent pour connoisseurs dans les Beaux-Arts: mais peu d'entre eux ont assez de lumières pour en bien parler. Dans le nombre de ceux qui en écrivent et raisonnent mal, il est juste encore de distinguer ceux qui se trompe de bonne foi, et sans intention maligne, de ceux chez lesquels l'ignorance se trouve réunie à l'esprit de parti. C'est à ces derniers seulement que ce discours s'adresse." (Many people today promote themselves as connoisseurs of the Fine Arts: but few of them are enlightened enough to speak intelligently about art. Among those who write and reason badly about art, it is only fair to distinguish between those who make their mistakes in good faith and without ill intent and those whose ignorance is united with the spirit of partisanship. It is exclu-

sively to the latter that this discourse is addressed.) Anonymous [Girodet], *La Critique des critiques du Salon de 1806. Etrennes aux connaisseurs* (Paris: Firmin Didot, 1807) Avertissement.

38. "Mais un fat envieux, qui lui-même se ronge,/ Vrai miroir d'impudence, écho sûr de mensonge,/ D'une plume brutale, exercée aux pamphlets,/ Attaquant le talent qui dédaigne ses traits,/ Dénigrant des beautés qu'en secret il admire." *Critique des critiques* 7–8.

39. "Il n'est pas un seul morceau de mon poème que je n'aie fréquemment retouché et souvent même refait tout entier, après l'avoir fait d'abord avec soin." OP 1: 36.

40. Jacques Delille (1738–1813) was among the most popular poets of his day, renowned for his dense, often precious versification and turn of phrase, relying heavily on periphrasis and elegant wordplay. Elected to the Academy in 1774, he remained an influential voice during the postrevolutionary period, especially in his efforts to liberate poetry from the Classical influence and introduce new and original subject matter and form. His best known works include *Les Jardins* (1782), *L'Imagination* (1788/1806) and *Les Trois Règnes* (1808) as well as translations of Virgil's *Georgics* (1788), the *Aeneid* (1804) and Milton's *Paradise Lost* (1805). Although pronounced "the greatest contemporary poet" at his funeral, Delille was, like Girodet, subject to contemporary satire as well, and was the target of ridicule in Rivarol's *Le Chou et le navet* (1782). Girodet refers specifically to Delille's influence several times in his *Discours préliminaire*, see especially 1: 27–28 and 37.

41. "On sait que le poète dans ses descriptions, comme le peintre dans ses tableaux, tire un avantage inappréciable des souvenirs qui lui sont personnels. J'ai donc cru devoir, le plus souvent, prêter à mon peintre mes propres impressions et mes vrais sentiments" (We know that the poet in his descriptions, like the painter in his paintings, derives an inestimable advantage from personal memories. Thus I believed it necessary, for the most part, to lend to my painter my own impressions and my true feelings). OP 1: 33.

42. "La peinture, comme la poésie, s'élève aux conceptions métaphysiques. Toutes deux habitent le palais diaphane de l'allégorie; toutes deux aussi peuvent s'armer du fouet de la satire ou s'affubler du masque de Momus." OP 1: 13.

43. "Comment ne seraient-ils pas souvent tentés de s'exprimer dans le langage des pays limitrophes où ils vont échanger les inspirations de leur génie?" (OP 1:14).

44. G. Lessing, *Laocoön: An Essay on the Limits of Painting and Poetry* (New York: Bobbs-Merrill, 1962) 91.

45. "Il aurait donc fallu, dès le premier pas, m'engager dans une lutte dangereuse avec des écrivains dont la réputation, comme poètes, était solidement établie. . . . Ces auteurs et M. Watelet lui-même avaient parlé de la peinture sans avoir le droit incontestable de faire autorité, et je ne pouvais,

dans mon opinion, les élever au rang des classiques. Ils n'étaient pas peintres; conséquemment ils ne pouvaient connaître à fond la pratique de l'art; je trouvais donc leurs théories incomplètes et même assez souvent erronées." (OP 1: 19).

46. MacGregor, "Girodet's poem *Le Peintre*" 29.

47. Leonardo, *On Painting*, ed. Martin Kemp and Margaret Walker (New Haven: Yale University Press, 1989) 26–28.

48. In the *Salon de 1859*, Baudelaire claimed that for Delacroix "La nature n'est qu'un dictionnaire" and went on to explain, "Pour bien comprendre l'étendue du sens impliqué dans cette phrase, il faut se figurer les usages nombreux et ordinaires du dictionnaire. On y cherche des mots, la génération des mots, l'étymologie des mots; enfin on en extrait tous les éléments qui composent une phrase et un récit; mais personne n'a jamais considéré le dictionnaire comme une composition dans le sens poétique du mot. Les peintres qui obéissent à l'imagination cherchent dans leur dictionnaire les éléments qui s'accordent à leur conception; encore, en les ajustant avec un certain art, leur donnent-ils une physionomie toute nouvelle. Ceux qui n'ont pas d'imagination copient le dictionnaire." (To understand fully the scope of the meaning implied in this sentence, you must imagine the numerous ordinary uses of a dictionary. One searches for the meanings of words there, for the generation of words, and for the etymologies of words; indeed, one takes from it all of the elements that compose a sentence and a narrative; but nobody has ever considered the dictionary as a composition in the poetic sense of the word. Painters who obey their imaginations look in their dictionaries for the elements that correspond to their conceptions; still, in adjusting them with a certain art, they give them a completely new physiognomy. Those who have no imagination copy the dictionary.) Baudelaire, *Oeuvres complètes*, ed. Claude Pichois, 2 vols. (Paris: Gallimard-Pléiade, 1975–76) 2: 624–25.

49. As will be discussed in chapter 6, Apelles and Alexander was also an extremely popular topos for painters during the Restoration. The fact that Girodet chooses to narrate rather than paint it is of course significant.

50. Wrigley, *The Origins of Art Criticism* 129. See *Journal des Arts* 5 vendémiaire, an XI no. 229: 3.

51. See, for example, A. Levain, *Girodet considéré comme écrivain* (Montargis: Bulletins de la société d'Emulation de l'arrondissement de Montargis, XII, n.d.) for a more or less contemporary evaluation of *Le Peintre* (probably appearing shortly after the appearance of Coupin's *Oeuvres posthumes* in 1829), which alternately sees Girodet's poem as too painterly ("Dans cet essai d'un autre art, Girodet n'a pas assez oublié le sien" [in this effort at another art, Girodet has not sufficiently forgotten his own] [15]) and not painterly enough: "que de lacunes! du dessin, du coloris, de la composition, de la partie théorique de l'art, pas un mot" (what lacunae! not a single word on

drawing, color, composition or the theoretical part of art) (15). MacGregor, Levitine and Crow all present late twentieth-century views of Girodet's poem as equally misguided and unsuccessful.

Chapter 3

1. Francis Haskell, "An Italian Patron of French Neo-Classical Art," *Past and Present in Art and Taste: Selected Essays* (New Haven: Yale University Press, 1987) 56–57.

2. Kératry wrote that Sommariva "appartient à la France par son goût, comme par ses affections" in *Annuaire de l'école française de peinture, ou lettres sur le Salon de 1819* (Paris: Baudouin, 1820) xiv.

3. "Ses figures de femmes surtout sont faites pour inspirer au spectateur le désir de voir se réaliser la fable gracieuse de Pygmalion." Arnault, et al., *Biographie nouvelle des contemporains* 4: 79. This same entry on Canova called him "le Delille de la sculpture: il a fait de bons ouvrages et de mauvais élèves" (the Delille of sculpture: he made good art and bad students).

4. The correspondence from Sommariva to Canova is included in Fernando Mazzocca, "G. B. Sommariva o il borghese mecenate: il *cabinet* neoclassico di Parigi, la galleria romantica di Tremezzo," *Itinerari: Contrubuti alla Storia dell'Arte in Memoria di Maria Luisa Ferrari II* (Studio per Edizioni Scelte, 1981) Appendix A (227–68). All references below are taken from these letters.

5. "Trovasi già installata e posta precisamente alla piazza del mio letto. Tutti quelli che l'ebbero finora ad ammirare nel suo letto nuziale la trovano ancora meglia che all'Esposizione del Museo." Mazzocca 262–63.

6. Baron Frénilly called the *Magdalene's* gallery "un petit sacellum, moitié chapelle, moitié boudoir," in *Souvenirs du Baron de Frénilly, pair de France, 1768–1828* (Paris: Plon, 1908) 279. Frénilly gives a firsthand account of Sommariva's career in France, from his questionable past ("il sortait de dessous terre") to his triumphant reception as a connoisseur.

7. T.F. Dibdin, *A Bibliographical, Antiquarian and Picturesque Tour in France and Germany* (London, 1821) 2: 486–87. For another contemporary account of a visit to Sommariva's gallery and a response to Canova's statues, see Lady Morgan, *France* 2 vols. (London: Colburn, 1817) 2: 51–52.

8. Marx, *Collected Works* (London: Lawrence and Wishart, 1975) 3: 325.

9. "Aucun n'a réuni les suffrages universels comme le célèbre sculpteur Canova, dont la Muse et la Terpsychore auraient pu prolonger chez les anciens, l'empire de l'Idolatrie." *Journal des arts,* 5 January 1814.

10. David Simpson indicates that the terms "idolatry" and "fetishism" were considered synonymous during this period in *Fetishism and Imagination: Dickens, Melville, Conrad* (Baltimore: Johns Hopkins Univeristy Press, 1982) 9.

11. Both Haskell and Mazzocca accept Sommariva's interpretation of the painting and label Girodet's *Pygmalion et Galatée* as a tribute to Canova, but none of the voluminous criticism written on the painting in 1819 mentions Canova as a possible model for Pygmalion, nor does Girodet in his infrequent references to his painting.

12. "Il est impossible de se figurer le nombre de belles choses qu'il a successivement recouvertes en faisant ce tableau." OP 1: xxxij.

13. "Girodet travaillait lentement avec une sorte de mystère, effaçant de belles choses dont le résultat ne le satisfaisait point." E.-F. Miel, *Notice sur Girodet-Trioson, peintre d'histoire, membre de l'Institut* in *Annales de la Société libre des Beaux-Arts* XII (1842): 1845.

14. In a letter to Turpin-Crissé, for example, he complained "Voici la cinquième année que j'ai commencé un tableau de Pygmalion que je n'ai pu parvenir à terminer encore" (This is the fifth year that I have begun a painting of *Pygmalion* that I still cannot manage to finish). Quoted from Henri Jouin, "Lettres inédites d'artistes français du XIXe siècle," *Nouvelles archives d'art français* XVI, 3e série (1900) 47. Count Turpin de Crissé was chamberlain to the Empress Josephine, serving as her artistic advisor for Malmaison. In the letter quoted above, Girodet is trying to arrange a sitting for a portrait of Mme Turpin de Crissé and claims that he only has time for portraiture during the winter because the nature of his studio is such that he can only pose nudes (presumably for the all-consuming Galatea) in warm weather. Girodet writes, "je suis forcé par la nature de mes travaux et la construction de mon atelier qui ne me permet de modèles nus que pendant le temps des chaleurs, de remettre tous les portraits à l'hiver" (I am forced by the nature of my work and the construction of my studio, which only allows me to pose nude models in warm weather, to postpone all portraits until the winter) (47). This physical constraint may have been another cause for the tremendous delays in the completion of the painting, though there is little question that most artists dealt with similar difficulties in their ateliers more efficiently.

15. In a letter to Fabre, dated 20 June 1819, Girodet wrote "je suis fort occupé encore d'un tableau qui me tient depuis longtemps, et j'ai recommencé plusieurs fois sans succès, ne sachant même si je serai plus heureux ce dernier." Reproduced in *Nouvelle revue retrospective* V, 127.

16. "Voyez Girodet, voilà cinq ans qu'il travaille comme un galérien dans le fond de son atelier, sans que personne voie rien de lui. Il est comme une femme qui serait toujours dans les douleurs de l'enfantement, sans accoucher jamais." Delécluze, *Louis David: Son Ecole et son temps* (Paris: Macula, 1983) 264.

17. See Christine Battersby, *Gender and Genius: Toward a Feminist Aesthetic* (Bloomington: Indiana University Press, 1989) for discussion of the maternal metaphor and male creativity.

18. On the back of the miniature copy is written "Portrait de M. Girodet/il travaille à son tableau de Pygmalion et Galatée/en présence de M. le comte de Sommariva et de M. Dejuinne,/ un de ses élèves qui est l'Auteur de l'original de cette copie en émail;/fait pour M. le comte de Sommariva/Adèle Chavassieu/1822" (Portrait of Girodet/ he is working on his painting of Pygmalion and Galatea/ in the presence of the Count de Sommariva and M. Dejuinne,/ one of his students who is the author of the original of this enamel copy; made for the Count de Sommariva/ Adèle Chavassieu/ 1822) (in Mazzocca, *Neoclassico e troubadour*, no. 103). The figure standing beside Sommariva has since been identified as his friend Breguet (in *Girodet: 1767–1824* [Montargis, 1967] no. 154). Chavassieu (1788–1831) executed nearly 80 miniature copies of works in Sommariva's collection. For a complete list, see Mazzocca, *Sommariva*, Appendix C, 279–282.

19. Girodet's own approval of the image is witnessed by a letter to Dejuinne dated 13 February 1820 in which he dictates the inscription he would like on the bottom of the painting as follows: "Si vous me permettez de vous dire ce que je croirais plus convenable et surtout ce que j'aimerais mieux qui fût mis au bas du portrait que vous avez pris la peine de dessiner d'après moi, le voici: *Anne-Louis Girodet-Trioson*, peintre d'histoire, membre de l'Académie des Beaux-Arts./ Et voilà tout. Les autres particularités se sauront toujours après ma mort, si l'on croit avoir intérêt de s'en informer" (If you will let me tell you what I think would be most appropriate and what I would prefer to see inscribed at the bottom of the portrait that you have taken the time to paint of me, here it is: *Anne-Louis Girodet-Trioson*, history painter, member of the Académie des Beaux-Arts./ And that is all. The other details will be known after my death, if anyone cares to learn them). In Jouin, *Lettres inédites d'artistes français* 58.

20. See James H. Rubin, "*Pygmalion and Galatea*: Girodet and Rousseau," *The Burlington Magazine* 989 (1985): 517–20, for discussion of this painting as "an aesthetic manifesto of a new and reinvigorated classicism."

21. Crow caracterizes Girodet's *Pygmalion* as "stiff and insipid . . . a bitterly ironic commentary on the artist's declining powers" (*Emulation: Making Artists for Revolutionary France* [New Haven: Yale University Press, 1995] 272) while Robert Rosenblum condemns the painting "une sorte de décoration piquante. . . . L'extraordinaire volupté de *l'Endymion* n'est plus ici que le traitement banal d'une mythologie érotique, frisant le classicisme académique du XIXe siècle" (a sort of piquant decoration. . . . The extraordinary voluptuousness of *Endymion* is here nothing more than the banal treatment of erotic myth, bordering on the academic Classicism of the nineteenth century) ("Girodet," *Revue de l'art* 3 [1969]: 100). Lorenz Eitner calls *Pygmalion and Galatea* "a feeble and affected work, in which scarcely a trace remains of Girodet's ingenious eccentricity and calculated perfection of finish" (*An Outline of 19th-Century European Painting from David to*

Cézanne [New York: Icon, 1987] 41), and Haskell captures the general feeling of deprecating condescension as he comments, "This weird painting, in which the Nude is so coyly turning into the Naked, is today a source of embarrassment even to Girodet's most enthusiastic admirers" ("An Italian Patron" 54). Indeed, nearly every critic from the middle of the nineteenth century on has considered the painting an immense failure, but little analysis has been accorded its meaning, outside of James Rubin's excellent article on Girodet and Rousseau.

22. "Enfin, dans les derniers jours de l'exposition, parut le tableau de *Pygmalion et Galatée*, dans lequel il semblait avoir voulu surmonter les difficultés qui paraissaient insurmontables, et reculer les bornes de son art." OP 1: xx.

23. Girodet located his primary challenge in portraying "l'effet de la dégradation et du passage le plus doux qu'il m'a été possible de le faire, de la partie animée avec celle qui est encore du marbre." Letter from Girodet to Fabre, 20 June 1819, in *Nouvelle Revue rétrospective* 5: 127.

24. "Que les beaux-arts entretiennent religieusement ce feu sacré. . . . cette beauté ineffable, image éblouissante de la divinité sur terre, après avoir vu tomber à ses pieds les honteuses idoles qui avaient usurpé son temple et profané ses autels, asseoir pour jamais, sur leur débris, son empire inébranable." OP 2: 203–4.

25. In "Considérations sur le génie particulier à la peinture et à la poésie" Girodet wrote, "le génie ressemble alors à un arbre vigoureux dont la sève surabondante s'égare dans un luxe de végétation." OP 2: 91.

26. These metaphors are particularly prominent in "Considérations sur le génie particulier à la peinture et à la poésie" (OP 2: 89–125), where *enfanter* is the operative verb for the creation of a work of art.

27. See Margaret Waller, *The Male Malady: Fictions of Impotence in the French Romantic Novel* (New Brunswick: Rutgers University Press, 1993) for discussion of Romantic heroes and the male *mal du siècle*.

28. James Smith Allen surmises that some 60 percent of Parisian women could read by 1816–1820 (*Popular French Romanticism* [Syracuse: Syracuse University Press, 1981] 155), and while the novel was always considered a "feminine" genre, Stendhal declared in 1827, as he was finishing *Armance*, "The principal fear I had in writing this novel was being read by chambermaids and the marquises who resemble them." Quoted by Waller, *The Male Malady* 134.

29. See Waller, *The Male Malady* 2–5.

30. Naomi Schor, *Breaking the Chain: Women, Theory and French Realist Fiction* (New York: Columbia University Press, 1985) 135.

31. "Dans son coeur sans désir l'instinct de la pudeur." OP 1: 177.

32. Schor, "*Triste Amérique: Atala* and the Postrevolutionary Construction of Woman," *Rebel Daughters: Women and the French Revolution*, ed. Sara Melzer and Leslie W. Rabine (Oxford: Oxford University Press, 1992) 145.

33. Schor, "*Triste Amérique*" 151.

34. "L'histoire raconte que les trophées de Miltiade empêchaient Thémistocle de dormir; nous avons eu un *Marathon*, nous attendons un *Salamine*. M. Gérard n'est pas là, j'aurais voulu avoir le plaisir de lui dire devant Henri IV que je le nommais mon premier peintre." In *Lettres adressées au Baron Gérard*, 2 vols. (Paris: Quantin, 1886) 2: 162–63.

35. "Cette petite manoeuvre avait ordinairement le plus grand succès auprès des belles dames de Paris qui racontaient ensuite qu'elles avaient vu peindre Girodet, et qu'il n'était pas étonnant que les ouvrages de ce peintre fussent si parfaits, puisqu'il les corrigeait *jusqu'au dernier moment*." Delécluze, *David* 271–72.

36. "Si son tableau n'était point terminé à l'ouverture de l'exposition, c'est qu'il lui avait été impossible, malgré ses efforts, de l'avoir fini." Unpublished response from Girodet to the criticisms voiced by I. G. in *La Renommée* (19 November 1819), as reproduced in A. Porée, "Quelques lettres de peintres français," *Correspondance historique et archéologique* 14 (Paris, 1907) 286–87.

37. Letter from Géricault quoted by Lorenz Eitner in *Neoclassicism and Romanticism, 1750–1850* (New York: Icon, 1989) 306, from Charles Clément, *Géricault, étude biographique et critique* (Paris, 1868) 170 ff.

38. Although twentieth-century critics claim that Louis XVIII visited Girodet's studio for the viewing (see Wrigley 129; Crow, *Emulation* 272; Rubin, "Pygmalion" 518), in fact contemporary reports indicate that Girodet brought the painting to the king. See *Journal des débats* (6 November 1819): 3.

39. See Rubin, "Girodet and Rousseau."

40. See the *Journal des débats*, 5 November 1819; *Le Moniteur universel*, 6 November 1819 and *Description du tableau de Pygmalion et Galatée exposé au Salon par M. Girodet*, a pamphlet by P.C.

41. "On a généralement reconnu le génie poétique qui a dirigé la composition." *Le Moniteur universel* (6 November 1819): 1418.

42. The critic praised "l'esprit de cette composition poétique" and "un coloris aussi poétique que la composition" T. (Toussaint Bernard Emeric-David), "Beaux-Arts. Salon. Sixième Article," *Moniteur universel* (15 November 1819) 1455; 1456.

43. "Tout est poésie, tout est magique dans ce tableau." P. A., "Notice sur l'exposition des tableaux, en 1819," *Revue encyclopédique* 4 (1819): 364.

44. *Journal des débats* (8 November 1819): 3.

45. The poem begins: "O Vénus! Je te rends hommage,/ Semble dire *Pygmalion*,/ 'Si *Galatée* est ton image,/ 'Anime ma création./ 'Séduit par l'objet que j'admire,/ 'Mon esprit trompe-t-il mes yeux? [. . .] Lorsqu'au défaut de la victoire,/ Les arts couronnent leur succès,/ On peut assurer que la gloire/ Est toujours avec les Français./ Girodet, vainqueur de l'envie,/ Du Grec faire pâlir le ciseau,/ Car le mouvement et la vie/ Naissent vraiment de son pinceau." P. C. *Description du tableau de Pygmalion et Galatée exposé au Salon par M. Girodet* (Paris, 1819) 8.

46. A fourth poem, "Sur la *Galatée* de M. Girodet," published by F. Massé in *La Quotidienne* (18 November 1819) is almost exclusively devoted to the theme of international rivalry, vaunting Girodet's "magique tableau" as the French answer to Apelles and Raphael.

47. See P. A., "Notice" 4.

48. Gault de Saint-Germain, *Epitre aux amateurs sur le tableau de Galatée pour faire suite aux choix des productions de l'art dans le Salon de 1819* (Paris: Huzard, 1819) 3–4.

49. "En effet, le peintre devait réunir, dans le même cadre, ce qui, dans Ovide, fait une suite de tableaux; montrer, d'une manière instantanée, la succession des circonstances qui composent le récit du poète." OP 1: xx.

50. "S'il était donné à la peinture de s'emparer à la fois de deux instants, soyons-en assurés, nous verrions sa main frémir; ainsi que ses lèvres sont entr'ouvertes, nous verrions sa poitrine pantelante soulever le vêtement qui la couvre." Kératry, *Lettres sur le Salon de 1819* 239.

51. "Moins heureux que le poète, le peintre ne peut représenter qu'une action, un moment déterminé, et ne saurait offrir sur le physionomie du même personnage qu'une seule sensation, une seule passion, à la fois." C.-P. Landon, *Salon de 1819*, 2 vols. (Paris: Imprimerie Royale, 1820) 2: 13.

52. Landon ranked *Pygmalion et Galatée* in "le premier rang parmi les productions modernes de nos meilleurs artistes" (16) yet complained "Il a tenté de reculer les bornes de son art, et du moins on doit lui savoir gré de l'intention; mais il faut convenir qu'il s'est proposé un but que la peinture ne saurait atteindre, et créé sans utilité des difficultés insurmontables." *Salon de 1819* 12.

53. "Il est évident que les maîtres de l'art d'écrire qui ont retracé la passion de Pygmalion et la beauté de Galathée, ont un rival dans l'art de peindre." T. (Emeric-David) *Moniteur universel* (15 November 1819): 1455.

54. "Suivant les lois de la peinture, souvent très différentes de celles de l'épopée ou de l'art dramatique . . . il a créé en imitant." Emeric-David 1455.

55. Emeric-David contends, "L'explication la plus plausible qu'on puisse donner de cette métamorphose d'une statue en femme, est d'y voir une allégorie enseignant que l'art de la sculpture doit réunir et porter à la plus haute perfection possible, la vérité et la beauté, et que le chef-d'oeuvre le plus accompli est celui qui se montre le plus propre à faire naître en même temps l'illusion et l'enthousiasme." (The most plausible explanation that one could give for this metamorphosis of a statue into a woman is to see in it an instructive allegory for the art of sculpture, which should combine truth and beauty, and bring them to the highest perfection possible. The most accomplished masterpiece is the one that inspires both illusion and enthusiasm at the same time.) *Moniteur universel* (15 November 1819): 1455.

56. W. J. T. Mitchell, "Space and Time: Lessing's *Laocoön* and the Politics of Genre," in *Iconology: Image, Text, Ideology* (Chicago: University of Chicago Press, 1986) 109.

57. Mitchell, "Space and Time" 109.

58. Emeric-David wrote, "Ce n'est pas une statue que l'artiste a peinte, et ce n'est pas entièrement une femme" in *Moniteur universel* 1456. Kératry insists "Galatea est encore marbre, mais elle est déjà femme" in *Lettres sur le Salon de 1819* 237.

59. Ann Bermingham, "The Aesthetics of Ignorance: The Accomplished Woman in the Culture of Connoisseurship," *Oxford Art Journal* 16.2 (1993): 7.

60. "Le prodige de l'animation parcourt déjà ce beau corps; il a fait palpiter le sein; il a laissé sa trace sur les appas les plus secrets; il est descendu aux jambes; il va les enlever à la pierre qui, de degrés en degrés, s'assouplit et se colore." Kératry, *Lettres sur le Salon de 1819* 237.

61. Delécluze, "Au Rédacteur du *Lycée français* sur l'exposition des ouvrages de peinture, sculpture et gravure des Artistes vivants," *Lycée français* II (1819): 243–44.

62. Anonymous, *Notice sur la Galatée de M. Girodet-Trioson avec la gravure au trait* (Paris: Pillet, 1819) 4–5.

63. "Rien de plus fin, de plus délicat pour la galbe et pour le modelé, que le cou, la poitrine et l'attache des épaules; il n'y a point d'exagération à dire que le col est mobile, et qu'on voit remuer la tête." I. G. "Salon de 1819. Lettre de l'Artiste à Pasquin et à Marferio," *La Renommé* (19 November 1819): 620.

64. Gault criticizes Girodet's sculptor who is "gauchement posé, et dans un apprêt qui suppose le calme prolongé d'une âme sans agitation" and goes on to contrast the painted Pygmalion with Rousseau's more passionate creation in *Epitre* 7–8.

65. "Pygmalion vient de terminer un chef-d'oeuvre dont la beauté lui inspire une passion désordonnée. Galatea est devenue, pour lui, l'objet d'un culte particulier. Depuis que son imagination lui a fait voir en elle autre chose qu'une statue, il l'a fait transporter sur une terrasse magnifiquement ornée, où il a élevé un autel." P. A., "Notice sur l'exposition des tableaux, en 1819" 363.

66. "C'est là que Pygmalion s'est enfermé mystérieusement avec le nouveau chef-d'oeuvre de son ciseau, pour le dérober aux regards importuns, et se livrer sans contrainte aux illusions d'un fol amour." Landon, *Salon de 1819* 10.

67. Bernard François Fonvielle, *Examen Critique et impartial du tableau de M. Girodet (Pygmalion et Galatée), ou Lettre d'un amateur à un journaliste* (Paris: Boucher, 1819) 21.

68. Mitchell, "Space and Time" 113.

69. "A lui appartient la gloire d'avoir mis le sceau à la restauration de l'art." *Journal des débats* (6 November 1819): 3.

70. "C'est seulement depuis que les peintres ont été enrégimentés sous la ban-

nière de Lebrun ou sous celle des artistes qui lui ont succédé en qualité de *premier peintre*, qu'on a vu se former cette multitude d'imitateurs, dont les productions, variées dans les sujets, mais uniformes dans le style et dans la couleur, se reconnaissaient au premier coup d'oeil." I. G., *La Renommée* (26 August 1819): 282–83.

71. "Après le concert de louanges que les amis plus indiscrets qu'éclairés ont fait rentenir aux oreilles de M. Girodet, mes éloges paraîtront faibles, mes critiques sembleront sévères." I. G., *La Renommée* (19 November 1819): 619.

72. "Telle est la description que M. Girodet donne lui-même de son tableau." I. G., *La Renommée* (19 November 1819): 620. The paragraphs in question, quoted in full by I. G., are found in P. C.'s *Description du tableau de Pygmalion et Galatée exposé au Salon par M. Girodet* (Paris: 1819) 3–4.

73. "Les colporteurs vendent sans difficulté aucune, à la porte du Musée, la description du tableau de *Pygmalion*, où se trouvent les plus pompeux éloges de M. Girodet. Ils vendent sans plus d'obstacle l'*Observateur au Muséum*, où les louanges ne sont pas menagées non plus à M. le comte de Forbin. Cependent, *Arlequin au Muséum* est impitoyablement proscrit. Est-ce parce qu'il s'est permis quelques plaisanteries sur les ouvrages de M. le directeur du Musée?" I. G. *La Renommée* (19 November 1819): 620.

74. Landon, *Salon de 1819* 15–16.

75. "Si vous n'altérez pas la pureté de l'antique, votre tableau n'est qu'une copie comme la *Galatée* de M. Girodet dans son tableau de *Pygmalion* (galerie de M. de Sommariva). Si vous entreprenez de rendre la passion, les têtes de vos personnages seront en contraste perpétuel avec les corps, car la première condition de la statuaire antique était le CALME PROFOND, sans lequel, chez les Grecs, il n'y avait point de *beau idéal*." Stendhal, *Mélanges d'art et de littérature* (Paris: Michel Lévy, 1867) 210.

76. "Je ne sais quelle odeur d'empire vous saisit à la gorge; mais c'est qu'en effet vous êtes en plein dans l'art impérial. La mythologie vous offusque, l'histoire ancienne vous poursuit. . . . Jamais M. David, jamais M. Gérard, jamais M. Girodet, ne se sont montrés à nous dans une vérité plus misérable." "De la galerie de M. de Sommariva," *L'Artiste* 2e série (1839): 185.

77. "Voilà la Galatée de Girodet; mais il faudrait allumer un réchaud à cette femme; elle tremble, elle a froid, elle est verte. Ce n'est pas le sang qui anime le marbre qui devient chair, c'est la chair qui devient marbre." *L'Artiste* (1839): 185.

78. "Regardez au-dessous du Pygmalion de Girodet, cette admirable petite tête de Rembrandt! vous ne sauriez dire si c'est la tête d'un homme ou d'une femme; mais quel éclat! quelle vie! Comme ce beau front est éclairé! et qui ne changerait contre cette simple esquisse tous les chefs-d'oeuvre de David?" *L'Artiste* (1839): 185.

79. "Il serait possible de faire servir cet usage [l'éloge] à former une suite de portraits, qui, s'ils étaient l'image fidèle du caractère et du genre de qualités,

du degré de talent et de succès de chaque artiste, mis et vu en rapport avec les circonstances dont il éprouva l'empire, seraient propres à devenir une sorte de cours historique du goût et de l'esprit de chaque période." Quatremère de Quincy, "Eloge historique de M. Girodet, peintre" in *Recueil de Notices historiques* (Paris: Le Clere, 1834) 308.

80. "Il aurait été difficile de méconnaître ici l'active influence de chaque âge sur les talents qu'il produit; et de ne pas rapprocher de leurs causes certains effets que ce rapprochement seul explique. C'est en confrontant l'artiste avec son siècle et le siècle avec l'artiste, qu'on peut saisir dans l'histoire du peintre célèbre que nous avons perdu, l'occasion de passer en revue la période qu'il a illustrée." Quatremère, "Eloge" 309.

Chapter 4

1. Marmontel's recollections of painters at Mme Geoffrin's soirées typifies the general social reception of artists in the eighteenth century in terms of their inferior class and culture. He recalled of Van Loo, Vernet, Boucher, Lemoine and La Tour, "je n'avais pas eu de peine à m'apercevoir qu'avec de l'esprit naturel, ils manquaient presque tous d'instruction et de culture" (it was not hard to see that, although naturally bright, nearly all of them lacked education and culture). He found Vernet "un homme commun," while Boucher "avait du feu dans l'imagination, mais peu de vérité, encore moins de noblesse" (had passion and imagination, but little truthfulness and even less nobility). *Mémoires*, 2 vols. (Clermont-Ferand: Bussac, 1972) 1:168.

2. Michael Moriarty, "Structures of Cultural Production in Nineteenth-Century France," *Artistic Relations: Literature and the Visual Arts in Nineteenth-Century France*, ed. Peter Collier and Robert Lethbridge (New Haven: Yale University Press, 1994) 21.

3. James Smith Allen, *Popular French Romanticism: Authors, Readers and Books in the Nineteenth Century* (Syracuse: Syracuse University Press, 1981) 89.

4. According to statistics gathered by Louis Maggiolo during the Third Republic and reported by Allen, in 1686–90 only 29 percent of the men and 14 percent of the women in France were literate enough to sign their names in the marriage register. These numbers saw a steady increase up though the nineteenth century, and by 1876–80, 83 percent of French men and 72 percent of French women were functionally literate, representing a nearly threefold increase for men and a fivefold rise for women in less than 200 years. See James Smith Allen, *In the Public Eye: A History of Reading in Modern France, 1800–1940* (Princeton: Princeton University Press, 1991) 57–61.

5. See Moriarty 22.

6. César Graña, *Modernity and its Discontents* (New York: Harper & Row, 1964) 32.

7. In *Popular French Romanticism* Allen explains, "Between 1817 and 1839 there was a 41 percent increase in the number of men and women aged 30 to 39 [in Paris], while from 1836 to 1851 this same age group dropped 8 percent. Apparently a rejuvenation, fostered by rural-to-urban migration, occurred among the Parisian population simultaneously with the wave of younger authors and others in the national population. It is also known that alongside this largely working class migration to the city, there was another brief immigration of middle class occupational groups, authors included, whose mean ages were in the 30s during the constitutional monarchies. Thus both the French and the Parisian populations in the romantic period experienced a temporary infusion of youth parallel to that among published authors: in effect, age data on the samples from the *Bibliographie de la France* reflected a large demographic trend" (86–87).

8. Regnault, "L'Homme de lettres," *Les Français peints par eux-mêmes*, 8 vols. (Paris: Curmer, 1839–42) 3: 223.

9. "Le moindre essai fait un écrivain, la moindre rime fait un poème. . . . Contestez le titre d'homme de lettres au plus imbécile des rentiers, il lui suffit, pour vous donner tort, d'aller rêver une pastorale au clair de la lune ou au bord d'un ruisseau." Regnault, *Les Français peints par eux-mêmes* 3: 223.

10. "Ce n'est plus le temple des Muses qu'il faut ouvrir aux poètes, c'est le temple de la Bourse; c'est le tribunal de commerce, dont ils veulent à toute force devenir justiciables, pour faire le négoce de leurs vers et le courtage de leurs inspirations." Regnault, *Les Français peints par eux-mêmes* 3: 231.

11. Allen, *Popular French Romanticism* 93.

12. Sainte-Beuve, "De la littérature industrielle," *Revue des deux mondes* 19 (1839) 3: 675–91.

13. "Un talent inconnu n'a pas de valeur vénale; [. . .] le taux de l'esprit varie comme celui des actions industrielles." Regnault, *Les Français peints par eux-mêmes* 3: 229.

14. Graña 33.

15. Petra Ten-Doesschate Chu and Gabriel P. Weisberg, *The Popularization of Images: Visual Culture under the July Monarchy* (Princeton: Princeton University Press, 1994) 4.

16. Ségolène Le Men, "Book Illustration," *Artistic Relations* 94. See pp. 95–98 for further discussion of these techniques.

17. Chu, "Pop Culture in the Making: The Romantic Craze for History," *The Popularization of Images* 176.

18. Le Men 103.

19. See Walter Benjamin, "The Work of Art in the Age of Mechanical Reproduction" in *Illuminations*, ed. Hannah Arendt (New York: Schocken, 1969): 217–51.

20. As Suzanne Damiron observes, "à chaque page de notre revue est écrite, dans le texte comme dans les illustrations, l'histoire du Romantisme. C'est,

en plus, la gazette des événements du temps et de toute la France; les portraits des principales personnalités se juxtaposent à leur nécrologie. *L'Artiste* a été le miroir fidèle de la Société française et de Paris au XIXe siècle" (The history of Romanticism is written on every page of the revue, both in the text and in the illustrations. It is, furthermore, the gazette of current events and of all of France; portraits of the principal personalities are juxtaposed with their obituaries. *L'Artiste* was the faithful mirror of French society and of Paris of the nineteenth century). "La Revue *L'Artiste*: Sa fondation, son époque, ses amateurs," *Gazette des Beaux-Arts* (Oct. 1954): 202. See also Damiron, "La Revue *L'Artiste*: Histoire administrative. Présentation technique. Gravures romantiques hors texte," *Bulletin de la société de l'art français* (1951–52): 131–42.

21. "Une tribune aux artistes pour que tour à tour ils pussent y défendre leurs doctrines et contredire celles de leurs adversaires." *L'Artiste* (1831)1: 185.

22. David Scott, *Pictorialist Poetics: Poetry and the Visual Arts in Nineteenth-Century France* (Cambridge: Cambridge University Press, 1988) 12.

23. Jules Janin (1804–74), later known as the "Prince of critics," was to become a key player on the French artistic scene, penning the Introduction to *Les Français peints par eux-mêmes* in 1839. A friend of Nadar's, an acquaintance of Balzac's and the model for a character in *Un Grand Homme de province à Paris,* Janin was best known as the theatre critic at the *Journal des débats* from 1831 until his death. In his capacity as critic at *L'Artiste*, he wrote equally on literature, theatre and painting, and despite his early revolutionary leanings he was elected to the *Académie française* in 1873. "Etre artiste" is found in *L'Artiste* (1831) 1: 9–12.

24. "L'art c'est la vie, l'art c'est un don de l'âme sous des formes diverses." Jules Janin, *L'Artiste* (1831)1: 9.

25. "Il y a deux divisions principales à faire entre les artistes. L'homme qui sait et qui juge, et l'homme qui crée. Le premier est l'artiste heureux, spectateur de tous les efforts, applaudissant tous les succès; le second est l'artiste laborieux, acteur intéressé dans cette noble lutte des arts, plein de vastes espérances, et à défaut du présent, jouissant de l'avenir." Janin, *L'Artiste* (1831) 1: 10.

26. Robert Lethbridge, "Manet's Textual Frames," *Artistic Relations* 145.

27. Lethbridge 144.

28. Bourdieu, *Artistic Relations* 35–36.

29. Eugène Delacroix, "Des Critiques en matière d'art," *Revue de Paris* (May 1829).

30. "A l'homme qui juge des jugements à porter, à l'homme qui compose des gravures pour reproduire sa composition, à tous les deux un journal à écrire; un journal où ils diront franchement leur pensée la plus intime." Janin, *L'Artiste* (1831) 1: 10.

31. "C'est ce qu'on nomme en littérature le style, le rhythme, l'idiome. [. . .] Il

en est de ceci comme des langues; nous accorderons toujours la préférence à la langue maternelle pour rendre nos impressions les plus intimes." Alfred Johannot, "Du point de vue dans la critique," *L'Artiste* (1831) 1: 109.

32. Victor Schoelcher, "Le Salon de 1831," *L'Artiste* (1831) 1: 280.

33. Among the most important studies are Mary Wingfield Scott's *Arts and Artists in Balzac's* Comédie humaine (Chicago: University of Chicago Press, 1937); Jean Adhémar, "Balzac et la peinture," *Revue des sciences humaines* (1953); Pierre Laubriet, *L'Intelligence de l'art chez Balzac* (Didier, 1961); and Olivier Bonard, *La Peinture dans la création balzacienne* (Geneva: Droz, 1969).

34. Much of Balzac's writing before 1829 was signed with pseudonyms including Lord R'Hoone and Horace Saint-Aubain. His first novel, *Les Chouans*, was published in 1829, thus marking the beginning of his mature career.

35. "J'aime aller à la chasse des tableaux et de faire péniblement *un petit musée*, mais malheureusement je ne me connais pas en tableau." Quoted by Jean Adhémar in "Balzac, sa formation artistique et ses initiateurs successifs," *Gazette des Beaux-Arts* 104 (1984): 239 from an 1849 letter to Thoré.

36. Mary Wingfield Scott documents 102 references to Raphael, 28 to Titian, 19 references to Rubens, 13 to Leonardo and to Rembrandt. Girodet is by far the most common contemporary reference in *La Comédie humaine* with 20 mentions, while Delacroix merits only 6.

37. "Il faut que cela soit sublime, tout le long dans le genre d'*Atala* de Girodet en peinture." Balzac, *Correspondance*, 4 vols. (Paris: Garnier, 1960–66) 1: 39.

38. Although chapter 3 above primarily cites articles written *after* Girodet's *Pygmalion* appeared in early November 1819, articles published as early as August and September of that year mentioned the painting, and by October it was a frequent topic of reference, anticipation and speculation in the *feuilletons* and Salon reviews.

39. "Si Girodet met son *Endymion* à l'exposition, ayez l'obligeance de me procurer un billet pour le jour où il est censé n'y avoir personne. J'irai le matin, on ne me verra pas." Balzac, *Correspondance* 1: 46–47. Balzac insisted on going at a time when he would not be seen because a condition of his parents' supporting his two-year stint alone in Paris was that he remain incognito. When the rest of the family left Paris for Villeparisis in the summer of 1819 they told everyone that Honoré had gone to visit relatives in Albi.

40. In a letter to Dablin he attests "je vous attends dimanche matin, fournissez-vous de [détails sur les] tableaux. Je veux vous intérroger sur le musée" (I will be waiting for you Sunday morning, so be sure to remember lots of details about the paintings. I want to interrogate you on the museum) (*Correspondance* 1: 40). He complained to his sister that "le perfide Dablin n'est pas venu, je l'attendais pour lui faire rendre gorge sur tous les tableaux" (the perfidious Dablin did not come, and I was waiting for him to make him tell me everything about all the paintings) (*Correspondance* 1: 38).

41. See Adhémar, "Balzac, sa formation artistique" 234.

42. A letter to Balzac from his cousin Edouard Malus dated 26 March 1820 indicates that his mother was trying to procure him tickets to Sommariva's gallery, and although the person who could help her get them was away from the capital, Edouard tells Honoré to keep his fingers crossed that "l'Absent" will return soon, so that they might have the pleasure of obliging their cousin.

43. "Son peintre était Girodet. Quelques-unes de ses premières nouvelles portent les traces de cette admiration arriérée qui lui valait de notre part des plaisanteries qu'il acceptait de bonne grâce." Théophile Gautier, *Honoré de Balzac, sa vie et ses oeuvres* (Paris: Poulet-Malassis, 1859) 89.

44. In an 1883 review of Champfleury's *Les Vignettes romantiques: Histoire de la littérature et de l'art 1825–1840*, Louis Gonse placed the Devéria brothers at the center of "cette pléiade qui ont illustré les oeuvres de Hugo, de Vigny, d'Eugène Sue, de Balzac et de tous les poètes de la jeune France d'alors" (the constellation of artists who illustrated the works of Hugo, Vigny, Eugène Sue, Balzac and all of the poets of the *jeune France* movement), along with Tony Johannot and Célestin Nanteuil. Quoted in *Champfleury: son regard et celui de Baudelaire* (Paris: Hermann, 1990) 195.

45. See Michele Hannoosh, *Baudelaire and Caricature: From the Comic to an Art of Modernity* (University Park, PA: Penn State University Press, 1992) 75–76 for a definition of caricature in terms of identity and deformation.

46. "Où croyez-vous aller en suivant cette prestigieuse et céleste créature . . . Que croyez-vous voir dans la personne de ce gros garçon, joufflu, prosaïque . . ." Balzac, *Oeuvres diverses*, ed. Marcel Bouteron and Henri Longnon, 2 vols. (Paris: Conard, 1935) 2: 9. Referred to hereafter in parenthetical citations as OD.

47. Richard Sieburth adds, "En fait, les *physiologies* fournissent un exemple parfait de la transformation du livre en marchandise" (In fact, the *physiologies* provide a perfect example of the transformation of the book into merchandise), in "Une idéologie du lisible: le phénomène des 'Physiologies,' *Romantisme* 47 (1985): 42–43.

48. Richard Terdiman, *Discourse/Counter-Discourse: The Theory and Practice of Symbolic Resistance in Nineteenth-Century France* (Ithaca: Cornell University Press, 1985) 93–94.

49. "*Physiologie*, ce mot se compose de deux mots grecs dont la signification est désormais celle-ci: Volume in-18, composé de 124 pages et d'un nombre illimité de vignettes, de culs-de-lampe, de sottises et de bavardage (*logos*) à l'usage des gens niais de leur nature (*phusis*)." *Physiologie des physiologies* (Paris: Desloges, 1841) 43.

50. Judith Wechsler, *A Human Comedy: Physiognomy and Caricature in 19th-Century Paris* (Chicago: University of Chicago Press, 1982) 33. Wechsler notes that Balzac himself "claimed paternity of the *Physiologies* as a genre—

his own *Physiologie du mariage* had been published eleven years before the Aubert series appeared. Balzac also acknowledged Brillat-Savarin's *Physiologie du goût ou méditation de gastronomie transcendente* (1826) as a predecessor" (33). Balzac's boast did not go unchallenged, and several others claimed to have originated the *physiologie*, including Louis Huart, an editor of *Le Charivari*.

51. Other examples of Balzac's active and formative interest in the form include "Physiologie de la toilette: de la cravate, considérée en elle-même et dans ses rapports avec la société et les individus" (*La Silhouette*, 3 June, 8 & 15 July 1830); "Physiologie Gastronomique" (*La Silhouette*, 15 August & 17 October 1830); "La Grisette" (*La Caricature*, 13 January 1831); "Le Provincial" (*La Caricature*, 12 May 1831); "Physiologie des positions" (*La Caricature*, 21 July 1831); "Le Banquier" (*La Caricature*, 4 August 1831); and "Physiologie du cigare" (*La Caricature*, 10 November 1831), to name just a few, while his contributions to *Les Français peints par eux-mêmes* a decade later include "La Femme comme il faut" and "La Femme de province" (both illustrated by Gavarni), "Monographie du rentier" (illustrated by Grandville) and "Le Notaire."

52. Christopher Rivers, "'L'homme hiéroglyphé': Balzac, Physiognomy and the Legible Body," *The Faces of Physiognomy: Interdisciplinary Approaches to Lavater*, ed. Ellis Shookman (Columbia, S.C.: Camden House, 1993) 144.

53. Balzac, *La Comédie humaine*, ed. P. G. Castex, 12 vols. (Paris: Gallimard-Pléiade, 1976–81) 11: 1044–45. All further reference to the *Comédie humaine* will be to this edition and will be indicated by volume and page number.

54. Michael Tilby indicates "Lavater's conviction that there was a unique harmony discernible in every individual physiognomy extended to gesture, gait and setting, this last dimension making him a particular source of stimulus for Balzac in his determination to convey to the reader the character of an individual's abode." See "'Tel main veut tel pied': Balzac, Ingres and the art of portraiture," *Artistic Relations* 113.

55. See Barthes, *S/Z* (Paris: Seuil, 1970) 9–10 for defintions of readerly and writerly texts.

56. Sieburth notes, "visuellement, le texte est disloqué en petits chapitres souvent fragmentaires, en paragraphes et phrases ponctuées par l'incursion fréquente d'illustrations. Il est pourtant difficile de déterminer si c'est le texte qui commente l'image ou le contraire" (visually, the text is broken up into little chapters that are often fragmented, in paragraphs and sentences punctuated by the frequent incursion of illustrations. It is difficult to determine whether it is the text that comments on the image or vice versa). "Une idéologie du lisible" 54.

57. "En publiant cet ouvrage, [l'auteur] ne fait que rendre au monde ce que le monde lui a donné." 1: 1173.

58. "Serait-ce possible qu'il a essayé de peindre avec fidelité les événements dont un mariage est suivi ou précédé, que son livre serait refusé à de jeunes personnes destinées à paraître un jour sur la scène sociale? Serait-ce donc un crime que de leur avoir relevé le rideau du théâtre qu'elles doivent un jour embellir?" 1: 1173.

59. Terdiman 75. For discussion of the *physiologies* as counter-discourse, see 163–65.

60. "Au milieu de la rue Saint-Denis, presque au coin de la rue du Petit-Lion, existait naguère une de ces maisons précieuses qui donnent aux historiens la facilité de reconstruire par analogie l'ancien Paris. Les murs menaçants de cette bicoque semblaient avoir été bariolés d'hiéroglyphes. Quel autre nom le flâneur pouvait-il donner aux X et aux V que traçaient sur la façade les pièces de bois transversales ou diagonales dessinées dans le badigeon par de petites lézardes parallèles?" 1: 39.

61. It is worth noting that the original title of this story was the more abstract and thematic *Gloire et malheur (Glory and Misfortune)*. Balzac did not use *La Maison du chat-qui-pelote* as its title until the first edition of *La Comédie humaine* in 1842, when the author chose it as the introductory narrative.

62. "A la vérité, ce débris de la bourgeoisie du seizième siècle offrait à l'observateur plus d'un problème à résoudre." 1: 39.

63. "Ces croisées avaient de petites vitres d'une couleur si verte, que, sans son excellente vue, le jeune homme n'aurait pu apercevoir les rideaux de toile à carreaux bleus qui cachaient les mystères de cet appartement aux yeux des profanes." 1: 40.

64. "Dessin, couleurs, accessoires, tout était traité de manière à faire croire que l'artiste avait voulu se moquer du marchand et des passants." 1: 40.

65. "Ces enseignes, dont l'étymologie semble bizarre à plus d'un négociant parisien, sont les tableaux morts de vivants tableaux à l'aide desquels nos espiègles ancêtres avaient réussi à amener les chalands dans leurs maisons." 1: 41.

66. "En altérant cette peinture naïve, le temps l'avait rendue encore plus grotesque par quelques incertitudes qui devaient inquiéter de consciencieux flâneurs. Ainsi la queue mouchetée du chat était découpée de telle sorte qu'on pouvait la prendre pour un spectateur, tant la queue des chats de nos ancêtres était grosse, haute et fournie." 1: 40–41.

67. Priscilla Parkhurst Ferguson, "The *Flâneur*: Urbanization and Its Discontents," *Home and its Dislocations in Nineteenth-Century France*, ed. Suzanne Nash (Albany: SUNY Press, 1993) 47.

68. "Son manteau, plissé dans le goût des draperies antiques, laissait voir une élégant chaussure. . . . les boucles de ses cheveux noirs défrisés éparpillés sur ses épaules indiquaient une coiffure à la Caracella, mise à la mode autant par l'Ecole de David que par cet engouement pour les formes grecques et romaines qui marqua les premières années de ce siècle." 1: 41.

69. "Quant à la première vision d'Augustine au début du récit, elle a pu être inspirée à Balzac par certaine célèbre *Etude de vierge* de Girodet. . . . La description d'Augustine à sa fenêtre a des qualités d'exactitude, d'autheticité, qui semblent confirmer que Balzac traduit une émotion ressentie, une contemplation réelle" (As for the first vision of Augustine at the beginning of the narrative, it could have been inspired by a certain famous *Study of a Virgin* by Girodet. . . . The description of Augustine at her window has the qualities of exactitude and authenticity that seem to confirm that Balzac is translating a genuine emotion, a real contemplation). Anne-Marie Meininger, *Introduction* to *La Maison du chat-qui-pelote* in *La Comédie humaine* 1: 35.

70. "Une vierge de Rafaël luttait de poésie avec une esquisse de Girodet." 2: 1190.

71. "M. Guillaume pensait donc assez naturellement que cette figure sinistre en voulait à la caisse du Chat-qui-pelote." 1: 45.

72. "Augustine était petite, ou, pour la mieux peindre, mignonnne. Gracieuse et pleine de candeur, un homme du monde n'aurait pu reprocher à cette charmante créature que des gestes mesquins ou certaines attitudes communes, et parfois de la gêne. Sa figure silencieuse et immobile respirait cette mélancolie passagère qui s'empare de toutes les jeunes filles trop faibles pour oser résister aux volontés d'une mère." 1: 49.

73. The Guillaume daughters were "Elevées pour le commerce, habituées à n'entendre que des raisonnements et des calculs tristement mercantiles." 1: 49.

74. Sommervieux returns from Rome, "Son âme nourrie de poésie, ses yeux rassasiés de Raphaël et de Michel-Ange." 1: 53.

75. The Duchesse d'Abrantès frequently boasted of her many artistic and literary friends in her voluminous memoirs, some of which she composed with the help of Balzac. In an early entry she indicates: "Je l'ai connu particulièrement, Girodet, et j'ai pu apprécier son esprit, son talent et tout ce qui en faisait un homme supérieur." (In particular, I knew Girodet and I was able to appreciate his intelligence, his talent and everything that made him a superior man). *Mémoires* 3: 55.

76. "De l'enthousiasme imprimé à son âme exaltée par le tableau naturel qu'il contemplait, il passa naturellement à une profonde admiration pour la figure principale: Augustine paraissait pensive et ne mangeait point; par une disposition de la lampe dont la lumière tombait entièrement sur son visage, son buste semblait se mouvoir dans un cercle de feu qui détachait plus vivement les contours de sa tête et l'illuminait d'une manière quasi surnaturelle." 1: 53.

77. "Girodet saute au cou de son camarade et l'embrasse, sans trouver de paroles. Ses émotions ne pouvaient se rendre que comme il les sentait, d'âme à âme." 1: 54.

78. "Quant au portrait, il est peu d'artistes qui ne gardent le souvenir de cette

toile vivante à laquelle le public, quelquefois juste en masse, laissa la couronne que Girodet y plaça lui-même." 1: 54.

79. "Je sais tout, répéta-t-elle, et je viens dans l'arche de Noé, comme la colombe, avec la branche d'olivier. J'ai lu cette allégorie dans *Le Génie du christianisme.* . . . Savez-vous, ajouta-t-elle en souriant à Augustine, que ce M. de Sommervieux est un homme charmant? Il m'a donné ce matin mon portrait fait de main de maître. Cela vaut au moins six mille francs." 1: 68.

80. "Cette observation n'empêcha pas que les arts et la pensée ne fussent pas condamnés encore au tribunal du Négoce." 1: 57.

81. See Muriel Amar, "Autour de *La Maison du chat-qui-pelote*: Essai de déchiffrage d'une enseigne," *L'Année balzacienne* n.s. 14 (1993): 141–155.

82. "Incapable de deviner les rudes chocs qui résultent de l'alliance d'une femme aimante avec un homme d'imagination, elle crut être appelée à faire le bonheur de celui-ci, sans apercevoir aucune disparate entre elle et lui." 1: 57.

83. "Le bandeau qui couvrait les yeux du jeune artiste fut si épais qu'il trouva ses futurs parents aimables." 1: 70.

84. "Théodore ne put se refuser à l'évidence d'une vérité cruelle: sa femme n'était pas sensible à la poésie, elle n'habitait pas sa sphère, elle ne le suivait pas dans tous ses caprices, dans ses improvisations, dans ses joies, dans ses douleurs; elle marchait terre à terre dans le monde réel, tandis qu'il avait la tête dans les cieux." 1: 74.

85. "A-t-on jamais vu un homme [. . .] coucher des statues sous de la mousseline, faire fermer ses fenêtres le jour pour travailler à la lampe?" 1: 83.

86. See Meininger, *La Comédie humaine* 1: 32–34.

87. "Elle tâcha d'y deviner le caractère de sa rivale par l'aspect des objects épars; mais il y avait là quelque chose d'impénétrable dans le désordre comme dans la symétrie, et pour la simple Augustine ce fut lettres closes." 1: 85.

88. "Nous devons admirer les hommes de génie, en jouir comme d'un spectacle, mais vivre avec eux! jamais. Fi donc! c'est vouloir prendre plaisir à regarder les machines de l'Opéra, au lieu de rester dans une loge, à y savourer ses brillantes illusions." 1: 88–89.

89. "L'artiste resta immobile comme un rocher et ses yeux se dirigèrent alternativement sur Augustine et sur la toile accusatrice." 1: 92.

90. Charles Bernheimer, "Fetishism and Decadence: Salomé's Severed Heads," *Fetishism as Cultural Discourse* 65.

91. Elizabeth Grosz, "Lesbian Fetishism?" *Fetishism as Cultural Discourse* 107.

92. Grosz 107.

93. "La douceur ou plutôt la mélodie enchanteresse de la voix de cette ange eût attendri des Cannibales, mais non un artiste en proie aux tortures de la vanité blessée." 1: 92.

94. "Je me vengerai, dit-il en se promenant à grand pas, elle en mourra de honte: je la peindrai! oui, je la représenterai sous les traits de Messaline sortant à la nuit du palais de Claude." 1: 92.

95. "Mme Guillaume surprit sa fille pâle, tenant à la main un mouchoir trempé de pleurs, contemplant sur le parquet les fragments épars d'une toile déchirée et les morceaux d'un grand cadre doré mis en pièce." 1: 93.

96. "Le narratif se construit en réalité aux dépens d'un *échec* pictural, d'une incapacité à représenter qui vient conditionner la possibilité de l'avènement du récit. . . . le tableau balzacien doit s'effacer, voire s'annihiler au profit de l'avènement de l'histoire." Franc Schuerewegen, "La Toile déchirée: Texte, tableau et récit dans trois nouvelles de Balzac," *Poétique* 65 (1986): 21; 26.

97. Shoshana Felman, "Rereading Femininity," *Yale French Studies* 62 (1981): 41.

98. Felman 22.

Chapter 5

1. Lucienne Frappier-Mazur contends "Balzac's initial success as a novelist was to a great extent achieved through a female audience," in "Balzac and the Sex of Genius," *Renascence* 27.1 (1974): 23. Annemarie Kleinart concurs, insisting "On sait bien que Balzac dut son succès d'écrivain, métier qu'il reprit en 1828, surtout aux femmes" (It is well known that Balzac owed his success as a writer, the career he took up in 1828, above all to women). "Balzac vu par *Le Journal des Dames et des Modes,*" *L'Année balzacienne* n.s. 9 (1988): 375.

2. "Tout cela veut dire qu'un *ouvrage de femme* est une bien meilleure spéculation de gloire qu'un ouvrage viril." Balzac, *Lettres à Mme Hanska*, ed. R. Pierrot, 4 vols. (Paris: Le Delta, 1967–71) 2: 183.

3. Owen N. Heathcote, "The Engendering of Violence and the Violation of Gender in Honoré de Balzac's *La Fille aux yeux d'or,*" *Romance Studies* 22 (1993): 101.

4. Catherine Nesci outlines Balzac's strategy to "put women back in their place" in *La Femme mode d'emploi: Balzac, de la Physiologie du mariage à La Comédie humaine* (Lexington, KY: French Forum, 1992) 28.

5. The Salon of 1831 included several paintings beside Delacroix's depicting women's participation in *les trois glorieuses*. Inexpensive popular prints also helped to disseminate the image of the heroic *femme-soldat*. See Janice Bergman-Carton, *The Woman of Ideas in French Art* (New Haven: Yale University Press, 1995) 19–22.

6. "A la guerre des classes semble donc s'ajouter une guerre des sexes, et ce sont deux thèmes nouveaux qui viennent enrichir le roman tel qu'il renaît après 1830." Richard Bolster, *Stendhal, Balzac et le féminisime romantique* (Paris: Minard, 1970) 9.

7. Maïté Albistur and Daniel Armogathe, *Histoire du féminisme français du moyen âge à nos jours* (Paris: Editions des femmes, 1977) 253.

8. Christine Planté, *La petite soeur de Balzac: Essai sur la femme auteur* (Paris: Seuil, 1989) 111–12.

9. "Ecrire et être publiée constituait déjà une provocation subversive pour une femme, immédiatement traitée de bas-bleu et taxée de crime de lèse-fémininité. Dès que la femme 'veut émuler un homme c'est un singe', écrivait Joseph de Maistre en 1808, et Barbey d'Aurevilly fait écho " 'Les femmes qui écrivent ne sont plus des femmes. Ce sont des hommes—du moins de prétention—et manqués!' " Michèle Sarde, *Regard sur les Françaises Xe siècle–Xxe siècle* (Paris: Stock, 1983) 540.

10. See Planté 9–13, 152–54.

11. *Journal des femmes* (6 April 1833): 168.

12. "Je prétends seulement que la femme possède une âme forte, un coeur courageux, des vertus patriotiques, je prétends qu'elle peut tout ce que peut faire un homme par la force et la puissance de la volonté." Duchesse d'Abrentès, *Mémoires* (Paris: Garnier, 1893) 6: 396.

13. "J'aime beaucoup qu'une femme écrive et étudie, mais il faut que comme vous l'avez fait, elle ait le courage de brûler ses oeuvres." *Lettres à Madame Hanska* 1: 577.

14. "Ainsi le rôle de la femme, dans l'optique balzacienne, l'éducation qu'il convient de lui donner, sa place dans le ménage et la société, n'ont guère changé depuis la *Physiologie du mariage*, et même depuis Molière. Mme de Staël, George Sand, la princesse de Belgiojoso restent d'admirables et dangereuses monstruosités." Maurice Regard, "Introduction" to *La Femme auteur, La Comédie humaine* 12: 599–600.

15. "Alléguant l'existence d'un grand nombre de jeunes personnes détournées d'une vie paisible par un semblant de gloire, Balzac emplie le terme 'sandisme.' Il s'agirait d'une espèce de 'lèpre sentimentale' qui gâte les femmes en leur donnant des prétensions à la supériorité de coeur et au génie littéraire." Bolster 66.

16. "Elle est garçon, elle est artiste, elle est grande, généreuse, dévouée, *chaste*, elle a les grands traits de l'homme, *ergo* elle n'est pas femme." *Lettres à Madame Hanska* 1: 585.

17. Quoted by Graham Robb in *Balzac: A Biography* (New York: Norton, 1994) 329.

18. "Vous avez quelque chose des hommes, vous vous conduisez comme eux, rien ne vous arrête, et si vous n'avez pas tous leurs avantages, vous avez dans l'esprit leurs allures, et vous partagez leur mépris envers nous." Balzac, *Béatrix* (Paris: Gallimard, 1979) 259.

19. See Mary Sheriff, *The Exceptional Woman*, chapter 2, "The Mother's Imagination and the Fathers' Tradition" for an important discussion of Vigée-Lebrun's use of the metaphor of pregnancy to discuss her own creations.

20. "Partout éclate [. . .] en mille témoinages irrécusables, l'impuissance de l'homme." Quoted in Bolster 11–12.

21. The author claimed in a preface to *Eugénie Grandet* that his creative act of virility "exiterait des émeutes dans une république où, depuis longtemps, il

est défendu par la critique des eunuques, d'inventer une forme, un genre, une action quelconque." 3: 1026.

22. "Le siècle est comme une femme enceinte qui n'accoucherait jamais." Balzac, *Oeuvres diverses*, ed. Bouteron and Longnon, 2 vols. (Paris: Conard, 1935) 1: 347. Referred to hereafter parenthetically as OD.

23. As Thomas Laqueur has demonstrated, by the nineteenth century, "The body generally, but especially the female body in its reproductive capacity and in distinction from that of the male, came to occupy a critical place in a whole range of political discourses." See "Orgasm, Generation and the Politics of Reproductive Biology," *The Making of the Modern Body: Sexuality and Society in the Nineteenth Century*, ed. Catherine Gallagher and Thomas Laqueur (Berkeley: University of California Press, 1987) 1.

24. Christine Battersby, *Gender and Genius: Toward a Feminist Aesthetic* (Bloomington: Indiana University Press, 1989) 86. For a fascinating examination of the "metaphor of thought as incarnation or of the concept/conception" and the idea of "this 'masculine' biological preformationism . . . as an essentially bodiless abstraction of the flow of production, " see Barbara Maria Stafford, *Body Criticism: Imaging the Unseen in Enlightenment Art and Medecine* (Cambridge: MIT Press, 1993) 234–79.

25. Battersby 103.

26. Battersby 37.

27. Zola will be one of many nineteenth-century authors who will also exploit this trope, most notably in *L'Oeuvre*.

28. Frappier-Mazur 26; 30.

29. See Per Nykrog, "On Seeing and Nothingness: Balzac's *Sarrasine*" *Romanic Review* 83.4 (1992): 437–44, and Barthes, *S/Z* (Paris: Seuil, 1970). For an influential discussion of Barthes and Balzac see Babara Johnson, "The Critical Difference: BartheS/BalZac," *The Critical Difference: Essays in the Contemporary Rhetoric of Reading* (Baltimore: Johns Hopkins University Press, 1980): 3–12.

30. See Helen O. Borowitz, "Balzac's *Sarrasine*: The Sculptor as Narcissus," *Nineteenth-Century French Studies* 5. 3–4 (1977): 171–85, for discussion of Hoffmann's influence on Balzac.

31. See Richard D. E. Burton, "The Unseen Seer, or Proteus in the City: Aspects of a Nineteenth-Century Parisian Myth," *French Studies* 42 (1988): 50–68 for an analysis of transcriptions of the "régime panoptique" in literature ca. 1815–60.

32. "Assis dans l'embrasure d'une fenêtre, et caché sous les plis onduleux d'un rideau de moire, je pouvais contempler à mon aise le jardin de l'hôtel où je passais la soirée. Les arbres . . . ressemblaient vaguement à des spectres mal enveloppés de leurs linceeuls, image gigantesque de la fameuse *danse des morts*. Puis, en me retournant de l'autre côté, je pouvais admirer la danse des vivants! un salon splendide, aux parois d'argent et d'or . . ." 6: 1043.

33. "Personne ne savait de quel pays venait la famille de Lanty, ni de quel commerce, de quelle spoliation, de quelle piraterie ou de quelle héritage provenait une fortune estimée à plusieurs millions." 6: 1044.

34. See Thomas E. Crow, "B/G," in *Vision and Textuality*, ed. Melville and Reading (Durham: Duke University Press, 1995): 296–314.

35. "Qui n'aurait épousé Marianina, jeune fille de seize ans, dont la beauté réalisait les fabuleuses conceptions des poètes orientaux? Comme la fille du sultan dans le conte de *La Lampe merveilleuse*, elle aurait dû rester voilée." 6: 1045.

36. "La beauté, la fortune, l'esprit, les grâces de ces deux enfants venaient uniquement de leur mère." 6: 1046.

37. "Pour tout dire en un mot, ce jeune homme était une image vivante de l'Antinoüs." 6: 1046.

38. "Cette mystérieuse famille avait tout l'attrait d'un poème de lord Byron, dont les difficultés étaient traduites d'une manière différente par chaque personne du beau monde: un chant obscur et sublime de strophe en strophe." 6: 1046.

39. "Mais par malheur, l'histoire énigmatique de la maison Lanty offrait un perpétual intérêt de curiosité, assez semblable à celui des romans d'Anne Radcliffe." 6: 1046.

40. "Là, les écus même tachés de sang ou de boue ne trahissent rien et représentent tout. Pourvu que la haute société sache le chiffre de votre fortune, vous êtes classé parmi les sommes qui vous sont égales, et personne ne vous demande à voir vos parchemins, parce que tout le monde sait combien peu ils coûtent." 6: 1046.

41. Baron de Frénilly, *Souvenirs du Baron de Frénilly, pair de France, 1768–1828* (Paris: Plon, 1908) 278.

42. "Sa préoccupation, presque somnambulique, était si concentrée sur les choses qu'il se trouvait au milieu du monde sans voir le monde." 6: 1050.

43. "Ils étaient là, devant moi, tous deux, ensemble, unis et si serrés." 6: 1050.

44. Jean Molino, "Balzac et la technique du portrait autour de *Sarrasine*," *Lettres et Réalités: Mélanges de littérature générale et de critique romanesque*. (Aix-en-Provence: Université de Provence, 1988) 280.

45. "Un sentiment de profonde horreur pour l'homme saisissait le coeur quand une fatale attention vous dévoilait les marques imprimées par la décrépitude à cette casuelle machine." 6: 1051.

46. "Ce visage noir était anguleux et creusé dans tous les sens. Le menton était creux; les tempes étaient creuses; les yeux étaient perdus en de jaunâtres orbites . . ." 6: 1052.

47. "Du reste, la coquetterie féminine de ce personnage fantasmagorique était assez énergiquement annoncée par les boucles d'or qui pendaient à ses oreilles, par les anneaux dont les admirables pierreries brillaient à ses doigts ossifiés, et par une chaîne de montre qui scintillait comme les chatons d'une rivière au cou d'une femme." 6: 1052.

48. At the time of the sale of the contents of the *galerie de Sommariva* in 1839, *L'Artiste* reported that the crowds were still flocking to see the collection "à cet hôtel, dont elle sait le chemin aussi bien que s'il fallait visiter la galerie du Louvre" (at this mansion, to which they know the way as well as that to visit the gallery at the Louvre). "De la galerie de M. de Sommariva," *L'Artiste,* 2e série (1839) 185.

49. "Il est dû au talent de Girodet . . . ce peintre cher aux poètes." Balzac, "Sarrasine," *Revue de Paris* XX (1830): 164. In the 1844 Furne version, Girodet is replaced by Vien and reference to the poets is dropped.

50. Laura Mulvey observes "Woman then stands in patriarchal culture as signifier for the male other, bound by a symbolic order in which man can live out his fantasies and obsessions through linguistic command by imposing them on the silent image of woman still tied to her place as bearer, not maker of meaning." In *Visual and Other Pleasures* (Bloomington: Indiana University Press, 1989) 7.

51. Carol Ockman, *Ingres's Eroticized Bodies: Tracing the Serpentine Line* (New Haven: Yale University Press, 1995) 4.

52. For a discussion of the phallic gaze and its relation to knowledge, power and castration anxiety see Luce Irigaray, *The Speculum of the Other Woman* (Ithaca: Cornell University Press, 1986) 47–48.

53. "'Un être si parfait existe-t-il?' me demanda-t-elle après avoir examiné, non sans un doux sourire de contentement, la grâce exquise des contours, la pose, la couleur, les cheveux, tout enfin. 'Il est trop beau pour un homme', ajouta-t-elle après un examen pareil à celui qu'elle aurait fait d'une rivale." 6: 1054.

54. "Oh! comme je ressentis alors les atteintes de cette jalousie à laquelle un poète avait essayé vainement de me faire croire! la jalousie des gravures, des tableaux, des statues, où les artistes exagèrent la beauté humaine, par suite de la doctrine qui les porte à tout idéaliser." 6: 1054.

55. "Ce grand peintre n'a jamais vu l'original, et votre admiration sera moins vive peut-être quand vous saurez que cette académie a été faite d'après une statue de femme." 6: 1054.

56. "Qu'est-ce que cela veut dire? . . . Est-ce son mari? . . . Où suis-je?" 6: 1055.

57. "Vous, madame, qui êtes exaltée et qui, comprenant si bien les émotions les plus imperceptibles, savez cultiver dans un coeur d'homme le plus délicat des sentiments, sans le flétrir, sans le briser dès le premier jour, vous qui avez pitié des peines du coeur, et qui à l'esprit d'une Parisienne joignez une âme passionnée digne de l'Italie ou de l'Espagne . . ." 6: 1055–56.

58. "Oh! vous me faites à votre goût. Singulière tyrannie! Vous voulez que je ne sois pas *moi*." 6: 1056.

59. Ross Chambers, *Story and Situation: Narrative Seduction and the Power of Fiction* (Minneapolis: University of Minnesota Press, 1984) 10.

60. "Tu es plus capricieuse, plus fantasque mille fois peut-être . . . que mon imagination." 6: 1056.
61. "Le lendemain, nous étions devant un bon feu, dans un petit salon élégant, assis tout deux; elle sur une causeuse; moi sur des coussins, presque à ses pieds, et mon oeil sous le sien." 6: 1056.
62. See Ernst Kris and Otto Kurz, *Legend, Myth and Magic in the Image of the Artist* (New Haven: Yale University Press, 1979) for a presentation of the archetypes and myths of the artist, and particularly the formulae for the biography of the artist and his youth, which Balzac follows closely here.
63. "Au lieu d'apprendre les éléments de la langue grecque, il dessinait le révérend père . . . Au lieu de chanter les louanges du Seigneur à l'église, il s'amusait, pendant les offices, à déchiqueter un banc; ou quand il avait volé quelque morceau de bois, il sculptait quelque figure de sainte." 6: 1057.
64. "Soit qu'il copiât les personnages des tableaux qui garnissaient le choeur, soit qu'il improvisât, il laissait toujours à sa place de grossières ébauches, dont le caractère licencieux désespérait les plus jeunes pères." 6: 1057–58.
65. "Fanatique de son art comme Canova le fut depuis, il se levait au jour, entrait dans l'atelier pour n'en sortir qu'à la nuit, et ne vivait qu'avec sa muse." 6: 1059.
66. "Il n'eut pas d'autre maîtresse que la Sculpture et Clotilde, l'une des célébrités de l'Opéra." 6: 1059.
67. Crow, "B/G" 311. See also 306–7.
68. "Il avait déjà passé quinze jours dans l'état d'extase qui saisit toutes les jeunes imaginations à l'aspect de la reine des ruines, quand, un soir, il entra au théâtre d'*Argentina*." 6: 1059.
69. "Les lumières, l'enthousiasme de tout un peuple, l'illusion de la scène, les prestiges d'une toilette qui, à cette époque, était assez engageante, conspirèrent en faveur de cette femme." 6: 1060.
70. "Quand la Zambinella chanta, ce fut un délire. . . . il éprouvait un mouvement de folie, espèce de frénésie qui ne nous agite qu'à cet âge où le désir a je ne sais quoi de terrible et d'infernel. Sarrasine voulait s'élancer sur le théâtre et s'emparer de cette femme. Sa force, centuplée par une dépression morale impossible à expliquer, puisque ces phénomènes se passent dans une sphère inaccessible à l'observation humaine, tendait à se projeter avec une violence douleureuse. . . . Il était si complètement ivre qu'il ne voyait plus ni salle, ni spectateurs, ni acteurs, n'entendait plus de musique. Bien mieux, il n'existait pas de distance entre lui et la Zambinella, il la possédait, ses yeux, attachés sur elle, s'emparaient d'elle." 6: 1061.
71. Mieke Bal, "Reading the Gaze: The Construction of Gender in 'Rembrandt,'" *Vision and Textuality*, ed. Melville and Reading (Durham: Duke University Press, 1995) 150.
72. "Je ne vois encore ni Marianina ni son petit vieillard." 6: 1063.
73. Bal 158.

74. "Vous ne voyez que lui, m'écriai-je impatienté comme un auteur auquel on fait manquer l'effet d'un coup de théâtre." 6: 1063.

75. "Il se para comme une jeune fille qui doit se promener devant son premier amant." 6: 1064.

76. "Il avait espéré une chambre mal éclairée, sa maîtresse auprès d'un brasier." 6: 1065.

77. "Oh! comme son coeur battit quand il aperçut un pied mignon, chaussé de ces mules qui, permettez-moi de le dire, madame, donnait jadis au pied des femmes une expression si coquette, si voluptueuse, que je ne sais pas comment les hommes pouvaient résister." 6: 1065.

78. "Le théâtre sur lequel vous m'avez vue, ces applaudissements, cette musique, cette gloire, à laquelle on m'a condamnée, voilà ma vie, je n'en ai pas d'autre." 6: 1070.

79. "Cette matinée s'écoula trop vite pour l'amoureux sculpteur, mais elle fut rempli par une foule d'incidents qui lui dévoilèrent la coquetterie, la faiblesse, la mignardise de cette âme molle et sans énergie. C'était la femme avec ses peurs soudaines, ses caprices sans raisons, ses troubles instinctifs, ses audaces sans causes, ses bravades et sa délicieuse finesse de sentiment." 6: 1070.

80. "Sans cesse je penserai à cette femme imaginaire en voyant une femme réelle . . . tu m'as dépeuplé la terre de toutes ses femmes . . . Plus d'amour! je suis mort à tout plaisir, à toutes les émotions humaines." 6: 1074.

81. "Madame, le cardinal Cicognara se rendit maître de la statue de Zambinella et la fit exécuter un marbre. Elle est aujourd'hui dans le musée Albani. C'est là qu'en 1791 la famille Lanty la retrouva. Elle pria Girodet de la copier; et ce portrait qui vous a montré Zambinella à vingt ans un instant après l'avoir vu centenaire, lui a servi plus tard pour son *Endymion* dont vous avez pu reconnaître le type dans l'Adonis" (6: 1075). In the Furne version of 1844, on which the Pléiade edition is based, Girodet's *Endymion* is a copy after Vien's copy of Sarrasine's statue.

82. Gen Doy, *Women and Visual Culture in Nineteenth-Century France, 1800–1852* (London: Leicester University Press, 1998) 130.

Chapter 6

1. See Dore Ashton, *A Fable of Modern Art* (University of California Press, 1991) for an intriguing discussion of *Le Chef-d'oeuvre inconnu*, and Frenhofer in particular, among the moderns.

2. Among the most influential studies of this story are Pierre Laubriet's *Un Catéchisme esthétique: Le Chef-d'oeuvre inconnu* (Paris: Didier, 1961); Michel Serres's *Genèse* (Grasset, 1982); Georges Didi-Huberman's *La Peinture incarnée* (Paris: Minuit) 1985; and the collected essays in *Autour du Chef-d'oeuvre inconnu de Balzac* (Paris: ENSAD, 1985).

3. For detailed discussion of the various versions of *Le Chef-d'oeuvre inconnu* see René Guise's *Histoire du texte* in Balzac, *La Comédie humaine*, ed. P. G. Castex, 12 vols. (Paris: Gallimard-Pléiade, 1976–81) 10: 1401–09.

4. Jules Claretie opened the debate in 1879 when he attributed Frenhofer's words to Gautier in *L'Indépendence belge* (5 January 1879), a position that Spoelberch de Lovenjoul also embraced in *Etudes balzaciennes: autour de Honoré de Balzac* of 1897. François Fosca charts the convergence of Frenhofer's words with Delacroix's in "Les Artistes dans les romans de Balzac," *La Revue critique des idées et des livres* 34 (1922): 133–52; and Pierre Laubriet sees Delacroix as an indirect, but potentially important source for Balzac's ideas in *Un Catéchisme esthétique* 106. Margaret Gilman has traced Diderot's influence on Balzac's understanding of art and its language ("Balzac and Diderot: *Le Chef-d'oeuvre inconnu*" *PMLA* 65 [1950]: 644–48), a position adopted by René Guise in the Pléiade edition of the story, which documents the extensive overlap between Frenhofer's observations and Diderot's *Salons* and *Pensées détachées sur la peinture*. Joyce O. Lowrie adds that Frenhofer may in fact have been based on Diderot's portrayal of Maurice Quentin de la Tour in his *Additions à La Lettre sur les aveugles*, where he depicts a painter who slowly goes mad, ruining his canvases by compulsively and fruitlessly retouching them until they become illegible, in "The Artist, Real and Imagined: Diderot's Quentin de la Tour and Balzac's Frenhofer," *Romance Notes* 31.3 (1991): 267–73. Finally, Helen O. Borowitz traces the original conception of the story to the contemporary aesthetics of Victor Cousin, Gustave Planche and Henri Latouche in "Balzac's Unknown Masters," *Romanic Review* 72.4 (1981): 425–81.

5. Francis Haskell, "The Old Masters in Nineteenth-Century French Painting," *Past and Present in Art and Taste* (New Haven: Yale University Press, 1987) 94.

6. Nadia Tscherny and Guy Stair Sainty, *Romance and Chivalry: History and Literature Reflected in Early Nineteenth-Century French Painting* (New York: Stair Sainty Matthiesen, 1996) 16.

7. For discussion, see Michael Levey, *The Painter Depicted: Painters as Subject in Painting* (London: Thames and Hudson, 1981).

8. While Vasari's *Lives of the Painters* was the most important resource, Landon's *Vies et oeuvres des peintres les plus célèbres*, Stendhal's *Histoire de la peinture en Italie*, Gault de Saint-Germain's *Guide des amateurs pour les écoles allemande, flamande et hollandaise* and Quatremère de Quincy's *Histoire de la vie et des ouvrages de Raphaël* also provided ready reference for painters and authors.

9. Pierre Georgel and Anne-Marie Lecoq, *La Peinture dans la peinture* (Dijon: Musée des Beaux-Arts, 1982) 68.

10. Haskell, "Old Masters" 105.

11. Marie Lathers explains "From the seventeenth to the early nineteenth centuries, the official French Academy hired only male models for the nude

pose; the life drawing—also called an *académie*—was a practice exclusively reserved for the representation of the male body, and the conflation of the terms *Académie* (official governing body) and *académie* (official representation of the body) is indicative of this exclusivity." "The Social Construction and Deconstruction of the Female Model in Nineteenth-Century France," *Mosaic* 29.2 (1996): 24. See also, Candace Clements, "The Academy and the Other: *Les Grâces* and *Le Genre Galant,*" *Eighteenth-Century Studies* 25.4 (1992): 469–94.

12. See Mary Sheriff, "The New Model and her Sisters" in *Fragonard: Art and Eroticism* (Chicago: University of Chicago Press) 185–191 for further discussion.

13. Patrick O'Donovan, "Avatars of the Artist: Narrative Approaches to the Work of the Painter," *Artistic Relations: Literature and the Visual Arts in Nineteenth-Century France*, ed. Peter Collier and Robert Lethbridge (New Haven: Yale University Press, 1994) 223.

14. Although it is fairly clear from contemporary sources that models did not usually sleep with the painters they posed for, their association with prostitutes in the mind of the public persisted throughout the century. Not infrequently women who became too old to model ultimately did turn to prostitution, one further step down the social ladder, to support themselves. See Lathers, *Bodies of Art: French Literary Realism and the Artist's Model* (Lincoln: University of Nebraska Press, forthcoming 2001) for further discussion.

15. See C. J. Bulliet, *The Courtezan Olympia: An Intimate Survey of Artists and their Mistress-Models* (New York: Covivi, Friede, 1930) and Frances Borzello, *The Artist's Model* (London: Junction Books, 1982).

16. Lathers, "The Social Construction and Deconstruction of the Model" 24–25.

17. Lathers, "The Social Construction and Deconstruction of the Model" 25, 29.

18. See Charles Bernheimer, *Figures of Ill-Repute: Representing Prostitution in Nineteenth-Century France* (Cambridge: Harvard University Press, 1989); and Hollis Clayson, *Painted Love: Prostitution in French Art of the Impressionist Era* (New Haven: Yale University Press, 1991).

19. Outside of the paradigms of art, the association of the female model with prostitution may also be read in terms of a more general social anxiety over the increasing number of women entering the workforce as France moved toward a modern industrial society in the nineteenth century. As women abandoned the private for the public sphere, leaving the confines of the home for employment in factories, stores and offices, they became sexually suspect, and the unassailable purity of the stay-at-home bourgeois wife and mother was contrasted with the imagined availability of the lower- and lower-middle-class "working girl."

20. Kenneth Clark, *The Nude: A Study in Ideal Form* (Garden City, NY: Doubleday-Anchor, 1956) 23.

21. Marcia Pointon, *Naked Authority: The Body in Western Painting 1830–1908* (Cambridge: Cambridge University Press, 1990) 15.

22. Pointon 26.

23. Carol Duncan, "Virility and Domination in Early Twentieth-Century Vanguard Painting," *The Aesthetics of Power: Essays in Critical Art History* (Cambridge: Cambridge University Press, 1993) 86.

24. Duncan 98.

25. Lynda Nead, *The Female Nude: Art, Obscenity and Sexuality* (London: Routledge, 1992) 44–45.

26. Pointon 26.

27. Linda Nochlin, "Courbet's Real Allegory: Rereading *The Painter's Studio*," in *Courbet Reconsidered*, ed. Sarah Faunce and Linda Nochlin (New York: The Brooklyn Museum, 1988) 31.

28. Nead 23.

29. Balzac, *Lettres à Madame Hanska* 1: 311.

30. Balzac's story is closely connected to Hoffmann's *La Leçon de violon*, which appeared in *L'Artiste* (1: 138–42) three months before *Le Chef-d'oeuvre inconnu*.

31. In all some 122 paintings of Henri IV were displayed at the Salons from 1804 to 1835.

32. "Après avoir assez longtemps marché dans cette rue avec l'irrésolution d'un amant qui n'ose se présenter chez sa première maîtresse, quelque facile qu'elle soit, il finit par franchir le seuil de cette porte." 10: 413.

33. Porbus is "le peintre de Henri IV, délaissé pour Rubens par Marie de Médicis." 10: 414.

34. "A ce compte, le jeune inconnu paraissait avoir un vrai mérite, si le talent doit se mesurer sur cette timidité première, sur cette pudeur indéfinissable que les gens promis à la gloire savent perdre dans l'exercice de leur art, comme les jolies femmes perdent la leur dans le manège de la coquetterie." 10: 414.

35. "Ce travail semble cotonneux et paraît manquer de précision." 10: 425.

36. "Vous aurez une image imparfaite de ce personnage auquel le jour faible de l'escalier prêtait encore une couleur fantastique." 10: 415.

37. A description of Girodet's studio, based on students' accounts and the sale of his effects, corresponds closely to Balzac's image of Frenhofer's atelier. Archival research documented the painter's studio as follows: "There one found two marquetry armoires that had belonged to Mme de Maintenon; lion, zebra and leopard skins on which Girodet liked to pose his models; ancient weapons, Henri II's shield and helmet, sabres, clubs, daggers and quivers from primitive peoples; Turkish costumes; a bronze anatomical figure, two skeletons, some mannequins. A rich art library, a cabinet of medals

containing five hundred ancient coins; finally traditional plaster casts: the *Apollo of Belvedere,* the *Medici Venus,* busts, masks; cups and Etruscan vases."

In Jean Adhémar, "L'enseignement académique en 1820: Girodet et son atelier," *Bulletin de la société de l'histoire de l'art français,* 2e fascicule (1933): 275.

38. Balzac, "Le Chef-d'oeuvre inconnu," *L'Artiste* (1831) 1: 320.

39. "Ta sainte me plaît, dit le vieillard à Porbus, et je te la paierais dix écus d'or au-delà du prix que donne la reine." 10: 416.

40. Balzac wrote in letter to Charles Gosselin of 30 juillet 1831, "N'ayant plus le sou, j'ai promis à *L'Artiste,* à la *Revue des Deux Mondes* et à celle de *Paris,* des articles pour plus de 1000 francs" (Being penniless, I promised *L'Artiste,* the *Revue des Deux Monde* and the *Revue de Paris* articles for more than 1000 francs). *Correspondance,* 4 vols. (Paris: Garnier, 1960–66) 1: 550.

41. "Cette prostitution de la pensée qu'on nomme: *la publication.*" 8: 1669.

42. See Gita May, *Diderot et Baudelaire, Critiques d'art* (Geneva: Droz, 1957).

43. "Je ne saurais croire que ce beau corps soit animé par le tiède souffle de la vie. Il me semble que si je portais la main sur cette gorge d'une si ferme rondeur, je la trouverais froide comme du marbre." 10: 417.

44. "Non, mon ami, le sang ne court pas sous cette peau d'ivoire, l'existence ne gonfle pas de sa rosée de pourpre les veines fibrilles qui s'entrelacent en réseau sous la transparence ambrée des tempes et de la poitrine." 10: 417.

45. "Maître, lui dit Porbus, j'ai cependant bien étudié sur le nu pour cette gorge; mais pour notre malheur, il est des effets vrais dans la nature qui ne sont plus probables sur la toile. . . –La mission de l'art n'est pas de copier la nature, mais de l'exprimer! Tu n'es pas un vil copiste, mais un poète! s'écria vivement le vieillard en interrompant Porbus. . . . Nous avons à saisir l'esprit, l'âme, la physiognomie des choses et des êtres." 10: 418.

46. Quoted in Duncan, "Modern Erotic Art," *The Aesthetics of Power* 113 from Max Kozloff, "The Authoritarian Personality in Modern Art," *Artforum* (May 1974): 46.

47. "Frenhofer-comme-peintre n'est qu'un pauvre corps agité par le malin génie lui-même . . . lorsque Frenhofer peint, ce n'est pas lui, mais un démon qui agit par ses mains, les agite . . . Sujet divisé, sujet confus pour cela, indistinct." Didi-Huberman 15.

48. Hubert Damisch, "The Underneaths of Painting," trans. Francette Pacteau and Stephen Bann, *Word & Image* 1.2 (1985): 198.

49. Didi-Huberman 114–132.

50. "Montrer mon oeuvre, s'écria le vieillard tout ému. Non, non, je dois la perfectionner encore. Hier, vers le soir, dit-il, j'ai cru avoir fini. Ses yeux me semblaient humides, sa chair était agitée. Les tresses de ses cheveux remuaient. Elle respirait!" 10: 424.

51. "Le dessin n'existe pas! . . . La ligne est le moyen par lequel l'homme se rend compte de l'effet de la lumière sur les objets; mais il n'y a pas de lignes dans la nature où tout est plein: c'est en modelant qu'on dessine, c'est-à-dire

qu'on détache les choses du milieu où elles sont, la distribution du jour donne seule l'apparence au corps!" 10: 424–25.

52. Nead 58–59.

53. "J'ai des doutes. . . . Je doute de mon oeuvre!" 10: 425. For extensive discussion of the question of the painter's doubt, see Didi-Huberman, *La peinture incarnée.*

54. Balzac's friend and potential collaborator, Théophile Gautier, explained "Il n'accepta rien des mythologies et des traditions du passé, et il ne connut pas, heureusement pour nous, cet idéal fait avec les vers des poètes, les marbres de la Grèce et de Rome, les tableaux de la Renaissance, qui s'interpose entre les yeux des artistes et la réalité. Il aima la femme de nos jours telle qu'elle est, et non pas une pâle statue . . ." (He did not embrace the mythologies and traditions of the past, and fortunately for us, he wasn't familiar with that ideal rendered in verse by the poets, in Greek and Roman statuary, Renaissance paintings, that comes between artists' vision and reality. He liked the women of our own day as they were, and not a pale statue). *Honoré de Balzac, sa vie et ses oeuvres* (Paris: Poulet-Malassis, 1859) 132.

55. "Frenhofer a sacrifié la plus grande partie de ses trésors à satisfaire les passions de Mabuse; en échange Mabuse lui a légué le secret du relief, le pouvoir de donner aux figures cette vie extraordinaire, cette fleur de nature, notre désespoir éternel." 10: 426–27.

56. "Notre art est, comme la nature, composé d'une infinité d'éléments: le dessin donne un squelette, la couleur est la vie, mais la vie sans le squelette est une chose plus incomplète que le squelette sans la vie." 10: 427.

57. "Tes yeux ne me disent plus rien. Tu ne penses plus à moi, et cependant tu me regardes." 10: 429.

58. "Si je me montrais ainsi à un autre, tu ne m'aimerais plus. . . . 'Ce n'est portant un vieillard, reprit Poussin. Il ne pourra voir que la femme en toi. Tu es si parfaite.' . . . Ne voyant plus que son art, le Poussin pressa Gillette dans ses bras." 10: 429–30.

59. "Il ne m'aime plus! pensa Gillette quand elle se trouva seule. . . . Elle croyait aimer déjà moins le peintre en le soupçonnant moins estimable." 10: 430.

60. Marie Lathers, "Modesty and the Artist's Model in *Le Chef-d'oeuvre inconnu,*" *Symposium* 46.1 (1992): 49.

61. "Elle rougirait si d'autres yeux que les miens s'arrêtaient sur elle." 10: 431.

62. "Voilà dix ans que je vis avec cette femme. Elle est à moi, à moi seul. Elle m'aime. Ne m'a-t-elle pas souri à chaque coup de pinceau que je lui ai donné?" 10: 431.

63. E.L. Gans, *Essais d'esthétique paradoxale* (Paris: Gallimard, 1977) 183.

64. "L'oeuvre que je tiens là-haut sous mes verrous est une exception dans notre art; ce n'est pas une toile, c'est une femme! une femme avec laquelle je pleure, je ris, je cause et pense. Veux-tu que tout à coup je quitte un bonheur de dix années comme on jette un manteau? Que tout à coup je cesse

d'être père, amant et Dieu? Cette femme n'est pas une créature, c'est une création." 10: 431.

65. Hal Foster, quoted by Emily Apter in *Feminizing the Fetish: Psychoanalysis and Narrative Obsession in Turn-of-the-Century France* (Ithaca: Cornell University Press, 1991) 12.

66. "J'aurai la force de brûler ma Catherine à mon dernier soupir; mais lui faire supporter le regard d'un homme, d'un peintre? non, non! Je tuerais le lendemain celui qui l'aurait souillée d'un regard!" 10:432.

67. "Je te tuerais à l'instant, toi, mon ami, si tu ne la saluais pas à genoux! Veux-tu que je soumette mon idole aux froids regards et aux stupides critiques des imbéciles?" 10: 432.

68. "Mon oeuvre est parfaite, et maintenant je puis la montrer avec orgeuil. Jamais peintre, pinceaux, couleurs, toile et lumière ne feront une rivale à *Catherine Lescault!*" 10: 434–35.

69. "Je ne vois là que des couleurs confusément amassées et contenues par une multitude de lignes bizarres qui forment une muraille de peinture." 10: 436.

70. For an extended Freudian reading of the foot in Balzac's story see Dorothy Kelly, *Fictional Genders: Role and Representation in Nineteenth-Century French Narrative* (Lincoln: University of Nebraska Press, 1989).

71. Linda Nochlin, *The Body in Pieces: The Fragment as a Metaphor of Modernity* (New York: Thames and Hudson, 1995) 19.

72. Nochlin 23–24.

73. As Claude E. Bernard observes, "Si Frenhofer n'a rien produit, ou a détruit ses productions, il reste sa production essentielle: sa parole. *La Belle-Noiseuse* n'est pas l'objet d'un tableau, mais d'une 'description', d'un portrait en mots, mots dont le locateur se grise" (If Frenhofer produced nothing, or destroyed his productions, his essential production—his words—remained. *La Belle Noiseuse* is not the object of a painting, but of a 'description,' of a 'word portrait,' words that intoxicated their speaker). "Le Problématique de l'échange dans *Le Chef-d'oeuvre inconnu*" *L'Année balzacienne* n.s. 5 (1984): 211.

74. Max Milner, "Le Peintre fou," *Romantisme* 66 (1989): 5.

75. "Vous êtes des jaloux qui voulez me faire croire qu'elle est gâtée pour me la voler! Moi, je la vois! cria-t-il, elle est merveilleusement belle." 10: 438.

76. William Paulson, "Pour une analyse de la variation textuelle: *Le Chef-d'oeuvre trop connu*," *Nineteenth-Century French Studies* 19.3 (Spring 1991): 413.

77. "Mais Balzac zébrait de ratures une dixième épreuve, et lorsqu'il nous voyait renvoyer à la *Chronique de Paris* l'épreuve de l'article fait d'un jet, sur le coin d'une table, avec les seules corrections typographiques, il ne pouvait croire, quelque content qu'il en fût d'ailleurs, que nous y eussions mis tout notre talent. 'En le remaniant encore deux ou trois fois, il eût été mieux,' nous disait-il." Théophile Gautier, *Honoré de Balzac* 55.

78. "Le refus de la certitude, c'est à dire l'ironie. . . [qui] empêche la réalité

d'être totalement contrôlée par le sujet, le narrateur ou l'auteur. . . . Elle reconnaît la possibilité de contradiction et même de folie; à l'intérieur d'un système de connaissances elle est le signe de l'inconnu, et peut-être l'inconnaissable." Michele Hannoosh, "La femme, la ville, le réalisme: fondements épistemologiques dans le Paris de Balzac," *Romanic Review* 82.2 (1991): 128; 141.

Bibliography ✒

Abélès, Luce and Guy Cogeval. *La Vie de Bohème.* Paris: Musée d'Orsay, 1986.

Abrantès, Laure. *Mémoires de Madame la Duchesse d'Abrantès.* Paris: Garnier, 1893.

Adhémar, Jean. "Balzac et la peinture." *Revue des sciences humaines* (1953).

——. "Balzac, sa formation artistique et ses initiateurs successifs." *Gazette des Beaux-Arts* 104 (1984): 231–242.

——. "L'enseignement académique en 1820: Girodet et son atelier." *Bulletin de la société de l'histoire et de l'art français,* 2e fascicule (1933): 270–283.

Adorno, Theodor. *Aesthetic Theory.* Trans. C. Lenhardt. Ed. Gretchen Adorno and Rolf Tiedemann. London: Routledge & Kegan Paul, 1984.

Albistur, Maïté and Daniel Armogathe. *Histoire du féminisme français du moyen âge à nos jours.* Paris: Editions des femmes, 1977.

Allen, James Smith. *In the Public Eye: A History of Reading in Modern France, 1800–1940.* Princeton: Princeton University Press, 1991.

——. *Popular French Romanticism: Authors, Readers and Books in the Nineteenth Century.* Syracuse: Syracuse University Press, 1981.

Alpers, Svetlana and Paul Alpers. "*Ut Pictura Noesis?* Criticism in Literary Studies and Art History." *New Literary History* 3.3 (1972): 437–58.

Amar, Muriel. "Autour de *La Maison du chat-qui-pelote:* Essai de déchiffrage d'une enseigne." *L'Année balzacienne* n.s. 14 (1993): 141–153.

Apter, Emily. *Feminizing the Fetish: Psychoanalysis and Narrative Obsession in Turn-of-the-Century France.* Ithaca: Cornell University Press, 1991.

——, and William Pietz, eds. *Fetishism as Cultural Discourse.* Ithaca: Cornell University Press, 1993.

Arlequin au Museum ou critique des tableaux en vaudevilles. Paris: Marchant, 1802.

Arnault, A.V., A. Jay, E. Jouy, J. Norvins. *Biographie nouvelle des contemporains.* 20 Vols. Paris: Babeuf, 1820–25.

Ashton, Dore. *A Fable of Modern Art.* Berkeley: University of California Press, 1991.

Autour du Chef-d'oeuvre inconnu de Balzac. Paris: ENSAD, 1985.

Bailey, Colin B. *1789: French Art During the Revolution.* New York: Colnaghi, 1989.

——, ed. *The Loves of the Gods: Mythological Painting from Watteau to David.* New York: Rizzoli, 1992.

Bal, Mieke. *Reading 'Rembrandt': Beyond the Word-Image Opposition.* Cambridge: Cambridge University Press, 1991.

——. "Reading the Gaze: The Construction of Gender in Rembrandt." Melville and Readings. 147–173.

Balzac, Honoré. *La Comédie humaine.* Ed. P.G. Castex. 12 Vols. Paris: Gallimard-Pléiade, 1976–81.

——. "Le Chef-d'oeuvre inconnu." *L'Artiste* (1831) 1: 319–323 and 2: 7–10.

——. *Correspondance.* 4 Vols. Paris: Garnier, 1960–66.

——. *Lettres à Madame Hanska.* 4 Vols. Ed. R. Pierrot. Paris: Le Delta, 1967–71.

——. *Oeuvres diverses.* Ed. Marcel Bouteron and Henri Longnon. 2 Vols. Paris: Conard, 1935.

——. "Sarrasine." *Revue de Paris* xx (1830): 150–167; 227–252.

Barthes, Roland. *The Pleasure of the Text.* Trans. Richard Howard. New York: Hill and Wang, 1975.

——. *S/Z.* Paris: Seuil, 1970.

Battersby, Christine. *Gender and Genius: Toward a Feminist Aesthetic.* Bloomington: Indiana University Press, 1989.

Baudelaire, Charles. *Oeuvres Complètes.* Ed. Claude Pichois. 2 Vols. Paris: Gallimard-Pléiade, 1975–76.

Benjamin, Walter. *Charles Baudelaire: A Lyric Poet in the Era of High Capitalism.* London: Verso, 1976.

——. "The Work of Art in the Age of Mechanical Reproduction." *Illuminations.* New York: Schocken, 1969. 217–251.

Bergman-Carton, Janice. *The Woman of Ideas in French Art, 1830–1848.* New Haven: Yale University Press, 1995.

Bermingham, Ann. "The Aesthetics of Ignorance: The Accomplished Woman in the Culture of Connoisseurship." *Oxford Art Journal* 16.2 (1993): 3–20.

Bernard, Claude E. "Le Problématique de l'échange dans *Le Chef-d'oeuvre inconnu.*" *L'Année balzacienne* n.s. 5 (1984): 201–213.

Bernheimer, Charles. "Fetishism and Decadence: Salomé's Severed Heads." Apter and Pietz 62–83.

——. *Figures of Ill-Repute: Representing Prostitution in Nineteenth-Century France.* Cambridge: Harvard University Press, 1989.

Bernier, Georges. *Anne-Louis Girodet, 1767–1824.* Paris: Damase, 1975.

Bodek, Evelyn Gordon. "Salonnières and Bluestockings: Educated Obsolescence and Germinating Feminism." *Feminist Studies* 3 (1976).

Bolster, Richard. *Stendhal, Balzac et le féminisme romantique.* Paris: Minard, 1970.

Bonard, Olivier. *La peinture dans la création balzacienne.* Geneva: Droz, 1969.

Boime, Albert. *Art in the Age of Revolution.* Chicago: University of Chicago Press, 1987.

Borowitz, Helen O. "Balzac's *Sarrasine*: The Sculptor as Narcissus." *Nineteenth-Century French Studies* 5.3–4 (1977): 171–85.

——. "Balzac's Unknown Masters." *Romanic Review* 72.4 (1981): 425–441.

Borzello, Frances. *The Artist's Model.* London: Junction, 1982.

Boureau-Deslandes. *Pygmalion ou la statue animée.* Paris, 1741.

Bourdieu, Pierre, *The Field of Cultural Production: Essays on Art and Literature.* New York: Columbia University Press, 1993.

——. "The Link between Literary and Artistic Struggles." Collier and Lethbridge. 30–39.

——. *Le Règles de l'art: Genèse et structure du champ littéraire.* Paris: Seuil, 1992.

Brooks, Peter. *Body Work: Objects of Desire in Modern Narrative.* Cambridge: Harvard University Press, 1993.

Bryson, Norman. *Vision and Painting: The Logic of the Gaze.* New Haven: Yale University Press, 1983.

——. *Word and Image: French Painting of the Ancien Régime.* Cambridge: Cambridge University Press, 1981.

——, Michael Holly and Keith Moxey, eds. *Visual Culture: Images and Interpretations.* Hanover: Wesleyan University Press, 1994.

——. *Word and Image: French Painting of the Ancien Régime.* Cambridge: Cambridge University Press, 1981.

Bulliet, C. J. *The Courtezan Olympia: An Intimate Survey of Artists and their Mistress-Models.* New York: Covivi, Friede, 1930.

Burns, Sarah. "Girodet-Trioson's *Ossian*: The Role of Theatrical Illusionism in a Pictorial Evocation of Otherworldly Bodies." *Gazette des Beaux-Arts* 95 (1980): 13–24.

Burton, Richard D. E. "The Unseen Seer, or Proteus in the City: Aspects of a Nineteenth-Century Parisian Myth." *French Studies* 42 (1988): 50–68.

Butler, Judith. *Gender Trouble: Feminism and the Subversion of Identity.* New York: Routledge, 1990.

Carr, J. L. "Pygmalion and the *Philosophes*: The Animated Statue in Eighteenth-Century France." *Journal of the Warburg and Courtauld Institutes* 23. 3–4 (1960): 239–255.

Caws, Mary Ann. *The Eye in the Text: Essays on Perception, Mannerist to Modern.* Princeton: Princeton University Press, 1981.

Chambers, Ross. "Gautier et le complexe de Pygmalion." *Revue d'histoire littéraire de la France* 72.4 (1972): 641–658.

——. *Story and Situation: Narrative Seduction and the Power of Fiction.* Minneapolis: University of Minnesota Press, 1984.

Champfleury. *Champfleury: son regard et celui de Baudelaire.* Paris: Hermann, 1990.

Chateaubriand, René. *Oeuvres romanesques et voyages.* 2 Vols. Ed. Maurice Regard. Paris: Gallimard-Pléiade, 1969.

Chu, Petra and Gabriel P. Weisberg, eds. *The Popularization of Images: Visual Culture under the July Monarchy.* Princeton: Princeton University Press, 1994.

Clark, Kenneth. *The Nude: A Study in Ideal Form.* Garden City, NY: Doubleday, 1956.

Clayson, Hollis. *Painted Love: Prostitution in French Art of the Impressionist Era.* New Haven: Yale University Press, 1991.

Clements, Candace. "The Academy and the Other: *Les Grâces* and *Le Genre Galant.*" *Eighteenth-Century Studies* 25.4 (1992): 469–94.

Collier, Peter and Robert Lethbridge, eds. *Artistic Relations: Literature and the Visual Arts in Nineteenth-Century France.* London: Yale University Press, 1994.

Condillac. *Oeuvres philosophiques.* Ed. Georges Leroy. 3 Vols. Paris: Presses Universitaires de France, 1947.

Crow, Thomas E. "B/G." *Vision and Textuality.* Eds. Melville and Reading. Durham: Duke University Press, 1995. 296–314.

——. *Emulation: Making Artists for Revolutionary France.* New Haven: Yale University Press, 1995.

——. "Observations on Style and History in French Painting of the Male Nude 1785–1794." Bryson, Holly and Moxey 141–167.

——. *Painters and Public Life in Eighteenth-Century France.* New Haven: Yale University Press, 1985.

——. "Revolutionary Activism and the Cult of Male Beauty." *Fictions of the French Revolution.* Ed. Bernadette Fort. Evanston: Northwestern University Press, 1991.

Damiron, Suzanne. "La Revue *L'Artiste*: Histoire administrative. Présentation technique. Gravures hors texte." *Bulletin de la société de l'art français* (1951–52): 131–42.

——. "La Revue *L'Artiste*: Sa fondation, son époque, ses amateurs." *Gazette des Beaux-Arts* (October 1954): 191–226.

Damisch, Hubert. "The Underneaths of Painting." Trans. Francette Pacteau and Stephen Bann. *Word & Image* 1.2 (1985): 197–209.

Davis, Natalie Zemon. *Society and Culture in Early Modern France.* Stanford: Stanford University Press, 1975.

Davis, Whitney. "The Renunciation of Reaction in Girodet's *Sleep of Endymion.*" Bryson, Holly and Moxey 168–201.

Delacroix, Eugène. "Des critiques en matière d'art." *Revue de Paris* (May 1829).

"De la galerie de M. de Sommariva." *L'Artiste* 2e série (1839): 185–186.

De la Motte, Dean and Jeannene Przyblyski, eds. *Making the News: Modernity and the Mass Press in Nineteenth-Century France.* Amherst: University of Massachussets Press, 1999.

Delécluze, E. J. "Au Rédacteur du *Lycée français* sur l'exposition des ouvrages de peinture, sculpture et gravure des Artistes vivants." *Lycée français* 2 (1819): 236–45.

——. *Louis David: Son Ecole et son temps.* 1855. Paris: Macula, 1983.

——. *Journal 1824–1828.* Paris: Grassat, 1948.

DeMan, Paul. *Allegories of Reading: Figural Language in Rousseau, Nietzsche, Rilke, and Proust.* New Haven: Yale University Press, 1979.

D'Este, Lauriane Fallay. *Le Paragone: Le Parallèle des arts*. Paris: Klincksieck, 1992.

Dibdin, T.F. *A Bibliographical, Antiquarian and Picturesque Tour in France and Germany*. London, 1821.

Diderot, Denis. *Essais sur la peinture. Salons de 1759, 1761, 1763*. Ed. Gita May and Jacques Chouillet. Paris: Hermann, 1984.

——. *Oeuvres complètes*. Ed. J. Assézat and M. Tourneux. 20 Vols. Paris: Garnier, 1875–77.

Didi-Huberman, Georges. *La Peinture incarnée*. Paris: Minuit, 1985.

Doy, Gen. *Women and Visual Culture in Ninteenth-Century France 1800–1852*. London: Leicester University Press, 1998.

Duncan, Carol. *The Aesthetics of Power: Essays in Critical Art History*. Cambridge: Cambridge University Press, 1993.

Easton, Malcolm. *Artists and Writers in Paris: The Bohemian Idea 1803–1867*. London: Edward Arnold, 1964.

Eisenman, Stephen. *Nineteenth-Century Art: A Critical History*. London: Thames and Hudson, 1994.

Eitner, Lorenz. *An Outline of 19th-Century European Painting from David to Cézanne*. New York: Icon, 1987.

E. J. [Victor Etienne, dit Jouy]. "Pygmalion et Galatée." *La Minerve française* 8 (1819): 170–73.

Farwell, Beatrice. *The Charged Image: French Lithographic Caricature 1816–1848*. Santa Barbara Museum of Art, 1989.

Feldman, Burton and Robert Richardson. *The Rise of Modernity Mythology 1680–1860*. Bloomington: Indiana University Press, 1972.

Felman, Shoshana. "Rereading Femininity." *Yale French Studies* 62 (1981): 19–44.

Ferguson, Priscilla Parkhurst. "The *Flâneur*: Urbanization and its Discontents." *Home and its Dislocations in Nineteenth-Century France*. Ed. Suzanne Nash. Albany: SUNY Press, 1993. 45–61.

Fonvielle, Bernard-François-Anne. *Examen critique et impartiel du tableau de M. Girodet (Pygmalion et Galatée), ou Lettre d'un amateur à un journaliste*. Paris: Boucher, 1819.

Fosca, François. "Les Artistes dans les romans de Balzac." *La Revue critique des idées et des livres* 34 (1922): 133–52.

Frank, Joseph. *The Widening Gyre: Crisis and Mastery in Modern Literature*. New Brunswick: Rutgers University Press, 1963.

Frappier-Mazur, Lucienne. "Balzac and the Sex of Genius." *Renascence* 27.1 (1974): 23–30.

Freedberg, David. *The Power of Images: Studies in the History and Theory of Response*. Chicago: University of Chicago Press, 1989.

Frénilly, Baron de. *Souvenirs du Baron de Frénilly, pair de France, 1768–1828*. Paris: Plon, 1908.

Freud, Sigmund. *The Standard Edition of the Complete Psychological Works*. Trans. James Strachey, et alia. 24 Vols. London: Hogarth, 1953–74.

Fried, Michael. *Absorption and Theatricality: Painting and the Beholder in the Age of Diderot.* Chicago: University of Chicago Press, 1977.

Gamboni, Dario. *La Plume et le pinceau: Odilon Redon et la peinture.* Paris: Minuit, 1989.

Gans, E.L. *Essais d'esthétique paradoxale.* Paris: Gallimard, 1977.

Garnier, M. *Funérailles de M. Girodet.* Paris: Firmin Didot, 1824.

Gault de Saint-Germain. *Epitre aux amateurs sur le tableau de Galaée pour faire suite aux choix des productions de l'art dans le Salon de 1819.* Paris: Huzard, 1819.

Gautier, Théophile. *Honoré de Balzac, sa vie et ses oeuvres.* Paris: Poulet-Malassis, 1859.

——. *Portraits contemporains.* Paris: Charpentier, 1881.

Georgel, Pierre and Anne-Marie Lecoq. *La Peinture dans la peinture.* Dijon: Musée des Beaux-Arts, 1982.

Gilman, Margaret. "Balzac and Diderot: *Le Chef-d'oeuvre inconnu.*" *PMLA* 65 (1960): 644–48.

Girodet, Anne-Louis. *Critique des critiques. Etrennes aux connoisseurs.* Paris: Firmin Didot, 1807.

——. *Oeuvres posthumes.* Ed. P.A. Coupin. 2 Vols. Paris: Renouard, 1829.

Goncourt, Jules and Edmond. *Histoire de la société française pendant le Directoire.* 1864. Paris: Gallimard, 1992.

Graña, César. *Modernity and its Discontents.* New York: Harper & Row, 1964.

Greenberg, Clement. "Towards a Newer Laocoön." *Partisan Review* 7 (1940).

Gross, Kenneth. *The Dream of a Moving Statue.* Ithaca: Cornell University Press, 1992.

Grosz, Elizabeth. "Lesbian Fetishism?" Apter and Pietz 101–115.

Guise, René. "Balzac et la presse de son temps: Le romancier devant la critique féminine." *L'année balzacienne* n.s. 3 (1982): 77–105.

Guizot, François. *Essai sur les limites qui séparent et les liens qui unissent les Beaux-Arts.* 1816–18. La Rochelle: Rumeur des Ages, 1995.

Gutwirth, Madelyn. *Madame de Staël, Novelist: The Emergence of the Artist as a Woman.* Urbana: University of Illinois Press, 1978.

——. *The Twilight of the Goddesses: Women and Representation in the French Revolutionary Era.* New Brunswick: Rutgers University Press, 1992.

Hagstrum, Jean. *The Sister Arts: The Tradition of Literary Pictorialism and English Poetry from Dryden to Gray.* Chicago: University of Chicago Press, 1958.

Hannoosh, Michele. *Baudelaire and Caricature: From the Comic to an Art of Modernity.* University Park: Pennsylvania State University Press, 1992.

——. "La femme, la ville, le réaisme: fondements épistemologiques dans le Paris de Balzac." *Romanic Review* 82.2 (1991): 127–45.

Harding, James. *Artistes Pompiers: French Academic Art in the Nineteenth Century.* New York: Rizzoli, 1979.

Harris, A.S. and Linda Nochlin, *Women Artists 1550–1950.* New York: Knopf, 1978.

Harter, Deborah. "From Represented to Literal Space: Fantastic Narrative and the Body in Pieces." *L'Esprit Créateur* 28.3 (1988): 23–35.

Haskell, Francis. *Past and Present in Art and Taste: Selected Essays.* New Haven: Yale University Press, 1987.

Heathcote, Owen. "The Engendering of Violence and the Violation of Gender in Honoré de Balzac's *La Fille aux yeux d'or.*" *Romance Studies* 22 (1993): 99–112.

I. G. "Salon de 1819. Lettre de l'Artiste à Pasquin et Marferio." *La Renommée* (19 November 1819): 619–620.

Irigaray, Luce. *The Speculum of the Other Woman.* Ithaca: Cornell University Press, 1986.

Janin, Jules. "Etre artiste." *L'Artiste* I (1831): 9–12.

Johnson, Barbara. *The Critical Difference: Essays in the Contemporary Rhetoric of Reading.* Baltimore: Johns Hopkins University Press, 1980.

Jouin, Henri, ed. "Lettres inédites d'artistes français du XIXe siècle." *Nouvelles Archives d'art français* XVI, 3e série, 1900. 20–349.

Kelly, Dorothy. *Fictional Genders: Role and Representation in Nineteenth-Century French Narrative.* Lincoln: University of Nebraska Press, 1989.

Kératry. *Annuaire de l'Ecole française de peinture, ou lettre sur le Salon de 1819.* Paris: Baudouin, 1820.

Kleinart, Annemarie. "Balzac vu par *Le Journal des Dames et des Modes.*" *L'Année balzacienne* n.s. 9 (1988): 367–393.

Krieger, Murray. *Ekphrasis: The Illusion of the Natural Sign.* Baltimore: Johns Hopkins University Press, 1992.

Kris, Ernst and Otto Kurz. *Legend, Myth and Magic in the Image of the Artist.* New Haven: Yale University Press, 1979.

Lacan, Jacques. *Ecrits.* Paris: Seuil, 1966.

La Fontaine, Jean. *Oeuvres complètes.* 7 Vols. Paris: Garnier, 1872.

Landes, Joan. *Women and the Public Sphere in the Age of French Revolution.* Ithaca: Cornell University Press, 1988.

Landon, C.P. *Le Salon de 1819.* 2 Vols. Paris: Imprimerie Royale, 1820. 2: 10–16.

Lanes, Jerrold. "Art Criticism and the Authorship of the *Chef-d'oeuvre inconnu*: A Preliminary Study." *The Artist and Writer in France.* Ed. Francis Haskell, Anthony Levi and Robert Shackleton. Oxford: Clarendon Press, 1974. 86–99.

Laqueur, Thomas. "Orgasm, Generation and the Politics of Reproductive Biology." *The Making of the Modern Body: Sexuality and Society in the Nineteenth Century.* Ed. Catherine Gallagher and Thomas Laqueur. Berkeley: University of California Press, 1987. 1–41.

———. *Making Sex: Body and Gender from the Greeks to Freud.* Cambridge: Harvard University Press, 1990.

Lathers, Marie. *Bodies of Art: French Literary Realism and the Artist's Model.* Lincoln: University of Nebraska Press, forthcoming 2001.

———. "Modesty and the Artist's Model in *Le Chef-d'oeuvre inconnu.*" *Symposium* 46.1 (1992): 49–71.

———. "The Social Construction and Deconstruction of the Female Model in Nineteenth-Century France." *Mosaic* 29.2 (1996): 23–52.

Laubriet, Pierre. *Un Catéchisme esthétique: Le Chef-d'oeuvre inconnu.* Paris: Didier, 1961.

——. *L'Intelligence de l'art chez Balzac.* Paris: Didier, 1961.

Lavater, J. C. *Essays on Physiognomy for the Promotion of the Knowledge and Love of Mankind.* Trans. T. Holcroft. 3 Vols. London: Robinson, 1789.

Laveissière, Sylvain. *Pierre-Paul Prud'hon.* New York: Metropolitan Museum of Art, 1998.

Lee, Rensselaer W. *Ut Pictura Poesis: The Humanistic Theory of Painting.* New York: Norton, 1967.

Le Men, Ségolène. "Book Illustration." Collier and Lethbridge 94–110.

Lethbridge, Robert. "Manet's Textual Frames." Collier and Lethbridge 144–158.

Leonardo. *On Painting.* Trans. and ed. Martin Kemp and Margaret Walker. New Haven: Yale University Press, 1989.

Les Français peints par eux-mêmes. Paris: Curmer, 1841.

Lessing, G. *Laocoön: An Essay on the Limits of Painting and Poetry.* Ed. E. A. McCormick. New York: Bobbs-Merrill, 1962.

Lettres adressées au Baron Gérard. 2 Vols. Paris: Quantin, 1886.

Levey, Michael. *The Painter Depicted: Painters as a Subject in Painting.* London: Thames and Hudson, 1981.

Levain, A. *Girodet considéré comme écrivain.* Montargis: Bulletins de la société d'Emulation de l'arrondissement de Montargis, XII, n.d.

Levine, Steven Z. "To See or Not to See: The Myth of Diana and Actaeon in the Eighteenth Century." Bailey, *The Loves of the Gods* 73–95.

Levitine, George. "Girodet's *New Danaë:* The Iconography of a Scandal." *Minneapolis Institute of Arts Bulletin* 58 (1969): 69–77.

——. *Girodet-Trioson: An Iconographical Study.* New York: Garland, 1978.

——. "*L'Ossian* de Girodet et l'actualité politique sous le Consulat." *Gazette des Beaux-Arts* (1956): 39–56.

Locquin, Jean. *La Peinture d'histoire en France de 1747 à 1785.* 1912. Neuilly-sur-Seine: Arthéna, 1978.

Lowrie, Joyce. "The Artist Real and Imagined: Diderot's Quentin de la Tour and Balzac's Frenhofer." *Romance Notes* 31.3 (1991): 267–73.

Lucian. *Loves of the Gods.* Trans. M.D. Macleod. Cambridge: Harvard University Press, 1961.

MacGregor, Neil. "Girodet's poem *Le Peintre.*" *Oxford Art Journal* 4.1 (1981): 26–30.

Mainardi, Patricia. *Art and Politics of the Second Empire: The Universal Expositions of 1855 and 1867.* New Haven: Yale University Press, 1987.

——. *The End of the Salon: Art and the State in the Early Third Republic.* Cambridge: Cambridge University Press, 1993.

——. *Collected Works.* London: Lawrence and Wishart, 1975.

Marin, Louis. "Le moi et les pouvoirs de l'image: Glose sur *Pygmalion, scène lyrique.*" *MLN* 107 (1992): 659–672.

Marmontel. *Mémoires.* 2 Vols. Clermont-Ferand: Bussac, 1972.

Marx, Karl. *Capital.* London: Dent, 1974.

Massé, F. "Sur la *Galatée* de M. Girodet." *La Quotidienne* (18 November 1819): 1.

Massengale, J. M. "Fragonard's *Elève*: Sketching in the Studio of Boucher." *Apollo* 226 (1980): 392–97.

May, Gita. *Diderot et Baudelaire: Critiques d'art.* Geneva: Droz, 1957.

Maza, Sarah. *Private Lives and Public Affairs: The Causes Célèbres of Prerevolutionary France.* Berkeley: University of California Press, 1993.

Mazzocca, Fernando.. "G.B. Sommariva o il borghese mecenate: il *cabinet* neoclassico di Parigi, la galleria romantica di Tremezzo." *Itinerari: Contributi alla Storia dell'Arte in Memoria di Maria Luisa Ferrari II.* Studio per Edizione Scelte, 1981.

Melville, Stephen and Bill Readings, eds. *Vision and Textuality.* Durham: Duke University Press, 1995.

Mercier. *Tribune Publique.* October 1796.

Miel, E.-F. *Notice sur Girodet-Trioson, peintre d'histoire, membre de l'Institut.* Annales de la Société libre des Beaux-Arts 12 (1842).

Miller, Jane. "Some Versions of Pygmalion." *Ovid Renewed.* Ed. Charles Martindale. Cambridge: Cambridge University Press, 1988. 205–224.

Miller, J. Hillis. *Versions of Pygmalion.* Cambridge: Harvard University Press, 1990.

Milner, Max. "Le Peintre fou." *Romantisme* 66 (1989): 5–21.

Mitchell, W.J.T. *Iconology: Image, Text, Ideology.* Chicago: University of Chicago Press, 1986.

———. "Word and Image." Nelson and Shiff 47–57.

Molino, Jean. "Balzac et la technique du portrait autour de *Sarrasine*." *Lettres et Réalité: Mélanges de littérature générale et de critique romanesque.* Aix-en-Provence: Université de Provence, 1988. 247–283.

Montaiglon, Anatole, ed. "Lettres du Comte Sommariva (1814–1825)." *Nouvelles Archives de l'art français* (1879): 297–320.

Morgan, Cheryl. "Unfashionable Feminisim?: Designing Women Writers in the *Journal des Femmes* (1832–1836)." *Making the News: Modernity and the Mass Press in Nineteenth-Century France.* Ed. Dean de la Motte and Jeannene M. Przyblyski. Amherst: University of Massachussetts Press, 1999. 207–232.

Moriarty, Michael. "Structures of Cultural Production in Nineteenth-Century France." Collier and Lethbridge 15–29.

Mulvey, Laura. *Visual and Other Pleasures.* Bloomington: Indiana University Press, 1989.

Nead, Linda. *The Female Nude: Art, Obscenity and Sexuality.* London: Routledge, 1992.

Nelson, Robert S. and Richard Shiff, eds. *Critical Terms for Art History.* Chicago: University of Chicago Press, 1996.

Nesci, Catherine. *La Femme mode d'emploi: Balzac, de la Physiologie du mariage à La Comédie humaine.* Lexington, KY: French Forum, 1993.

Nochlin, Linda. *The Body in Pieces: The Fragment as a Metaphor of Modernity.* London: Thames and Hudson, 1995.

———. "Courbet's Real Allegory: Rereading *The Painter's Studio.*" *Courbet Reconsidered.* Ed. Sarach Faunce and Linda Nochlin. New York: Brooklyn Museum, 1988.

———. *Women, Art and Power and Other Essays.* New York: Harper & Row, 1988.

Noël, François, ed. *Dictionnaire de la fable.* 2 Vols. Paris: Le Normant, 1803.

Notice sur la Galatée de M. Girodet avec la gravure au trait. Paris: Pillet, 1819.

Nykrog, Per. "On Seeing and Nothingness: Balzac's *Sarrasine.*" *Romanic Review* 83.4 (1993): 223–79.

Ockman, Carol. *Ingres's Eroticized Bodies: Retracing the Serpentine Line.* New Haven: Yale University Press, 1995.

O'Donovan, Patrick. "Avatars of the Artist: Narrative Approaches to the Work of the Painter." Collier and Lethbridge 222–236.

Orwicz, Michael, ed. *Art Criticism and its Institutions in Nineteenth-Century France.* Manchester: Manchester University Press, 1994.

Osborne, Carol Margot. "Pierre Didot the Elder and French Book Illustration, 1789–1822. Diss. Stanford University, 1979.

Ovid. *Metamorphoses.* Trans. Mary M. Innes. Harmondsworth: Penguin, 1955.

P. A. "Notice sur l'exposition des tableaux, en 1819." *Revue encyclopédique* 4 (1819): 363–66.

P. C. *Description du tableau de Pygmalion et Galatée exposé au Salon par M. Girodet.* Paris, 1819.

Paradissis, A.G. "Balzac's Relationship with the Caricaturists and Popular Dramatic Satirists of the July Monarchy." *Australian Journal of French Studies* 2.1 (1965): 59–81.

Paulson, William. "Pour une analyse de la variation textuelle: *Le Chef-d'oeuvre* trop connu." *Nineteenth-Century French Studies* 19.3 (1991): 404–416.

Planté, Christine. *La Petite soeur de Balzac: Essai sur la femme auteur.* Paris: Seuil, 1989.

Physiologie des physiologies. Paris: Desloges, 1841.

Pillet, Fabien. "Pygmalion et Galathée, tableau de M. Girodet." *Journal de Paris* (9 November 1819): 2–3.

Pointon, Marcia. *Naked Authority. The Body in Western Painting 1830–1908.* Cambridge: Cambridge University Press, 1990.

Pollock, Griselda. *Vision and Difference: Femininity, Feminism and Histories of Art.* London: Routledge, 1988.

Porée, A. "Quelques lettres de peintres français." *Correspondance historique et archéologique.* Paris, 1907. 283–287.

Potts, Alex. "Beautiful Bodies and Dying Heroes: Images of Ideal Manhood in the French Revolution." *History Workshop Journal* 30 (1990): 1–21.

Praz, Mario. "Girodet's *Mlle Lange as Danaë.*" *Minneapolis Institute of Arts Bulletin* 58 (1969): 64–68.

———. *Mnemosyne: The Parallel between Literature and the Visual Arts.* Princeton: Princeton University Press, 1970.

Pruvost-Auzas, J., Ed. *Girodet, 1767–1824, Exposition du deuxième centenaire*. Montargis: Musée de Montargis, 1967.

Quatremère de Quincy. "Eloge historique de M. Girodet, peintre." *Receuil de Notices historiques lues dans les séances publiques de l'Académie des Beaux-Arts à l'Institut par Quatremère de Quincy*. Paris: Le Clère, 1834.

———. *Histoire de la vie et les ouvrages de Raphael*. Paris: Le Clère, 1833.

Rivers, Christopher. "*L'Homme hiéroglyphé*: Balzac, Physiognomy and the Legible Body." *The Faces of Physiognomy: Interdisciplinary Approaches to Lavater*. Ed. Ellis Shookman. Columbia, S.C.: Camden House, 1993.

Robb, Graham. *Balzac: A Biography*. New York: Norton, 1994.

Rose, Jacqueline. *Sexuality in the Field of Vision*. London: Verso, 1986.

Rosenblum, Robert. "Girodet." *Revue de l'art* 3 (1969): 100–101.

Rousseau, Jean-Jacques. *Lettre à M. d'Alembert sur les spectacles*. Paris: Garnier-Flammarion, 1967.

———. "Pygmalion: Scène lyrique." *Oeuvres complètes*. Paris: Gallimard-Pléiade, 1964. 1224–31.

Rubin, James H. "Endymion's Dream as a Myth of Romantic Inspiration." *The Art Quarterly* n.s. 1.2 (1978): 47–84.

———. "'Pygmalion and Galatea': Girodet and Rousseau." *The Burlington Magazine* 989 (1985): 517–520.

Saint-C. "De la position sociale des artistes." *L'Artiste* 4 (1832): 50–53.

Sainte-Beuve. "De la littérature industrielle." *Revue des deux mondes* 19 (1839) 3: 675–91.

Salm, Constance de. *Sur Girodet*. Paris: Firmin Didot, 1825.

Sarde, Michèle. *Regard sur les Françaises: Xe siècle- XX e siècle*. Paris: Stock, 1983.

Schehr, Lawrence R. "The Unknown Subject: About Balzac's *Le Chef-d'oeuvre inconnu*." *Nineteenth-Century French Studies* 12.4 (1984): 58–69.

Schlüter, Hermann. *Das Pygmalion-Symbol bei Rousseau, Hamann, Schiller*. Zurich: Juris Druck, 1968.

Schneider, Mechthild. "Pygmalion-Mythos des Schöpferischen Künstlers." *Pantheon* 45 (1987).

Schor, Naomi. *Breaking the Chain: Women, Theory and French Realist Fiction*. New York: Columbia University Press, 1985.

———. "*Triste Amérique: Atala* and the Postrevolutionary Construction of Woman." *Rebel Daughters: Women and the French Revolution*, ed. Sara Melzer and Leslie Rabine. Oxford: Oxford University Press, 1992.

Scheurewegen, Franc. "La Toile déchirée: Texte, tableau et récit dans trois nouvelles de Balzac." *Poétique* 65 (1986): 19–27.

Sckommodau, Hans. *Pygmalion bei Franzosen und Deutschen im 18. Jahrhundert*. Wiesbaden: Steiner, 1970.

Scott, David. *Pictorialist Poetics: Poetry and the Visual Arts in Nineteenth-Century France*. Cambridge: Cambridge University Press, 1988.

Scott, Mary Wingfield. *Arts and Artists in Balzac's Comédie humaine.* Chicago: University of Chicago Press, 1937.

Sée, Raymond. *Le Costume de la Révolution à nos jours.* Paris: Editions de la Gazette des Beaux-Arts, 1929.

Serres, Michel. *Genèse.* Paris: Grasset, 1982.

———. *L'Hermaphrodite.* Paris: Garnier-Flammarion, 1989.

Sheriff, Mary. *The Exceptional Woman: Elisabeth Vigée-Lebrun and the Cultural Politics of Art.* Chicago: University of Chicago Press, 1996.

———. *Fragonard: Art and Eroticism.* Chicago: University of Chicago Press, 1990.

Sieburth, Richard. "Une idéologie du lisible: le phénomène des 'Physiologies.'" *Romantisme* 47 (1985): 39–60.

Siegfried, Susan. *The Art of Louis-Léopold Boilly. Modern Life in Napoleonic France.* New Haven: Yale University Press, 1995.

———. "The Politicization of Art Criticism." *Art Criticism and its Institutions in Nineteenth-Century France.* Ed. Michael Orwicz. Manchester: Manchester University Press, 1994. 9–28.

Simpson, David. *Fetishism and Imagination: Dickens, Melville, Conrad.* Baltimore: Johns Hopkins University Press, 1982.

Solomon-Godeau, Abigail. "Male Trouble: A Crisis in Representation." *Art History* 16.2 (1993): 286–312.

———. *Male Trouble: A Crisis in Representation.* London: Thames and Hudson, 1997.

Spencer, Samia, ed. *French Women and the Age of Enlightenment.* Bloomington: Indiana University Press, 1984.

Stafford, Barbara Maria. *Body Criticism: Imaging the Unseen in Enlightenment Art and Medecine.* Cambridge: MIT Press, 1993.

———. "Les *Météores* de Girodet." *Revue de l'art* 46 (1979): 46–51.

Steiner, Wendy. *The Colors of Rhetoric: Problems in the Relation between Modern Literature and Painting.* Chicago: University of Chicago Press, 1982.

Stendhal. *Mélanges d'art et de littérature.* Paris: Michael Lévy, 1867.

Suleiman, Susan Rubin, ed. *The Female Body in Western Culture: Contemporary Perspectives.* Cambridge: Harvard University Press, 1986.

T. [Toussaint Bernard Emeric-David]. "Beaux-Arts. Salon. Sixième Article." *Moniteur universel* (15 November 1819): 1455–1456.

Terdiman, Richard. *Discourse/Counter-Discourse: The Theory and Practice of Symbolic Resistance in Nineteenth-Century France.* Ithaca: Cornell University Press, 1985.

Tilby, Michael. "'Tel main veut tel pied': Balzac, Ingres and the Art of Portraiture." Collier and Lethbridge 111–119.

Tourneux, M., ed. *Correspondance littéraire, philosophique et critique, par Grimm, Diderot, etc.* Paris: Garnier, 1875–82.

Tscherny, Nadia and Guy Stair Sainty, eds. *Romance and Chivalry: History and Literature Reflected in Early Nineteenth-Century Painting.* New York: Stair Sainty Matthiesen, 1996.

Ubersfeld, Annie. "Théophile Gautier ou le regard de Pygmalion." *Romantisme* 66 (1989): 51–59.

Valori, Marquis de. *Sur la mort de Girodet: Ode dédié à ses élèves.* Paris: Boucher, 1825.

Vasari. *The Lives of the Painters.* Oxford: Oxford University Press, 1991.

Vigny, Alfred. *Aux Mânes de Girodet. Elégie.* Paris, 1824.

Waller, Margaret. *The Male Malady: Fictions of Impotence in the French Romantic Novel.* New Brunswick: Rutgers University Press, 1993.

Wechsler, Judith. *A Human Comedy: Physiognomy and Caricature in 19th-Century Paris.* Chicago: University of Chicago Press, 1982.

White, Harrison and Cynthia White. *Canvases and Careers: Institutional Change in the French Painting World.* Chicago: University of Chicago Press, 1993.

Williams, Raymond. *Culture and Society, 1780–1950.* New York: Columbia University Press, 1983.

Winckelmann, J. J. *The History of Ancient Art.* Trans. G.H. Lodge. 2 Vols. London: Sampson Low, 1881.

Wood, Paul. "Commodity." Nelson and Shiff 257–280.

Wrigley, Richard. *The Origins of French Art Criticism from the Ancien Régime to the Restoration.* Oxford: Oxford University Press, 1993.

Ziolkowski, Theodore. *Disenchanted Images.* Princeton: Princeton University Press, 1977.

Zola, Emile. *L'Oeuvre.* Paris: Garnier-Flammarion, 1974.

Zmijewski, Helene. "La Critique des Salons en France avant Diderot." *Gazette des Beaux-Arts* (1970).

Index